DIAGHILEV AND THE GOLDEN AGE
OF THE BALLETS RUSSES 1909–1929

DIAGHILEV
AND THE GOLDEN AGE
OF THE BALLETS RUSSES
1909–1929

Edited by Jane Pritchard

V&A Publishing

This book is published to coincide with the
exhibition *Diaghilev and the Golden Age
of the Ballets Russes 1909–1929* at the
Victoria and Albert Museum, London
25 September 2010 – 9 January 2011

With thanks to the
BLAVATNIK FAMILY FOUNDATION

First published by
V&A Publishing, 2010

V&A Publishing
Victoria and Albert Museum
South Kensington
London SW7 2RL

Hardback edition
ISBN 978 1 85177 613 9

Library of Congress Control Number 2010923426

10 9 8 7 6 5 4 3 2 1
2014 2013 2012 2011 2010

A catalogue record for this book is available from the
British Library.

Design by Rose
Copy-editor: Kate Bell

V&A Photography by the V&A Photographic Studio

Front jacket: Léon Woizikovsky, Lydia Sokolova,
 Bronislava Nijinska and Anton Dolin in
 Le Train bleu photographed on the set of *Baba
 Yaga* at the London Coliseum, December 1924.
 Photograph by Sasha.
 V&A: Theatre & Performance Collections
Back jacket: Detail of pl.83. V&A: S.837–1981
Overleaf: Serge Diaghilev, 1916.
 Photograph by Jan de Strelecki.
 Jerome Robbins Dance Division, The New York
 Public Library for the Performing Arts

Printed in Singapore by CS Graphics

V&A Publishing
Victoria and Albert Museum
South Kensington
London SW7 2RL
www.vandabooks.com

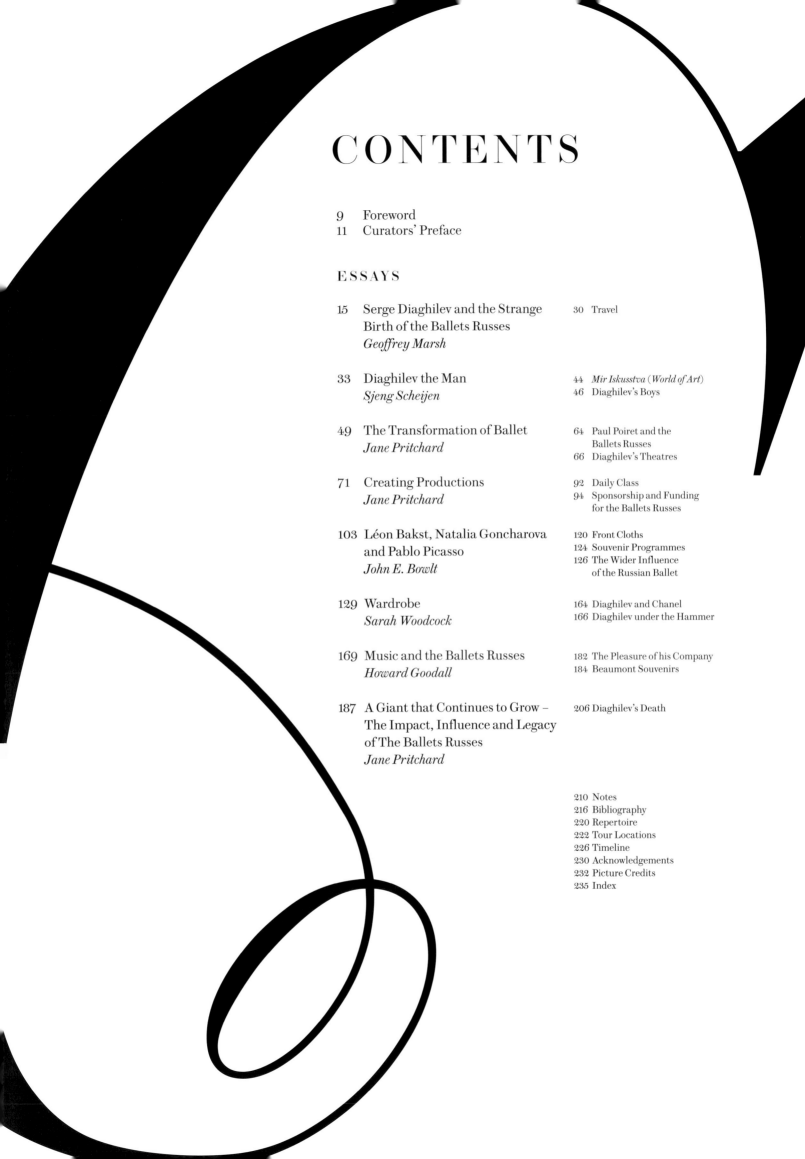

CONTENTS

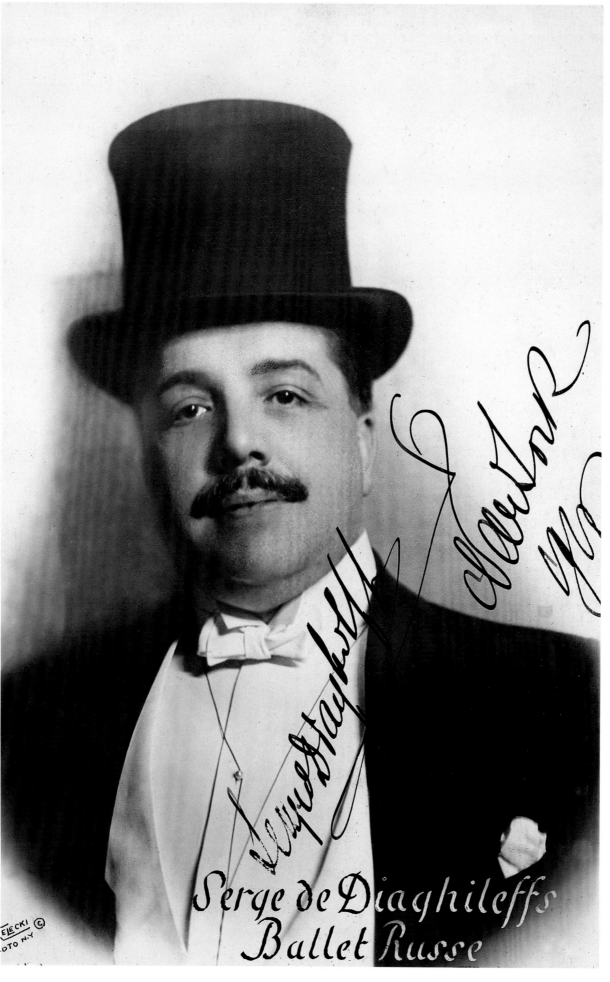

Serge de Diaghileffs
Ballet Russe

I MET DIAGHILEV IN THE AUTUMN OF 1909.... FROM ALL THAT I
HAD HEARD OF HIM, I IMAGINED HIM HAUGHTY, ARROGANT, AND
SNOBBISH. TO TELL THE TRUTH, I FOUND, AFTER I MET HIM, THAT
THE REPUTATION PEOPLE HAD GIVEN HIM WAS NOT ENTIRELY
WITHOUT FOUNDATION. HE HAD MANY UNSYMPATHETIC TRAITS –
WHICH, HOWEVER, WERE NOT THE ESSENCE OF HIS NATURE....
I THINK THE EXPRESSION 'RUSSIAN BARIN' CHARACTERIZES
DIAGHILEV'S NATURE AND EXPLAINS HIS AMAZING ACTIVITY
AS THE INSPIRER, PROMOTER, AND ORGANIZER OF A LONG SERIES
OF ARTISTIC EVENTS ... IT IS ONLY BY UNDERSTANDING THE
NATURE OF A CULTURED BARIN SUCH AS USED TO EXIST IN
RUSSIA (A NATURE GENEROUS, STRONG, AND CAPRICIOUS; WITH
INTENSE WILL, A RICH SENSE OF CONTRASTS, AND DEEP ANCESTRAL
ROOTS) THAT WE CAN EXPLAIN THE CHARACTER AND ORIGINALITY
OF DIAGHILEV'S CREATIONS, SO DIFFERENT FROM THE AVERAGE
ARTISTIC ENTERPRISES. APART FROM HIS INTELLIGENCE, HIS
CULTURE, HIS EXTRAORDINARY ARTISTIC FLAIR, AND HIS SINCERE
ENTHUSIASM, HE POSSESSED A WILL OF IRON, TENACITY, AN
ALMOST SUPERHUMAN RESISTANCE AND PASSION TO FIGHT AND
TO OVERCOME THE MOST INSURMOUNTABLE OBSTACLES.... HE
DISPLAYED CHARACTERISTICS OF THE ENLIGHTENED DESPOT,
OF THE NATURAL LEADER WHO KNOWS HOW TO DRIVE THE MOST
UNYIELDING ELEMENTS, AT TIMES USING PERSUASION, AT OTHERS,
CHARM. HIS PASSIONATE DEVOTION TO THE CAUSE HE SERVED AND
TO THE IDEAS HE WAS THEN PROMULGATING AND HIS COMPLETE
DISINTERESTEDNESS AND LACK OF PERSONAL AMBITION IN ALL
HIS ENTERPRISES WON THE HEARTS OF HIS CO-WORKERS. WORKING
WITH HIM, THEY REALIZED, MEANT WORKING SOLELY FOR THE
GREAT CAUSE OF ART.

FROM IGOR STRAVINSKY, 'THE DIAGHILEV I KNEW', *ATLANTIC MONTHLY* (NOVEMBER 1952), VOL.192 (5), PP.33–6

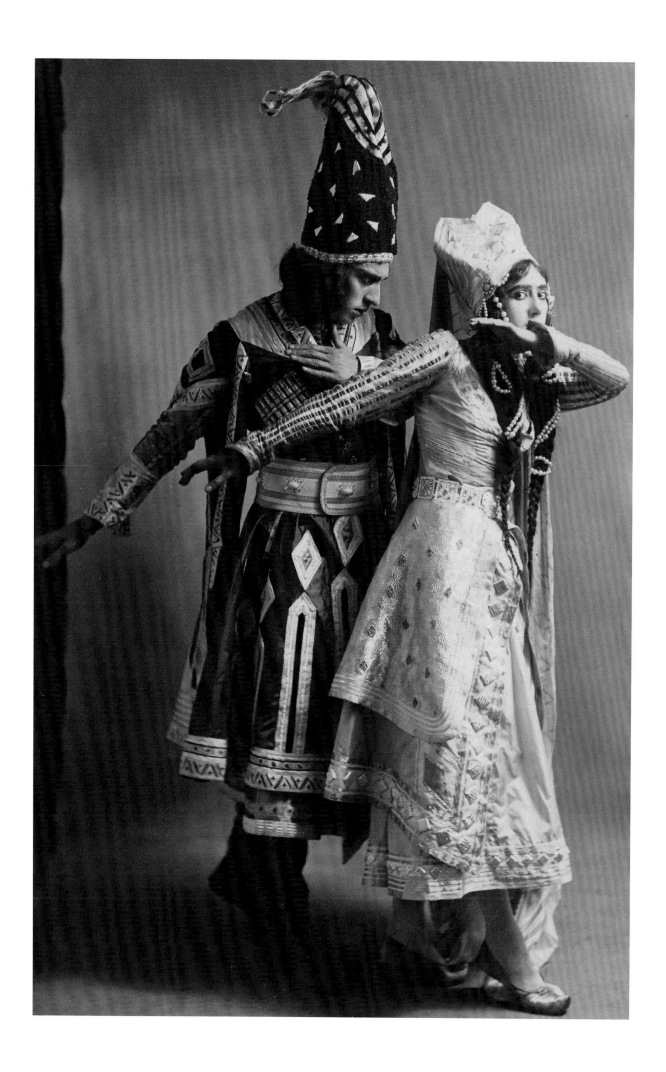

FOREWORD

MARK JONES

Over the course of five evenings in Paris – 19 June 1910, 29 May 1913, 18 May 1917, 13 July 1923, 7 June 1927, the premières of *The Firebird*, *The Rite of Spring*, *Parade*, *Les Noces*, *Le Pas d'acier* – the Ballets Russes brought into being dances that echo the twentieth century. *Diaghilev and the Golden Age of the Ballets Russes 1909–1929* recounts the story of a remarkable man and his creations, which coloured modernism with a riot of innovative showpieces in the space of 20 years.

The responsibility of a world-class museum such as the V&A is not simply to preserve the great creations of humanity, but also to highlight and resurrect the complex relationship of commissioning, creativity and communication between artists, patrons and consumers that has shaped our culture and identity. Serge Diaghilev came to prominence at a crucial moment in the history of European art. Just a few years earlier in October 1906, at the newly built Grand Palais in Paris, the fourth Salon d'Automne art show presented contemporary French work and the famous Gauguin retrospective, while Diaghilev, aged 34, provided a special exhibition of Russian Art. Picasso, a still little-known 24-year-old, certainly visited the Salon but did he visit the Russian section? Did he see Diaghilev, or speak to him? No one knows.

What is certain is that within a few months Picasso had begun painting *Les Demoiselles d'Avignon* (1907), the turning point in early twentieth-century art. Almost in parallel, Diaghilev created the Ballets Russes, which was to revolutionize dance, and began to commission the scores which shaped twentieth-century music. Ten years later both men were international celebrities and began to work together. By July 1916, when *Les Demoiselles d'Avignon* was first shown to the public at the Salon d'Antin, on the premises of fashion designer Paul Poiret's couture house, Picasso had agreed to design Jean Cocteau and Erik Satie's *Parade* for the Ballets Russes – the production which he claimed brought Cubism to the notice of a general audience.

Picasso continued to work for Diaghilev until 1924, and the V&A's exhibition contains a triumph of this collaboration – the front cloth for *Le Train bleu*, painted in celebration of the 1924 Paris Olympics, and now one of the museum's prize objects. Dedicated by Picasso to Diaghilev, it symbolizes the intensity of their often fraught relationship. It also illustrates the challenges of preserving ballet – the most fugitive of performance arts.

The V&A has pioneered the use of video to record performance in the UK but, alas, Diaghilev actively prevented the Ballets Russes from being filmed. We therefore rely on designs, costumes, scores, drawings and reminiscences to evoke this extraordinary chapter of early twentieth-century cultural history. This book demonstrates the huge artistic achievement of the company – a century later, in theatres around the world, audiences are still thrilled by the ballets created by this unique man.

Mark Jones
19 June 2010

Adolph Bolm and Tamara
Karsavina in *Thamar*, 1912.
Photograph by Bert.
V&A: Theatre &
Performance Collections
THM/165

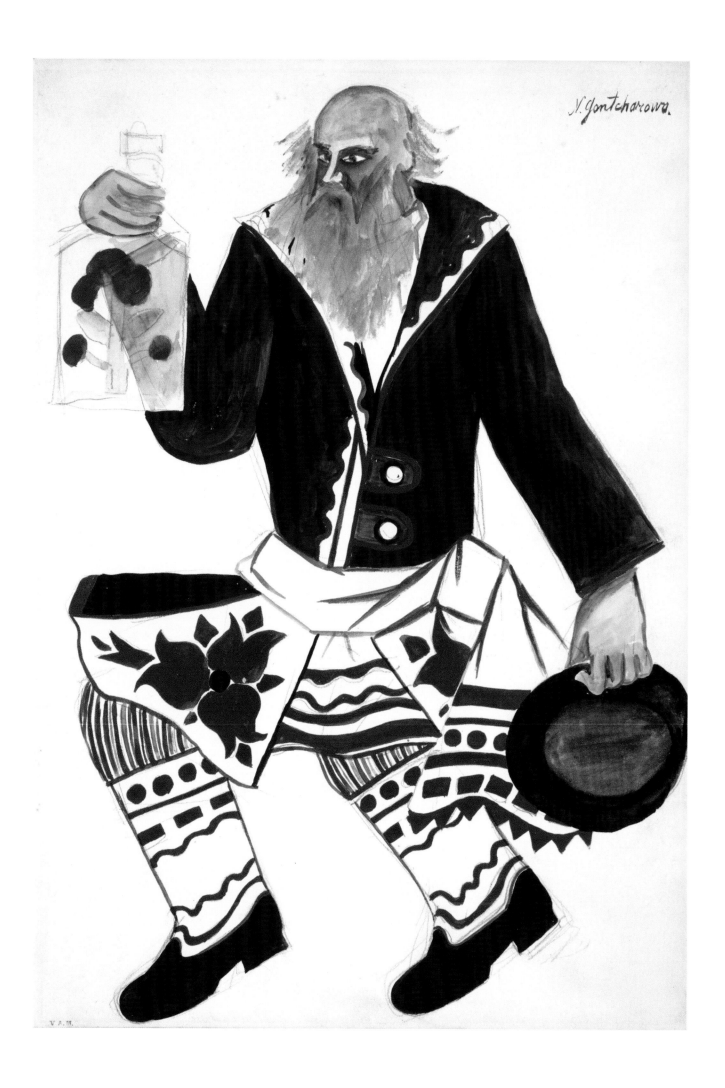

CURATORS' PREFACE

JANE PRITCHARD AND
GEOFFREY MARSH

Serge Diaghilev's driving ambition created a ferment in European culture in the early twentieth century, and left a powerful legacy of music, dance and art which resonated across the century. However, as an individual he remains elusive, a puppet master who created the Ballets Russes as a vehicle for great art but also to fulfil his own complex dreams and destiny.

In looking at the productions of the Ballets Russes, we place the focus on Diaghilev's collaborations and the work of his peripatetic performing company. We also recognize that in theatre the creative process does not end with the first performance, but continues throughout the life of the production – and then on through developments by other companies. The tables at the end of the book set out the 'life-line' of Diaghilev's productions, and the extent of the company's tours. Accurately dating designs for ballets that were subsequently reworked, and costumes which were adapted and re-thought is a challenge but we have tried to be precise in dating objects, rather than giving the generic dates of the first performance. Russian dates are all given in new style unless otherwise stated.

We would like to thank particularly Howard Goodall, Sjeng Scheijen and Nina Lobanov-Rostovsky. Howard acted as curator for the music aspects of the exhibition. Music is notoriously difficult to integrate into museum displays and is a special challenge in Ballets Russes exhibitions. Howard's enthusiasm and vast knowledge have ensured that Diaghilev's huge contribution in this area is fully recognized. Sjeng not only gave extremely valuable advice, but allowed

us to preview his biography of Diaghilev, for which everyone interested in the subject is indebted to him. Nina has been not only a generous lender to the exhibition, but also acted as an external consultant to the project. As such she has given us the benefit of a lifetime studying the Ballets Russes and opened many doors to private collections and individuals. The exhibition would have been much the poorer without her assistance.

We would also like to thank John Bowlt and Sarah Woodcock, both internationally recognized specialists, for their essays, and the V&A curators who provided the lively articles on different aspects of the company.

The V&A has substantial holdings of Ballets Russes material, particularly within the Theatre & Performance Collection. These include the cloths for six Diaghilev ballets and the world's largest collection of costumes worn by the dancers. We must acknowledge a huge debt to former colleagues and supporters, most notably Richard Buckle and Alexander Schouvaloff, who enabled the museum to acquire its varied archives and collections.

The exhibition and book have benefited from the generosity of individuals and collections who have lent material, and full acknowledgement of contributors is found on p.230–1. We must, however, offer our heartfelt thanks to our Research Assistant, Sarah Sonner who has worked with dedication and tireless good humour throughout the project.

Finally, for the exhibition we offer our sincere thanks to the Blavatnik Family Foundation and gratefully acknowledge the support of the American Friends of the V&A.

Natalia Goncharova,
costume design for a
Russian peasant with a flask
of vodka from *Le Coq d'or*.
Watercolour and body-
colours, 1914.
V&A: E.297–1961

Valentine Gross,
woodcut-style drawing of a
coachman and nursemaids
in *Petrushka*. Ink on tracing
paper, 1912.
V&A: S.2310–2009

OUCHKA 1912

SERGE DIAGHILEV AND THE STRANGE BIRTH OF THE BALLETS RUSSES

GEOFFREY MARSH

Relishing National Acclaim: Spring 1905
In the Banqueting Suite of the Metropole Hotel, Moscow, a tall, bulky, elegantly dressed man stands up and acknowledges the appreciative applause of his colleagues – artists, critics, writers and friends (frontispiece, p.2). They have gathered at a gala banquet to honour Serge Pavlovich Diaghilev's creation of the stupendous *Exhibition of Russian Historical Portraits* in the capital, St Petersburg.[1] The tsar, Nicholas II, has already opened the display in person and spent two hours viewing most of his Romanov ancestors among the many famous Russians (pl.1).

As Diaghilev looks down at his speech, provocatively entitled 'The Hour of Reckoning', he is acutely aware of the political turmoil outside and its extreme violence. Seven weeks earlier, and only a few hundred metres away, the Grand Duke Sergei Aleksandrovich, the tsar's uncle and brother-in-law, had been blown apart by a terrorist bomb inside the precincts of the Kremlin.[2]

After reflecting that his tour of country houses, hunting for paintings, had revealed that 'The end was here in front of me', Diaghilev concludes:

> We are witnessing the greatest historic hour of reckoning, of things coming to an end in the name of a new, unknown culture – one which we will create but which will also sweep us away … I raise my glass … to the new commandments of a new aesthetic. The only wish that I, an incorrigible sensualist, can express, is that the forthcoming struggle should not damage the amenities of life, and that the death should be as beautiful and illuminating as the Resurrection.[3]

As Diaghilev spoke these words, he must have felt at the peak of his artistic success and that full official recognition was within his grasp. At 33, he had assembled an exhibition recognized as a benchmark in the appreciation of Russian art and identity. Even his enemies acknowledged his astonishing organizational abilities, particularly during the dramatic political upheavals following the 'Bloody Sunday' massacre.[4]

Diaghilev's Changing World
In 1905, Diaghilev would probably have dismissed as absurd the idea that he would manage a commercial ballet company outside Russia. Yet, four years later, it had become his peculiar destiny – a strange mixture of creative adventure, nationalistic responsibility and entrepreneurial burden. Like Diaghilev's complex character, the birth of the Ballets Russes was not straightforward. A coincidence of external circumstances created an unusual opportunity, but it was the infusion of Diaghilev's restless ambition that provided the catalyst for the creation of one of the greatest artistic enterprises of the twentieth century.

If Diaghilev had successfully ridden out the cultural storm predicted in his Moscow speech, his Imperial connections combined with his radical artistic stance might have resulted in the offer of a key position in the Russian art world. Diaghilev aimed high and believed he could be Minister of Culture.[5] Such an appointment would secure his reputation, status and fortune for life. Yet, despite his immediate triumph in 1905, this happy outcome was not to be. Whereas before 1906 his artistic endeavours had been within Russia, after 1906 they were all to take place abroad. In this profound change lay the origins of the Ballets Russes. For the next 20 years Diaghilev's entire life would be devoted to creating great performance, everywhere but in Russia.

To understand the origins of the Ballets Russes in these years, it is essential to appreciate that Diaghilev was intensely driven to succeed, a characteristic that went back to his early years. He was born on 19 March 1872, near

Nizhny Novgorod, but his mother died a few months later. His father, a colonel in the cavalry, remarried two years later and Diaghilev was brought up by his stepmother Yelena Panayeva. Diaghilev recalled how she instilled in him a will to succeed, telling him never to use the words 'I can't', insisting that 'when people want to, they can'.[6]

Diaghilev was part of an extensive family of landed nobility, some of whom reached senior government positions. His family's wealth was based on a monopoly for distilling vodka and spirits in Perm. Soon Serge had two half-brothers, Valentin and Yury, and he seems to have had a generally happy childhood in St Petersburg where there were many relatives. From 1879–90 the family lived in the Perm region near the Urals, first on the family estate and then in a large mansion in Perm itself.

Diaghilev's drive was accentuated by the financial disaster that overwhelmed his family in 1890, when he was just 18 and about to go to university. His father was made bankrupt and all the family property was auctioned to pay off his debts. Overnight, Diaghilev, who had a small inheritance from his mother, became responsible for his father, stepmother and half-brothers. Instead of being able to live the life of a leisured nobleman, he needed to find a source of income that would provide public recognition without compromising his social status.

His career during his twenties shows Diaghilev trying to make his mark in the world of the arts, as a researcher, critic, editor, publisher and exhibition organizer. Success might eventually lead to a public position and in 1901 he was arguing for the reorganization of Russia's art galleries with the clear implication that he was the right man to achieve it. However, all such preferment was dependent on the tsar and just at the time when Diaghilev's reputation was in the ascendant, the 1905 Revolution was to erupt.

The Road to Revolution: 1904–5

If Diaghilev reflected on the months since autumn 1904, even he would have been staggered at the pace of events and the changed condition of Russia. Since graduating in law from the University of St Petersburg in 1896, he had pursued a career as a critic, organized numerous painting exhibitions[7] and co-founded Russia's first arts magazine *Mir iskusstva* (*World of Art*).[8] He had met the tsar several times, having briefly held a position in the Imperial Theatre,[9] and had triumphed in 1905 with his spectacular *Exhibition of Russian Historical Portraits* (pl.1).[10] Although political tension was rising during this time, dissent was largely controlled by harsh repression. However, in 1904–5, political and economic pressures built up until they exploded into revolution.

In May 1903 when the capital, St Petersburg, celebrated its 200th anniversary, such upheaval would have seemed improbable, but the underlying problems that would eventually destroy Imperial Russia were clear. Over the previous 40 years the city, Peter the Great's 'Window to the West' built on the marshes at the mouth of the River Neva, had expanded at breakneck speed (pls 2 and 3). Migrants

1. Room of Empress Catherine II, *Exhibition of Russian Historical Portraits*, Tauride Palace, St Petersburg, 1905. Russian Museum, St Petersburg

2. The Nevsky Prospect, St Petersburg, showing the Admiralty Spire, *c.*1901. The capital's main street was lined with luxury shops.

ПЛАНЪ
С.ПЕТЕРБУРГА
Составленный
ПО НОВѢЙШИМЪ СВѢДѢНІЯМЪ
С. ПЕТЕРБУРГЪ
ИЗДАНІЕ КАРТОГРАФИЧЕСКАГО ЗАВЕДЕНІЯ А. ИЛЬИНА.

3. *St Petersburg: Il'yin
Cartographic Soc.*, 1911.
By 1900 the elegant central
boulevards were surrounded
by railways, factories and
workers' housing.
Courtesy of the Royal
Geographical Society

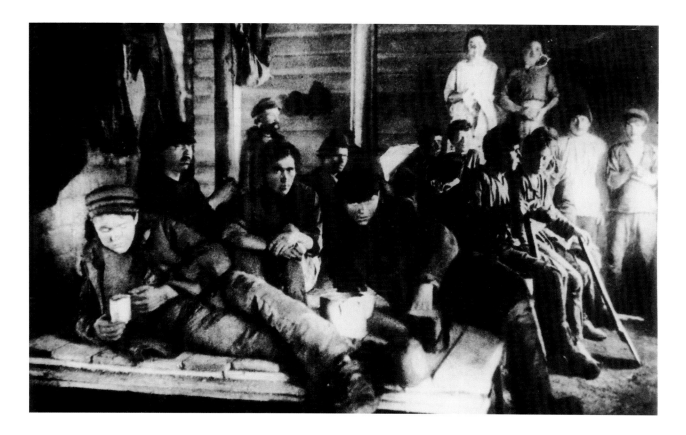

4. Poor citizens in
St Petersburg, *c*.1900.
Society for Cooperation
in Russian and
Soviet Studies

from all over Russia sought economic betterment in its new factories, mills, businesses and shops.

By 1890 the capital's population was nudging nearly a million but over the next decade another 400,000 people moved in. It was estimated that 70 per cent of the population were new arrivals, largely peasants fleeing the countryside. Factories sprang up ringing the elegant centre. It was a city of extraordinary contrasts where industrialists were making vast fortunes while most of the workers lived in very poor conditions (pl.4).[11] At its heart was the tsar, surrounded by the most brilliant court in Europe.[12] Unfortunately Nicholas II, who had succeeded in 1894 on the unexpected death of his father at the age of 49, was singularly ill suited to solving the country's problems (pl.5).[13] His reactionary views were backed by the huge influence and wealth of the Orthodox Church.[14]

From the summer of 1904 political tension increased, particularly following the assassination in July of the Interior Minister, Vyacheslav von Plehve. By November there were nationwide demands for liberalization of the press, and in December 1904 the tsar issued a manifesto promising some political reforms. This, however, merely prompted a strike at the huge Putilov engineering works in south-west St Petersburg which in turn led to the tragic events of 'Bloody Sunday' a few weeks later. From then on Russia descended into escalating violence throughout 1905.[15]

The growing opposition to Imperial rule was exacerbated by the war with Japan over Manchuria, begun in February 1904, which revealed the general incompetency of the administration. The Japanese won a succession of victories culminating in the capture of Port Arthur on 2 January 1905 (pl.6). This defeat by a non-Western power was a huge blow to Russia's international prestige, but worse was to follow. On 27 to 28 May 1905, the Japanese destroyed the Russian fleet at the Battle of Tsushima Strait.[16]

The tsar became the focus of increasing political opposition and by early October there was a de facto general strike across the country, in which the dancers of the Imperial Theatres participated.[17] Diaghilev, who was in St Petersburg organizing the return of the loans from his portrait exhibition, described the atmosphere:

> Don't be angry at my silence. It's impossible to describe what's going on here: we're shut in on all sides, in complete darkness, no chemists, trams, newspapers, telephones or telegraphs and waiting for the machine guns![18]

5. Henri Gervex, *The Coronation of Nicholas II – sketch*. Oil on canvas, 1896. One of the most opulent events of the period, it was also one of the earliest to be filmed.
Musée d'Orsay, Paris

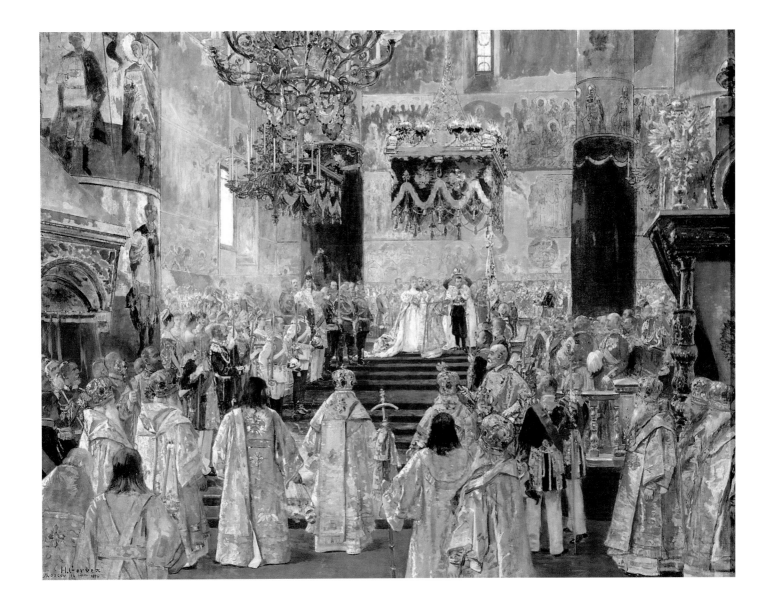

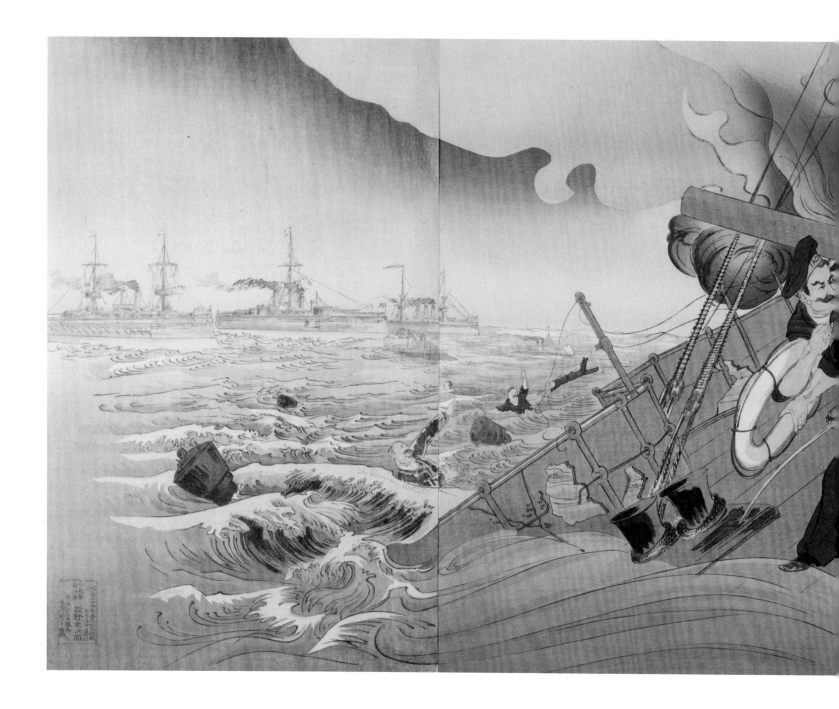

When the tsar's uncle refused to take over as dictator, Nicholas signed a manifesto promising constitutional government on 30 October 1905 (new style).[19] St Petersburg exploded in celebration, recorded in Ilya Repin's famous painting *17 October 1905*, which captures the bourgeois nature of the cheering crowds (pl.7).[20] Even the cynical Diaghilev was caught up in the excitement. Lifar records Diaghilev's radical aunt writing the following day: 'We are rejoicing. Yesterday, even, we had champagne. You would never guess who bought the manifesto … Seriozha [Diaghilev] of all people. Wonderful!'[21]

Diaghilev, who had helped support the strike of dancers at the Imperial Theatre, was personally affected in at least one way. His friend the dancer Sergei Legat,[22] feeling he had sold out his colleagues, slit his throat with a razor on 17 October when he heard of the tsar's capitulation.

What to do?
By the end of 1905 Diaghilev was less positive about the progress of events and their impact on his own future. Over the preceding six years the tsar had directly or indirectly funded much of his activity.[23] Thus, as the revolution gathered strength, Diaghilev had to negotiate a tricky path. While he welcomed the overall liberalization, he must have become increasingly concerned that growing instability would result in less subsidy and fewer cultural opportunities.

So things are coming out badly – it can't be helped.
One just has to sit and waste time, but when will this wild bacchanal be over, which is not without some elemental beauty but which like every tempest brings so much hideous misery.[24]

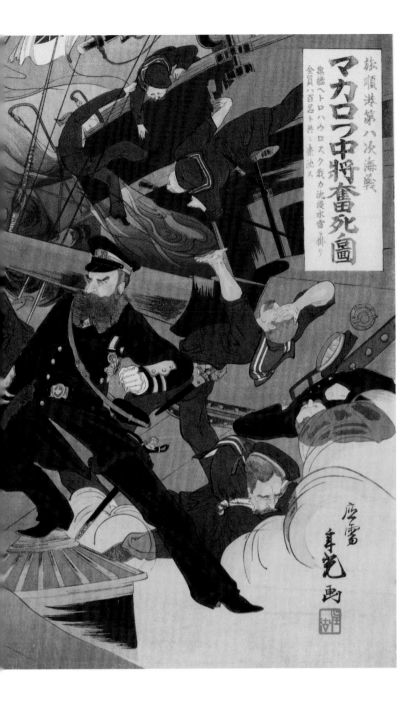

6. *The Last Stand of Vice Admiral Makaroff*.
Woodblock print, 1904.
The Russo-Japanese War
was a disaster for Tsar Nicholas II.
V&A: E.923–1959.
Given by James Laver CBE

Overleaf
7. Ilya Repin, *17 October 1905*.
Oil on canvas, *c*.1907–11.
The celebrants in the painting
come from every part of society.
Russian Museum,
St Petersburg

Following the closure of his portrait exhibition in October, it was difficult to see how Diaghilev could deliver another similar success, especially with the ongoing political crisis.[25] However, as one door of opportunity closed, another opened. Russia was becoming ever more dependent on French loans[26] and thus maintaining Franco-Russian relations was of critical importance.[27] It was essential to improve French confidence in the aftermath of the disaster of the Russo-Japanese War and the upheavals of 1905. The Russian government was thus willing to support cultural initiatives in Paris, which promoted a positive image of the country as part of the 'European club'.[28]

Diaghilev was well aware of the opportunities this threw up but also the tensions, writing to Rimsky-Korsakov: 'Don't forget that I have to convince the Grand Duke Vladimir that our enterprise will be useful from a national point of view [and] the Minister of Finance that it will be profitable on the economic side...'.[29]

Two Centuries of Russian Painting and Sculpture: Paris 1906
Early in 1906 Diaghilev conceived the idea of mounting a major exhibition of Russian paintings as part of the new Salon d'Automne in Paris.[30] However, there is no evidence that Diaghilev saw this as a permanent move to the West. On the contrary, it was a convenient means of occupying his time, making contacts and advancing his reputation while things settled down in Russia.[31] Nor did he head straight to Paris, instead taking his new boyfriend, Aleksey Mavrin, on a tour of the Mediterranean, and arriving in Paris in late May.

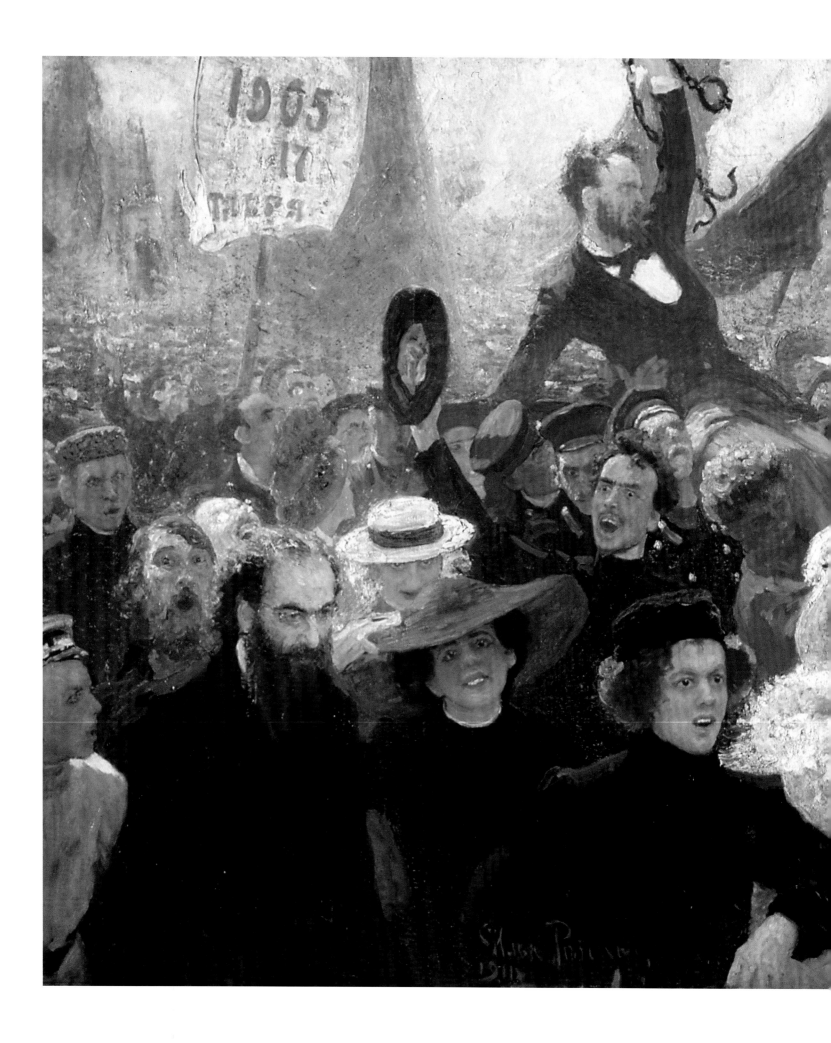

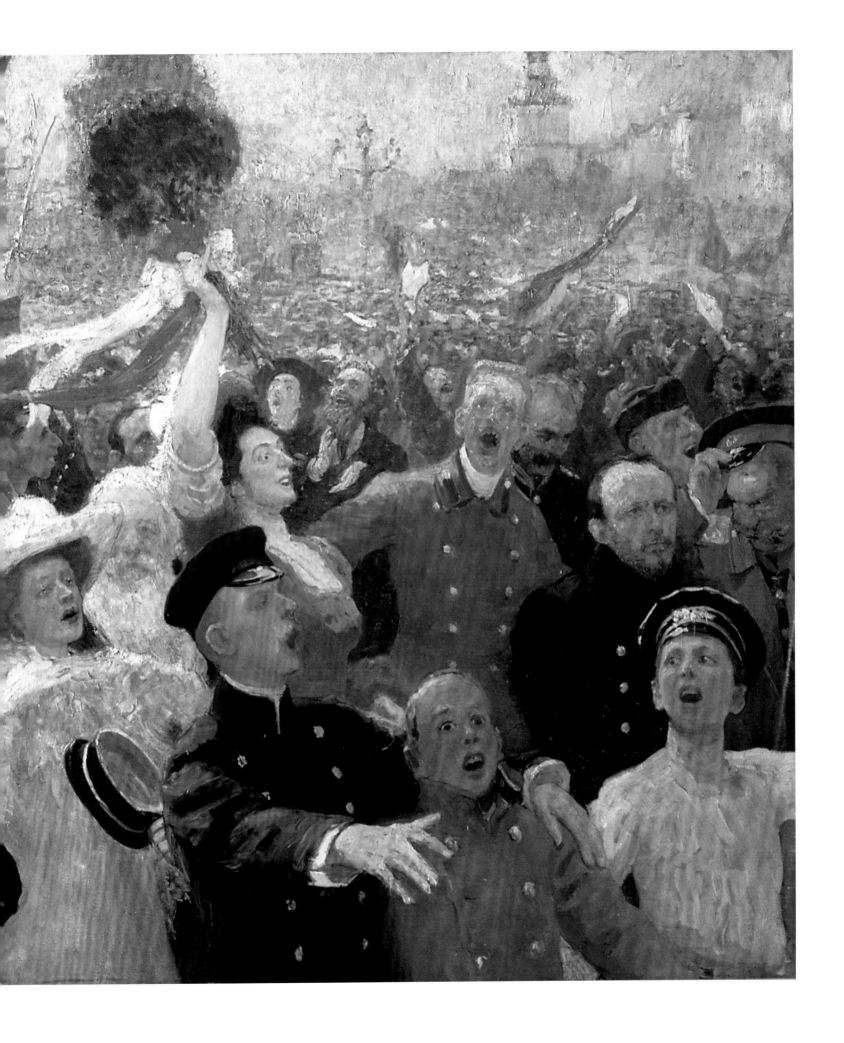

8. Valentine Gross, cover of the
souvenir programme for Théâtre
national de l'Opéra, May–June 1914.
The illustration, drawn from a
photograph, shows Vera Fokina and
Mikhail Fokine in *Schéhérazade*.
V&A: Theatre & Performance Collections

24

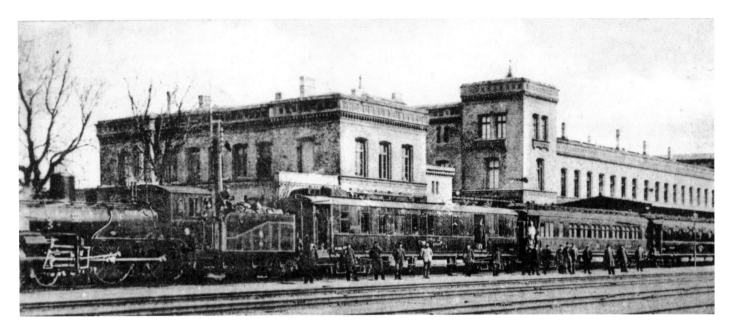

9. Wagon de Nord Train at
an interchange station on the
Russian-German border, 1903.
Diaghilev could travel from
St Petersburg to Paris in
about 50 hours.
Sammlung Jürgen Klein

During this tour, Diaghilev visited the 1906 IV Olympic Games held at the Panathenian Stadium in Athens from 22 April to 2 May 1906.[32] Since Athens was difficult to get to and Diaghilev showed little interest in sport it is worth asking why he made this trip.[33] Like any sophisticated Russian of his generation, he was steeped in ancient Greek culture and the Pan-Slavic movement promoted interest in the region.[34] In addition, the homoerotic attraction of 900 athletes should not be underestimated. But there was perhaps a more strategic reason in his mind. The great nineteenth-century international exhibitions typically included major art shows. Baron Pierre de Coubertin, who helped found the modern Olympics, considered artistic endeavour to be as important as physical competition, and organized the awarding of medals.[35] Diaghilev may have been seeking opportunities to promote art shows at future Olympics, particularly since the 1908 Games were planned for Rome.[36]

Whatever the precise reasons for Diaghilev's 1906 trip to the Aegean, his main focus in Paris was to secure a Russian section at the Salon d'Automne. By the end of May he had met the organizers and it was agreed that he would supply a summary exhibition of Russian art over the last two centuries. By 2 June he had drawn up a list of artists and set himself the immense task of organizing the loan and transport of 750 works in 15 weeks ready for the opening in October.

The exhibition was a great success and the critical reception alone fully justified Diaghilev's switch to promoting Russian culture abroad. Earlier in the year Diaghilev had met the Comtesse Greffuhle, a hugely wealthy patron of the arts.[37] Impressed by his knowledge of Russian music, then little known in France, she offered to support a series of 'historic' Russian concerts at the Paris Opéra, arguably the most prestigious venue in Europe.[38] The five concerts in May 1907 would be well received,[39] not least because Diaghilev had persuaded Fyodor Chaliapin, the renowned Russian bass, to sing.[40] The success of the 1906 Russian art exhibition had proved that Russia had the quality of arts to impress Western audiences. However, Diaghilev was shrewd enough to realize that continuing commercial success would depend on playing to their prejudices, particularly the view that Russia had a bloody history and was a vast country full of exotic tribes, music and dancing.[41] Even during Diaghilev's own lifetime, Russia had expanded to colonize many 'exotic' peoples. Opera was an established way of presenting Russia's mainstream history. However, perhaps as early 1906, Diaghilev may have turned to considering ballet as a way of presenting the diverse cultures along Russia's borders.

By the Christmas of 1906, Diaghilev was heading back to Paris to resume his self-appointed task of introducing Russian art and music to Western Europe.[42] Although he did not yet know it, this departure would be one of his last as a resident of St Petersburg. Soon he would dispose of his apartment on the fashionable Fontanka Embankment, where Bakst had painted his famous portrait of Diaghilev with his nanny (see pl.18). From now on he would stay at the nearby luxury Hotel d'Europe on his increasingly brief visits. He would become a wanderer and, in eight years time in 1914, an exile, never to return to his homeland.

The 2,000 kilometres between St Petersburg and Paris represented for Diaghilev far more than a train journey between two Imperial capitals (pl.9). It was a leap from the

double-headed eagle of the Romanov tsars to the tricolour of the Third Republic, from autocracy to democracy, from Orthodoxy to Catholicism, and from state-controlled culture to the creative ferment of the internationally acknowledged capital of fashion and the arts, 'The City of Light',[43] where entertainment has evolved into a quasi-capitalist industry. For Diaghilev the move to Paris was the opportunity to escape the turmoil and chaos of political revolution in Russia, and to savour the cultural, aesthetic and sexual opportunities of a sensual city which had embraced decadence in all aspects of life.

More importantly, Paris would provide a new and a potentially profitable platform for Diaghilev's unique form of cultural entrepreneurship.[44] In 1906 his focus had been promoting Russian painting. In 1907 he would turn to Russian music and opera. But he was also well aware of the latent resources of the Russian Imperial Ballet, commenting:

> From Opera to Ballet is but a step. At that time there were more than 400 ballet dancers on the roster of the Imperial Theatres. They had all had a remarkably good training, and they danced the traditional classical ballets … All these ballets I was very familiar with, having been attached to the Director of the Imperial Theatres for two years or so.[45]

Such was his creative energy that within 28 months he had founded one of the most famous and influential dance companies in history.

Diaghilev: Maverick or Canny Operator?
Did Diaghilev take a leap in the dark in 1906? Hardly. His move to the West was an astute and pragmatic response to the complex political and cultural situation in Russia. By shifting his activities to Paris and later elsewhere in Western Europe, he could avoid the paralysis back home while notching up high-profile successes abroad. He could also exploit the substantial Imperial subsidies and other support available for foreign projects to underwrite the financial risks, while building a network of his own contacts. As and when things improved in Russia, he would be able to return, covered in glory from his patriotic activities overseas.

However, Diaghilev demonstrated the full extent of his steely ambition in March 1909 when the tsar suddenly withdrew all financial and practical support, and disaster loomed.[46] By April, Diaghilev was rehearsing a group of ballet dancers in St Petersburg and cabling his promoter in Paris: 'No opera this year. Bringing brilliant ballet company, eighty strong, best soloists, 15 performances. Repertory can be enlarged … three ballets per programme…. Start big publicity.'[47] The group of dancers, choreographers, artists and technicians that was to become the Ballets Russes was underway.[48] The court was amazed that rather than giving up, Diaghilev carried on regardless, albeit at the cost of dropping opera and focusing on ballet, which was much cheaper, for the 1909 season. In truth, however, he had little

alternative. Diaghilev had burnt his bridges in Russia and must have realized that the only way left open to him was to develop a 'mixed' economic model based on a commercial operation combined with subsidies from rich supporters.[49]

Like many new operations he overreached himself financially in the 1909 season but avoided disaster by adroit negotiation. Two years later, on the back of five performance seasons, Diaghilev had his own loyal ballet company, excellent self-generated productions, a growing 'brand' and following, and Nijinsky – who was also his boyfriend – established as an international star. Although he never went back to exhibiting art on a large scale he had the pleasure of being able to commission artists and composers for his ballets as and when he wanted.[50] In addition, he had found a sustainable way to make a reasonable living and to develop his own reputation. Above all, he was absolutely in charge and answerable only to the paying public. The Ballets Russes was never going to make him a fortune but it provided a rich platform for his ambitions, an outlet for his unique mix of talents and a dependent 'family' of his own.

By the end of 1911, with the success of the London Coronation season behind him, Diaghilev felt confident enough to book the Narodny Dom Theatre in St Petersburg for spring 1912 to compete head to head with the Imperial Ballet in its home city.[51] Unfortunately, at the crucial moment, the theatre burnt down. Diaghilev could not secure another venue in time and the tour was cancelled. Diaghilev would have seen these events as merely delaying his triumphant return to his homeland. However, changing world events outwitted him, and the Ballets Russes was never to perform in Russia.

Finale
In January and March 1914 Diaghilev visited St Petersburg on brief business trips but then returned to Berlin to begin the Ballets Russes' European and South American tour for the year. He was never to return to Russia and he became a nomadic exile.[52]

Over the next 15 years, until Diaghilev's sudden death in 1929, the Ballets Russes continued to provide a purpose, a living, a status and, ultimately, eternal fame.[53]

> He lived and died 'a favourite of the gods'. For he was a pagan, and a Dionysian pagan – not Apollonian. He loved everything earthly – earthly love, earthly passions, earthly beauty. Heaven for him was just a lovely dome above a lovely earth.[54]

10. After Aleksandr Golovin, costume worn by Fyodor Chaliapin as Boris Godunov in the Coronation Scene from *Boris Godunov* for Diaghilev's Saison Russes. Silk and metal thread, glass beads, 'essence d'orient' pearls, metal, painted silk lining, replacement fur, *c.*1908. V&A: S.459(& parts)–1979

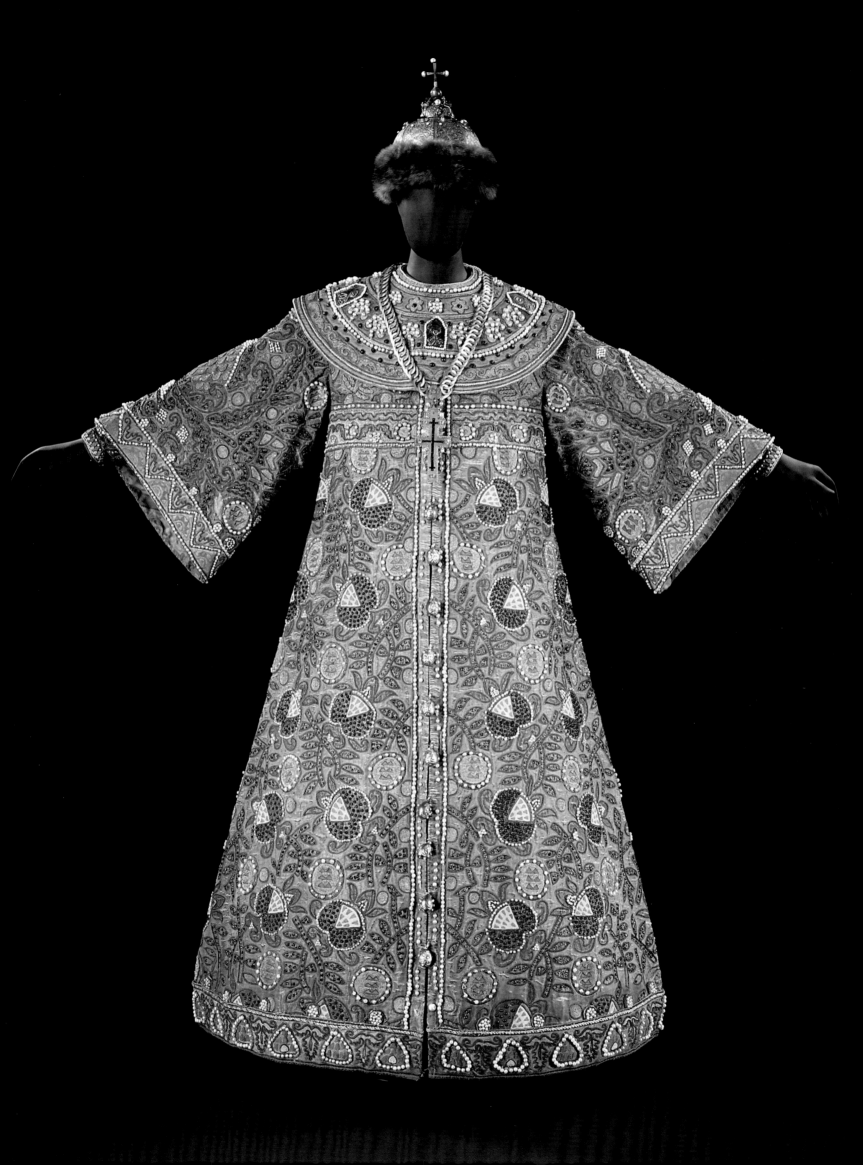

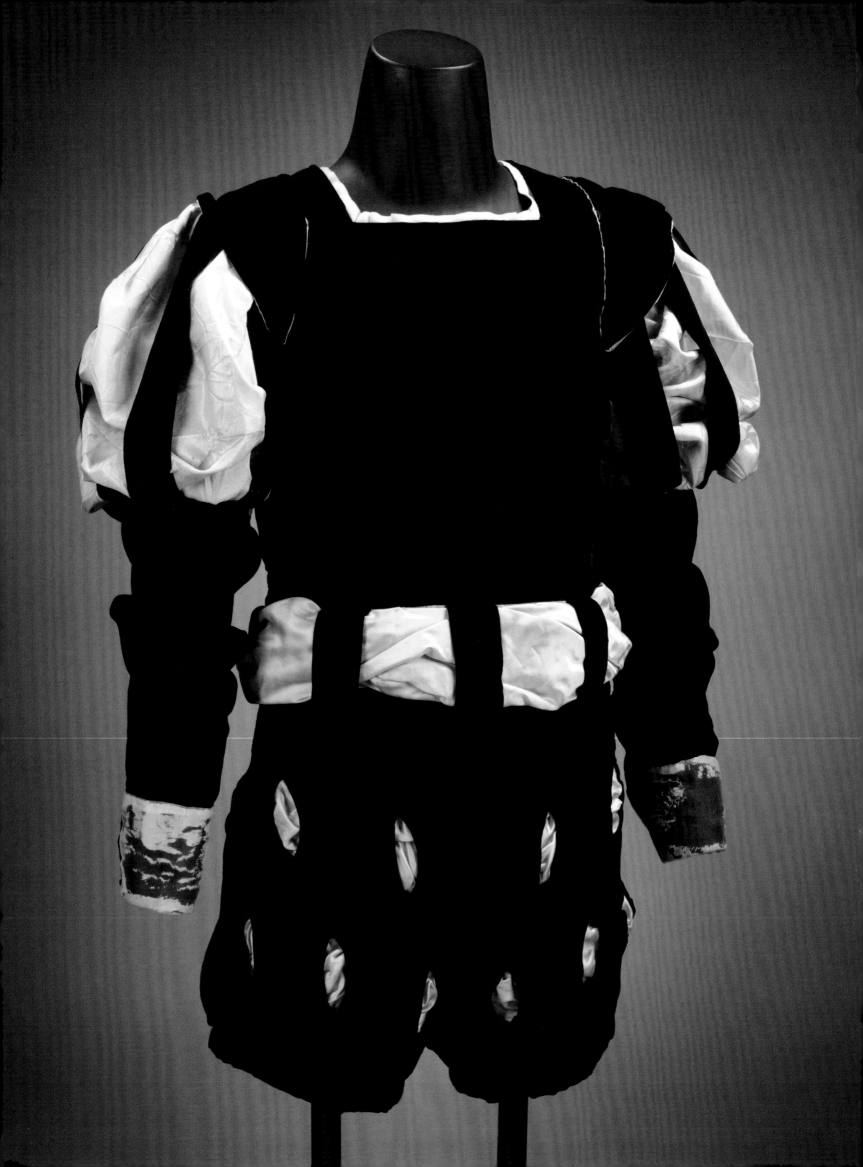

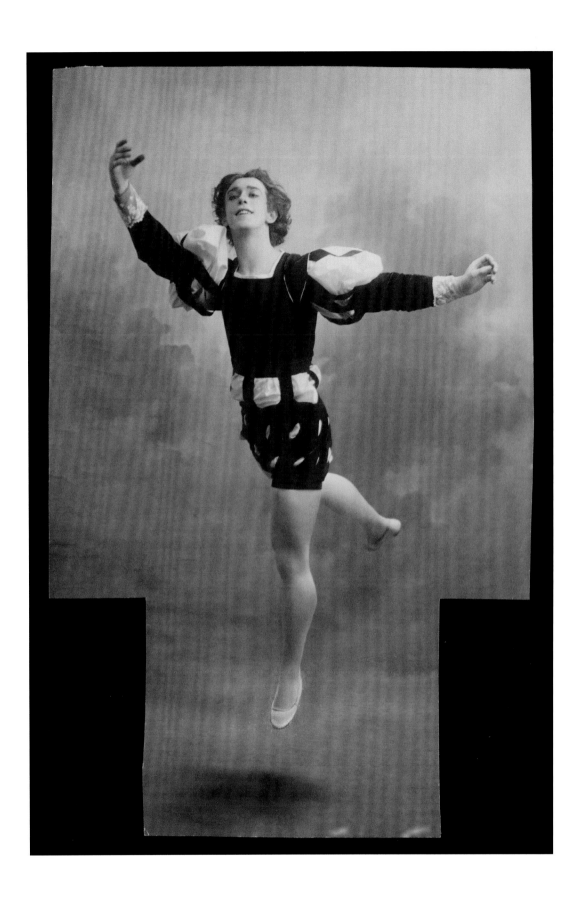

Opposite
11. After Alexandre Benois,
costume worn by Vaslav
Nijinsky as Albrecht from
Giselle (Act II). Silk velvet
with replica silk shirt, 1910.
V&A: S.836(&A)–1981

12. Vaslav Nijinsky as
Albrecht from *Giselle*
(Act II), 1910.
Photograph by Bert.
V&A: Theatre &
Performance Collections
THM/165

TRAVEL
Kristian Volsing

The Ballets Russes toured extensively, traversing the globe during the company's 20-year existence. They travelled by train and ferry across Europe and the USA, Canada and South America, performing in most of the major cities. Diaghilev transported many of the company's first dancers, who were originally from the Imperial Russian Ballet of St Petersburg, from Russia to Paris for long summer seasons. The train journey was a distance of over 2,000 kilometres and took about two and a half days, with changes at Warsaw and Berlin.

The company's first engagements outside Europe took place in 1913. The journey from Southampton to Rio de Janeiro took over three weeks, and Diaghilev, afraid of crossing the ocean, did not accompany them. His only excursion beyond Europe was during the First World War, when in 1916 he took the ten-day voyage by ship from Bordeaux to New York. Unable to secure a season of performances in France or Britain during this period, he had to take his company to the USA, which had not yet entered the conflict. The Ballets Russes performed in cities traversing North America, from New York to San Francisco.

Transportation systems were prone to disaster. Principal character dancer Lydia Sokolova recalled a train fiasco during the company's 1917 tour of South America, while travelling from Rio de Janeiro to São Paulo. As the train climbed through the Mantiqueira Mountains, sparks from the timber-powered engine flew past the open truck containing the scenery designed by Léon Bakst for *Le Spectre de la rose* and *Cléopâtre*, setting them on fire. The train was forced to stop in the middle of the mountains while the cast saved what they could from the burning wreckage. Serge Grigoriev, the *régisseur*, had a nasty surprise when he arrived later in São Paulo by car. A further incident befell Sokolova on a journey back from Monte Carlo to Paris in 1921, during which she shared a berth with singer Zoia Rosovska. On waking at dawn, Rosovska was shocked to find that her necklace had been stolen while she was asleep. During the night, a thief had filled the compartment with chloroform before stealing the performers' possessions.[1]

The 1918 tour of Spain saw the company travelling by more

Igor Stravinsky and Serge Diaghilev at Croydon Aerodrome, *c.*1926.

The company travelling to South America on the *Reina Victoria-Eugenia* in July 1917. Snapshot from Stanislas Idzikowski's photo album.
V&A: Theatre & Performance Collections
THM/376

rudimentary means. Many of the engagements were in small towns, which involved crossing rough terrain by horse and cart. Performances were reduced to the simplest of sets, which could be transported by the cast themselves; the larger sets were seen only in major cities.

Although train travel was the dominant means of transportation at this time, scheduled flights between European cities began to emerge after the First World War. At the beginning of the 1920s, Croydon Aerodrome, near London, established regular passenger services to Paris, Rotterdam and Berlin. The Ekstrom Collection at the V&A Theatre & Performance department holds a single aeroplane ticket from Croydon, purchased for a Ballets Russes conductor.

1 Sokolova 1960, p.108.

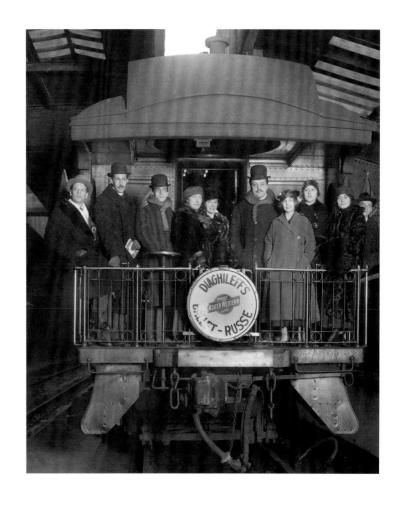

Above
Adolph Bolm, Serge Grigoriev, Léonide Massine, Lydia Sokolova, Hilda Bewicke, Serge Diaghilev, Lydia Lopokova, Lubov Tchernicheva, Olga Kokhlova and Nicholas Kremneff on board a train in Chicago, 1916. Russian State Theatre Museum, St Petersburg

Right
Ballets Russes dancers, with Lubov Tchernicheva in the foreground, posing in costumes from *Schéhérazade*, Granada, Spain, May 1918. V&A: Theatre & Performance Collections THM/376

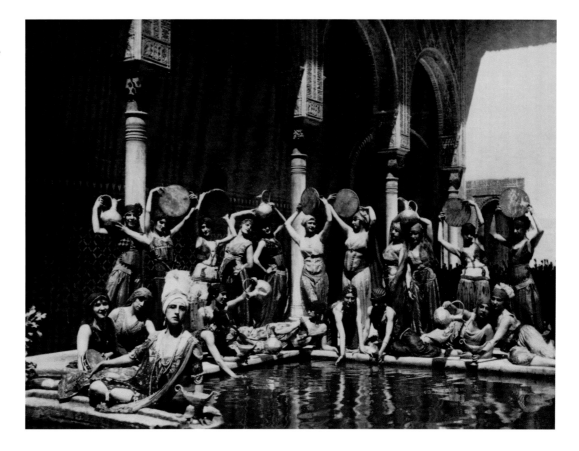

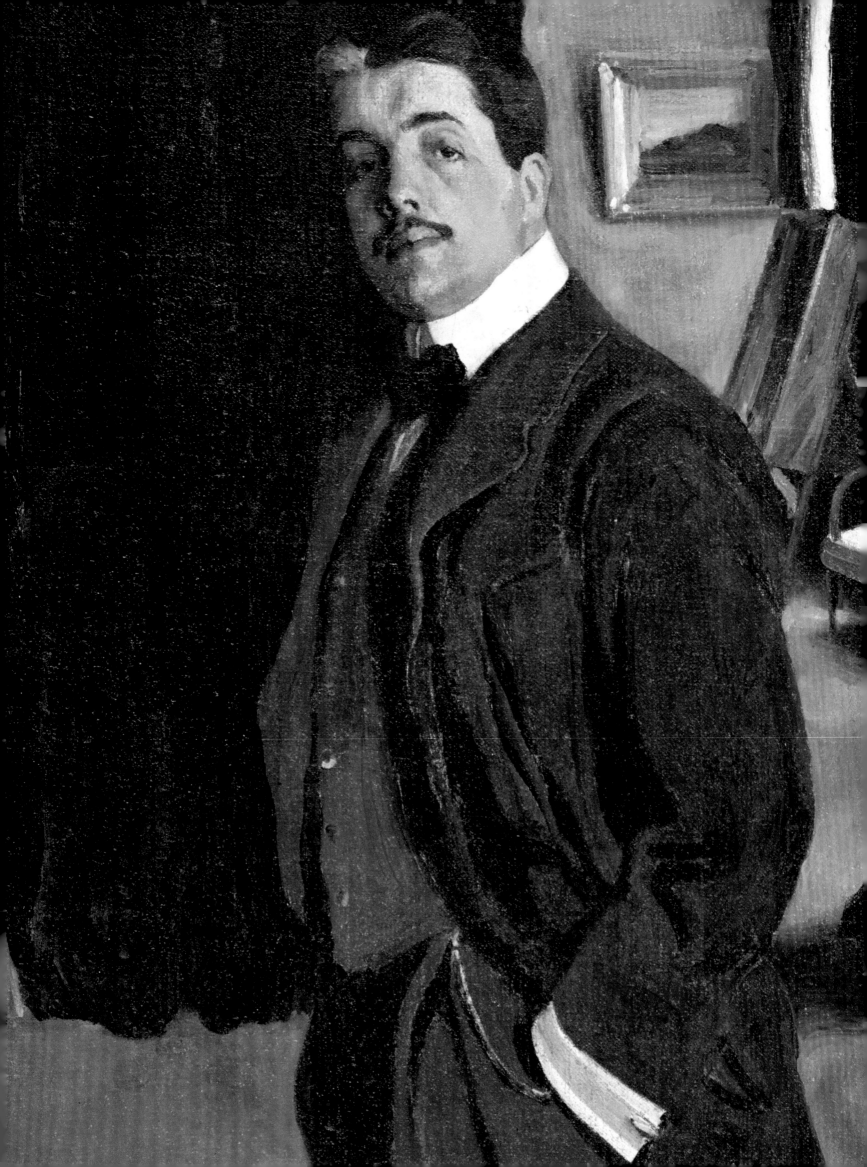

DIAGHILEV THE MAN

SJENG SCHEIJEN

On 14 July 1902, the Campanile of St Mark's Basilica in Venice collapsed and was completely destroyed. A major crack, which had appeared days before, gradually widened, but even once it was declared that the tower could not be saved it took exactly 3 days and 19 hours before it fell down.[1] Watching the mighty structure slowly crumble must have been eerie, and no one knew whether it would take other buildings in its fall – perhaps even St Mark's itself. The collapse of the Campanile was seen by many as symbolic, not only of the fragility of Venice itself, but also of the glories of European civilization, of which Venice was such a stunning example. Although the twentieth century had only just begun and spirits in general were high, many felt that the rapid industrialization and modernization sweeping across Europe were changing the very fabric of the civilized world – not always for the better.

This was certainly the case for the young Russian, Serge Diaghilev, who was already a regular visitor to the city and who that summer had taken a prolonged stay, hoping to heal his ailing relationship with his lover and first cousin, Dimitry 'Dima' Filosofov, to whom he had been dedicated for more than 12 years.

At that time, Diaghilev was far from being the man who would confront the European theatre public with such beacons of modernism as *The Rite of Spring* or *Parade*. Indeed, he firmly believed that 'in music one cannot go further than Wagner, and you cannot undress the art of painting more than Manet and Zorn'.[2] He considered craftsmanship to be, if not the essence of artistic creation, then surely the first condition within which it took place. In his celebrated magazine *Mir iskusstva* (*World of Art*), there was plenty of room for younger artists, but it was never a soapbox for the newest tendencies in European art. The Impressionists were paid little attention, and Cézanne and Van Gogh were only mentioned for the first time in 1904, the

fifth year of the journal's existence and fourteen years after Van Gogh's death. Meanwhile, Diaghilev devoted much space to the art of bygone years – especially that of the eighteenth century, about which he was passionate.

But in 1902 many things changed for Diaghilev. Although he had only just turned 30 he was already at the forefront of the visual arts world in St Petersburg. Where to go from there? Shortly before his visit to Venice he spent a few months at the clinic of the Viennese psychiatrist, Richard von Krafft-Ebing, where he tried to come to terms with his homosexuality. He also confronted his pathological fear of death. In two long and uncommonly philosophical and poetic letters to his stepmother, written five weeks after he saw the Campanile collapse, he predicted that he would 'manage to act like Wagner and will come to Venice to die'.[3] For Diaghilev, staging the circumstances of his own death was a means of containing his fears, and 27 years later, in the summer of 1929, he duly dragged himself to Venice to die.

The collapse of the Campanile (pl.13) left a lasting impression on both Diaghilev and his cousin. Shortly after the event Dima wrote an essay entitled 'Contemporary Art and the Campanile of San Marco', in which he argued that rebuilding the tower was pointless, and if attempted, should be done by a contemporary architect 'like Olbrich or Mackintosh'.[4] In a heartfelt statement he advocated that it was better to embrace contemporary life, and contemporary art, than to lose oneself in a stultifying respect for the art of the past:

> So museums with their bric-a-brac will do no good, if outside, on the street, in schools, in factories, in short in our everyday, working, grey and vulgarized, but at the same time grand life, does not tremble the artistic nerve. We live in an age of trams, train stations, theatres, schools, department stores, restaurants, apartment buildings, factories, newspapers, books. Our artists

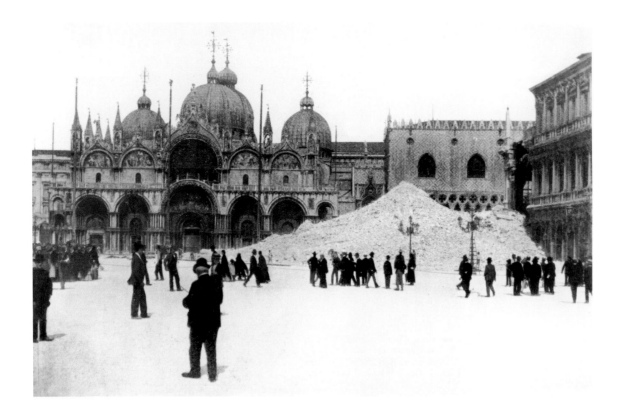

13. View across St Mark's Square, Venice, showing pedestrians in front of the rubble left after the collapse of the Campanile of St Mark's Basilica, July 1902.

must, on every side of our new life, impose their stamp.... In this respect the idea of resurrecting the Campanile is in the highest sense unfortunate. Millions will be spent to create a dead, soundless bell tower. I do not say that future architects cannot raise bell towers. But these will be bell towers for new cathedrals, and for a new religion.[5]

Diaghilev himself expressed similar sentiments when he wrote that 'The culture of twenty centuries, pressing down on our shoulders, prevents us from creating, and if along with S. Marco's Campanile the whole of our beloved Venice tumbled down, we would go mad with grief, but ... for men of the future there would be one serious obstacle the less.'[6] Though expressed less audaciously, there is little difference between this and the Futurists' credo of demolishing museums and libraries for the sake of new art. In Venice that summer of 1902, the modernist spirit was ignited in Diaghilev.

Born on 19 March 1872, Diaghilev was raised from his tenth year in the city of Perm, near the northern Ural Mountains in an administrative district called the Permskij Kraj, an area larger than England and Wales combined. Although Perm is still technically in Europe, it is located at the furthest reaches of the continent.

It is hard to appreciate the isolation and the vastness of such a place. Apart from Perm there were no other cities within a few day's distance. Winters were harsh and long,

with temperatures dropping to minus 40°C, and from October to April it was almost impossible to travel. Only in the city centre were the houses made of stone. Though Russia by then already had a large bureaucracy, the isolation of many regions meant that government control was sparse.

The Diaghilevs owned the Bikbarda Estate, almost 300 kilometres outside Perm, which they visited every summer – travelling for several days by horse and carriage on almost non-existent roads. It must have been an adventurous but tedious and exhausting journey for the ten-year-old Serge and his two- and four-year-old half-brothers. In Bikbarda, which contained only two stone houses and a church, there were no police, courts or judges, and people had to settle their accounts among themselves. The local newspaper, *Permskie vedomosti*, reported violent deaths almost every month. Even the Diaghilevs could not avoid the near proximity of violence. In 1884, when Serge was 12 years old, the estate manager, Afanasay Eskin, committed suicide after killing his wife, his sister and two peasants with a knife.

It is almost impossible to imagine that a man who was considered the ruler of European taste during one of its finest periods of cultural blossoming – perhaps the greatest theatre producer who ever lived – emerged from such remote surroundings. The enigma is that however isolated the environment in which Diaghilev was brought up, it was

not uncultured. Indeed, it was the fervent longing for culture, and the passion and stubbornness with which his family tried to maintain a level of civilization that could compete with the *haute bourgeoisie* in Vienna or Paris, that encouraged Diaghilev to become such a champion of beauty. In the great house at Perm (pl.14) amateur musicians performed operas and concertos, plays were staged and poetry learned by heart. The Diaghilevs did everything possible to reassure themselves that they were not living in the Wild East but in a province of Europe, close to centres of learning and the arts. A German teacher recruited to educate the children, Eduard Dennebaum, not only taught them languages and grammar but was also an able musician, conducting a choir made up of family members and friends. He taught Diaghilev to play the piano well enough to perform the first movement of Schumann's piano concerto just before his 18th birthday. According to his life-long friend, Walter Nouvel, Diaghilev was a competent pianist, but above all, he had a good ear, and could quickly read a score and judge its quality. This proved a very important skill for the later impresario, both in editing the music of Debussy, Stravinsky and Prokofiev, and when searching for

early music by forgotten composers in Italian archives. The teachings of an exiled German in Perm were to have a lasting impact on the future of Western music.

The young Diaghilev had an intense relationship with his stepmother, Yelena Diaghileva, his mother having died three months after he was born, apparently from an infection. Much has been made of Yelena's great appreciation of the arts, and the influence she had on Diaghilev's development, but in some ways she was a typical example of the Russian intelligentsia. She was undoubtedly well-read, and knew her painters and composers, but this was relatively commonplace among women of her social status. Evidently, it was not the substance but rather the intensity of her intellect that was so important for the development of the young Diaghilev. Yelena worshipped the arts with a furious dedication that left no room for critical distance or valuation. However, she succeeded in creating a sanctuary of high culture and stimulation in the cultural desert of the northern Urals, and she passed on her dedication to the arts to her stepson. Whatever can be said about Diaghilev – and in his time he was as often loathed as praised – nobody questioned his unselfish commitment to the arts. However great his artistic

14. The sitting room of Serge Diaghilev's family home in Perm, *c.*1880.
Diaghilev Archive, Pushkinskij Dom
Fund 102.N5

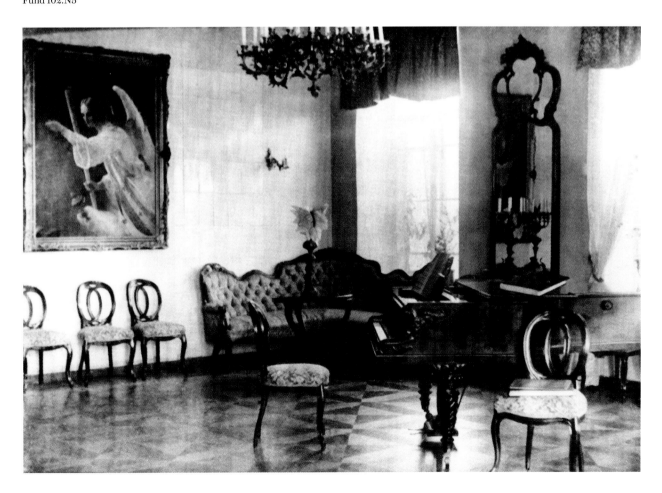

victories throughout the world, Diaghilev never amassed any personal wealth, but he didn't seem to care.

While one major influence on the formation of his personality was the cultural enclave harboured by the Diaghilevs in Perm and Bikbarda, another was the sudden and complete destruction of that community. Diaghilev's father, Pavel Pavlovich, had great financial troubles for many years, but the family continued to live in grand style, disregarding their dismal situation. Their wealth had been based on a vodka monopoly, but following the liberalizing reforms of the 1860s and 1870s such monopolies were gradually becoming exposed to the workings of the market and were steadily losing share to newcomers with a more businesslike approach. Pavel's sense of identity and self-esteem were grounded in his position as an officer in the cavalry of the Imperial Guard, the elite corps in the army of the Russian Empire.[7] He took not the slightest interest in the management of his estate or the vodka factories, and witnessed the ruin of the family property with a stubborn carelessness. Debts accumulated rapidly and Pavel had to take a mortgage on the entire estate, which from the beginning imposed an impossible burden on the family.

By 1890, when Diaghilev was 18 years old, his family was declared bankrupt. The estate, the factories in Bikbarda and other family properties, the big house in Perm (pl.15), the

works of art, grand pianos and carriages were all auctioned off.[8] The buyer was a Polish Catholic from Ekaterinburg. Unlike Diaghilev's father, he was not a 'man of honour', indeed his prospect of a State career was greatly hampered by his Catholicism. But he was a serious businessman who had made his fortune selling a European alcoholic drink, beer, to the Russians. Perhaps the strangest consequence of these events was the fact that Diaghilev was now the only member of the family who had any money because he still had the inheritance of his biological mother. Therefore, the care of his two younger half-brothers was given over to the youthful Diaghilev (pl.16). His departure to study law in St Petersburg and the bankruptcy of his father coincided, so from the moment Diaghilev started living independently he also assumed responsibility for his family.

When the declaration of bankruptcy was published in the local newspaper – followed by long descriptions of goods that were to be auctioned – Diaghilev was making his first 'grand tour' through Europe with his cousin and soon to become lover Dmitry Filosofov. There are no accounts of Diaghilev's direct reaction to the loss of his childhood world. It is also unknown whether he saw it coming. The letters he wrote to his stepmother during that period are seemingly carefree – though the collapse of his family life

15. The exterior of Serge Diaghilev's family home in Perm, late 1800s. Diaghilev Archive, Pushkinskij Dom: Fund 102.N5

Opposite
16. Serge Diaghilev and his half-brothers, Yury and Valentin, *c*.1880. Diaghilev Archive, Pushkinskij Dom: Fund 102.N5

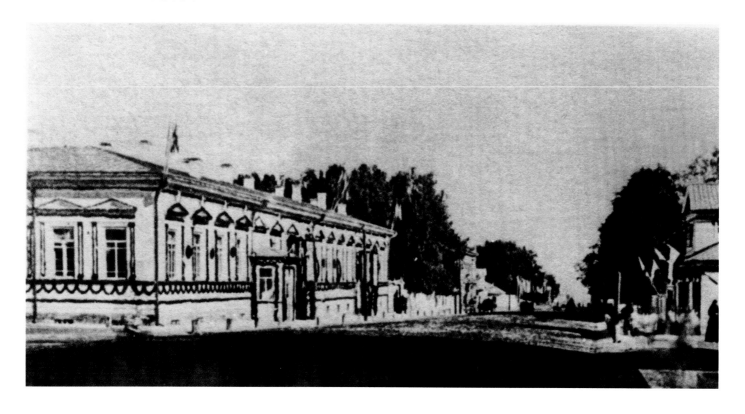

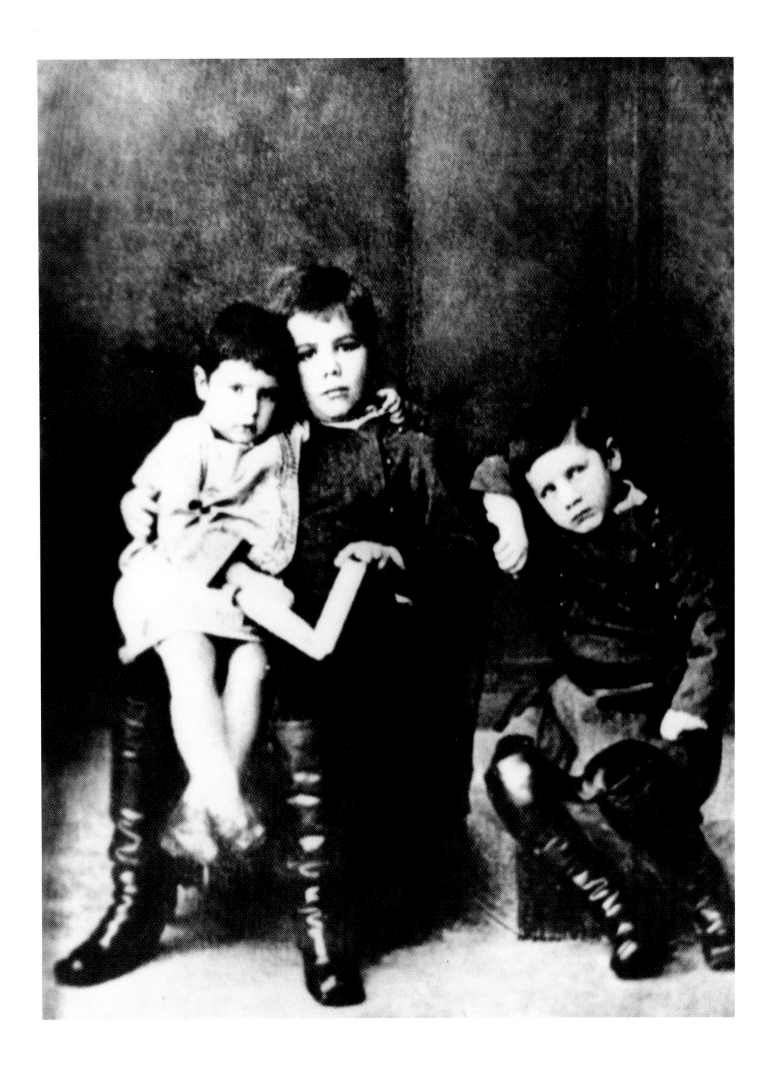

must have come as a heavy blow. He was never to see Bikbarda again and Perm only once more. Indeed it seems that the bankruptcy was a taboo subject, he never spoke about it; neither did Alexandre Benois nor Walter Nouvel, his close friends, although they must have known, even if they decided to remain silent. Nor did Boris Kochno or Serge Lifar mention this significant moment in Diaghilev's life, though both wrote lengthily about him, and both were his lovers and companions for years. Could it be that even they knew nothing about it? Possibly Diaghilev wiped the event from the construction of his own mythology.

It is revealing that everywhere Diaghilev went, and through all stages in his career, he habitually created a family atmosphere in his enterprises. He was neither supported by a professional organization when he published *Mir iskusstva*, nor when he was making his exhibitions, not even during the tremendous collaborative schemes that shaped the Ballets Russes. Instead, he always relied on friends and family members (his cousins Dima and Pavka, for example) to help him with his efforts. At the end of his life in 1929, when he was world famous and had reigned over European ballet for more than 20 years, the management structure of his enterprise was just the same as it had been in 1898 when he first started to publish *Mir iskusstva* in St Petersburg. Walter Nouvel was still there, now acting as a kind of general manager, as was his cousin Pavka, who ran errands as he had always done (indeed it was Pavka who first saw Balanchine dance and told Diaghilev about it). As in the early years, he was still living with his personal secretary, no longer Dima Filosofov (pl.17), but a much younger variant, Boris Kochno. He referred to his most cherished artistic discoveries, the composers Igor Stravinsky and Sergei Prokofiev, as his 'sons' – Stravinsky being his 'first son' and Prokofiev his 'second'. Clearly, this characteristic, if unusual, management structure was the only environment in which Diaghilev could flourish. In some ways, it was also the secret of his success. He could demand a much greater dedication from 'family members' (and for a much lower price – if he paid them at all) than from ordinary employees, and it provided a form of continuity of quality that was extremely important for a company that in so many other respects was very fluid and hybrid.

Another, more profound effect of the loss of his childhood, was his almost paranoid fear of dying. Nobody who knew Diaghilev closely failed to mention his sometimes comically expressed but undeniably genuine terror of diseases and the panic that gripped him when facing the prospect of sea travel – a gypsy once predicted that

he would die on water.[9] His fear of contagious diseases, recorded by so many memoirists who knew him well, bordered on the hysterical, and it seems from a modern perspective that he had an extreme form of mysophobia.

In the popular, often gossip-based, memoir literature that the Ballets Russes inspired Diaghilev is sometimes depicted like an operetta character with a larger than life personality constructed merely to attract attention. Certainly, Diaghilev had a very theatrical, often narcissistic personality, but his fear of death was graver than was earlier recognized. In 1892, when Diaghilev was still a young and none too ambitious law student at St Petersburg University, he appears to have undergone a series of crises that forced him to come to some profound conclusions about his life.

On the day he turned 21, he wrote a long letter to Leo Tolstoy – at the time unquestionably Russia's most celebrated public figure (many people thought him more influential than the tsar). Diaghilev had met Tolstoy in January of that year, and following that visit he wrote him three letters in which he asked Tolstoy's personal advice on a number of issues. Of these, the letter written on his 21st birthday is by far the most important, and it is a key text in Diaghilev's biography.

Today, at the moment of my majority, in trying to sum up a long period of turmoil, I decided to fulfil the long-cherished dream to confess to you, Lev Nikolaevich.... After my childhood years, untroubled by moral dilemmas, the first question that afflicted me was connected to sexuality. I tried to solve that question, as did so many people of my age, by finding a sense of direction as best as I could. It was a hard problem to solve, but not as agonizing and dreadful as the new one that started to dominate my thoughts. This was the question of death.

At first, I experienced fleeting thoughts about the fact that I too would die, and that I too would be outlived and forgotten. But I suppressed them, feeling that they were out of harmony with my age and the powers of my youth. But the questions persisted, occurring more often and with a deeper impact. I often looked behind me and noticed that, even in the most joyous minutes of existence, in the theatre or at a dance … I thought, looking at the crowd around me: why are you happy? You too will die! And even tomorrow, perhaps, you will be forgotten and replaced by others.

And I thought about this more and more frequently, and started to be consumed with suffering.... Though raised in a religious family, I threw off the old faith when I started to live my own life, as did so many men of my age … and unwillingly I had to convince myself that many things I had previously accepted were mere fairytales, which couldn't be subordinated to even the simplest logic. And thus appeared the agonizing question of death and the consciousness of the total and irrevocable discontinuity of my existence.

These problems led to other questions, and he adds, the first question that it evoked was the question of morality.

> Why do we need morals? Aren't they mere prejudices? Why do we need to work on ourselves, if without this we can much better live through the few dreams that are granted us? The dream and purpose of my life is to work in the field of art.[10]

The questions that Diaghilev raised with Tolstoy had been disturbing his thoughts for some time. Six months earlier he had discussed with his stepmother the same 'mass of insoluble problems and my continual pursuit by the inevitability, the incomprehensibility and the sensing of death, in short the whole aim of life'. Indeed, they had talked of his anxieties before: 'Do you remember you and I spoke last summer about this? During those long evenings this autumn in the country I was especially led by everything to this never-ending chain of thought.'[11]

But besides his obvious pressing problems concerning the meaning of life and death, caused by the loss of religious certainties, he briefly mentions some other matters that were 'haunting' him and needed some kind of resolution: problems about his sexuality and his wish to lead a life in the realm of the arts. We may be sure – as he confided to Tolstoy – that he had not yet resolved his concerns about his sexuality at that young age, and he was far from the overt and unwavering homosexual he was later to become. Indeed, his very clear-cut sexual preference for men must have presented him with a colossal problem. Though in Russian society it was more or less accepted that before marriage young men could experiment with sexuality, a continuing and openly homosexual life was unheard of, indeed it was illegal.

Most homosexuals at that time conformed to the rules of society, and would marry for outer appearance while secretly leading a double life. It is interesting to speculate what Diaghilev would have done if there had not been any bankruptcy and if his family had stayed together. Would he have had the courage and the will then to choose explicitly for an unmarried life? It seems highly unlikely.

That Diaghilev was, at a young age, seriously contemplating the issue of homosexuality is clearly suggested by a fragment from an earlier letter to Tolstoy, where he asks for the writer's advice in dealing with the sexual education of his brother Valentin, who had turned 16 in 1892. Having told Tolstoy that he had read the latest book by the famous sexologist Veniamin Tarnovsky, he asks if he should confront his younger brother with its conclusions. Diaghilev is quick to claim that he finds the 'spirit of the book inappropriate', but nevertheless he seems to have read it with more than usual attention. This is perhaps not surprising, as Tarnovsky's book was one of the first studies to acknowledge that homosexuality is 'inborn' rather than a question of moral choice. With his conclusions Tarnovsky (whose work was translated into both German and English) had great influence on the more widely

known Austrian psychiatrist, von Krafft-Ebing, in whose clinic Diaghilev had stayed for a few months in 1902.

But in 1893 Diaghilev had not as yet completely come to terms with his sexuality. It is hard to say precisely when he took the decision to stop being secretive about his feelings, but it is significant that from 1902 onwards he starts to feature in various diaries as an overt homosexual. Indeed, there is an elucidating moment in the diary of Vladimir Telyakovsky, then Director of the Imperial Theatres and one of Diaghilev's sworn enemies in the tsarist capital, who in February 1903 records with some amazement that Diaghilev is representative of a group that practises the 'Sodomic Sin' (*Sodomsky Grekh*).[12] This is especially telling since despite having known Diaghilev for almost four years this was apparently the first time that Telyakovsky had heard the rumours about his behaviour. At the same time Diaghilev starts to appear regularly in the diary of the poet Mikhail Kuzmin, another known representative of the Petersburgian 'small homosexual world', as Kuzmin calls it. Together with the poet and with his friend Walter Nouvel, one of the co-editors of *Mir iskusstva*, Diaghilev starts to cruise the parks and bathhouses in search of romance and sex.

Not everybody was happy with Diaghilev's new self-confidence. The artist Alexandre Benois complained that '[Diaghilev] sickens me with his frankness about his homosexuality. What a bore and vulgarity. It's worse than going to the whores.'[13] But Diaghilev apparently never went back on his decision to be frank about his sex life, consequently risking much more than the irritation of friends.[14] While his scandalous sexuality may have been easier for European moralists to digest because he was a Russian, and therefore an exotic being for whom different rules applied, there was undeniably a degree of opposition to his behaviour, especially in the United Kingdom. Diaghilev's dear friend and staunch supporter of the Ballets Russes, Misia Sert, noticed a 'wave of fine puritan approval' when London was confronted with the news of Nijinsky's marriage (which heralded the end of Diaghilev's long relationship with the young dancer). Much later in the 1920s, when Diaghilev for a short time had a relationship with Anton Dolin, the dancer (and wife of the British economist Maynard Keynes) Lydia Lopokova wrote that it was 'dangerous for Serge to be in sexual relations with a Britt [*sic*]. Shadow of Oscar Wilde.'[15]

By that stage, however, Diaghilev was already 52 years old, and he could not care less about the narrow-mindedness of strangers. The composer Nicolas Nabokov remarked to John Drummond that:

> [Diaghilev's] homosexuality is the assertion of a scandal in terms of morality. And this revelation of a scandal was one of Diaghilev's qualities and at the same time weaknesses, and therefore everything he did was a desire, a little bit to shock but always to react. Part of it was showmanship, part of it was superficiality, but the core was a real, very deep, very profound understanding of what he was doing.[16]

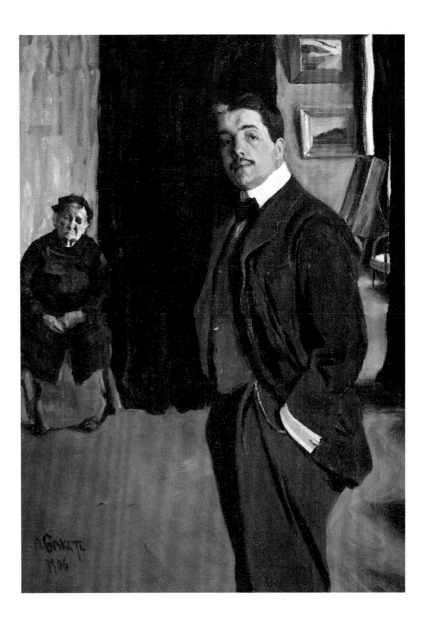

18. Léon Bakst,
*Portrait of Serge Diaghilev
and his Nanny.* Oil on
canvas, 1905.
Russian Museum,
St Petersburg

Diaghilev was indeed very self-aware, and he had been so from a very young age. In 1893, a few months after his letter to Tolstoy, he confided to his stepmother: 'Yes, I start to feel a force in myself and come to realize that I for the devil am not an ordinary person (!!!). This is rather immodest, but I don't care about that.'[17] As he told Tolstoy, he was already very sure about his mission, 'The dream and purpose of my life is to work in the field of art'. But he was not yet aware of the transgressive forces that he was to unleash on that art. Because of the crises he suffered, the loss of his childhood and, later, the loss of his homeland, Diaghilev would become a trans-national and trans-sexual figure, somebody who distorted the boundaries between forms of art and between the old and the new.

But he was not merely an innovator or a transformer. If Diaghilev in the end will be remembered chiefly for his promotion of the avant-garde, historians will have done a bad job. He was a transformer not by purpose but by mentality. Diaghilev was in everything, first and foremost, a man in constant contradiction with himself. And he loved the contradictory. He loved the friction, the struggle and the fire that was engendered by the new, but not necessarily the new for its own sake. Indeed, it seems that his greatest passion was for the art of the past rather than that of the future. He may have hated routine, but he did not hate tradition.

Diaghilev could not help being an innovator. If the collapse of his family had not cut him off from his youth; if his sexuality had not cut him off from building a family of his own; and if war and revolution had not cut him off from his homeland, he would have been a much more conventional figure. But fate decided otherwise. Diaghilev's reaction to trauma was always to take a grand leap forward without looking back. This approach, together with the unshakeable devotion to the glories of European art, nurtured in the outer reaches of the European continent, was the force behind this man who shook up so much more than just the world of dance. Indeed, it seems, that we are only now starting to recognize the extent of his influence – the imprint he left on our universal comprehension of beauty and what constitutes great art.

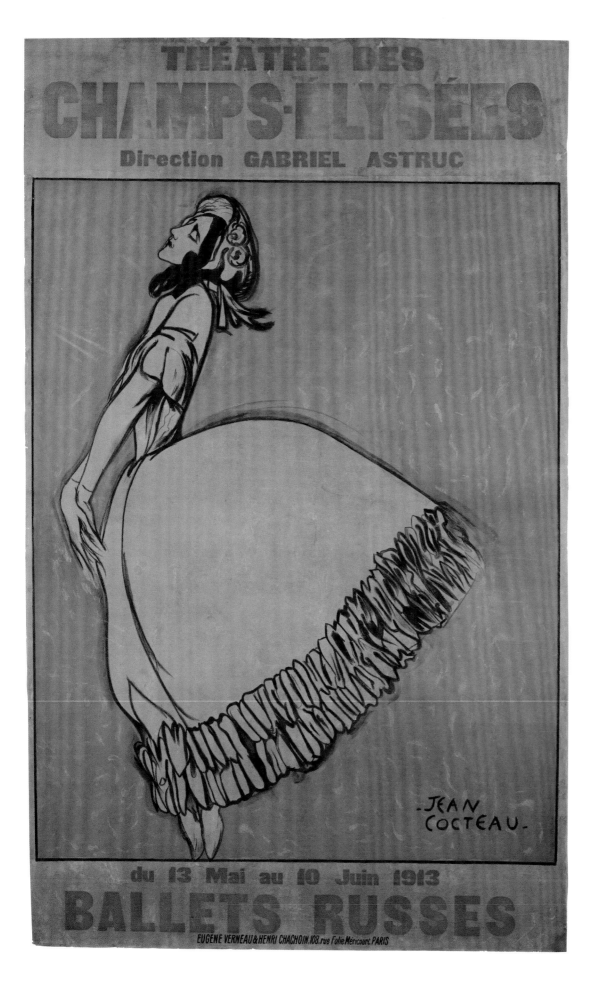

19/20. Jean Cocteau,
two posters for the opening
season of the Théâtre des
Champs-Elysées, Paris.
Colour lithographs, 1913.
The posters re-used images
of Tamara Karsavina and
Vaslav Nijinsky in *Le Spectre
de la rose*, originally created
for the 1911 season at
Monte Carlo.
V&A: S.562(&3)–1980.
Given by Mademoiselle
Lucienne Astruc and
Richard Buckle in memory
of the collaboration
between Diaghilev and
Gabriel Astruc

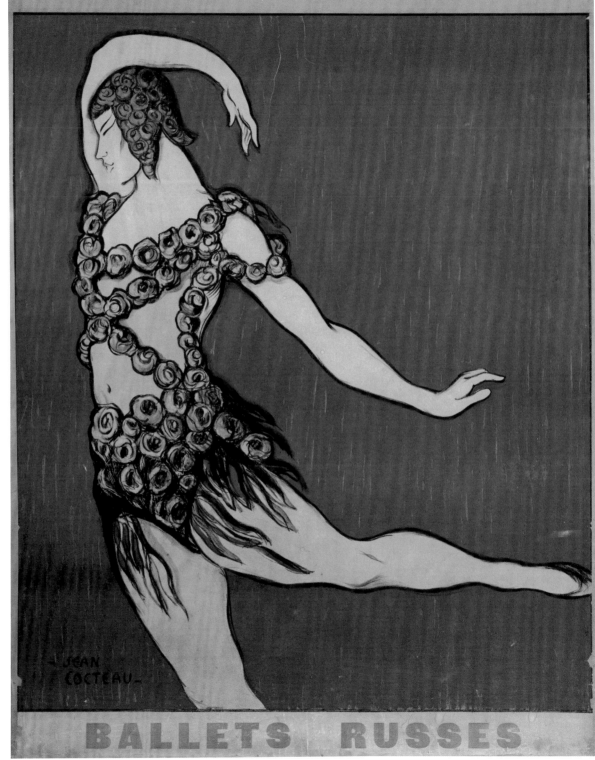

MIR ISKUSSTVA (WORLD OF ART)

Claire Hudson

Diaghilev founded his magazine, *Mir iskusstva* (*World of Art*), in late 1898. The title refers not only to the journal itself, but also to an exhibiting society for new artists. The aim of both was to educate artistic tastes and to raise the standard of Russian art, making it worthy of international recognition.

Diaghilev's first love had been music, and his passion for art developed comparatively late, around 1893–4, when he began buying pictures to hang in his St Petersburg apartment. He started organizing public exhibitions and writing art criticism before deciding to establish his own art journal. As he tellingly wrote at the time to Alexandre Benois, the articles would 'say openly what I think'. The

magazine's core editorial group would come to consist of himself, Benois, Léon Bakst, Dima Filosofov and Walter Nouvel, but Diaghilev's despotic zeal would always be its motor.

Mir iskusstva was published in St Petersburg, appearing in fortnightly numbers until 1900 and then monthly until 1904. Handsomely produced and copiously illustrated, it was clearly influenced by contemporary European art magazines such as *The Yellow Book*, *The Studio*, *Die Kunst* and *Pan*. At the time, this was a form of publication unknown in Russia, so much so that some of the printing had to be conducted elsewhere in Europe. The cover price was ten roubles a year in St Petersburg, more if sent to Moscow or overseas. The

Ivan Bilibin, title page for *Mir iskusstva* (1904), vol.2. Illustration for 'Folk Art of the Russian North'.
V&A: NAL II.RC.AA.38

Maria Yakunchikova, title page for *Mir iskusstva* (1899), vol.2. Cover showing illustration of a swan.
V&A: NAL II.RC.AA.27

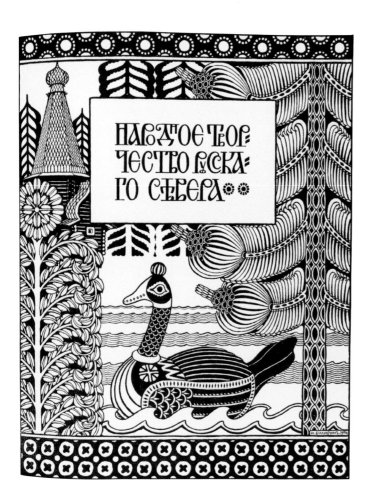

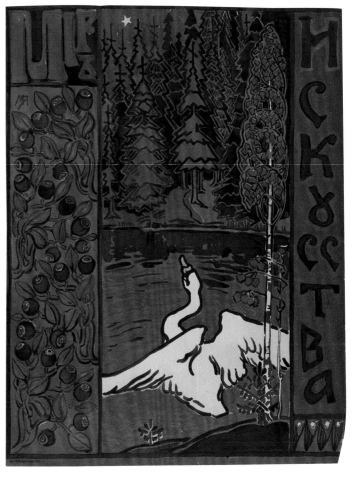

44

magazine was never funded by subscribers alone (who numbered fewer than 1,500) but was dependent for its existence on a series of patrons and five years of substantial state subsidy approved by Tsar Nicholas II.

The magazine's two initial supporters, the railway magnate Savva Mamontov and the wealthy patron of the arts, Princess Maria Tenisheva, had founded artists' colonies at Abramtsevo and Talashkino respectively. They were both actively involved in the Russian Arts and Crafts movement and the encouragement of progressive artists.

Diaghilev expressed the ideals of *Mir iskusstva* in a series of four essays entitled 'Complicated Questions'. The publication deliberately challenged the artistic establishment and championed aestheticism, innovation and artistic freedom, in opposition to the prevailing taste for social realism. While the content reflected the contemporary passion for Russian crafts, decoration and folklore, it also formed a bridge between ancient Russia and work by the best new artists in Russia and the rest of Europe. It introduced its readership to exciting new styles of painting and was the major promoter within Russia of the Post-Impressionists and the Fauves.

Eventually, in what was a period of huge social unrest, other more revolutionary artistic factions began to make the *Mir iskusstva* group seem less like Young Turks and more like part of the establishment they had set out to challenge. When the money finally ran out in 1904 the magazine ceased publication. The group's careers were leading them in new directions, but the relationships Diaghilev formed with artists such as Benois, Nicholas Roerich, Konstantin Korovin, Aleksandr Golovin and Léon Bakst during the *Mir iskusstva* period were fundamental to his later collaborations with them in creating stage productions of striking originality and artistic harmony.

Alexandre Benois,
illustrations for *The
Bronze Horseman* by
Alexander Pushkin.
Mir iskusstva (1904),
vol.1, pp.34–35.
V&A: NAL II.RC.AA.37

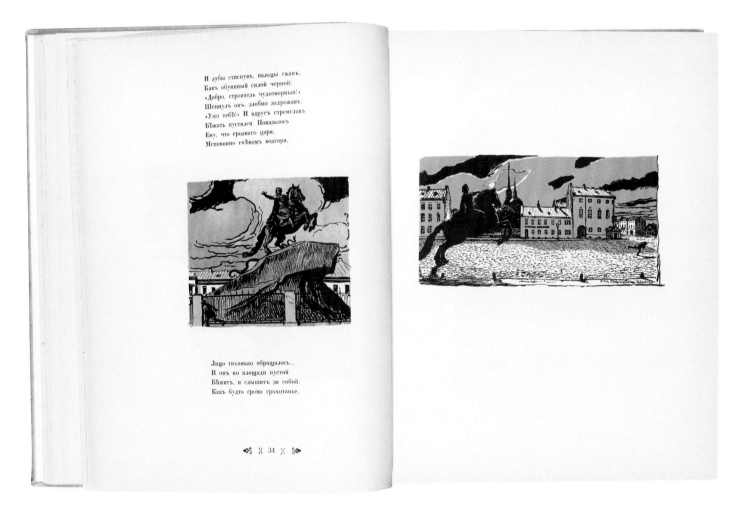

DIAGHILEV'S BOYS
Oliver Winchester

Male classical ballet has long been connected to homosexuality in the public consciousness, or to effeminacy at the very least. Yet such a rigid association has not always held firm. Theatrical ballet at the dawn of the twentieth century was a world dominated by women, and male dancers were of secondary importance to their female counterparts – in many cases male roles were performed by women dressed as men.

It was with the impresario Serge Diaghilev that an explicit and identifiable link between homosexual men and the ballet crystallized in the years prior to the outbreak of the First World War, and it was through the work of the Ballets Russes and its surrounding enterprises and images that the male dancing body first suggested itself as an object available for visual consumption.

Certainly Diaghilev was at ease with his own homosexuality. The composer and collaborator Nicolas Nabokov noted: 'I think one should never forget the fact that Diaghilev was an assertive homosexual, and the extraordinary thing about Diaghilev was that he was perhaps the first grand homosexual who asserted himself and was accepted as such by society.'[1] Diaghilev's social circle included the prominent homosexuals Jean Cocteau, Marcel Proust and Baron de Meyer, and his promotion of his star protégé male dancers such as Vaslav Nijinsky and Léonide Massine was not confined to the purely balletic, Massine having commented of Diaghilev that as a lover 'it was like going to bed with a nice fat old lady'.[2] Indeed, this coming together of a creative circle of homosexual men prompted the composer Igor Stravinsky's assertion that Diaghilev's

Léonide Massine in
costume designed by
Alexandre Benois for
an advance photoshoot
to promote *The Legend
of Joseph*, 1914.
Photograph by
Studio Dührkoop

Serge Lifar on the left
with the all-male corps de
ballet in *La Chatte*, 1927.
Photograph by Sasha.
V&A: Theatre &
Performance Collections

entourage constituted 'a kind of homosexual Swiss Guard'.[3]

Yet the Ballets Russes' significance to the aesthetic language of early twentieth-century dance reaches well beyond the biography of its founder or the sexuality of its key figures. The iconography at work within and around the ballet, and the dissemination of its images, is firmly rooted in the history of an emerging gay culture of the period. Many images were produced in limited editions or circulated in specialist magazines such as *Femina*, *La Gazette du Bon Ton* and *Le Théâtre*, with pictures of Nijinksy, for example, playing on the dancer's androgyny and sexless availability. Other images focused on the youthful beauty of Léonide

Massine or the athletic masculinity and confrontational machismo of Anton Dolin.

Writing for *Vogue* in 1928, Hubert Farjeon noted that the young men attending ballet performances 'wear the Ballets Russes like a carnation in their button holes'. Yet, significantly, he also observed a subtle shift in homosexual pathology and, in a nod towards a future identity, noted that these men are 'more formidable than [their] aesthetic predecessor of thirty or forty years ago. He is not so drooping, not so languishing ... on the contrary, he is surprisingly pink in the cheek, surprisingly fit, surprisingly unready to go down like a ninepin.'[4]

The Ballets Russes and the networks within and around it

provided an admissible context for the public spectacle of the male body in motion. Here, supposedly disinterested aesthetic appreciation was interwoven with private sexual desire, and erotic possibilities could be imagined. The early twentieth century thereby saw the opening up of a space, albeit the claustrophobic space of the closet, for the projection of a homosexual identity and desire.

1 Drummond 1997, p.300.
2 Stoneley 2007, p.67.
3 Spencer 1974, p.67.
4 Stoneley 2007, p.89.

THE TRANSFORMATION
OF BALLET

JANE PRITCHARD

The development of dance in the twentieth century owed an enormous debt to Serge Diaghilev. Thanks to his presentations, knowledge of and passion for Russian opera and ballet were augmented. He restored ballet to a position in high culture that it had lost for more than half a century. As Igor Stravinsky stated:

> The Ballets Russes are the *creation* of Diaghilev and his collaborators. Nothing of the kind ever existed before him and it is to him that we owe the recent development of choreographic art in the entire world....[1]

Stravinsky, writing in 1953, made a huge, but not unjustified, claim for the Ballets Russes, a company with which he had been closely involved. Giving such credit to the Ballets Russes, however, was nothing new. A 1914 article in the *Tatler* observed 'the Russian Ballet upset all our preconceived ideas concerning ballet dancing and pantomime', arguing that the initial appeal of the Ballets Russes lay in its:

> Extraordinary scenery, the even more extraordinary dresses, the most extraordinary colour schemes, rather than the dancing of Karsavina, Nijinski, and Bolm, an understanding of whose art lay beyond us – we, who had been brought up in the belief that ballet dancing meant a series of ungraceful postures, much idiotic gesture, and a great deal of over-muscular leg.[2]

Although Diaghilev had attempted to improve the quality of ballet at the Imperial Theatres with a new production of *Sylvia*, and supported his friends' interest in dance, as a young man he would never have foreseen that after 1909 ballet was to become a central feature in his life. He only turned to promoting dance when he realized that it was probably the most convenient medium for bringing together

in performance the arts he loved, notably music and painting. To promote ballet, although still costly, was less expensive than opera, which was one of Diaghilev's greatest passions: whenever possible, he included operas in his programmes. But Diaghilev was a great opportunist and recognized that, with the contributions of Wagner in Germany and Savva Mamontov and the Private Opera Company in Moscow – both working with new scores and approaches to design – opera had already been revitalized.

While the author of the *Tatler* article was perhaps overstating the situation, the training of *fin de siècle* dancers could result in unflattering physiques. There was certainly an overemphasis on the stage being decorated by attractive women, and there is no doubt that popular ballets set to light music were far less engrossing than the narratives produced by Diaghilev using more varied and dramatic scores.[3]

As far as dance was concerned, the early twentieth century was the ideal moment for change. Individuals including Loïe Fuller and Isadora Duncan had introduced new elements of movement and presentation into dance, and Diaghilev was lucky that in both Russia and Europe ballet was experiencing a period of decline. Marius Petipa's reign as ballet master at the Imperial Russian Ballet ended with his retirement in 1903, and the leading European choreographers Luigi Manzotti (1835–1905), Joseph Hansen (1842–1907), Katti Lanner (1828–1908) and Carlo Coppi (1845–1909), all died just before the advent of the Ballets Russes. Diaghilev's new company filled an extraordinary vacuum.

During the nineteenth century, as Europe became increasingly urbanized, the audience for ballet had both grown and shifted its focus. While in Russia and Eastern Europe audiences happily sat through a whole evening of ballet, such events were rare in Western Europe, where ballets were shorter and programmed with, or as scenes in, operas, operetta and musical productions (pl.21). They also

featured in *féeries*,[4] pantomimes and at variety theatres (pl.22). The rise of ballet in the popular theatres in the late nineteenth century had created new venues and audiences for dance that Diaghilev would use to his advantage when times became difficult for his company.[5]

Two trends dominated European ballet in the nineteenth century. The period between 1830 and 1850 saw the development in France of the Romantic ballet, which portrayed an Arcadian world of idealized rural communities and exotic places. Its subjects enabled audiences to escape their bourgeois urban culture, and it responded to a fashionable obsession with the irrational, especially with the supernatural world and its dangerous and erotic undercurrents. Ballet's fascination with the otherworldly and the exotic continued in what might be described as post-Romantic ballet throughout the century in Europe.[6]

In the 1880s the Italian *ballo-grande*, spectacular brash productions which presented huge numbers of dancers in almost military formations (often more scantily clad than the post-Romantic equivalents), became extremely popular throughout Europe and America. The internationally acclaimed *Excelsior* (1881), a ballet illustrating the progress of science and civilization, epitomized this genre. The success of the *ballo-grande* was such that in Paris, the stronghold of post-Romantic ballet, the Eden-théâtre was purpose-built in 1883 almost over the road from the new Palais Garnier. Surviving for a decade at the Eden-théâtre, *ballo-grande* was commercially more successful in Paris than Diaghilev's company would ever be. *Excelsior* alone was performed on more than 500 occasions while over 20 years the Ballets Russes staged fewer than 300 performances in Paris. However, although the *ballo-grande* at the Eden-théâtre paved the way for Parisian audiences to accept that ballet could be an imported art, the Ballets Russes exerted a much longer-lasting impact.

While the French and British increasingly presented women *en travestie* (dressed in male attire) as the 'heroes' of ballets, the Italians continued to develop virtuoso male dancers including Enrico Cecchetti who became ballet master for the Ballets Russes and, for specific productions, the distinctive male corps de ballet of 'tramagnini' (originally acrobatic warriors).[7] The virtuoso danseurs

21. Hilaire-Germain-Edgar Degas, the Ballet Scene from the opera *Robert le Diable*. Oil on canvas, 1876. Giacomo Meyerbeer's 1831 opera remained popular throughout the nineteenth century. V&A: CAI.19

22. The 'Snow Ballet' from *The Voyage to the Moon* (Act III) at Her Majesty's Theatre, London. Colour lithograph, 1883. V&A: S.194–2008

frequently took on roles of an exotic nature. Indeed they often performed as slaves or exotic characters, roles far more similar to those which would be danced for the Ballets Russes by Vaslav Nijinsky than those performed by the virile character danseur, Adolph Bolm.

Ballo-grande did not wipe out ballets presented in music halls or ballets in *féeries*, and both combined elements of post-Romantic and spectacular ballets. In parallel with the rise of the *ballo-grande*, *pointe*-work developed from being a new technique to suggest ethereality to a means of deliberately showcasing a ballerina's tricks. Wearing increasingly blocked shoes, dancers with '*pointes* of steel' prioritized multiple turns and sustained balances over the artistry of their roles. Both genres had an impact on teaching and were absorbed into the Imperial Ballet School in Russia. The Russian critic, André Levinson, succinctly summarized the contrast between the two 'schools': 'the Italian, more *terre à terre*, exceeded the limits of technique in regard to pointes and pirouettes; the French strove for elegance and elevation in both the poetic and gymnastic sense of the word.'[8]

During Marius Petipa's tenure as ballet master and choreographer-in-chief at the Imperial Ballet it developed into a company that was second to none. Petipa became a fine choreographer, particularly for women, although many of his large productions may be divided into scenes of narrative, procession, divertissement or post-Romanticism in ballet (the so called 'ballet blanc' scenes epitomized by the 'Shades' in *La Bayadère*).[9] An increasingly varied repertoire of ballets was created and, as ballet was court entertainment, its funding was relatively secure. After the

position of resident composer for theatre was abolished with the retirement of Leon Minkus in 1886, the company became more innovative musically, with commissions from Pyotr Tchaikovsky and Alexander Glazunov.[10] Significantly, the Imperial Ballet had developed a fine school, absorbing the best characteristics of the French and Italian dancers, and by the turn of the century its pupils were in demand internationally just as Italian ballerinas had been in the two previous decades.

Before the Ballets Russes it was not possible to have both an international career and to dance with one company. Whereas individual dancers and small troupes travelled, large companies were usually fixed at one theatre. Italian ballerinas would move between *ballo-grande*, music-hall ballets and the Imperial Ballet. The career of Carlotta Brianza (1867–*c*.1935), who had created the role of Aurora in Petipa's original *The Sleeping Beauty* (1890) and later performed that of the wicked fairy, Carabosse, in Diaghilev's *Sleeping Princess* (1921), indicates dancers' peripatetic lives. Having trained at La Scala, Milan, Brianza toured in the United States and performed at the Eden-théâtre, Paris in 1886. She danced in Cecchetti's production of *Excelsior* at the Arcadia Theatre, one of the commercial summer theatres in St Petersburg (1887), and starred at the Empire Theatre in London. She also danced at the Maryinsky on a number of occasions, commuting in the 1890s and early 1900s between St Petersburg, Paris, London, Milan and Brussels.[11]

Other individual dancers also toured, giving concerts of dance or being presented in popular theatres. Among those who exerted a significant influence were Loïe Fuller

and Isadora Duncan. Both took an aesthetic approach, celebrating movement for its own sake, although for Fuller this involved dance and light while Duncan was more concerned with Hellenism. Both emphasized a continuous flow of movement in which the dancers' *epaulement* or use of the upper torso was significant. Their style of dance was liberating. For decades the body had been encased in corsets or tight-fitting boned bodices, forcing dancers to hold their upper body tilted forward with minimal movement, encouraging static groups and poses. Fuller was equally renowned as a theatre technician and her use of coloured light directed onto billowing Chinese silk resulted in audiences considering her as the embodiment of Art Nouveau. Duncan's impact derived from her danced response to concert-hall music with heightened natural movements enhanced by her free-flowing tunic. Her body was unrestricted by her garments; her bare feet liberated from the steel *pointes* of the late-nineteenth-century ballerina (pl.23).

By the turn of the century, before Duncan made her first visit to Russia in 1904, a division was evident in supporters of the Imperial Ballet. While the old guard sung the praises of Petipa, whose greatest ballets are performed to this day,[12] devotees of the 'new ballet' favoured the work of Alexander Gorsky[13] who responded to Konstantin Stanislavsky's Moscow Art Theatre by making ballets more individual and 'realistic'.[14] Gorsky's influence on Mikhail Fokine, the choreographer on whom Diaghilev depended to launch his ballet in the West, should not be ignored and it was their individualization of dancers and fresh approach to choreography that later enhanced the Ballets Russes.

Recognized for his skills as an organizer of exhibitions and innovative editor of the journal *Mir iskusstva* (*World of Art*), on 22 September 1899 the 27-year-old Diaghilev was employed as a 'functionary for special assignments for the management of the Imperial Theatres'. Diaghilev's initial task was to edit its Year Book. Always ambitious, Diaghilev seized the opportunity to take a more active artistic role and immediately suggested a range of new productions for the Maryinsky Theatre, including *Sylvia*. It was perhaps surprising that Diaghilev should have suggested a ballet, but Russian opera had already experienced a renaissance through the work of the Private Opera Company, Moscow, which presented new Russian operas designed by fine

23. Edward Gordon Craig, *Isadora Duncan Dancing at Breslau, Germany*. Watercolour and pencil, 1905. V&A: S.196–2008

artists. Diaghilev seems to have been persuaded by his colleagues, Walter Nouvel and Alexandre Benois, who were passionate about ballet. Although internationally performed, *Sylvia* was little known in Russia[15] but its score had inspired Pyotr Tchaikovsky and its composer Léo Delibes was a particular hero for Benois.[16] The brothers, Nicolas and Sergei Legat, who were sympathetic to new ideas, were invited to choreograph it and the *Mir iskusstva* team set about the designs, their first experience for the stage. Benois took the lead and his design for Act I survives, while other sets were to be created by the artists Konstantin Korovin, Yevgeny Lancerey and Léon Bakst, who was also given responsibility for the costumes. Bakst's design for Olga Preobrajenska as the huntress Sylvia shows his first flowing 'Greek' costume avoiding the traditional short tutu and *pointe* shoes.

In February 1901, just as *Sylvia* was about to be announced, the Director of the Imperial Theatres, Prince Sergei Volkonsky, noticed that Diaghilev's ambitious plans were causing serious resentment among some of his colleagues and withdrew his support. Diaghilev refused to resign and was dismissed. Following this humiliating episode, he focused on *Mir iskusstva* and exhibitions, only returning to ballet at the end of the decade.

For such an important figure in the development of dance it perhaps comes as a surprise that although he grew up surrounded by music, Diaghilev's first recorded visit to a ballet did not occur until he was 18 years old. He was travelling with Dima Filosofov to Italy when they stopped in Vienna and saw a series of operas and a production of the new ballet *The Fairy Doll* (*Die Puppenfee*) of 1888, choreographed by Joseph Hassreiter (pl.24). With original music by Josef Bayer *The Fairy Doll* had been developed from a pantomime for amateurs and was (indeed still is) an endearing work with a simple narrative in two scenes. In the first a shopkeeper displays his dolls for various customers, while in the second, at night, the toys take on a life of their own. *The Fairy Doll* became one of the most successful ballet creations of the late nineteenth century and new versions were staged internationally from New York (1890) to St Petersburg (1903).[17] The latter production was choreographed by the Legat brothers with charming designs by Léon Bakst, all of whom had been involved with Diaghilev in his abortive production of *Sylvia*.

24. Advertising cards for Liebig beef extract featuring scenes from Joseph Hassreiter's ballet *The Fairy Doll* (*Die Puppenfee*) at the Viennese Opera, *c*.1890. Private collection

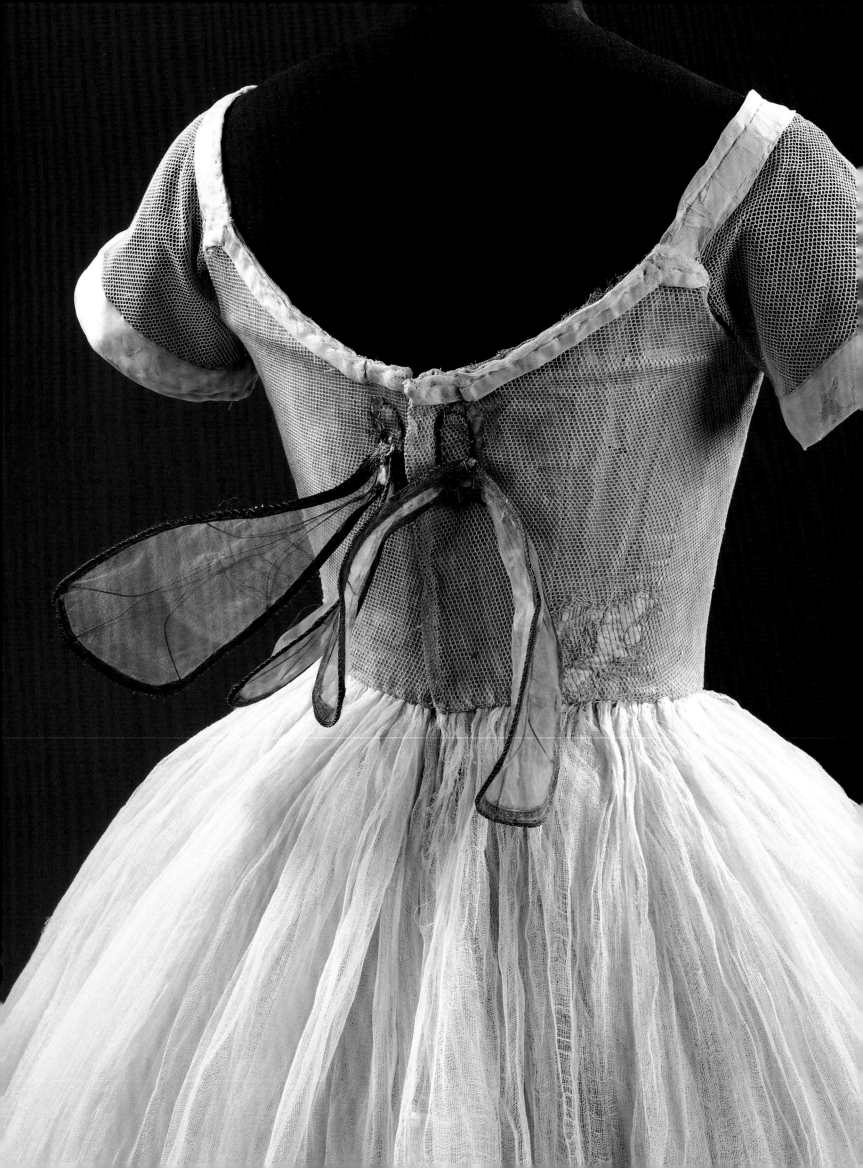

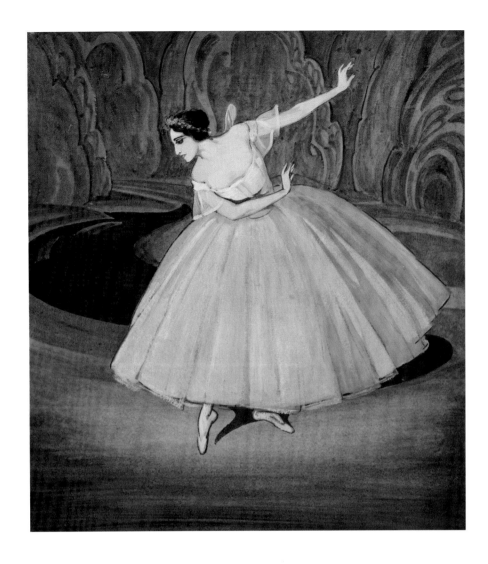

In his productions for the 1908–10 Saison Russe, including *Boris Godunov*, *Le Pavillon d'Armide* and *The Firebird*, Diaghilev followed accepted practice, but when in 1911 he formally established his own year-round company,[18] he both dropped those elements of spectacle which were impractical for touring and found his own voice in the theatre. Writing to a Parisian journalist about his plans for the opera *Boris Godunov* in 1908, Diaghilev stressed that the historical accuracy of the production would impress audiences.[19] This approach looked back to the archaeological stagings of the late nineteenth century, epitomized in Britain in productions by Charles Kean.[20] Soon Diaghilev and his designers were taking a more impressionistic approach to sets and costumes in which colour and imagination triumphed over pedantic research.

Initially Diaghilev tried to reproduce elements of spectacular theatre similar to those used at the Imperial Theatres, or indeed *féeries* at the Théâtre du Châtelet or the *ballo-grande* at the Eden-théâtre. During his first season Diaghilev brought to Paris the great Russian machinist, Carl Waltz, to ensure his special effects, such as the fountains in *Le Pavillon d'Armide*, shot up on stage.[21] In the first production of *The Firebird* (1910) the eponymous bird flew on wires and the Knights of Night and Day rode on horseback. Such elaborate devices were soon found to be unnecessary and were dropped before *The Firebird* returned (after its absence from the stage for a year and a half) as a more efficient, streamlined ballet (pl.27).[22] With his independent company Diaghilev no longer presented great crowds of performers, although he enlisted a number of extras at each venue, and

before the First World War he continued to bring from Russia vast opera choruses for summer seasons in Paris and London (pl.28).[23]

The ballets Diaghilev presented during his 1909 and 1910 seasons are clearly transitional works; *Prince Igor* with its aggressively masculine cast was the greatest novelty (pls 29–31). The other ballets were nevertheless cleverly chosen to appeal to French taste, *Le Pavillon d'Armide* (pl.28) acknowledged the Francophile academic ballet of St Petersburg, as well as French history in its representation of the court of Louis XIV, and *Les Sylphides* the Romantic ballet tradition (pls 25 and 26). The success of Mikhail Fokine's *Les Sylphides* was so great that earlier ballets of the same name or those danced to music by Chopin have been wiped out of history.[24] *Cléopâtre* in 1909, like *Schéhérazade* a year later, tapped into the French obsession with a perceived sensual Orient, and the audience was stunned by Bakst's designs and the performances of Vaslav Nijinsky, Ida Rubinstein and the other dancers. But the score for *Cléopâtre* was compiled from music by no less than five composers, an approach closer to an earlier ballet score with tunes pasted together than the more cohesive music Diaghilev subsequently presented.

Diaghilev was not alone in promoting Russian Ballet to new audiences, indeed many impresarios tapped into the Russian supply of well-trained dancers, although their choice of production was often backward looking. Raoul Gunsbourg, who became director of the Monte Carlo Opera House in 1893, recognized that as many Russians wintered on the Riviera, he would be advised to cater to their taste, and

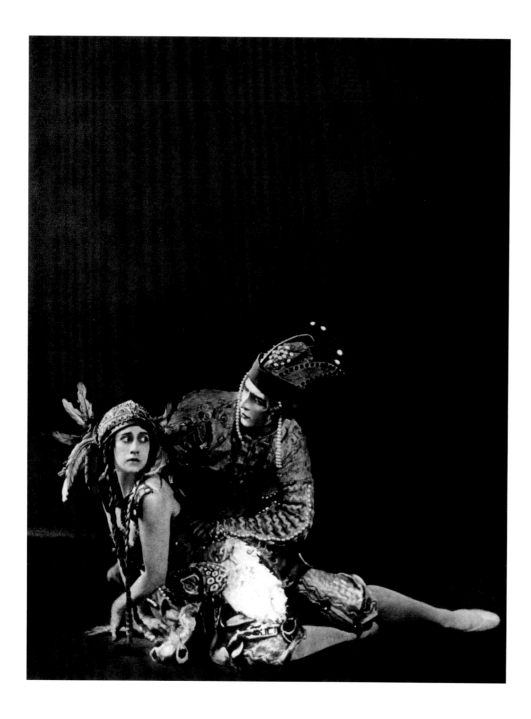

27. Tamara Karsavina and Adolph Bolm in *The Firebird*, 1912 production. Photograph by E.O. Hoppé. V&A: Theatre & Performance Collections

28. Alexandre Benois, set design for *Le Pavillon d'Armide* (Scene II). Watercolour, indian ink, pencil and gouache, 1907. This is the set as designed for St Petersburg; Benois re-worked it to show a symmetrical vista for Paris in 1909. Private collection

in 1895 he programmed stars of the Russian Imperial Ballet including Matilda Kschesinskaya, Olga Preobrajenska, Alfred Bekeffi, Iouzia Kschesinsky and George Kyasht. From 1905 he presented Fyodor Chaliapin as the eponymous Mefistofele ahead of his appearances in Paris, London and New York. Given the Russian population in Monte Carlo, and despite continuing rivalry between Gunsbourg and Diaghilev, it was a sympathetic place in which to launch the Ballets Russes as an independent company in 1911.[25]

In May 1908 Adolph Bolm and Anna Pavlova had toured the Baltic, and in August Bolm visited London to perform at the Empire Theatre with Lydia Kyasht, who found a niche for herself as the Empire's ballerina.[26] Tamara Karsavina arrived in Paris in 1909 via performances in Prague and with a small group of dancers, notably Theodore Kosloff, went on to dance at the London Coliseum immediately afterwards.[27] By the time she first danced for Diaghilev, Anna Pavlova was already well on the way to establishing her independent career, arriving in Paris from touring Central Europe after the Saison Russe had begun. During Diaghilev's 1910 season many impresarios were on the lookout for new stars. Lydia Lopokova, who Diaghilev had promoted, signed up to go to the USA.[28] At that time others were offering far longer and more lucrative contracts than Diaghilev and there was no way the dancers could foresee he would offer anything other than short contracts. By 1911 the capitals of Europe seemed to be flooded with Russian dancers. In Paris at the Théâtre Sarah Bernhardt, opposite the Théâtre du Châtelet in which Diaghilev's company was again to perform, a rival Saison Russe presented productions drawn from the Maryinsky's repertoire, choreographed by Marius Petipa, his former assistant Lev Ivanov and Nicolas Legat, as well as Russian opera.[29] When the Ballets Russes reached London for the 1911 coronation season the theatres were full of Russian dancers.[30]

Diaghilev's own theatrical apprenticeship was over by 1911. Once he had established his own company, much of the competition dwindled. It was obvious to audiences that the quality of his productions was superior to that of any rival. Others could attract the dancers but they did not have the original settings in which to show off their talents, and his ballets won hands down when it came to music, sets, costumes, choreography and overall production. He benefited from the development of large theatres in the late nineteenth century to provide venues in which his company could perform; the Théâtre des Champs-Elysées, opened by the music promoter Gabriel Astruc in 1913, was unusual in being constructed with companies such as Diaghilev's operation in mind. He convinced audiences in Western Europe and America that an evening devoted to dance was an exciting prospect and his productions made ballet a far more varied genre. Finally, Diaghilev was responsible for the creation of ballets in which the elements of dance, music and design fused together, establishing the standards to which subsequent companies throughout the world would aspire.

29. The Polovtsian
Dances from *Prince Igor*
performed at the London
Coliseum, *c.*1924.
Daily Mail archive

30. After Nicholas Roerich,
costumes for two Polovtsian
Warriors from *Prince Igor*.
Silk ground, silk ikat
fabric, cotton metal disks,
skull cap embroidered in
polychrome thread, *c.*1909.
V&A: S.576(A,B&C)–1980
with S.577–1980;
S.588(&B)–1980 with
S.587A–1980

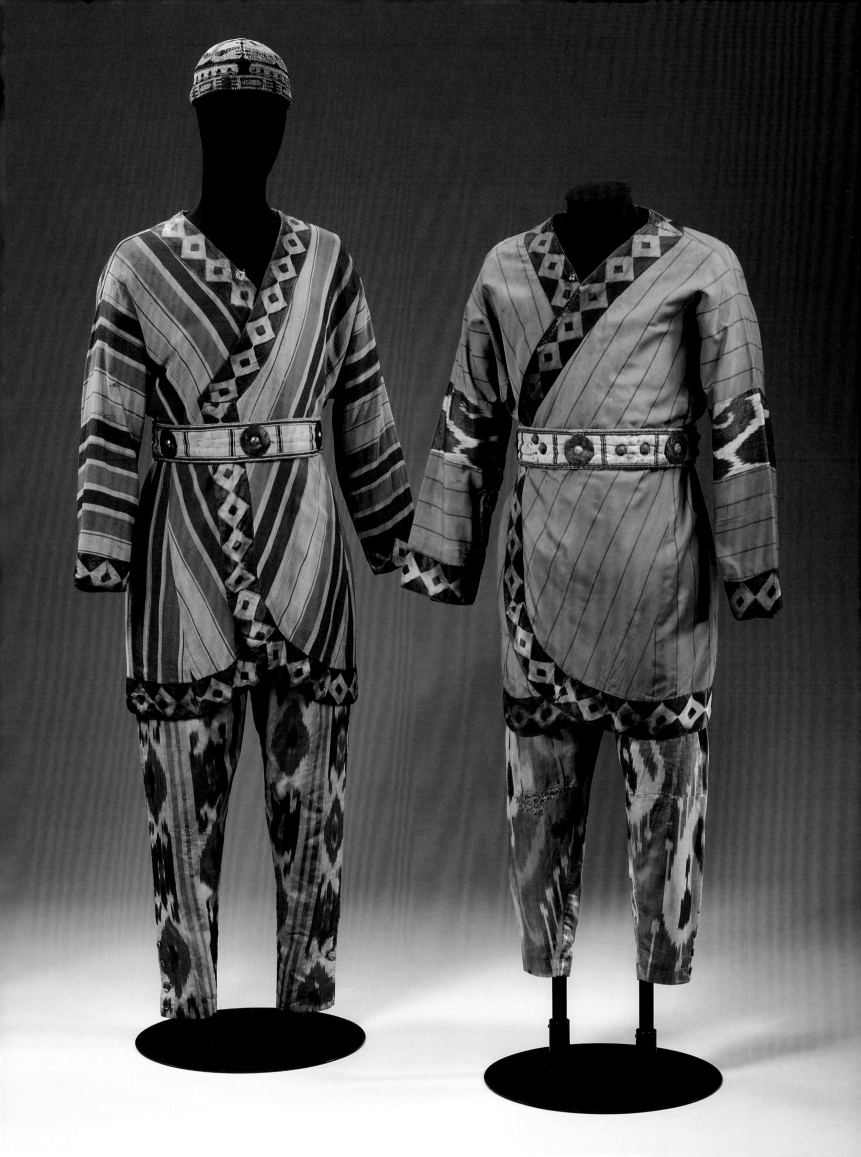

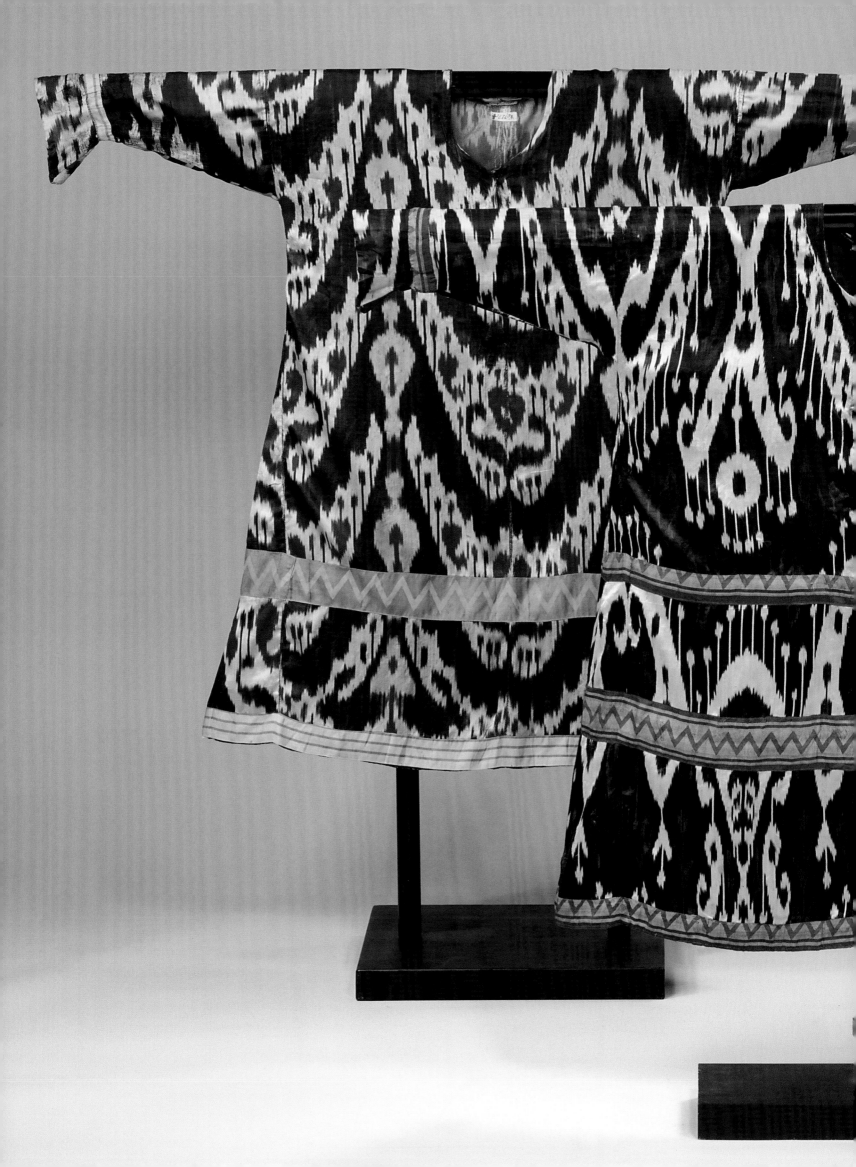

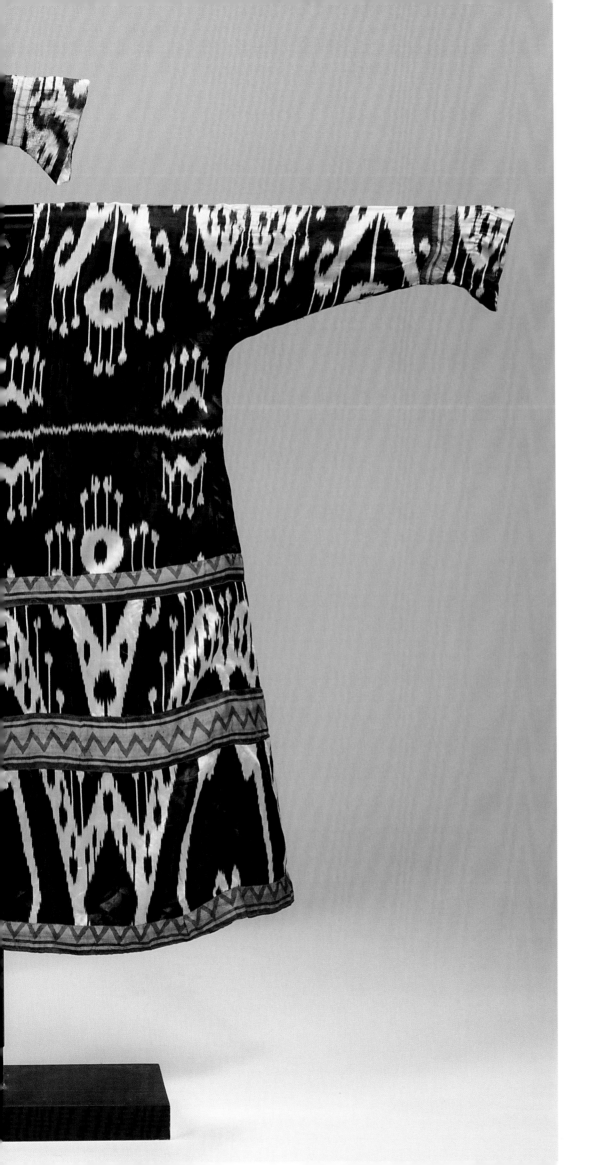

31. After Nicholas
Roerich, costumes for
two Polovtsian Girls
from *Prince Igor*. Silk
ikat fabric, *c*.1909.
V&A: S.589–1980;
S.573–1980

32–35. Nicolas and Sergei
Legat, caricatures from
*The Russian Ballet in
Caricatures*, published in
St Petersburg, 1902–5.

Left
32. Nicolas and Sergei Legat.
V&A: S.5309–2009

Below, left
33. Matilda Kschesinskaya
as Esmeralda.
V&A: S.5310–2009

Below, right
34. Tamara Karsavina.
V&A: S.5312–2009

Opposite
35. Mikhail Fokine as
Mercury.
V&A: S.5311–2009

М. М. ФОКИНЪ. M. FOKIN

PAUL POIRET AND THE BALLETS RUSSES
Claire Wilcox

Paul Poiret (1879–1944) launched his fashion house in 1903, and rapidly became one of the most renowned couturiers in Paris. His designs drew on the revolutionary freedom of dress of the Directoire period, informed by a contemporary interest in non-Western design that reached its height in Paris in the 1910s. Daringly, he banished corsets and totally redefined the fashionable silhouette with high-waisted gowns, tunics worn over harem trousers and hobble skirts. He introduced tassels and bold Ottoman embroidery, Indian-inspired turbans and oversized 'Chinese' opera cloaks in sumptuous fabrics, in an eclectic mélange of influences.

Although Poiret's aesthetic was suffused with colourful exoticism even before the arrival of the Ballets Russes in 1909, Léon Bakst's set and costumes must have had great resonance. While in his autobiography Poiret disputes Bakst's influence on him, the heightened sensuality of the vibrant, and sometimes shockingly revealing, stage garments gave Poiret's designs an additional frisson by association. These links were emphasized in illustrations by Georges Lepape and Paul Iribe, which often used the theatre or auditorium as a backdrop.

Throughout his life Poiret maintained a passion for the theatre.

Right
Georges Lepape, illustration from *Gazette du Bon Ton*, (1912/13), vol.1 (2), (pl.VI).

Far right
Illustration from *L'Illustration* (19 February 1911). Photograph by O'Doye. Poiret's voluminous harem trousers or jupe-culottes were worn under a long tunic or incorporated into dresses.

SERAIS-JE EN AVANCE ?
Manteau de théâtre de Paul Poiret

Gazette du Bon Ton N° 2 — Pl. VI

He designed for many actresses and dancers both on and off stage – including the Ballets Russes stars Ida Rubinstein and Tamara Karsavina – and was one of the few couturiers to maintain a specialized workshop for theatre costume. His love of spectacle was reflected in his impressive fashion shows and the sumptuous interior of his couture house. The photographer Cecil Beaton recalled: 'To enter Poiret's salons in the Faubourg St Honoré was to step into the world of the Arabian Nights. Here, in rooms strewn with floor cushions, the master dressed his slaves in furs and brocades and created Eastern ladies who were the counterpart of the Cyprians and chief eunuchs that moved through the pageantries of Diaghilev.'[1]

However, it was Poiret's extravagant fêtes that epitomized Orientalist fantasies of the time. The most renowned took place in June 1911, a 'Persian' spectacle 'The Thousand and Second Night', which featured dressing-up clothes for guests, storytellers, monkeys, fountains and fireworks, and was undoubtedly influenced by Diaghilev's production of *Schéhérazade* the year before. Poiret's guests lounged on antique carpets drinking sherbet and watching semi-naked dancers, amid 'a mass of silks, jewels and aigrettes that sparkled iridescently, like stained glass in moonlight'.[2]

Perhaps most dashing of all were the headdresses and turbans, inspired by Poiret's studies at the V&A. At the premiere of the *Rite of Spring* on 29 May 1913 'every woman wore a head-dress: dazzling tiara, embroidered bandeaux, or turbans with aigrettes and birds-of-paradise plumes.'[3] Poiret's exuberant vision benefited from and reflected the drama of the Ballets Russes, for in the heightened atmosphere of Diaghilev's productions, both dancers and audience became part of the act.

1 Beaton 1954, p.300.
2 Poiret 1931, p.189.
3 Mackrell 1990, p.28.

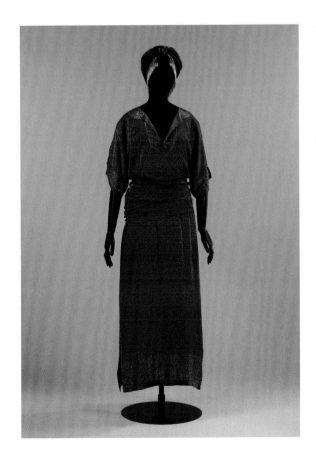

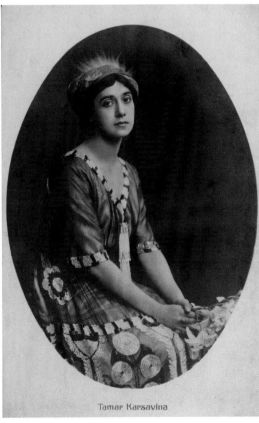

Tamar Karsavina

Far left
Paul Poiret, 'Lavallière' evening dress and turban. Silk with embroidery, *c.*1911. Collection Francesca Galloway

Left
The ballerina Tamara Karsavina wearing a dress designed by Paul Poiret, *c.*1914. V&A: Theatre & Performance Collections

DIAGHILEV'S THEATRES
Janet Birkett

To present his company in style Diaghilev used the most glamorous and well-appointed theatres. The purpose-built opera houses of late nineteenth-century Europe and the Americas fulfilled most of his requirements. They had a dominant location in the city, and contained stages wide and deep enough to accommodate up to 50 dancers plus supernumeraries, a large orchestra pit, up-to-date lighting equipment, and front-of-house facilities that showed off a fashionable audience. The Ballets Russes gave seasons at all the major houses including the Paris Opéra, the Royal Opera House, Covent Garden, the Colon in Buenos Aires, the Metropolitan Opera House, New York, and Monte Carlo's Salle Garnier, which became the company's base from 1922. If opera houses were not available

Diaghilev endeavoured to obtain large theatres and, if necessary, improved them to meet his exacting standards. Having secured the Théâtre du Châtelet for the company's debut, he organized the redecoration of the auditorium and foyer, had the size of the orchestra pit increased and the uneven stage renovated, all in five days. At the London Coliseum in 1918 Diaghilev had extra lights installed to supplement the follow-spots and floodlights, and he insisted that the sequins be removed from the theatre's front curtain as the glittering spoiled the subtle lighting effects.

Nevertheless, a company that survived on box office receipts was obliged to keep touring, accepting dates at any venue of suitable size. In North America the company danced at the prestigious Century Theatre in New York and the Boston Opera House, but,

Laura Knight, *In the Coulisse*. Oil on canvas, *c.*1920. Dancers from the corps de ballet in costumes for *Les Sylphides* and *Le Tricorne* with a dresser (in red) during a rehearsal at the Alhambra Theatre, London.
Falmouth Art Gallery

Above
Seating plan from the souvenir programme for the Théâtre des Champs-Élysées, 1913. V&A: Theatre & Performance Collections

Right
Théâtre du Châtelet, Paris, showing its location by the Seine, *c.*1865.

outside the principal cities, it appeared in halls and auditoria which lacked any of the amenities of a theatre. At the Convention Hall, Kansas City, it was necessary to install a proscenium arch and a grid for hanging the scenery.

In Britain, the Ballets Russes was able to appear at the large theatres designed for variety shows. Although Diaghilev may have regarded it as a come down to present one ballet in a mixed entertainment programme, the Coliseum was then London's key venue for dance and it had good sightlines for the audience. His seasons at the Alhambra and the Empire in

Leicester Square, both theatres with long traditions of music-hall ballet, were presented as ballet seasons independently from other variety acts.

Backstage facilities and dressing rooms were usually cramped and sometimes completely inadequate; at times the dancers even lacked water to wash off their make-up. At London's rat-infested Prince's Theatre (now the Shaftesbury) not all the dancers and extras could be accommodated, so the extras had to change at the nearby swimming baths and walk through the streets in full costume. The conditions onstage could also present problems.

Some stages were flat, others raked (tilted down towards the footlights), and wooden floors frequently included traps and grooves in which feet could be caught. At the Coliseum, which was notoriously hard, there was a three-centimetre gap around the stage revolve. In Spain, where many of the theatres were badly maintained, the dancer Alexander Gavrilov, fell through a rotting floorboard, tearing his Achilles tendon. The glamour projected by the company was often achieved in very basic conditions.

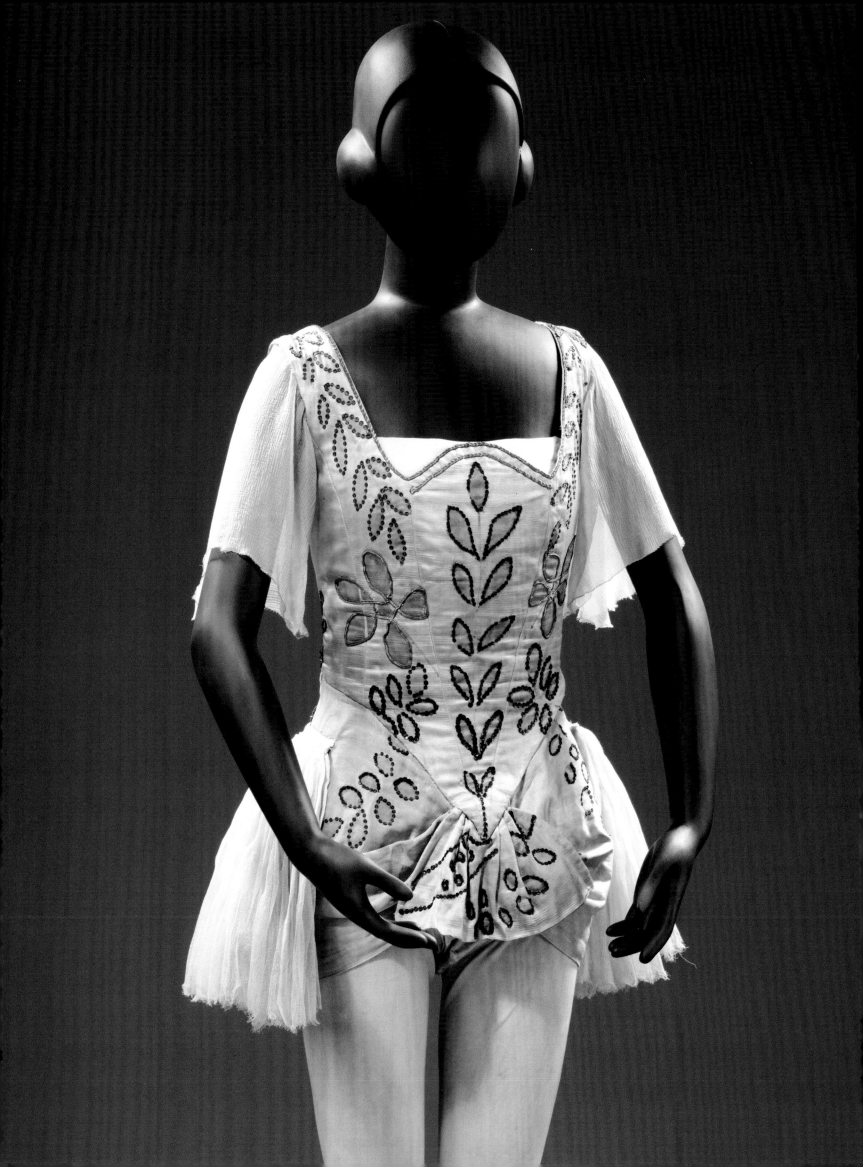

Opposite
36. After Georges
Braque, costume worn
by Alice Nikitina as Flore
from *Zéphire et Flore*.
Silk satin, cotton
tarletan, metal thread
braid, gelatine sequins,
paint, silk jersey (tights),
silk chiffon replica
sleeves, 1925.
V&A: S.838(&A)–1980

37. Alice Nikitina as
Flore from *Zéphire
et Flore*, 1925.
V&A: Theatre &
Performance Collections

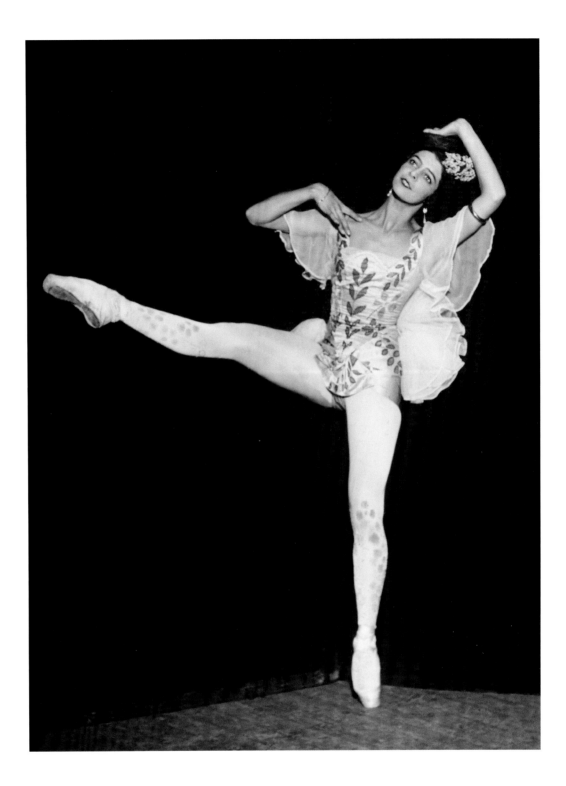

CREATING
PRODUCTIONS

JANE PRITCHARD

The ballerina Tamara Karsavina described Diaghilev as being 'rather like Napoleon, who had a wonderful gift for detail'.[1] Indeed, Diaghilev's ability as an artistic director has never been surpassed. Every aspect of a production underwent his scrutiny, and he was never afraid of asking great artists to rethink their proposals. The composer of the ballet *Zéphire et Flore*, Vladimir Dukelsky (Vernon Duke), explained that Diaghilev did not ask for specific amendments, 'He sits down, screws his eyeglass, and exudes a beneficent cloud of inspiration'.[2] When planning a ballet Diaghilev consulted his friends for ideas and approval, but once it came to stage rehearsals he would become dictatorial, directing everything from dancing to lighting and technical effects. His concentration never flagged, even if at times he appeared to be watching through half-closed eyes. 'If it pleases him, it stands. If it does not, it goes. He does not dance himself, nor paint, and he has only learned the theory of composition. Yet, somehow or other, he knows. And the experts know that he knows, and venerate his advice.'[3]

From the start Diaghilev was aware that his company was Russian ballet for export to audiences fascinated by his homeland, which extended from the frontier with the Baltic and Austro-Hungarian Empire through to Japan. Ballets Russes productions presented the Russian steppes in *Prince Igor*, shaman sites of Mongolia in *The Rite of Spring*, and the Caucuses in *Thamar*. The Indian frontier was reflected in *Le Dieu bleu*, and the sensuous 'Orient' of Samarkand in *Schéhérazade*. Russia was depicted as a country of highly painted wooden villages in *Contes Russes* and kremlins (walled cities) of onion-domed churches in *The Firebird*. While appreciating the coverage given to their dancers, Russian commentators were frustrated by the perceived barbarism of their nation presented by the Ballets Russes, especially by dancers performing an art favoured by their court.[4] Before the 1917 Revolution the company celebrated

the diversity of Russia. In the 1920s it looked back with nostalgia, an approach that appealed to émigré audiences. At the same time, however, it took on board the most recent Russian trends such as Constructivism in *Le Pas d'acier*, possibly in the misguided view that this would enable the company to perform in the Soviet Union.

While Diaghilev's ballets do not all conform to precisely the same template, certain groups of people would always be involved. At the heart of everything was Diaghilev's informal inner cabinet of advisers, friends, colleagues and sponsors, who were consulted on suggestions for and approval of productions. The cabinet frequently came up with the ideas for ballets (and operatic productions) and it served as a sounding board for ideas. Diaghilev's initial group, which included a number of his *Mir iskusstva* (*World of Art*) partners, would gather in his St Petersburg flat. Key members included the designers Alexandre Benois and Léon Bakst, General Bezobrazov (a privy councillor and balletomane who Diaghilev used as 'Company Manager'), the critic Valerian Svetlov, who Diaghilev sometimes sent to Paris to review his productions for Russian readers, and Walter 'Valichka' Nouvel, who remained involved with the company throughout its existence. Initially, it also included Diaghilev's lover and secretary, Aleksey Mavrin, until he eloped with the dancer Olga Fedorova during the 1909 Paris season. It was augmented by the choreographer Mikhail Fokine, *régisseur* and ballet master Serge Grigoriev, and occasionally with others, such as the artist Valentin Serov and the composer Nikolai Tcherepnin. The circle of advisers became more fluid when Diaghilev's work was focused on Paris, where it included Misia Sert, the Comtesse Greffulhe and the impresario Gabriel Astruc. While the Russian group focused on artistic concerns, the Parisians also concerned themselves with fundraising and promotion.

Some of the committee's early ideas are revealed in Diaghilev's black notebook where he jotted down points

discussed in meetings from 1910 to 1911.[5] These notes show that in 1911 Diaghilev was developing a three-year programme with proposals for a tour of the United States and preliminary ideas for casting ballets, including suggestions that Ida Rubinstein should be considered for chief nymph in *L'Après-midi d'un faune* and Leonid Leontiev for *Petrushka*. Diaghilev includes notes on how *The Firebird*, *Cléopâtre* and *Le Carnaval* could be improved. *The Firebird* was dropped from the repertoire in 1911, probably to allow for revisions to be implemented. The notebook also details the matters Diaghilev concerned himself with, including supplying publicity photographs to theatres he planned to visit in Rome, London and Russia. It becomes obvious that some ideas went through a long gestation. Proposals for a ballet featuring the Slavic house spirit, Kikimora, appear here, as does an idea from Benois – inspired by the visit of Henri and Marius Casadesus, founders of the Society of Ancient Instruments (which rediscovered and played the scores of long-dead composers) to St Petersburg in 1909 – of reconstructing courtly dance as performed at Versailles to music by Michel de Montéclair. *Kikimora* was staged in San Sebastiàn, Spain, in 1916 but Montéclair's music was not employed until *Les Tentations de la bergère* in 1924.

During the First World War Diaghilev developed a largely new advisory group which travelled with him to Switzerland, Spain and Italy (pl.38). After the Ballets Russes reformed in 1915, following a gap of nine months when all the dancers were dispersed, there was a strong representation of designers. These included Natalia Goncharova and her partner Mikhail Larionov who was invalided out of the war having been injured in 1914, Robert and Sonia Delaunay, and, from 1916, Pablo Picasso.

After the war patrons assumed a more significant role, but the artistic world was still represented. Describing his commission in the late 1920s to compose the score for *Ode*, Nicolas Nabokov outlined the process of approval:

First the 'foundling' was tested for several months by the closest members of His Majesty's household; these included Roger Desormière, the eminent French conductor, Boris Kochno, Valichka Nouvel. Then, after he had passed the preliminary 'household test,' he was to meet the great ones: Stravinsky, Picasso. Next came the influential friends and patrons of Diaghilev: Princess de Polignac (Singer sewing machines),

38. Mikhail Larionov, *Natalia Goncharova, Serge Diaghilev, Léonide Massine and Beppe Potetti*. Pencil on paper, *c*.1917. V&A: E.277–1961

39. Laura Knight, *Olga Spessivtseva
Backstage Tying her Shoe*. Oil
on canvas, *c*.1921–2.
Painted during the run of
The Sleeping Princess at the
Alhambra Theatre, London.
Private collection

Lord Rothermere (*Daily Mail*), Coco Chanel (*haute couture*), and Misia Sert, the clever, warm and attractive friend of Diaghilev and of two generations of famous painters and musicians.[6]

Interestingly Nabokov added that the 'ritual also included drawing up a list of people the foundling was advised not to see'. These included anyone with whom Diaghilev had quarrelled or those who were his perceived rivals, having joined or set up other companies.

As well as the advisory committee, there would be a librettist who wrote or adapted the narrative, recommending the number of scenes, the characters and the action, keeping it simple enough for an audience to follow. Usually one of the first to be involved was the composer who wrote, or arranged, the music. Fewer than half the Ballets Russes productions had entirely original scores, but many were arranged by fine composers – Ottorino Respighi's orchestration of piano pieces by Rossini for *La Boutique fantasque* (1919) and Igor Stravinsky's reinterpretation of early eighteenth-century music by Pergolesi and his contemporaries for *Pulcinella* (1920) being among the most notable examples – so that they had a unity and often the quality of an original composition. The practice of using established scores for ballet was growing in the early twentieth century and Diaghilev's own training as a musician ensured that the music selected was the best available and that the arrangements enhanced the

original. The design of the sets, costumes and lighting created the ambience for both the ballet and the dancers. Set designers had to allow space for the movement to take place, and costume designers and makers needed to be sensitive to the movement requirements of the dancers and choreographers. Diaghilev not only supervised the overall look of the production, he also served as the company's lighting designer (presumably learning the craft from his first theatrical seasons in 1908 and 1909). He was happy, nevertheless, to give credit to his colleagues; he never even claimed writing a libretto, and there is no credit for his lighting in any published programmes.

Diaghilev initiated most of the productions apparently with an awareness of balancing mixed programmes of works. For the 1909 season he adapted and enhanced existing works from the repertoire of the Imperial Russian Ballet. With *Parade* (1917), one of the most original productions created for the Ballets Russes, the collaboration appears to have been initiated by the artists Jean Cocteau and Pablo Picasso, and the composer Erik Satie, with support from Picasso's Chilean patron, Eugenia Errázuriz, before Diaghilev himself was involved. Even when the original ideas were not his own, all aspects of a production had to meet Diaghilev's exacting requirements. In the late 1920s, when collecting rare books and the letters of the great Russian poet Alexander Pushkin took precedence over ballets, he became slightly less involved, and Boris Kochno was encouraged to assume a

more active role as producer. Diaghilev would, nevertheless, appear to whip a production, such as *Ode* (1928), into shape before the first night.

It is rare for collaborators to create their elements at precisely the same time and place, but good collaborations, as the contemporary choreographer Richard Alston has shown, can 'open up work to other people's ideas rather than merely enlist support for one's own already explored concerns'.[7] Henri Sauguet recalled that for *La Chatte* he composed the music in Monte Carlo to the scenario by Sobeka (Boris Kochno) adapted from a fable by Æsop:

> I worked during the day and in the evening went to the casino. I met there the company pianist and Balanchine.... The following day it was put into rehearsal. Every day towards noon Diaghilev would come by ... [with guests] and listen to what I had done. Then I came back and got on with the work.[8]

Sauguet did not see the decor – which was being created in Monte Carlo at the same time – until the stage rehearsal, and felt it was Balanchine's choreography and understanding of the effect of the set and costumes as well as Diaghilev's overall vision that brought the elements together.

Diaghilev's production of *Petrushka* is often cited as a close collaboration in which the creators fed off one another, giving the ballet its remarkable unity. The creative process began with part of the score. In 1910 Diaghilev and Nijinsky visited Igor Stravinsky in Lausanne hoping to hear the progress he was making with *The Rite of Spring*. During the visit the composer played them his new composition, *Petrushka's Cry*, and a sketch for a Russian Dance. Diaghilev sensed these could be combined for a ballet about the traditional Russian puppet show held at Carnival. He knew that Alexandre Benois, who was fascinated with old St Petersburg, would make the ideal designer. Benois found the subject irresistible. He recalled his childhood impressions of the Butterweek (traditional pre-Lenten) Fair and studied lithographs of Russian life such as those published by Ignaty Schedrovsky and Vasily Timm, and the painting of the Shrovetide Fair by Konstantin Makovsky (pl.40), for his lively crowd scenes. Mikhail Fokine undertook choreography in Rome after the score and designs were completed and the larger company was assembling for the June season in Paris. He acknowledged that he was brought into the creative process after Stravinsky's score was composed and Benois had drawn up the narrative and designs, yet he, and most reviewers, recognized that Fokine was an integral part of creation of the ballet in which composer, designer and choreographer, each 'in his own language, told about Petrouchka's sufferings'.[9] Fokine claimed that *Petrushka* was the ballet that most completely illustrated his reforms, including presenting the story through the dance and only drawing on *pointe* work for specific effects, without which it would have been a far less impressive production.[10] Fokine also observed he was praised for his close collaboration

with the designer Nicholas Roerich on the Polovtsian Dances from *Prince Igor*, but they only met on one occasion when Roerich encouraged Fokine to take up the project which he had been commissioned to design: 'I am sure you will do something wonderful.'[11]

For the 1909 and 1910 seasons, Diaghilev had little difficulty in attracting dancers to his summer companies – many of whom would return to the Imperial Ballet when their season began in September. When Diaghilev decided to establish his year-round company towards the end of 1910 it was a different matter asking them to give up the security of a long-term contract with the Imperial Ballet and expected pension, even for an increased salary. Although he secured the services of Vaslav Nijinsky and his sister Bronislava as a result of Nijinsky's dismissal for wearing what was considered to be an inappropriate costume on the Maryinsky stage, and Adolph Bolm, who had already developed an independent career, most others were cautious. From the start he had to recruit from outside the St Petersburg Imperial Ballet. He contracted dancers from independent ballet schools in Warsaw and Moscow, as well as Russians performing in the West. Regular trips were made to seek out new talent and after the 1917 Revolution Diaghilev persuaded a group from Kiev trained by Bronislava Nijinska to emigrate. In 1924 he absorbed a concert group of four dancers, including George Balanchine and Alexandra Danilova, who left the Soviet Union. Although the nucleus of the company was Russian or Polish Diaghilev also employed British, Italian and American dancers, all disguised under Russian names. Teachers were important to weld the dancers from different backgrounds into a more-or-less cohesive group, and to bring those whose training was originally less complete up to the required standard. While the principal dancers were outstanding, some of the corps de ballet appear to have been little more than acceptable.

Having developed the company it was necessary to create ballets for the dancers to perform and five-sixths of the repertoire comprised newly choreographed productions. Subjects, narratives or themes had to be found or written, although a few ballets, such as the divertissement *Cimarosiana* drawn from the opera-ballet *Le Astuzie Femminili*, were simply an excuse to mount a suite of dances. Subject matter for the Ballets Russes fell into a number of categories with sources including fairy tales and folklore, archaeology and history – tributes to the past often incorporating a particular appeal to a specific country – topicality and a wide range of literature. The literature called upon included stories from the Bible for *Salome*, *The Legend of Joseph* and *The Prodigal Son*, and classical literature for *Narcisse*, *Daphnis et Chloé*, *Midas* and *Apollon musagète*.

Fairy tales and folklore provide the plots for some of the more colourful ballets. Although most of the sources were Russian, Hans Christian Andersen provided the plot of *Le Chant du rossignol* and Æsop's fables the story of the cat-woman who cannot resist chasing a mouse in *La Chatte*.

Contes Russes took several Russian folk tales and combined them into one ballet, although *Kikimora* and *Baba Yaga* also existed as independent ballets. *The Firebird* was an original story that combined characters and elements from several Slavic folk tales collected by Alexander Afanasiev to create an original fairy tale for export to Western Europe (pl.41). The Firebird, her feather, golden apples and the beautiful Yelena all feature in *Ivan the Tsar's Son, the Firebird and the Grey Wolf*, according to the edition illustrated by Ivan Bilibin in 1901, although the immortal demon Kashchei (the name translates as 'boney', hence his skeleton costume), whose soul is hidden in an egg, was drawn from other stories. He had also appeared in Nikolai Rimsky-Korsakov's eponymous short opera in 1902.

The two productions designed by Nicholas Roerich, *Prince Igor* and *The Rite of Spring*, owed much to his interest in ancient Russian culture. An active archaeologist, his knowledge of shamanism as well as his interest in the Slavic deity Yarilo, associated with vegetation, spring and fertility, fed into *The Rite of Spring*. The Ballets Russes' travels also resulted in other cultures being reflected. Following a period spent in Italy and Spain during the First World War, the company was able to recapture the atmosphere of those countries for British audiences in *The Good-Humoured Ladies* and *Le Tricorne* (*The Three-Cornered Hat*, 1919). As the dance historian Cyril Beaumont recalled, 'Massine did it in a wonderful way'.[12] The Italian ballets *The Good-Humoured Ladies* and *Pulcinella*, and the Spanish *Le Tricorne*, all owned their narratives to earlier stage works. *The Good-Humoured Ladies* drew on the play *Le Morbinose, Le donne de buon umore* by the eighteenth-century Venetian dramatist Carlo Goldoni, while *Pulcinella* was derived from Neapolitan *commedia dell'arte* plays (pl.42).

Le Tricorne was inspired by the novella from the nineteenth-century Spanish writer Pedro Alarcón which had been adapted into a play, *El Corregidor y La Molinera* by Gregorio Martínez Sierra, with music by Manuel de Falla. Typically, Diaghilev adapted the original, reducing the role of the Corregidor, who became more a figure of fun, and emphasizing those of the Miller and his Wife in order to clarify the plot.

The Ballets Russes habitually incorporated tributes to the history of the country in which they happened to be appearing: in France with *Le Pavillon d'Armide* and *Les Sylphides* in 1909; in Germany with *Le Carnaval*; and in Britain with *The Triumph of Neptune*. With such ballets, a combination of subject and design was used to reference the past. For *Le Pavillon d'Armide*, Alexandre Benois drew on his passion for the Versailles court of Louis XIV, especially Louis-René Boquet's costumes for spectacular entertainments. Designs by Boquet, along with those by Jean Bérain and Jean-Baptiste Martin, also provided source material for Bakst's costumes for *The Sleeping Princess* – Martin's Apollo for the *Opéra de Phaëton* appears, appropriately, for Apollo was the sun god, to have been the inspiration for Aurora's wedding gown. Bakst's palaces for

the ballet, memorable for their wonderful perspectives, were derived from baroque stage sets by Ferdinando Galli da Bibiena in his *Varie Opere di Prospettiva* (1703–8).[13]

The costumes for *Les Sylphides* in Paris were off-white, long, Romantic-ballet tutus with wings, inspired by those worn in the 1832 ballet, *La Sylphide*. Bakst had designed the costume for the solo Sylph in Fokine's *Chopiniana* in St Petersburg in 1906. In the revised production in 1908 the women wore Romantic tutus from the Imperial Ballet wardrobe but, for Diaghilev, Benois re-worked the costumes giving them a more flattering, streamlined look. For Berlin, Diaghilev premiered *Le Carnaval* acknowledging German interest in *commedia dell'arte* and Biedermeier fashion plates. In Britain, *The Triumph of Neptune* was inspired by nineteenth-century sets and costumes for toy theatres, and included foilstone tunics (costumes encrusted with fake jewels) left over from a Victorian pantomime found at the theatrical costumier C.W. May.[14] The costume for the Fairy Queen was inspired by tinsel prints of the Victorian dancer Mme Auriol as Columbine, and when Cupid was added to the cast of characters in 1927, Stanislas Idzikowski's costume was inspired by prints of the dancer John Reeve perched like Marie Taglioni on an unbending flower.[15] In the 1920s, a ballet based on an American theme was discussed. Projects such as these were unrealized as the company did not return to the USA, but ideas included one ballet with a score by John Carpenter and another based on George Gershwin's *An American in Paris*.[16]

Contemporary folk dress as well as historical artefacts influenced sets, costumes and accessories. Roerich was inspired by collections of folk dress and accessories for

The Rite of Spring, and many of the costumes for Prince Igor were ikat-weave tunics purchased in the markets of St Petersburg. Natalia Goncharova and Mikhail Larionov were more imaginative and theatrical than Roerich in their use of peasant dress and folk art, although Larionov's outré designs for *Le Soleil de nuit* and *Chout* in particular made them a challenge for performers:

> Although the costumes were vivid in colour and wonderful to look at, they were appallingly uncomfortable. All our abandon and zest for dancing was nipped in the bud. We had horrible thick pads tied around our waists, then there were tight heavy costumes on top of them. The tall, mitre-shaped Russian head-dresses, once they had slipped slightly to one side, just refused to stand up straight again.[17]

Other exotic elements were incorporated into design and movement. Both Bakst and Fokine were inspired by the St Petersburg performances of a troupe of dancers from the Royal Siamese Court in October 1900, which provided a stimulus for Nijinsky's Siamese dance in the divertissement, *Les Orientales*, as well as the pseudo-Indian/Hindu/Cambodian elements of *Le Dieu bleu* (pl.43).[18] Sculptures from the Chinese-Tibet border inspired designs by Henri Matisse for the 1920 *Le Chant du rossignol*. When Kenneth Archer and Millicent Hodson reconstructed the ballet in 1999 they discovered that the source of the costumes and their colours for the Warriors were the 'guardian kings' in the Buddhist gallery at the Musée Guimet in Paris, which once protected 'the four cardinal points of a temple: North, South, East,

42. Léonide Massine, manuscript for *The Good-Humoured Ladies*. Type and ink on paper, 1917. The pages shown here include a character list annotated with provisional casting, and a suggested plan for parallel action. V&A: S.311–1980

43. After Léon Bakst, costume for a Little God from *Le Dieu bleu*. Metal thread and cotton jersey, silk, brass decorations, papier-mâché, cotton, gauze, brass headdress, 1912. The faces on the child's headdress, like those on the set, are inspired by details from Angkor Thom in Cambodia. V&A: S.613–1980; S.615(A&B)–1980

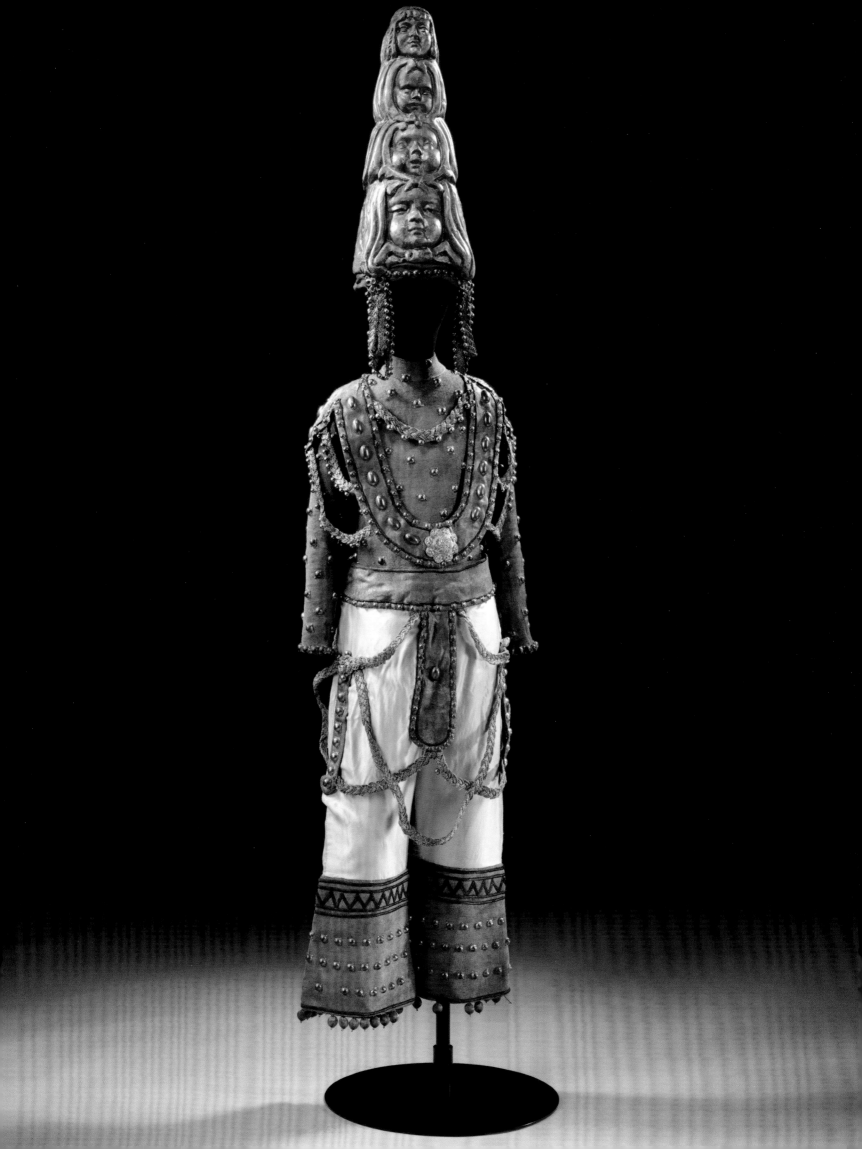

44. Mikhail Fokine, choreographic floor patterns for the opening of *Les Sylphides*. Pencil on paper, 1909.
Pallant House, Chichester
CHCPH 0264–2

West', while the scarlet figure of Death with her necklace of skulls was inspired by the Tibetan demi-goddess, the Red Dakini.[19]

Topical events were also influential. Most famously *Le Train bleu* was created to be premiered during the 1924 VIII Olympiad in Paris, while other works tied into anniversaries. *Le Spectre de la rose* was premiered in 1911, the centenary of the birth of Théophile Gautier, who wrote the poem that inspired the ballet. Jean-Louis Vaudoyer, who was the first individual not involved with the company in any other way to successfully suggest a subject to Diaghilev, would have been aware of company's interest in Gautier as it was his 1834 novella, *Omphale*, which provided the narrative for *Le Pavillon d'Armide*.[20]

Once ideas for the plots were gathered the detailed libretti were worked out. Frequently designers, choreographers, and/or composers were involved, but libretti were also the province of other collaborators. The two librettists who played the most dominant roles were the poet/artist Jean Cocteau who was responsible for *Le Dieu bleu*, *Parade*, *Le Train bleu* and the text for *Oedipus Rex*, and Boris Kochno, Diaghilev's secretary/assistant in the 1920s. Kochno wrote nine ballets, sometimes under the sobriquet of Sobeka: *Les Fâcheux* after Molière, *Zéphire et Flore*, *Les Matelots*, *La Pastorale*, *La Chatte*, *Ode*, *The Gods Go A-begging*, *Le Bal* (after a story by Count Vladimir Sologub) and *The Prodigal Son*. However, these ballets, which had quite complex plots, were generally less successful than those that appear to have evolved more organically.

Choreographers, like designers, turned to a range of sources for their inspiration. Diaghilev was lucky in that all five of his leading choreographers took highly original approaches to movement. At times this upset the dancers, particularly when Nijinsky in his two-dimensional *L'Après-midi d'un faune* (pl.45) and the weighty choreography for *The Rite of Spring*, challenged the dancers by having them move in ways that were completely alien to their training. But, with a few exceptions – Idzikovski left when Bronislava Nijinska became ballet mistress as he was unsympathetic to her choreography[21] – most dancers were eager for material to be moulded on their bodies.

Mikhail Fokine was determined to break away from the stereotypical movement of the turn of the century ballets and their formal structures (pl.44). He believed that characters should relate to their surroundings and to other characters rather than be arranged symmetrically with the

dancing 'addressing' the audience. Fokine's movements used the body more naturally, avoiding exaggeration. Rather than standing rigidly in formal positions with their feet turned out, dancers stood normally, assuming asymmetrical shapes, their weight often directed towards one hip. Fokine was a part of the trend for an 'art nouveau' flow of movement (pls 46–49). He had veered towards the style of dance advocated by Isadora Duncan before her visit to St Petersburg and took an interest in her performances. *Pointe* work returned to its original purpose of achieving effects: the other-worldliness of the Sylphs in *Les Sylphides*, the young girl's movement when she is asleep and dreaming in *Le Spectre de la rose* as opposed to her natural walk when awake, or the stiff wooden gait of the puppet Ballerina in *Petrushka*. Fokine tried to fit his movement to his subject and when faced with creating dances for the Polovtsian warriors he had to imagine how they might have danced. Fokine's choreography not only showcased the great dancers Vaslav Nijinsky and Tamara Karsavina but also the corps de ballet who were given a prominence rare in previous times. Much more than merely set dressing, their importance is indicated by the fact that it was considered an honour to dance in *Les Sylphides* which remained one of Diaghilev's favourite works.

Vaslav Nijinsky, who succeeded Mikhail Fokine as choreographer, approached movement in different and original ways. Both Nijinsky and Léonide Massine were absolute novices when Diaghilev thrust them into choreography and both were prepared to experiment. The artist Mikhail Larionov, who mentored Massine's early ballets, appears to have encouraged his use of character work and folk dance. In the 1920s the choreographers Bronislava Nijinska and George Balanchine returned to using the academic technique but each took it in new directions. Nijinska used *pointe* work to evoke the stabbing braiding of plaits in *Les Noces* in contrast to its use for chic styles of walking in *Les Biches*. Meanwhile, Balanchine offered clear sweeping movements and new ideas such as the sinking turns of *La Chatte* and *Apollon musagète*, while Massine looked on with envy, wishing he could produce such imaginative motion in a production both timeless and modern.

Nijinsky was remarkable in devising totally different styles of movement for each of his ballets. For *L'Après-midi d'un faune* he drew on red-figure archaic vases in the Louvre for some of the poses of the Faun and Nymphs.[22] One of his inspirations for the extraordinary weighty, angular, downward thrust of the movement for *The Rite of Spring* appears to have been a toy duck. Discussing Nijinsky, Edwin Evans recalled:

> Like many artists he had a weakness for clever toys. I discovered in Chelsea a jointed wooden duck which was capable of assuming extraordinarily expressive angular attitudes. I procured one for him, and he was delighted with it. The following year, after *The*

45. Valentine Gross, *Vaslav Nijinsky as the Faun confronting Lydia Nelidova as the principal Nymph*, sketched twice, from *L'Après-midi d'un faune*. Pencil on paper, 1912. V&A: S.182–1999

46–49. Valentine Gross, *Vaslav Nijinsky as the Golden Slave in Schéhérazade*. Pencil on paper, 1911. V&A: S.634–1989 (with Tamara Karsavina as Zobiede); S.636–1989; S.635–1989; S.637–1989

Rite of Spring had been produced with his angular choreography, one of his first questions to me was: 'Well, did you recognise it?' – 'What?' – 'Why, the duck, of course', and he told me that some of the most effective angular poses in the ballet had originated with the duck.[23]

The recently developed art of cinema made an impact on Massine's style, both colouring his movements and the structure of his works. When travelling in Spain in preparation for the creation of *Le Tricorne*, Massine filmed Spanish dance while he was studying with the inspired flamenco dancer Félix Fernández García.

George Balanchine's choreography for *Apollon musagète* took inspiration from sources as varied as the flat feet of the figures in the painting by designer André Bauchant that was used for the set, the flashing neon lights of London's Piccadilly Circus and Michelangelo's image of God reaching out to Adam in the Sistine Chapel. The flat

feet became the Muses' shuffling walk, the lights of Piccadilly inspired the opening and closing of Apollo's hands in his second solo, and Michelangelo is referenced at the start of the *pas de deux* for Apollo and Terpsichore. In addition, the ballet is rich in more obvious Apollonian imagery, including the famous arabesques by the Muses evoking the rays of the sun surrounding the god.

Ahead of dress rehearsals a costume parade would take place on stage. Cyril Beaumont was privileged to attend one:

Diaghilev sat in a chair, and Grigoriev stood near him, or sat also on a chair. Then there were one or two persons assisting, and they had the costume designs preserved under a talc sheet, and each dancer came on as he was called. They began with the principals, and Diaghilev compared the costume design with the actual costume realized. And after he had examined this very closely and had approved, he then asked the dancer to do a variation, or some of the steps that he was going

to do. And often the dancer found – especially, I remember, in the *Sleeping Beauty*, they were very heavy costumes with gold braid on them, and he started saying 'Oh, this will have to go, the skirt will have to be reduced, this trimming will have to come off', and kept trying things while the costumier was in despair at seeing his creation, as he thought, ruined.[24]

Designers of costumes would find inspiration from watching rehearsals. Pablo Picasso observed Tamara Karsavina rehearsing for *Le Tricorne* to ensure that his costume would move with the dance, telling her 'I am going to make it round you' (pls 50–56).[25] Bronislava Nijinska, having rejected Goncharova's elaborate designs for *Les Noces*, insisting that the peasant wedding should be more of a ritual than a joyful celebration, invited Goncharova to attend rehearsals. The designer adapted the women's rehearsal tunics and the men's shirts and breeches into their uniform costumes. The 'designs' for the costumes served as storyboards for the

groupings but interestingly Goncharova always showed the women in birch slippers, never the *pointe* shoes of Nijinska's choreography.

Costumes worn by one dancer might not suit another. The tiny dancer, Alicia Markova, found that her costumes often had to be adapted. In Manchester in 1928, when she was about to make her debut in the *pas de deux* from the *Bluebird*, Diaghilev produced the money for her to replace the ostrich feathers of her headdress with bird of paradise.[26] He kept an eye on all costumes, and decided that the blue tunic for the androgynous dancer of the andantino in *Les Biches* should be chopped to the top of the dancer's thighs. Since this left Vera Nemchinova feeling naked, Diaghilev suggested that she wear white gloves, but there may well have been more to his suggestion as the choreography draws attention to the dancer's hands.[27]

Unsung heroes of the Ballets Russes included those who translated the set and costume designs from page to stage, the wardrobe mistresses, the hairdresser who cared

50. Léonide Massine,
notes made while
studying Spanish dance.
Autograph manuscript
in bound notebook,
c.1918.
V&A: S.4–1980

51. Castanets, early 1900s.
These castanets were used
by Félix Fernández García
who gave them to Lydia
Sokolova when she worked
with Massine, studying
Spanish dance and creating
the choreography for
the Miller's Wife from
Le Tricorne.
V&A: S.284(&A)–1978

Opposite
52. Lydia Sokolova
playing her castanets
in *Le Tricorne*, c.1919.
V&A: Theatre &
Performance Collections

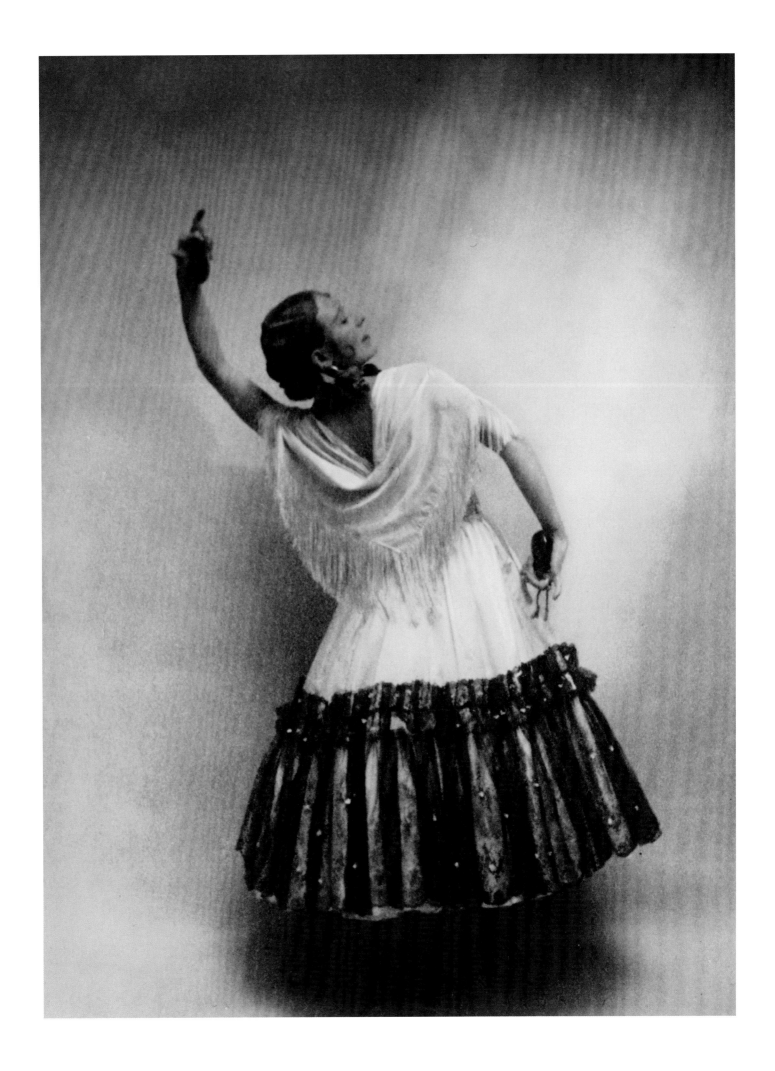

53. Pablo Picasso, costume
design for the Dandy from
Le Tricorne. *Pochoir* print,
published 1920.
V&A: S.440:25–1979

54. Ethelbert White,
backstage at *Le Tricorne*.
Ink on paper, *c.*1919
(see also Picasso's set
design, pl.74).
V&A: S.190–2008

55. Receipt from L. Gustave
of 10 Long Acre, Covent
Garden, London, for wigs
for *Le Tricorne*, 1919.
V&A: Theatre & Performance
Collections
THM/7/4/4/126 A/B

for the wigs, and stage technicians who kept the productions looking fresh and coped with the challenges of transferring productions between stages of different sizes.

Many costumes for the early seasons were made in Russia, but by 1910 the Parisian firm of La Maison Muelle was responsible for making productions, beginning with *The Firebird*. Muelle's involvement continued throughout the company's history and in the 1920s it was joined by the Monte Carlo atelier of Vera Soudeikina (later Mme Stravinsky who also performed as the Queen in *The Sleeping Princess*) and Mme A. Youkin. Many craftspeople would be involved in making, dyeing, painting and decorating the costumes, which had to be fitted on the individual dancers. When new casts took over roles the wardrobe mistress would have to adjust the garments once again. The costumes for some productions wore out constantly – the men's trousers for the vigorous *Prince Igor* look quite different from one photograph to the next.

After the First World War Diaghilev turned to theatrical costumiers in London. The firm of Alias, which had made virtually all the costumes for ballets at the Alhambra for 30 years, now remade costumes for the principals and ladies in *Schéhérazade* and the costume for the Swan Princess in *Contes Russes*, as well as the full productions of *La Boutique fantasque* and *Le Tricorne*.[28] Wigs and accessories came from the rival firms of Gustave and Clarksons, but even the major costumiers could not always cope with requirements. Three weeks before *The Sleeping Princess* opened the actress and dressmaker, Grace Lovat Fraser, was persuaded by Diaghilev into leading a team to complete the task. The costumes had arrived from Paris but many were missing, incomplete or not even begun. Bakst instructed Lovat Fraser how to interpret his designs – the decoration was all to be embroidered, not painted, which would have been much quicker, and, for the backs of the costumes, Bakst's 'Mme Collaboratrice' was to 'invent something très chic'. As so often happens with a huge production, some of the costumes only arrived at the last minute. In the first interval, Lovat Fraser collided with Diaghilev as she raced to fetch the costumes for the hunting scene, which had only just been delivered.[29]

The majority of the sets for the Ballets Russes were painted on canvas to evoke scenes as varied as pastoral glades in ancient Greece, a beach on the Riviera, a monumental temple in Egypt, a Venetian piazzetta or a collection of yurts on an open plain. Sets for the early productions were painted in Russia, calling on the skills of Oreste Allegri and Boris Anisfeld[30] in particular, but after the war Diaghilev turned primarily to Vladimir Polunin and his wife, and Prince Alexander Schervashidze.[31] At times the artist/designers would play an active part in the painting – André Derain certainly painted parts of *La Boutique fantasque* and Picasso both *Parade* and *Le Tricorne*. Goncharova and Larionov were also hands-on scene painters and it was while assisting Goncharova on painting the sets for *Les Noces* that Gerald Murphy learnt the craft of theatre design.

The sets for the Ballets Russes were painted flat on the floor rather than on large frames. The technical aspects of the craft are discussed in detail in Polunin's *The Continental Method of Scene Painting* and shown in the photographic record of the painting of the front cloth for *Le Tricorne* at his studio in Floral Street, Covent Garden (pl.56).[32] Essentially, the artwork was divided into a grid, or 'squared up' (pl.59), and the canvas was stretched, prepared and also squared up so that the outline could be enlarged onto it before being filled in with paint. Over time, sets had to be repaired and touched up, especially if cloths became damp, and they needed to be well lit to disguise the creases and folds that developed as cloths were toured. On the rare occasions in the late 1920s when traditional painted sets were not used the artist-designers took an active part in visualizing the setting. The sculptors Naum Gabo and Anton Pevsner (who created the central figure of Aphrodite) set up in Monte Carlo to construct their unusual set for *La Chatte*, while the artist Pavel Tchelitchev worked closely with film-maker Pierre Charbonnier on the screens and projections for *Ode*.

All theatre productions are, to some extent, collaborations but few company directors have Diaghilev's ability to orchestrate the roles of everyone involved to produce so many masterpieces. That not every ballet was a complete success was inevitable given the number of creations for the Ballets Russes and Diaghilev's constant search for novelty, but most works intrigue us even a century on. There was very little that he did not try, from productions without dancers to multimedia works. Diaghilev could be distant or he could charm, but above all he could radiate extraordinary authority and power, which enabled him to bring together a group of such innovative individuals to create original works of art.

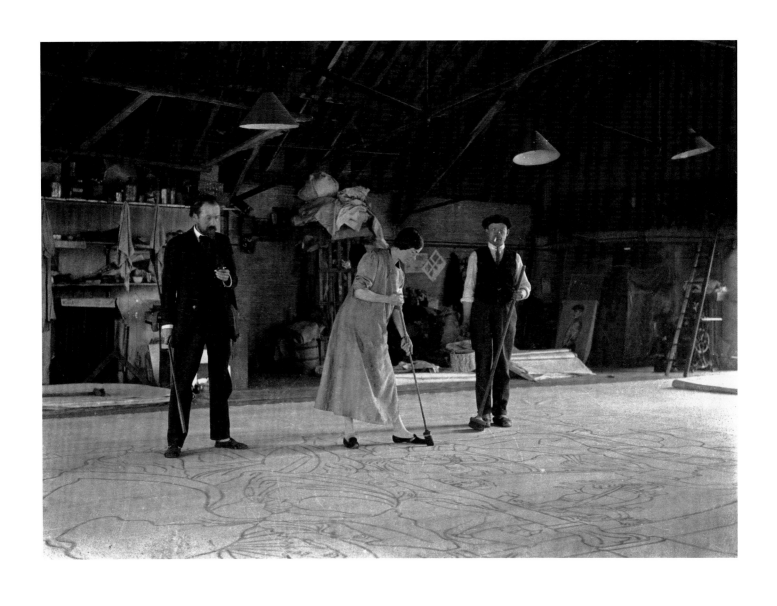

56. Vladimir and Elizabeth
Polunin with assistant
Alex Bray painting the
curtain for *Le Tricorne*
in their Covent Garden
workshop, 1919.
Private collection

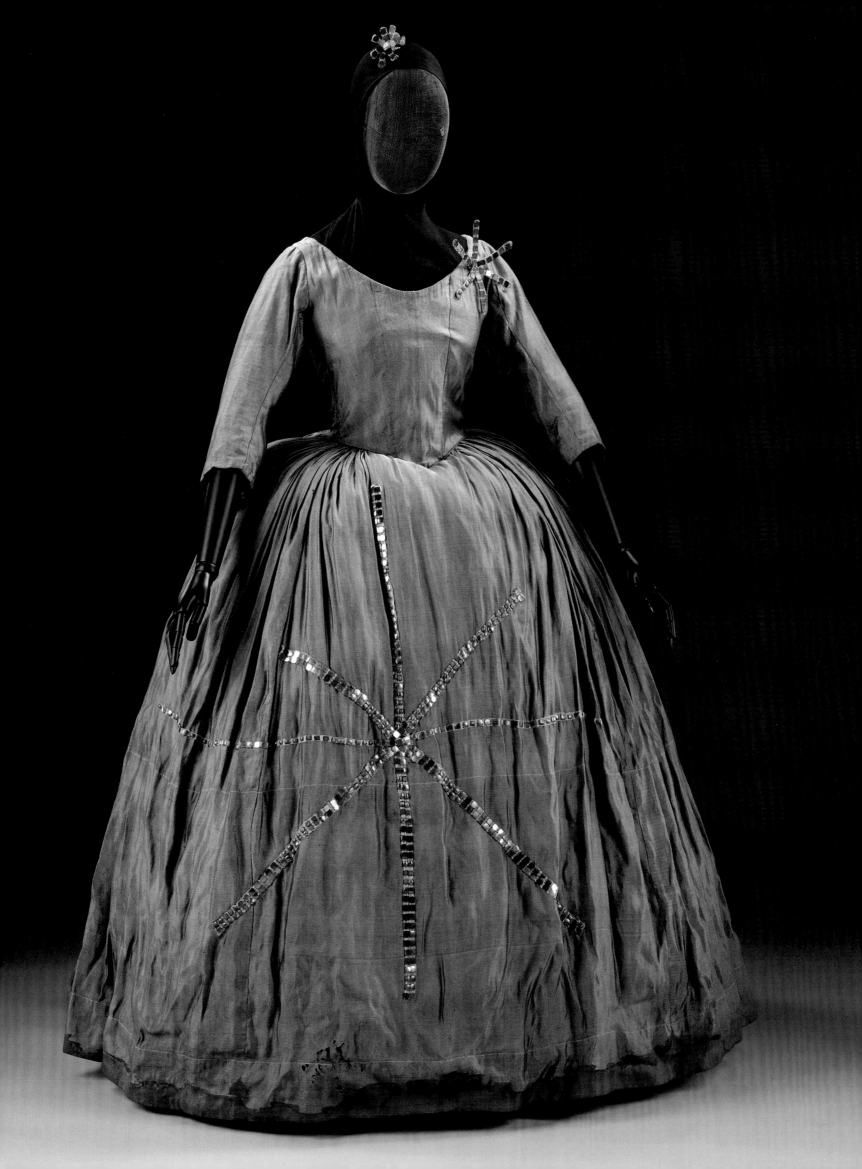

Opposite
57. After Pavel
Tchelitchev, costume for
a corps de ballet dancer
from *Ode*. Artificial silk
and cotton, cotton
jersey, cellulose nitrate
decoration, metal
fencing mask, 1928.
V&A: S.845–1980 with
S.846A–1980

58. *Ode* (Scene III)
showing Ira Belianina
as Nature and Serge
Lifar as the Student
with the women of the
corps de ballet in their
crinoline dresses.
Photograph by Lipnitsky.
V&A: Theatre &
Performance Collections

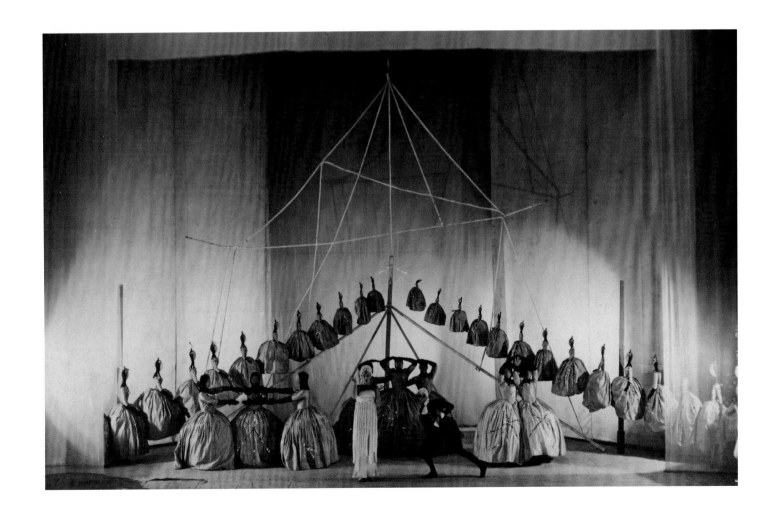

DAILY CLASS
Jane Pritchard

Class at the start of each working day – serving to warm up, tune and align the body – is an indispensable feature of a dancer's life. Beginning at the *barre*, slower exercises are followed by faster, more virtuosic steps as the dancers gradually move towards the centre of the studio. Diaghilev's Ballets Russes was no different from other companies and during its 20 years Enrico

Cecchetti, Nicolas Legat and Lubov Tchernicheva were responsible for most of these classes. In addition choreographers, notably Bronislava Nijinska in the early 1920s, sometimes taught, allowing them to try out ideas and assess the potential of dancers when creating new works. At other times (such as during the second tour of the USA) it appears that Nicholas Kremneff, assistant to the *régisseur*, Serge Grigoriev, deputized as teacher.

The Italian, former virtuoso dancer, Cecchetti was invited to join Diaghilev in 1910, and although he was absent touring with Anna Pavlova during the 1913–14 season and did not join the company's second tour of the USA, he remained its principal teacher until retiring to Italy in 1924. For dancers in St Petersburg at the turn of the century, Cecchetti's classes were inspirational and he was a key figure in the enriching of the dancers' *epaulement* – the flowing use of the upper body. By the 1920s, however, younger dancers considered his

classes to be out of date. Alexandra Danilova, who joined Diaghilev in 1924, complained that 'he never gave us enough exercises at the *barre* to get our muscles warmed up for the centre', resulting in cramp in her legs.[1] She also resented his formulaic classes, one set for each day of the week. The British dancer, Laura Wilson, found the classes fast: 'in no part of the class was one allowed to stop after a correction [but] everything had a precise logic.'[2]

Danilova preferred Legat's classes but Lydia Sokolova considered his method 'lighter, much less strict and accurate than Cecchetti's, so that although our classes became gayer, we lost strength and precision'.[3]

Continental opera houses had their own rehearsal studios. Tamara Karsavina recalled that 'at Monte Carlo we had a pleasant ground floor shaded by a pergola overlooking the promenade below…. In Paris [at the Opéra] we had to toil up the endless flights of stairs to the cupola room. In London we worked in the squalid basement of a sailor's night-club.'[4]

Enrico Cecchetti (kneeling) with a class soon after the Ballets Russes reformed in Switzerland in 1915. The men standing are Léonide Massine (on the left) and Adolph Bolm. V&A: Theatre & Performance Collections THM/376

Laura Knight, *Enrico Cecchetti Teaching*. Charcoal and pencil on paper, *c.*1920. V&A: S.195–2008

In London, the Ballets Russes performed at theatres without provision for rehearsals so classes were held at a number of places including Chandos Hall in Maiden Lane, West Street Studios and the London Territorial Drill Hall in Chenies Street, near Tottenham Court Road.

When Diaghilev was particularly interested in a dancer he ensured they undertook additional study to advance their careers. Vaslav Nijinsky and Karsavina had private classes from 1911; Nijinska coached Anton Dolin; Diaghilev invited Legat and his wife on holiday to Venice in 1924 so that Legat could continue Serge Lifar's tuition; and he advised Alicia Markova to study with the great ballerina Lubov Egorova (one of Diaghilev's Auroras) when the company was in Paris.

1 Danilova 1986, p.69.
2 Giannandrea Poesio, 'Laura Wilson', *Dancing Times* (May 1991), pp.757–8.
3 Sokolova 1960, p.238.
4 Tamara Karsavina, 'Family Album Cavaliere Enrico Cecchetti', *Dancing Times* (December 1964), pp.130–1.

Christopher Wood, the proposed creators of the ballet *Romeo and Juliet*. Pencil on paper, 1926. Reflected in a classroom or studio mirror are Bronislava Nijinska, Christopher Wood, Diaghilev (seated), Constant Lambert and Boris Kochno. The drawing was intended for the right-hand wing of Wood's rejected set. Private collection

A class onstage during the 1928 tour of Britain with Vera Petrova, Eugénie Lipkovska, Yadviga Karleveska and Natalie Branitska in the foreground, wearing their black rehearsal tunics. Allied Newspapers, Manchester

Serge Diaghilev,
draft telegram from
10 June 1926.
The telegram's urgent
query to Lady Ripon's
daughter, Juliet Duff,
translates as 'Have you
cashed Rothermere's
cheque?' The handwriting
is that of Diaghilev's
secretary, Boris Kochno.
V&A: Theatre &
Performance Collections
THM/7/2/1/4/21

Portrait photograph of
Lady Ripon, early 1900s.
V&A: Theatre &
Performance Collections

SPONSORSHIP AND FUNDING FOR THE BALLETS RUSSES
Sarah Sonner

Diaghilev brokered and exploited an extensive network of contacts to keep the Ballets Russes operating in a competitive commercial world. Income from patrons and box office receipts were essential. He worked constantly to gather the money necessary for his company to function, astutely identifying and managing multiple sources of capital. Records of Diaghilev's debts illustrate the continual challenge of securing sponsorship in the absence of government funding or a permanent home.

In contrast to Imperial patronage of the theatre in Russia, no single entity exclusively underwrote the Ballets Russes. For Diaghilev's ventures, this meant shifting from state support to a committee of individuals, gathered and organized by the impresario, and modernizing the practical means of cultural production. Advances and guarantees were necessary to carry the company around the world, as when funds from the United States played a key role in the continuation of the company during the First World War. Support could also take the form of cash payments; after the war, money was sometimes spent directly on a dancer's healthcare.

Diaghilev's commissioning of new artists encouraged innovative productions, but emerging talent also had the advantage of being cheaper than established names. A successful artist could contribute as a patron, as

Jean Cocteau,
*Vaslav Nijinsky dances
Le Spectre de la rose.*
Ink on paper, 1911.
Cocteau made this
drawing for Lady Ripon
at her New Year's Day
party. On 31 December
1911 Nijinsky had
danced *Le Spectre de la
rose* at the Théâtre
national de l'Opéra.
Stiftung John
Neumeier – Dance
Collection

did Coco Chanel. The financial success of Ballets Russes productions was not always coincident with artistic acclaim. Sometimes scandals boosted ticket sales, especially following a spectacular protest by the Surrealists during a 1926 performance of *Romeo and Juliet*, in which they accused the Ballets Russes of creating art at the behest of capitalism.

A change of scene sometimes brought a welcome fresh source of capital, as with the company's first visit to London during the gala celebration of George V's coronation in 1911. This coincidence elevated the company's profile, and its timing was credited to the influence of Diaghilev's first London patron, Lady Ripon. Other urbane society ladies, including the Princesse de Polignac (Winnaretta Singer), Lady Emerald Cunard, the Comtesse Greffuhle and later Lady Juliet Duff (Lady Ripon's daughter), formed a supportive committee of passionate Ballets Russes enthusiasts. Diaghilev also lured sponsors through appeal to their artistic practice, as with Sir Thomas Beecham, a conductor who became one of the company's most significant patrons after his father's financial backing of the initial London appearances, and his inheritance of the operas in 1914.

Diaghilev later found a sponsor in Harold Sidney Harmsworth, first Viscount Rothermere and *Daily Mail* newspaper magnate, who exemplified a new kind of patronage relationship in the 1920s. Diaghilev did not have the personal access to Rothermere that he enjoyed with other contacts, and had to work harder to orchestrate his financial backing. Soirées with the company were staged to capture his attention, with Diaghilev fostering Rothermere's close relationship with the dancer Alice Nikitina. Though reportedly platonic, this extended unprecedented influence into her role in the company, to the frustration of the impresario.

Diaghilev possessed a canny sense for likely supporters, and which of these should be pressed and when. This fell so totally within his control and influence that the company he created could not sustain itself after his death.

59. Natalia Goncharova,
design for *The Firebird*
back cloth. Pen and ink,
pencil, and white
bodycolour on card,
1926. This version of
the design shows the
squared-up drawing
ready for transfer to
the vast stage cloth.
V&A: S.751–2000

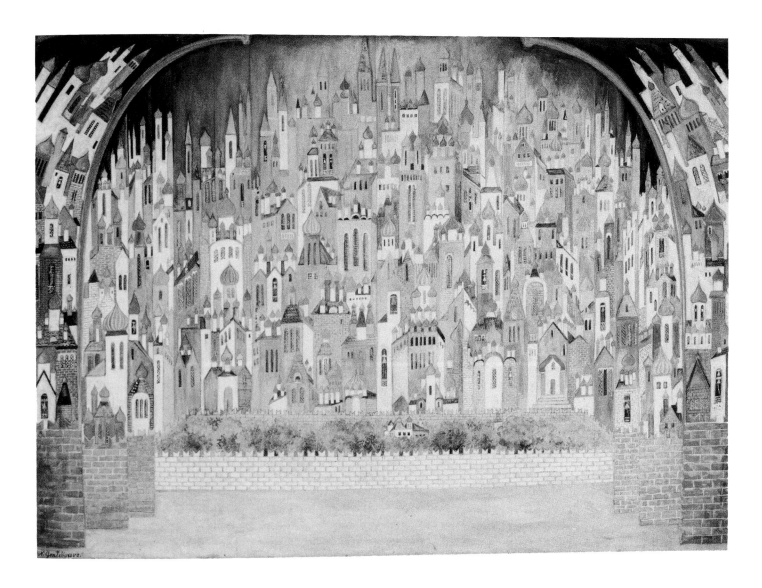

60. Natalia Goncharova,
design for the set of the
finale of *The Firebird*.
Watercolour on card, 1926.
Private collection

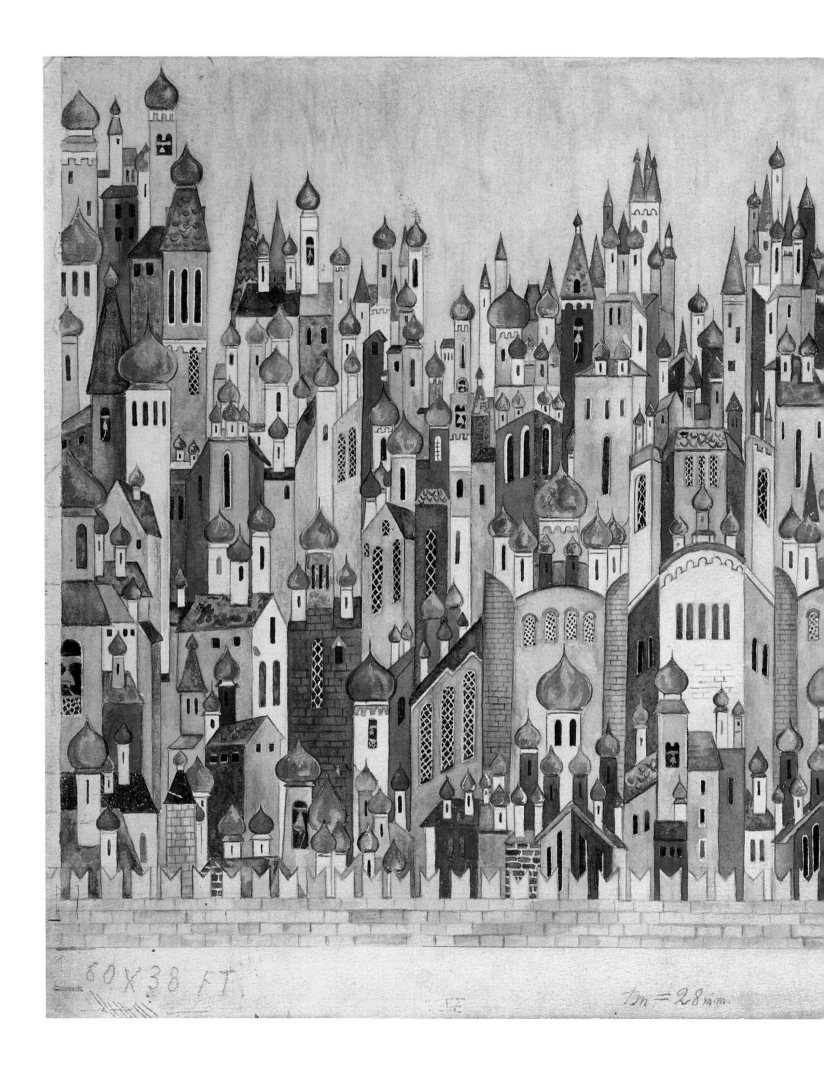

60 X 38 FT.

1m = 2·8 m·m.

61. Natalia Goncharova,
design for a back cloth
for *The Firebird*.
Watercolour, 1926.
V&A: S.1911–1986

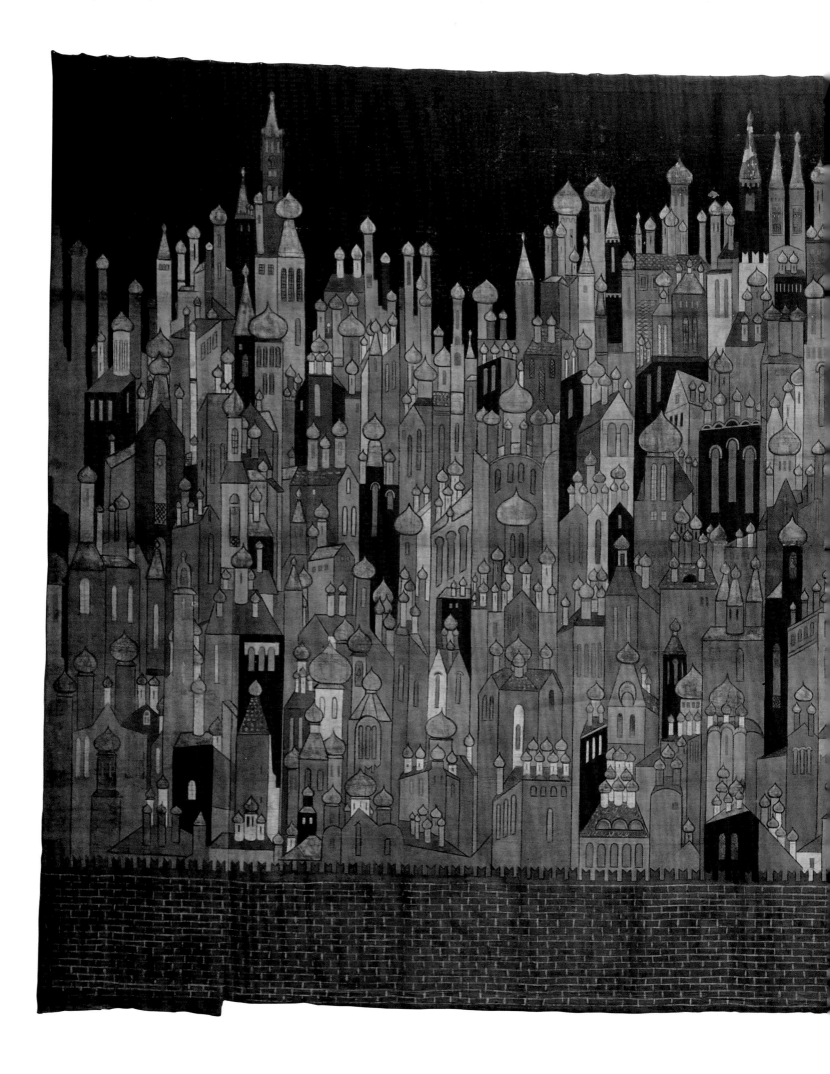

62. After Natalia
Goncharova, back cloth
for *The Firebird*. Painted
canvas, 1926.
V&A: S.455–1980

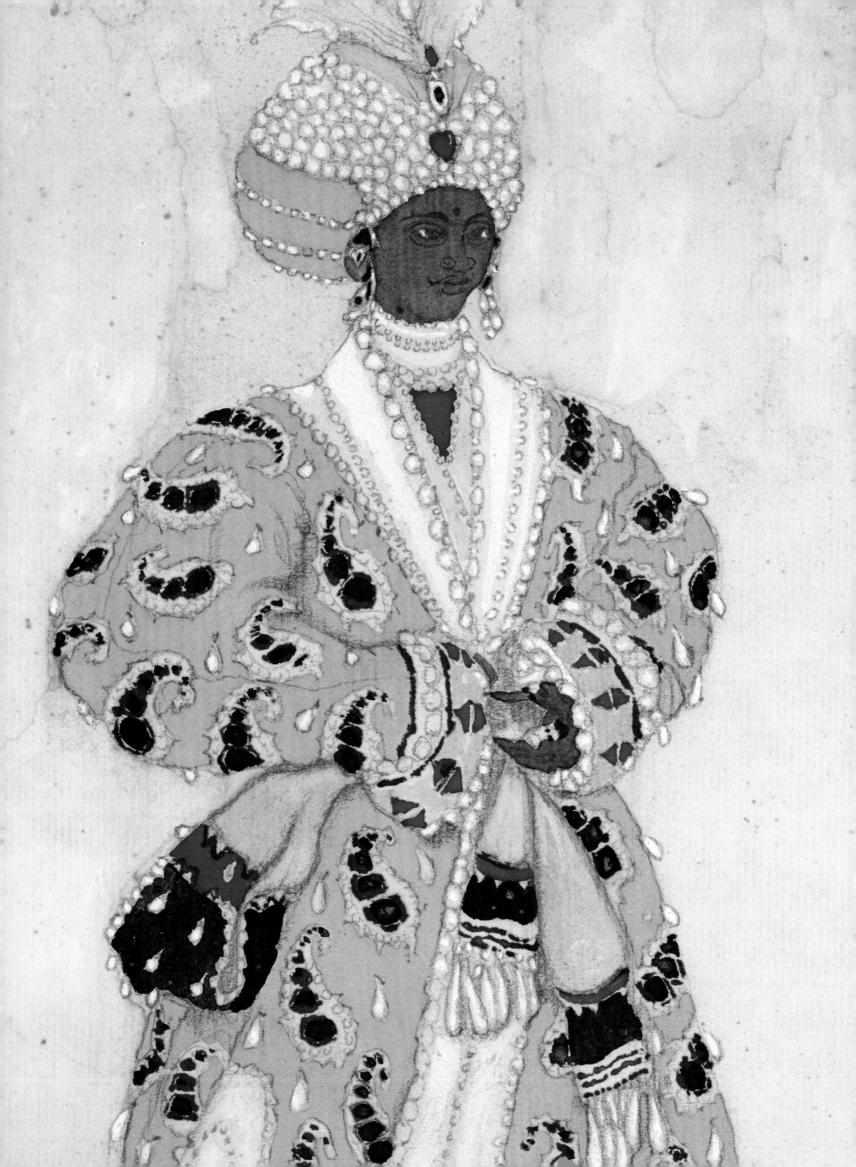

LÉON BAKST, NATALIA GONCHAROVA AND PABLO PICASSO

JOHN E. BOWLT

'CALL FORTH EMOTIONS BY CAPTIVATING THE EYE'[1]

During the 30 years of his enterprise, Serge Diaghilev employed almost 40 different artists to design the sets, costumes, properties and promotional materials for his ballet and opera productions. This host of painters, sculptors and decorators from the Russian Empire, Europe and the USA not only engineered visual celebrations, but also, with their ethnic diversity and cultural versatility, contributed much to the international composition and thematic complexity of the Ballets Russes. In turn, Diaghilev's designers assembled an extraordinarily varied arsenal of styles, accommodating Decadence and Cubism, Primitivism and Constructivism, Futurism and Surrealism. Needless to say, the principal repositories of Ballets Russes materials in St Petersburg, London, Paris, New York and Hartford,[2] the historic exhibitions devoted to the Ballets Russes, not least, Serge Lifar's *Ballets Russes de Diaghilew* at the Louvre, Paris, in 1939, and Richard Buckle's *Diaghilev Exhibition* at the Edinburgh Festival and Forbes House, London, in 1954, and the countless publications highlight this plurality, sometimes offering bizarre collocations of designs by Alexandre Benois and Georges Rouault, Mikhail Larionov and Pedro Pruna, Giorgio de Chirico and Robert Jones, André Bauchant and Georgii Yakulov.

For the most part studio painters by training, few of these artists entered the grand theatre with a professional understanding of scenography and yet, confronted by the exigencies of the stage, they were able to adjust their sights from two to three dimensions, from surface to depth – just as Diaghilev's key dancers and choreographers such as Mikhail Fokine, Tamara Karsavina, Léonide Massine and Vaslav Nijinsky grafted elements of the *danse plastique* (free dance), ragtime and even gymnastics on to their Imperial Ballet schooling. In other words, Diaghilev's most original and composite designers were those who adjusted the modern easel painting to the *bella prospettiva* of the Italian Renaissance, who restored the picture to its essential metaphor of the window opening on to another space, who reinforced the organic link between the spectacle, the spectacular and the spectator, and who ensured the constant interplay of plane and volume, stillness and movement.

Bringing to bear such a general formula upon the visual resolutions of this or that stage designer is conditional, indeed, and poses severe limits, but it would seem to have stimulated the most accomplished designers of Diaghilev's company, whether Henri Matisse or Pavel Tchelitchev, while embarrassing the less suited such as Mstislav Dobuzhinsky and Marie Laurencin. Such a criterion implies that the visual resolution of a ballet, opera or drama, especially the sets and costumes, is of paramount importance to the artistic totality of the production, that theatre, by its very nature, demands a three-dimensional perception and reception (which is why television screenings of ballets are so wanting) and that the stage is an architectonic medium created for the virtual interaction and circulation of the audience. After all, the true sign of a successful production is when the spectator experiences an almost irresistible urge to jump on to the stage and become at one with the performance.

Among the primary designers for the Ballets Russes who elicited this kind of audience response were Léon Bakst, Natalia Goncharova and Pablo Picasso. They transcended the frames of their studio paintings to use the theatre as a laboratory of material forms, each applying different strategies, but all united within what Larionov called a 'universe existing alongside the world of reality'.[3] Bakst, Goncharova and Picasso have long been acclaimed for their decorative contributions to the Ballets Russes, not least, to *Schéhérazade*, *Le Coq d'or* and *Le Tricorne* respectively, and there is no need to repeat the details of their biographies or repertoires.[4] However, by examining the essential methods of each artist and by focusing on exemplary productions, we

Detail of pl.75

may be able to explain why each of them left such a deep and lasting imprint upon the history of twentieth-century stage design, and why their sets and costumes remained so prominent within the historical repertoire of the Ballets Russes. Ultimately, it was to the genius of Diaghilev, too, that all three artists were indebted for their international reputations as stage designers.

Léon Bakst

Of the many talented artists of the Russian Silver Age, Léon Bakst (Lev Samoylovich Rozenberg, 1866–1924) merits the highest award for his activities as both studio painter and decorative artist. Among Russian stage designers, he enjoyed the highest laudation for triumphant productions such as *Cléopâtre*, *Schéhérazade* (pl.63), *Le Dieu bleu* and *The Sleeping Princess*, in which he amazed audiences with magnificence of colour, tactility of form and the ability to both vest and expose the primordial energy of the human body. From the first Paris season until his death Bakst was an arbiter of taste in the ballet, fashion and even interior design. Accepting appointments in Russia, France, Italy, England and America, he became an international celebrity who moved closely with the cultural luminaries of his time; and he was lionized for the vigour and gusto of his exotic costumes and sets, which are now regarded as an intrinsic part of modernist design.

In St Petersburg, Paris, London, New York and Monte Carlo, Bakst was both an artistic and a social star, fulfilling numerous commissions for the international stage, contributing statements to *Le Figaro* and the *New York Times*, and painting portraits of the rich and famous. By 1914 Bakst had become a 'legislator of fashion'[5] and although his reputation relied substantially on his successes as portrait painter and stage designer, especially after the reception of *Cléopâtre*, *Schéhérazade* and *Le Dieu bleu*, he continued to manifest his skill and originality in many other activities such as fashion, textiles and furniture design, and even creative literature, writing a romantic, highly autobiographical novel during the last years of his life.[6]

Bakst's achievements do not fall conveniently into easy critical moulds; rather, they contest categorical imposition. He painted and wrote extensively, and, by good fortune, arrived at the right time at the right place, but unlike his immediate literary colleagues such as Andrei Belyi, Viacheslav Ivanov and Dmitry Merezhkovsky he chose not to elaborate an intricate philosophical ideology. Rather, his life and his art constituted a prism which refracted the many concepts and caprices of the Symbolist movement. Like Oscar Wilde and Diaghilev, Bakst cosmeticized and cultivated outward appearance, waxing his moustache and hiding his balding pate. He spontaneously rather than deliberately investigated the condition of the *Gesamtkunstwerk* (total work of art), giving pride of place to the ballet, interior design and haute couture as total media. Finally, he shared the Symbolists' reassessment of ancient cultures (Greece, Siam, Egypt, Persia), without imposing

involved, idealist interpretations. Even in his more sophisticated statements on antiquity such as 'The Paths of Classicism in Art' (1909), Bakst avoided eschatological convolutions, posing more as the academic artist who identifies a superior beauty in the formal purity of Greek sculpture, but avoids abstract, metaphysical interpretations of that beauty: 'One may seek art in philosophy,' he wrote, 'but one resents philosophy in art.'[7]

Bakst felt at home with the Ballets Russes, relishing boldness of decoration, plasticity of gesture and sensuality of body. In particular, the sensational productions of the first phase inspired Bakst to investigate the emotional impact of unusual colour combinations and to calculate their spectacular effect. He declared:

> I have often noticed that in each colour of the prism there exists a gradation which sometimes expresses frankness and chastity, sometimes sensuality and even bestiality, sometimes pride, sometimes despair. This can be felt and given over to the public by the effect one makes of the various shadings. That is what I tried to do in *Schéhérazade*. Against a lugubrious green I put a blue full of despair, paradoxical as it may seem.[8]

Certainly, Bakst's languid sultanas captivate with their enticing colours and luscious proportions, although he did not expose the body merely for erotic appeal. He regarded the nude body as an aesthetic totality whose artistry had been forgotten under the weight of nineteenth-century social and theatrical dress. As he indicated in his various essays about nudity on stage,[9] Bakst felt that the Ancient Greeks had discovered physical beauty and, therefore, he welcomed the antique evocations of Isadora Duncan and Olga Desmond.[10] At the same time, and however much Bakst praised the human form, he saw its beauty in the tension between the seen and the unseen, something that he achieved so masterfully in his costumes for the Slave-Girl in *Cléopâtre* and for *La Péri*.

While Bakst was fascinated by the exotic vision of the East as a place of liberal desire and consummation (to which his designs for *Schéhérazade* are strong testimony), it would be wrong to associate him too closely with the fashion for nudity and 'sex' on stage. In spite of rumours to the contrary, Bakst was retiring rather than flamboyant and his 'Magdalenian' personality[11] sometimes dictated restrained and sober artistic forms, as is manifest, for example, in his simple costume designs for *Jeux* of 1913. The monochrome, functional sportswear for the Tennis Players in *Jeux* was not so very far from the Constructivist *prozodezhda* (work clothing) of Liubov Popova and her close colleague, the avant-garde designer, Varvara Stepanova, the more so since the action of *Jeux* was cast in the year 1925. Bakst's knee-length skirt for the female Tennis Player represented an audacious development in fashion, at once enhancing her sexuality and, at the same time, symbolizing woman's freedom from the strictures of her nineteenth-century social round:

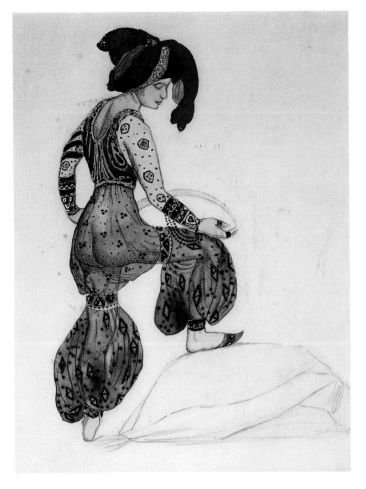

63. Léon Bakst,
costume design for
the Blue Sultana
from *Schéhérazade*.
Watercolour and
pencil on paper, 1910.
Private collection

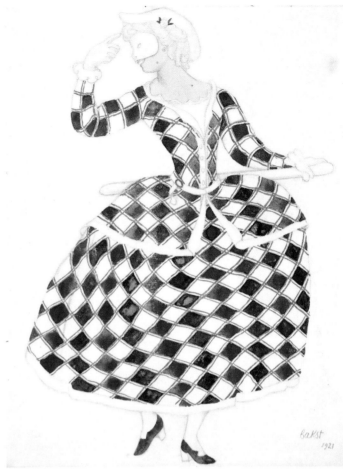

64. Léon Bakst, costume
design for Columbine
from *The Sleeping
Princess*. Watercolour
and gold paint, 1921.
V&A: E.1108–1922

Woman becomes every day more willing to accept the haste which finds its expression in the restlessness of modern life. This woman has two aspects. In the daytime she is pleased to show herself masculine in her tastes, and she wears tailor-made costumes. In the evening in the setting of artificial light which suits her well she regains all her powers of coquetry and elegance, and once more delights in being beautiful, becomes once again 'Woman Triumphant'.[12]

In his Paris stage productions between 1909 and 1914 (12 of which he designed for Diaghilev) Bakst exposed the mobility of the human body, rejecting the traditional notion of the theatrical costume as an ornamental disguise. But the result was still visual, and perhaps too much so, as he implied in his article 'On Contemporary Theatre. "No One Wants to Listen Any More, People Just Want to Look!"'.[13] For Bakst, spectacle, the pictorial, remained the guiding force of the theatre and *Jeux* notwithstanding, he seemed to yearn

constantly for surfeit and what Nikolai Evreinov called the 'theatre of excess'.[14]

In this respect, Bakst's grandiose concept for *The Sleeping Princess* of 1921, his most ambitious and extravagant commission, was an appropriate finale to his career (pl.64). It reinforced a new passion for the glamour of Hollywood and film design, which Bakst cultivated during his visits to America between 1922 and 1924.[15]

The Sleeping Princess was a brilliant, but falling, star in the firmament of a new, post-war and post-revolutionary world. It was not Bakst's last scenic commission (*Phaedre*, *La Nuit ensorcelée* and *Istar* following in rapid succession), but it was his most extravagant and epitomized the artistic opulence for which he had become so famous. Perhaps all this richness of colour and lushness of form in *The Sleeping Princess*, this 'beauty in vain',[16] was also Bakst's way of proving that, as he once told the theatre historian, Huntley Carter: 'It is the painter who ... should create everything, see everything in advance and organize everything.'[17]

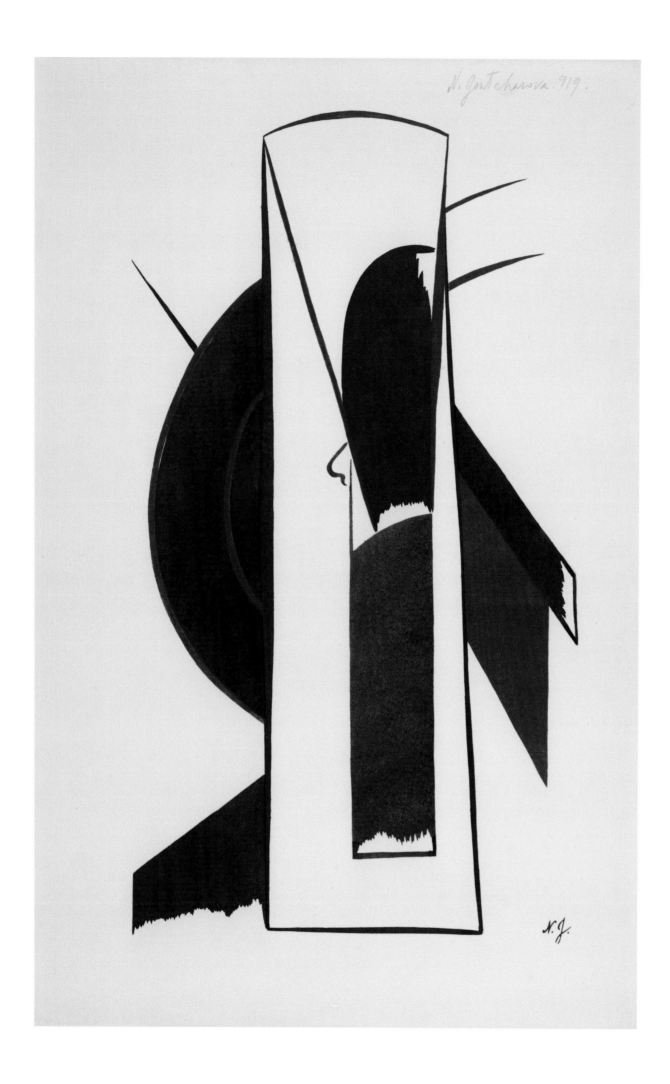

Natalia Goncharova

If Bakst was international, Natalia Sergeyevna Goncharova (1881–1962) was national, drawing artistic inspiration from the powerful traditions of Russian Orthodox culture. The most outstanding woman artist of twentieth-century Russia, Goncharova both nurtured an intellectual interest in the handicrafts and rituals of Old Russia and interpreted these subjects in her pictures and designs. She brought a ready appreciation of Russian peasant costume and ornament to her several commissions for the Diaghilev enterprise, especially *Le Coq d'or* (1914), *Liturgie* (1915; not produced) and *Les Noces* (1923).

Diaghilev discovered Goncharova and her companion, Mikhail Larionov, in their artistic prime, beckoning them from the convenient, indigenous environment of Moscow Cubo-Futurism to the urbane and abrasive world of pre-war Paris. Grateful to Diaghilev, Goncharova paid homage to him with the remarkable portrait, which she included in the portfolio *L'Art Décoratif Théâtral Moderne* (1919), emphasizing the large, long head with its mane of hair (pl.65).[18] Thanks to Diaghilev, Goncharova and Larionov attained global acclaim as leading stage designers – but with his passing they lost their celebrity status and financial wherewithal.

It was Goncharova's recognition of the vitality of indigenous Russian art which stimulated her to collect peasant artefacts, to acquire relevant commentaries and compendia such as Vladimir Stasov's album of Slavic and

Eastern ornaments and Dmitry Rovinsky's directory of *lubki* (hand-coloured broadsheets),[19] and in 1913 to help organize the exhibition *Icons and Broadsheets* in Moscow. In turn, Goncharova's appeal to the 'primitive' tradition influenced the formal arrangements of her painting, contributing to her pictorial manipulation of intense stylization, vigorous colour combinations and 'wrong' proportions, qualities which she – and other avant-gardists – tended to associate with Oriental rather than with Occidental culture. As she declared in 1913: 'I have turned away from the West…. For me the East means the creation of new forms, an extending and deepening of the problems of colour.'[20] Attracted to the simple pleasures of life, Goncharova celebrated them in her dancing peasants, ethnic costumes and happy beasts and birds, a revelry which found its strongest expression in the riotous sets and costumes for *Le Coq d'or*.

Le Coq d'or is an ebullient fable with sets more like Persian carpets or painted peasant furniture than backdrops for dancing (pl.66). Goncharova's gamut of colours and forms bring to mind the dynamism of Dionisy's 1502 frescoes for the St Ferapont Belozero Monastery. Be that as it may, the designs for *Le Coq d'or* were among her most successful endeavours for the stage and she edited and repeated their motifs many times, even as late as a record sleeve for the EMI Corporation *Hommage à Diaghilev*, released – two years after Goncharova's death – in 1964. Accepting Benois's suggestion that *Le Coq d'or* be staged as a ballet-cum-opera, she insisted that dancers

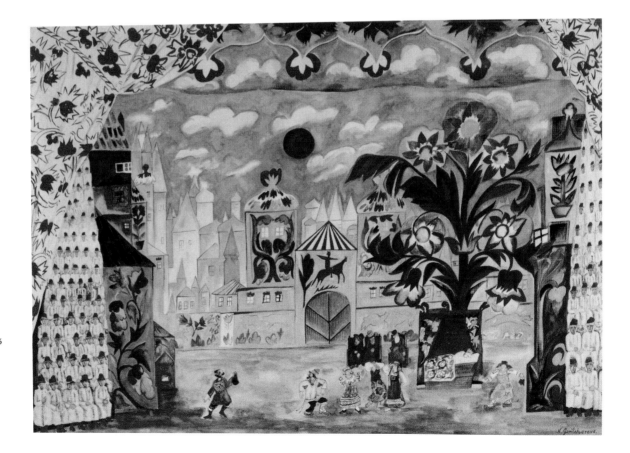

Opposite
65. Natalia Goncharova, *Portrait of Diaghilev*. Pochoir print, 1919. V&A: NAL, fol. PC 4/5

66. Natalia Goncharova, set design for *Le Coq d'or* (Scene I). Watercolour, 1914. Private collection

107

should mime the action and that the singers be positioned in choral formation on ramps at either side of the stage.

> The problem ... consisted in finding a space to accommodate the mass of 90 soloists and choir which the orchestra pit could not contain. Goncharova proposed putting the singers on the stage, seated and shelved one above the other, just as the Boyard Duma is represented in popular Russian imagery.[21]

Critics who saw the Paris premiere asserted that this resolution had 'inaugurated a new phase of stage decorations',[22] and Fokine, choreographer of *Le Coq d'or*, who, because of Goncharova's notoriety as a Cubo-Futurist, had experienced grave misgivings, now changed his mind:

> Gontcharova [*sic*] not only provided beautiful decors and costume designs, but she also manifested an extraordinary, fantastic love for her work on *The Golden Cockerel*. It was touching to see how, with their own hands, she and Larionov painted all the props. Each piece on stage was a work of art. What great work! Seeing the enthusiasm of the two artists, I was amused to recall the fears and rumours.[23]

'Beautiful' and 'fantastic' might also describe one of the most ambitious projects of the Diaghilev enterprise: *Liturgie*, a balletic interpretation of the life of Christ. Goncharova and Larionov collaborated with Diaghilev and Léonide Massine on the ballet in Lausanne, a juncture of keen artistic energy in spite of the trials of the First World War. In fact, between arriving there in the summer of 1915 and the end of 1916, when she accompanied Diaghilev to San Sebastián, Goncharova worked on no fewer than four ballets (*Liturgie*, *España*, *Triana* and *Foire Espagnole*) not one of which, unfortunately, was produced. Even so, the intense activity resulted not only in numerous designs for sets and costumes, but also in three portfolios of *pochoirs* (hand-coloured stencils) – *Liturgie*, *Album de 14 Portraits Théâtraux* (Paris, 1916) and *L'Art Décoratif Théâtral Moderne* (Paris, 1919), the last two of which were joint undertakings by Goncharova and Larionov.

The title, concept and structure of *Liturgie* were symptomatic of Goncharova's attitude towards the theatre as being a temple or hallowed space for the interaction of 'proscenium' and 'auditorium' – virtually an ecclesiastical act. With its appeal to sight, sound, smell and taste, the priest, art historian and mathematician, Pavel Florensky, defined the theatre as a 'synthesis of the arts'.[24] As in the Orthodox liturgy, here was the minister of experiences (the dancer or actor as priest) and here was the consumer of those experiences (the audience as congregation), whose colloquy was now enhanced by music, painting and movement. *Liturgie*, therefore, held particular appeal to Goncharova, at once Orthodox believer and stage designer.

But the production was bedevilled by misfortune and, ultimately, Goncharova's labours were in vain. Diaghilev had hoped that Stravinsky would write a score of four interludes for the ballet, but the composer refused to be party to a theatrical presentation of the holy story (which was to have included a Mass). Diaghilev then toyed with the idea of producing mere sounds as an accompaniment:

> After twenty-two rehearsals of *Liturgie*, we have come to the conclusion that absolute silence is death.... Therefore, the dance action will have to be supported not by music, but by sounds – that is to say, by filling the ear with harmonies.[25]

Even though Diaghilev discussed such a system with Filippo Marinetti, hoping that a Futurist orchestra might help, no score was forthcoming. Massine recalls that Diaghilev also tried to obtain copies of ancient chants from Kiev, but because of the upheavals of the war, they never arrived, much to the chagrin of the young choreographer:

> For me *Liturgie* had been not only a technical challenge, but even more the first artistic realization of a theme which had taken root deep in my subconscious when I was a child. I found it profoundly satisfying to interpret the scenes of the life of Christ in ballet form.[26]

In fact, Goncharova had not been Diaghilev's first choice of designer for *Liturgie*. According to Ivan Bunin, Dmitry Stelletsky had been invited to make the costumes, but had refused because – like Stravinsky – he did not approve of the presentation of such a deeply religious subject on stage, so, in turn, he recommended Goncharova:

> ... and she even made a design for an iconostasis, except that she confused the places of the Virgin and the Saviour. They were supposed to dance without music, on a double floor so that the sounds of their feet would echo. Stravinsky was supposed to compose chorales for the entr'actes.[27]

If Goncharova did position the Virgin and the Saviour wrongly in this iconostasis (a version of which is now in the collection of the Metropolitan Museum of Art, New York), she would have done so consciously, perhaps justifying her artistic licence by the need for an internal and innovative sequentiality. After all, the fact that she saw fit to compile her images for the album *Liturgie* as a numbered sequence of *pochoirs* also indicates that she was regarding the spectacle more as a procession of personages than as a confirmation of severe hierarchies:

> The costumes might intervene with each other mutually or come forth one from the other. One costume, put next to another might hardly be noticed ... This [process] can be compared to a game of cards with its rigid and complex rules and innumerable combinations.[28]

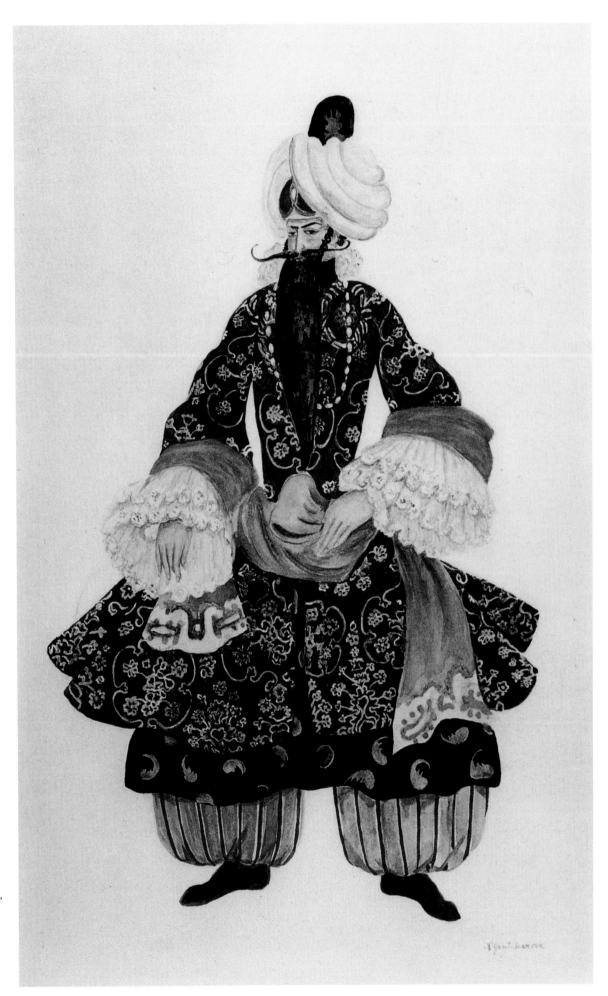

67. Natalia Goncharova,
costume design for
Shah Shariar from
Aurora's Wedding.
Gouache, gold,
silver and pencil
on paper, 1922.
Private collection

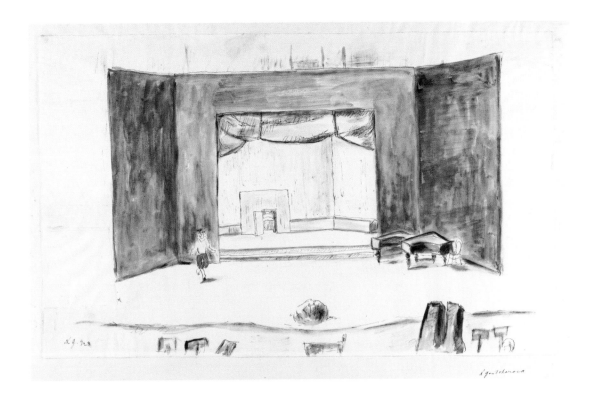

Goncharova returned to this cyclical element whereby 'innumerable combinations' could proceed from a highly contrived and controlled exercise (as in a game of cards) in *Les Noces*, which Diaghilev produced in Paris in 1923. Here again was a ritual – a Russian rural wedding – which was both obeisant to the rules of etiquette and decorum and yet also amazingly free within that controlled environment. In any case, both Goncharova and her choreographer, Bronislava Nijinska, envisioned *Les Noces* as the expression of both conditions – of a maiden's last delight in individual liberty and of its impending curtailment – a mood very different from the tinsel wedding which Goncharova designed for Diaghilev's Paris production of *Aurora's Wedding* (*Le Mariage de la Belle au Bois Dormant*) the year before (pl.67). Nijinska recalled:

> *Les Noces* opened up a new path in choreography for me: promoting the corps de ballet to a primary artistic level. I did not want there to be a dominant performer (soloist) in this spectacle. I wanted all the artistes to fuse in one Movement and to create a whole. In my choreography the mass of the ensemble was meant to 'speak' – able to create just as many choreographic nuances as the orchestra mass does musical ones.[29]

Well before her final rendering for *Les Noces*, Goncharova designed two other versions, one in vivid, folkloristic style and another in half-tones with gold and silver embroidery; but Diaghilev rejected them both, suggesting that she design the costumes as common work clothes with trousers and shirts for the men and tunics for the women (pl.68).[30] The result was costumes 'very sober ... in the two colours of brown and white',[31] a simple resolution which integrated fully with the austere background of a 'plain backcloth and wings, together with one or two central flats, in which windows of varying colours were inserted to indicate changes of place' (pl.69).[32] Stravinsky also worked for several years on the score of *Les Noces* (originally called *Les Noces Villageoises*) and Diaghilev refers to the ballet and to Stravinsky's involvement as early as November 1914. This extended gestation with its varied musical and visual offspring has, in the case of Goncharova, led to a number of misattributions, for example, some of the bright and 'primitive' designs for the first version of *Les Noces* are now misidentified as designs for *Le Coq d'or*.

Pablo Picasso

If Bakst treated the stage as a spectacular display of ornament, and if Goncharova regarded it as a dramatic temple, then Picasso (1881–1973) seems to have accepted the theatre as a cube, emphasizing the 'idea of integrating the spectator and the decoration within the decor of the theatre itself'.[33] In other words, for Picasso, the studio painter turned stage designer, the 'fourth wall' was an extremely important element in the theatre and the impression of many of his sets and costumes is that they have been engineered more for audience response than for the immediate needs of the actor or the directives of the playwright. This would seem to be especially true of Picasso's major commissions for Diaghilev, such as *Parade* (1917) and *Le Tricorne* (1919). Within the Ballets Russes they 'opened the gates of the twenties',[34] heralding a 'period of rejuvenation and high spirits'.[35]

Jean Cocteau, librettist for *Parade* (with music by Erik Satie), described his bizarre street scene with Managers and

a 'Chinese' Conjuror enticing passers-by into their booths as 'neither Dadaist, nor Cubist, nor Futurist, nor any other school. *Parade* is *Parade*'.[36] Obviously, Coctcau's sentiment was rhetorical and, in the spirit of his own avant-gardism, utterly paradoxical, because without the apprenticeship to both Cubism and Futurism, *Parade* would not have looked the way it did. On the other hand, Cocteau seemed to be arguing that the synthetic *Parade* transcended all traditional stylistic categories and nominal genres, and could not be accommodated under a single rubric. To some extent, Cocteau was right – in the sense that his Americanism and his insistence on the inclusion of machine noises (which Diaghilev removed) or Picasso's Sandwich-Men as the Managers and his rambunctious Dummy Horse had no legitimate precedents in the ballet and, of course, astonished the Parisian public with their patent absurdity. Picasso's highly autobiographical front cloth with portraits of friends and self, Pegasus, and Fortune, feeding a monkey could not have offered much respite, either.

But *Parade* does connect with at least one prototype within the Diaghilev repertoire, specifically, *Petrushka* (1911), which, if cast in mid-nineteenth-century St Petersburg, was also a theatre within a theatre, with a parade of wayward characters dependent upon a Tout or 'Manager' and a Magician, all moving to the 'cacophony' of Stravinsky's

music. On the other hand, *Petrushka* was still a ballet, as the brilliant dancing of Karsavina and Nijinsky demonstrated, and the sets and costumes by Benois, however imaginative, still represented a fairground, while the triangular love affair of Punch and Judy (which returned, incidentally, in *Le Tricorne*) was, after all, a universal and familiar adventure. *Parade* may, therefore, have been a French *balagan* (Russian fairground), but Picasso's costumes looked more like animated Cubist collages than dramatis personae. Put simply, *Parade* was about prancing and glancing, but not about dancing – so, if *Parade* was not a ballet, why did Diaghilev include it in his 1917 Paris programme, offering it to an eager audience which for three weary years had not seen a Ballets Russes performance?

Reasons may be obvious: Diaghilev's sensitivity to genuine innovation, his desire to transport his company from the 'hot house' of Bakst to the 'fresh air' of Picasso,[37] his aspiration to give his company a more international flair and his personal sympathy for Cocteau, Picasso and Satie. But perhaps there was a more perverse motive for Diaghilev's bold gesture, one implicit in Cocteau's outlandish book and Picasso's eccentric visual resolution, namely, a secret desire to remove the dancer from the ballet and to transform the traditional ballet into an industrial entity, wherein the dancer was no longer the star or the centrepiece, but simply a cog in the

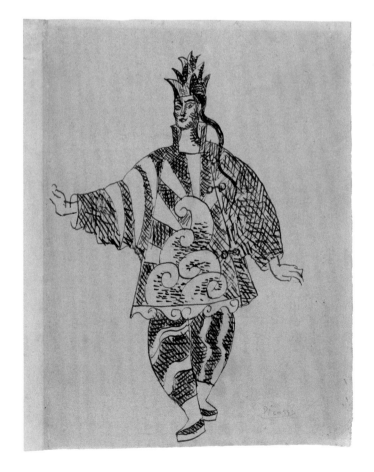

70. Pablo Picasso, costume design for the Chinese Conjuror from *Parade*. Pen and ink on paper, 1917.
V&A: S.562–1983

Opposite
71. After Pablo Picasso, costume for the Chinese Conjuror from *Parade*. Silk satin fabric with silver tissue and black thread. Cotton hat with woollen pigtail, *c*.1917. This costume was worn by Léon Woizikovsky both when he danced *Parade* with the Ballets Russes and the solo elsewhere. It survived the war buried in his native Poland.
V&A: S.84(&A)–1985

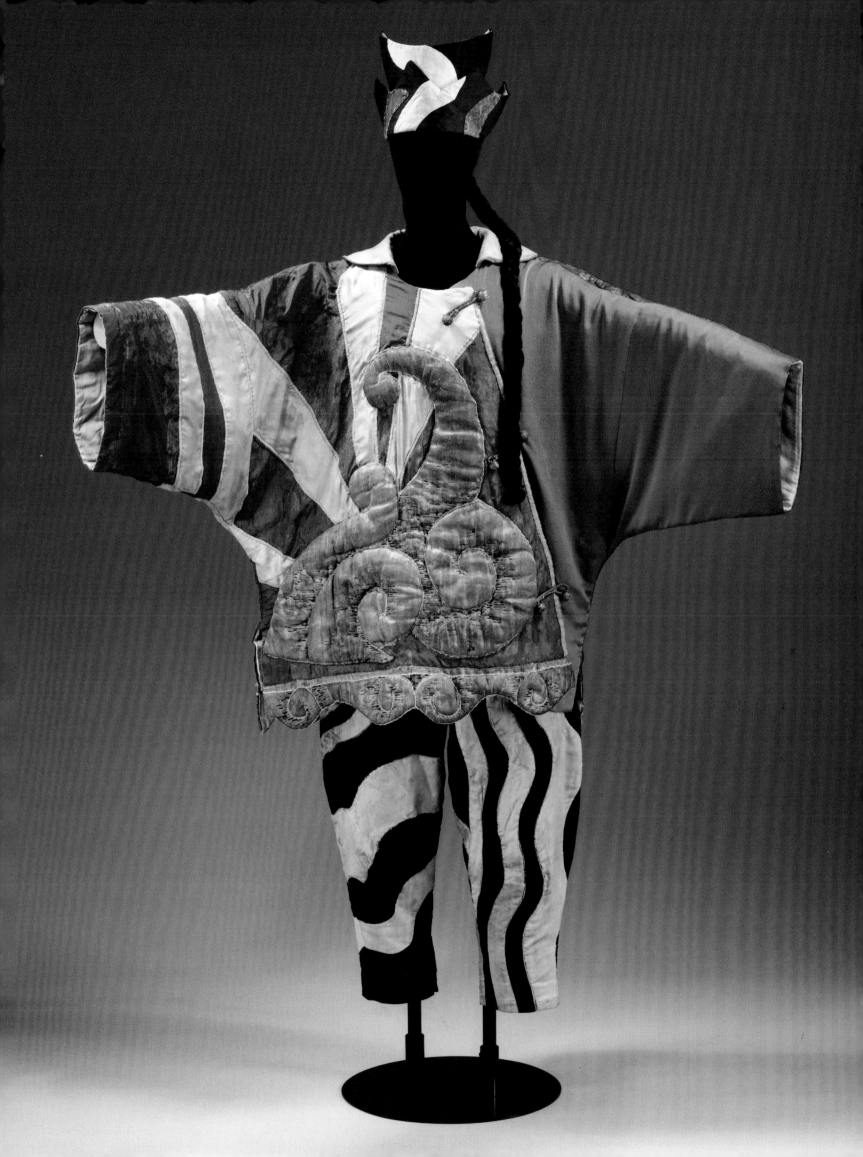

theatrical machine, anonymous, automatic and replaceable. True, Diaghilev's promotion of new dancers such as Anton Dolin and Serge Lifar in the 1920s undermines this allegation, but *Parade*, like *Jeux* in 1913, did herald the Machine Age of the Ballets Russes, anticipating the 'industrial' ballets of *Le Pas d'acier*, *La Chatte* and *Le Train bleu*.

No doubt, the suspension of the human dancer in *Parade* must also have appealed to Picasso who had long been fracturing, dismembering and erasing the human figure in his Cubist paintings. Indeed, the Managers, the Chinese Conjuror and the American Girl (a composite of Charlie Chaplin, the Marx Brothers and Mary Pickford) can scarcely be called dancers, and move more as automatons in an urban procession (pls 70 and 71). Picasso's costumes for these weird characters astonish not by similarity, but by dissimilarity and, ultimately, they comprise a gigantic Cubist canvas on stage, a volumetric picture whose dynamic composition is extended and enhanced by the motor responses of the audience.

Parade was an isolated experiment within the Ballets Russes and, if radical in its formal accomplishments, it did not represent a decisive trend in stage design, at least, for Picasso. On the contrary, thereafter, Picasso's visual engagement with the theatre was more traditional or, at least, more narrative, although no less engaging – *Le Tricorne* being a case in point. Set in an old Spanish town (pl.74), the ballet is a tale of love and jealousy, the characters expressing their emotions in farrucas, fandangos and sevillanas. Curiously enough, the distinguishing feature of their costumes is the black, which

Picasso foils with red, yellow or blue to produce bold contrasts (pls 72 and 73) – a black which Douglas Cooper has associated with Picasso's fascination with Francisco de Goya (and, one might add, with Jusepe de Ribera and Diego Velázquez).[38]

But Picasso's designs for *Le Tricorne* echo a distant era not only because the ballet itself concerns a bygone Spain, but also, perhaps unexpectedly, because Picasso seems to have drawn inspiration from his visits to Pompeii and Herculaneum. Accompanied by Cocteau and Diaghilev, Picasso explored the sites in March 1917, observing the artefacts, architecture, mosaics and wall paintings with eager attention, sketching 'many a rather licentious fantasy'[39] and noting qualities of form, perspective and colour which appeared in the sets and costumes for *Le Tricorne*. The sharp ochre ('Pompeian red') of the initial set and the flattened, schematic heroes such as the Corregidor and Las Sevillanas in their flowing garments bring to mind the figural repertoire of the Casa dei Vettii. Picasso himself even referred to his curtain for *Parade* as resembling 'the deteriorated frescoes of Pompeii'.[40] Last, but not least, the strategic arrangement of so many of the Pompeian *pitture pareatali* (wall-paintings) with their shepherds, fishes, bulls, grapes and wreaths, surrounding a square courtyard and greeting the visitor, must have struck Picasso as a highly theatrical device. Here was an architectural arrangement which confirmed Picasso's basic concept of the theatre as a space wherein the 'auditorium penetrated the stage.... and the place of action overlapped into the theatre'.[41]

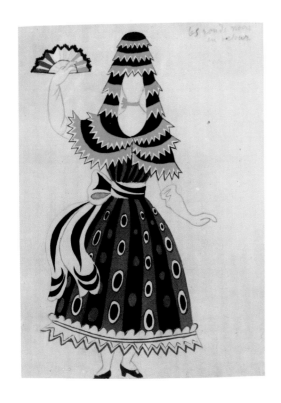

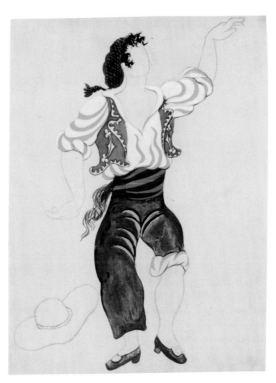

Far left
72. Pablo Picasso, costume design for the Dancer of the Sevillana from *Le Tricorne*. *Pochoir* print on paper, 1919. V&A: S.440:29–1979

Left
73. Pablo Picasso, costume design for the Miller from *Le Tricorne*. *Pochoir* print on paper, 1919. V&A: S.440:12–1979

Indeed, the idea of theatre within theatre, germane to the Roman villa (and, for that matter, to *Petrushka* and *Parade*) informed most of Picasso's theatrical commissions for Diaghilev, including *Pulcinella* (1920) with its 'Neapolitan street scene conceived in Cubist terms',[42] *Cuadro Flamenco* (1921) and *Mercure* (1924–7). In *Cuadro Flamenco*, Picasso even inserted boxes on either side of the stage (a tactic reminiscent of Goncharova's bilateral placement of choirs in *Le Coq d'or*) from which puppet-like balletomanes gazed at the action unfolding before them. Still, as the author W.A. Propert commented, *Cuadro Flamenco* had nothing to do with the ballet: 'It was a singing and dancing interlude given by a company of ten Spaniards whom Diaghilev had collected in Andalusia.'[43]

The brilliant culmination to Picasso's association with the Ballets Russes was, of course, his drop curtain or front cloth for *Le Train bleu* in 1924. Although Prince Alexander Schervashidze painted the actual cloth after Picasso's preparatory sketches, the basic theme – of two giantesses running along the beach hand in hand – was Picasso's. But beyond a rather distant association with the sounds and sea of the Côte d'Azur (the destination of the Blue Train), the two hieratic and monumental nymphs seem to derive more from primitive Iberian sculptures than from the svelte bodies of chic bathers on the Riviera. Their ample forms, russet flesh and flowing braids bring to mind the heavy limbs of the stone maidens which dotted the Iberian landscape, some of which to this day still carry traces of their blue and red pigments.

If the drop curtain looked back to a distant Iberia, they also carried a peculiar premonition of Vera Mukhina's gigantic statue, *Worker and Collective Farm Girl*, for the Soviet Pavilion at the 1937 Exposition Internationale in Paris, an artefact which also served as a front cloth to the spectacle of Soviet propaganda. It is unlikely that Mukhina knew of Picasso's curtain for *Le Train bleu*, but the conceptual parallel is intriguing, the more so since the flowing scarf of the barefoot *Collective Farm Girl* is a telling reference to the scarves of Russia's practitioners of the *danse plastique* and of their mentor, Isadora Duncan. This is an unlikely deviation, but it returns us to Picasso's special theatrical quality: his ability to combine what Guillaume Apollinaire called 'the plastic and the mimic'.[44]

The artistic destinies of Bakst, Goncharova and Picasso were very different. Bakst, full of plans and projects, died prematurely in 1924; Goncharova faded into relative obscurity; Picasso went on to become the most famous artist of the twentieth century. But under the command of Diaghilev each found inspiration within the creative laboratory of the Ballets Russes, discovered the full force and vitality of the ballet as a medium of artistic expression, and collaborated with choreographers, dancers, musicians and artisans. Designing for Diaghilev transposed these artists from the privacy of the studio to the public domain of the theatre and *Cléopâtre*, *Schéhérazade*, *Jeux*, *The Sleeping Princess*, *Le Coq d'or*, *Les Noces*, *Parade* and *Le Tricorne* all issued from that clement and singular coincidence.

74. Pablo Picasso, set design showing a view of a Spanish town for *Le Tricorne*. *Pochoir* print on paper, 1919. V&A: S.440:32–1979

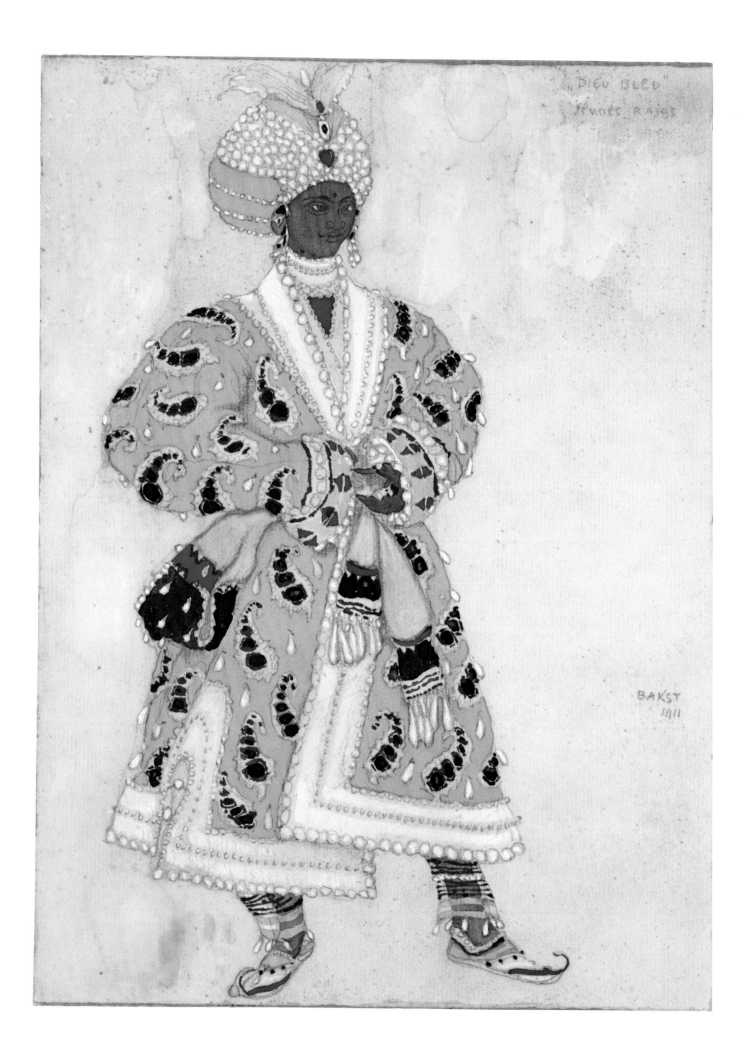

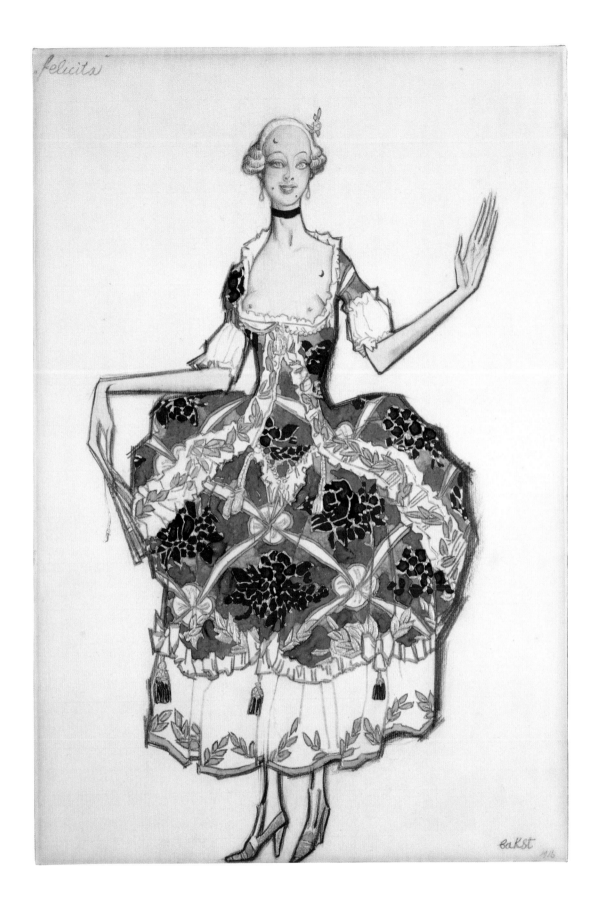

FRONT CLOTHS
Jim Fowler

A front cloth (sometimes referred to as a drop curtain) is the painted canvas hung at the front of the stage. In Diaghilev's productions, such a cloth served two purposes. First, it could be revealed during the overture of a ballet to establish its mood, as with Valentin Serov's Persian-miniature-inspired hunting scene, which was added to *Schéhérazade* in 1911, and the Spanish bullring produced by Pablo Picasso for *Le Tricorne*. Second, it could be used to cover a change of setting without breaking the atmosphere by bringing in the 'tabs' or velvet theatre curtain. An example of the latter is Alexandre Benois's night scene of the St Petersburg Butterweek Fair, which

is used to conceal the scene changes from fairground to puppet cells in *Petrushka*. On several occasions, for example *Les Biches*, *Le Train bleu* and *Apollon musagète*, the front cloth was based on an original painting (by Marie Laurencin, Pablo Picasso and André Bauchant respectively) and then enlarged by a skilled set painter.

The front cloth for *Le Train bleu* was first used by the Ballets Russes as its signature image at the Théâtre des Champs-Elysées, in Paris, during the 26 May – 30 June 1924 season, when the city was playing host to the VIII Olympiad. Diaghilev had noticed the painting, entitled *Two Women Running along the Beach (The Race)*, in Picasso's

Vladimir Polunin, design for a front cloth for the London Coliseum. Watercolour, body-colours and gold paint, 1925. The front cloth for the 1925 Ballets Russes season evoked Russian icon paintings by depicting St George and the dragon. V&A: E.480–1926

studio and persuaded the artist to allow him to have it copied and scaled up as a front cloth (details overleaf and on previous pages). On its completion, he commissioned a fanfare from Georges Auric to herald its first appearance.

Picasso had painted the image in gouache on plywood while on holiday at Dinard in 1922 with his wife Olga Kokhlova, a former dancer with the Ballets Russes. Although the figures are monolithic in conception, Picasso's original picture was modest in scale at 34 × 42.5cm.

Diaghilev's set painter, Prince Alexander Schervashidze, took less than 24 hours to enlarge the image to 6.78 × 8m onto a canvas 10 × 11m. The wide border around the painted area allowed the canvas to be folded to fit different stage openings on tour. Picasso was so impressed by its fidelity to the original that he signed and dedicated the new curtain to Diaghilev: *Dedie a Diaghilew. Picasso 24*.

The British dancer Anton Dolin, for whom *Le Train bleu* was created, recalled that it was only when the Ballets Russes returned to the London Coliseum in November 1924, that Diaghilev allocated the cloth to that ballet by which it is now known.[1] According to Richard Buckle, it was Picasso's delight and gratitude on seeing the finished curtain that convinced Diaghilev to use it 'as the official front cloth for the Russian Ballet'.[2] The association of the *Train bleu* curtain with the Ballets Russes gained Picasso's work a currency and influence it might not otherwise have had. The sculptor Henry Moore remarked that the image had been 'a landmark' in his youth, and had even changed his life.[3]

1 Buckle 1979, p.576.
2 Sotheby's catalogue, Scala Theatre, London (17 July 1968), pp.vi, 111.
3 Buckle 1982, p.232.

Pablo Picasso (in cap) and scene painters on the front cloth for *Parade*, 1917. Photograph by Lachmann. V&A: S.5401–2009

Alexandre Benois, *Portrait of Prince Alexander Schervashidze*. Pencil on paper, 1906. Private collection

Overleaf, and previous pages Alexander Schervashidze after Pablo Picasso, details of the front cloth for *Le Train bleu*. Oil on canvas, 1924. Picasso's signature and dedication of the cloth to Diaghilev is visible overleaf. V&A: S.316–1978

SOUVENIR
PROGRAMMES
Beverley Hart

In 1912, the future dance historian Cyril Beaumont was seduced. Borrowing a souvenir programme for the Ballets Russes Paris season he recounted: 'I turned over the pages of the ivory and gold programme, with all its coloured reproductions of Bakst's lovely designs ... amazed and captivated. I was all eagerness to go to Covent Garden.'[1]

The cover images by Léon Bakst and Alexandre Benois for the earliest Parisian programmes explode with the exuberance of the dance revolution and their collaboration with Diaghilev, first nurtured on his journal *Mir iskusstva* (*World of Art*). Relatively expensive at two francs, the programmes are an artful mixture of designs, photographs and full-page advertisements for luxury products – travel, perfume, restaurants,

millinery, Veuve Cliquot champagne, the *grands magasins*, and that staple underpinning of the contemporary theatre programme (and female society), corsetry – elite preoccupations. This canny collision of culture and commerce is echoed in London, albeit with the more prosaic addition of furniture, face powder and Yorkshire Relish, alongside advertisements for cars, and their ominous adjunct, motor insurance. The company also had an influence on the advertising itself: in 1912 Marquise de Sévigné chocolate, which filled the back-page slot for several seasons, references the style and jewel colours of Bakst.

These glossy production values reflect the involvement of Maurice de Brunhoff, co-founder of *Vogue* and art director of *Comœdia Illustré*, one of the

Advertisement for chocolate from a souvenir programme for the Théâtre du Châtelet, 13 May–10 June 1912. V&A: Theatre & Performance Collections

Souvenir programme for a matinee at the Théâtre national de l'Opéra, 29 December 1915. The cover shows an illustration by Mikhail Larionov of *Le Soleil de nuit*. V&A: Theatre & Performance Collections

Souvenir programme for the Théâtre du Châtelet, May 1912. The illustration shows a portrait of Vaslav Nijinsky by Georges Lepape. V&A: Theatre & Performance Collections

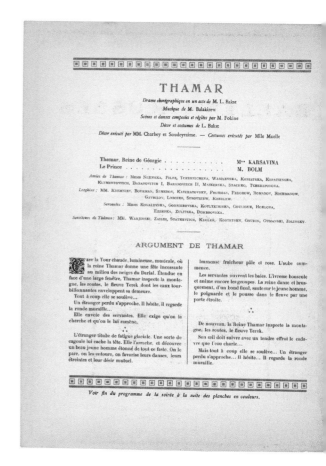

high-end periodicals, along with *La Danse* (from 1919), with which these programmes were originally issued (1909–21). By 1912 the crucial role of De Brunhoff (whose son Jean would later write *Babar the Elephant*) receives a handsome puff, flanked by a pair of nymphs, only a little lower than a profile of Bakst himself. Into these sumptuous programmes a printed flyer in the form of a removable centrefold gives details of specific performances.

As the company's repertoire and reputation grow, the programmes focus on its stars – no less the dancers than the designers and musicians whose vision they enact. Whereas group images dominate early programmes, there is soon a subtle focus on the public's favourites, in both adverts and features. For the ninth Paris season

(1914), Vera Fokina endorses upmarket apparel: '*les maillots du Grand Frédéric sont merveilleux.*'

The covers of the US touring programmes are more restrained in their colour and detail, but lavishly embossed. Diaghilev is prominently featured, perhaps as a safeguard against those who had traded on the company identity in America with pirated versions of Ballets Russes productions. In contrast, the European programmes emphasize the collaboration between young artists destined to become household names: Picasso, Stravinsky and Massine.

An increasingly international outlook, attracting brilliant new talent from across Europe, leads to a less 'Russian' appearance. Picasso's stylized tricolour Chinese Conjuror from

Parade (Empire Theatre, London, 1919) appears to lean nonchalantly against the decorative border echoing the palette of his costume. From 1923 Boris Kochno, whose *Guardian* obituary in 1990 was headlined 'Diaghilev's Man Friday', supervised the programmes. Henceforward artists' illustrations appeared in addition to designs. The 1924 Monte Carlo season featured five Picasso line drawings. This departure from the design-based formats of the early covers is noticeable in De Chirico's witty surreal illustration inspired by *Le Bal* (Paris, 1929), quite clearly a commission: the art itself has become the story.

1 Beaumont 1940, pp.7–8.

Souvenir programme for the Théâtre Sarah Bernhardt, 6–23 June 1928. The cover shows an illustration by Pavel Tchelitchev inspired by *Ode*.
V&A: S.34–1976

Giorgio de Chirico, illustration for the souvenir programme for the Ballets Russes seasons in Monte Carlo and Paris, 1929. Graphite, tempera and/or watercolour on paper, 1929. The illustration reflects costume designs for *Le Bal*. Wadsworth Atheneum 1933.438

THE WIDER INFLUENCE OF THE RUSSIAN BALLET
Stephen Calloway

Diaghilev's choice of Paris, the vibrant centre of innovation in the fine and decorative arts, for his inaugural seasons was astute. All Paris was alive to the breathtakingly novel, stylized beauty of the music and dance, but it was artists and designers who responded most excitedly to the explosion of saturated hues and sumptuous fabrics of the Russian costumes and decors. Accustomed to Orientalist fantasies in Salon paintings, Parisian couturiers and interior designers rapidly assimilated Léon Bakst's strident colour effects for fashionable women's dresses and the decoration of rooms. *Schéhérazade*, the hit of the 1910 season, especially seized the imagination, epitomizing the exoticism of '*le style ballets russes*'.

First to espouse the look was Paul Poiret, who daringly proposed harem trousers and turbans, and silks and velvets boldly splashed with colour for day or evening wear; other 'Oriental' accessories included overstated aigrettes and ropes of pearls with contrasting tassels. A fad for coloured jewels such as emeralds and rubies, carved jades or coral temporarily

Osbert Lancaster, *First Russian Ballet Period*, from *Homes Sweet Homes*, 1939. Courtesy of Clare Hastings

Georges Lepape, illustration from *Les Choses de Paul Poiret*. Hand-coloured *pochoir* stencil, 1911. V&A: CIRC.262–1976

Opposite
After Paul Poiret, room decoration for Atelier Martine, *c*.1920. Collage and hand-coloured *pochoir* print. Published in Jean Badovici, *Intérieurs français*, 1925. V&A: NAL 47.A.52

eclipsed demand for conventional diamonds. Through his Atelier Martine (founded 1911) Poiret also popularized highly coloured interiors, often replacing all conventional furniture with divans and tasselled cushions. Georges Lepape's *pochoir* (hand-coloured stencil) illustrations for *Les Choses de Paul Poiret* showcased the languid luxury of this world.[1]

Diaghilev's 1911 London season sparked a similar reaction. That year two important furnishing boutiques opened: Marcel Boulestin's Decoration Moderne – selling Poiret's wallpapers and silks by Raoul Dufy – and Speall's, the creation of that enterprising, eccentric Edwardian *grande dame* Victoria, Lady Sackville. In her diary for 1918 she described the bedroom she decorated for her daughter Vita Sackville-West: 'Her walls are shiny emerald green paper, floor green, doors and furniture sapphire blue; ceiling apricot colour. Curtain blue

and inside curtains yellowish. The decoration of the furniture mainly beads of all colours … six bright orange pots on her green marble mantelpiece and … salmon and tomato-colour cushions and lampshades.'[2]

In *Homes Sweet Homes* (1939), Osbert Lancaster celebrated this style as 'First Russian Ballet Period': 'Before one could say Nijinsky the pastel shades which had reigned supreme on the walls of Mayfair for almost two decades were replaced by a variety of barbaric hues – jade green, purple, every variety of crimson and scarlet, and, above all, orange.' The style's adherents possessed, he added, 'a tendency to regard a room not so much as a place to live in, but as a setting for a party'.[3]

Although Diaghilev's return to London in 1918 inspired a new generation of avant-garde aesthetes including the Sitwells and Lord Berners, following the war English taste retreated

into patriotic insularity, equating 'Mock-Tudor' and Neo-Georgian styling with 'Homes for Heroes'. In Paris, the leading designers, Groult, Iribe and Ruhlmann continued flirting with pre-war exoticism and, as prosperity returned, created furnishings of extraordinary luxury. This trend culminated in the great 1925 *Exposition des Arts décoratifs* in which the French offerings, now highly experimental in form and employing rich and rare materials such as ivory, silver leaf, vellum, green shagreen and black or scarlet lacquer, still seemed redolent of that first, unforgettable frisson caused by the designs of Bakst.

1 Lepape 1911.
2 Glendinning 1983, p.95.
3 Lancaster 1939, p.58.

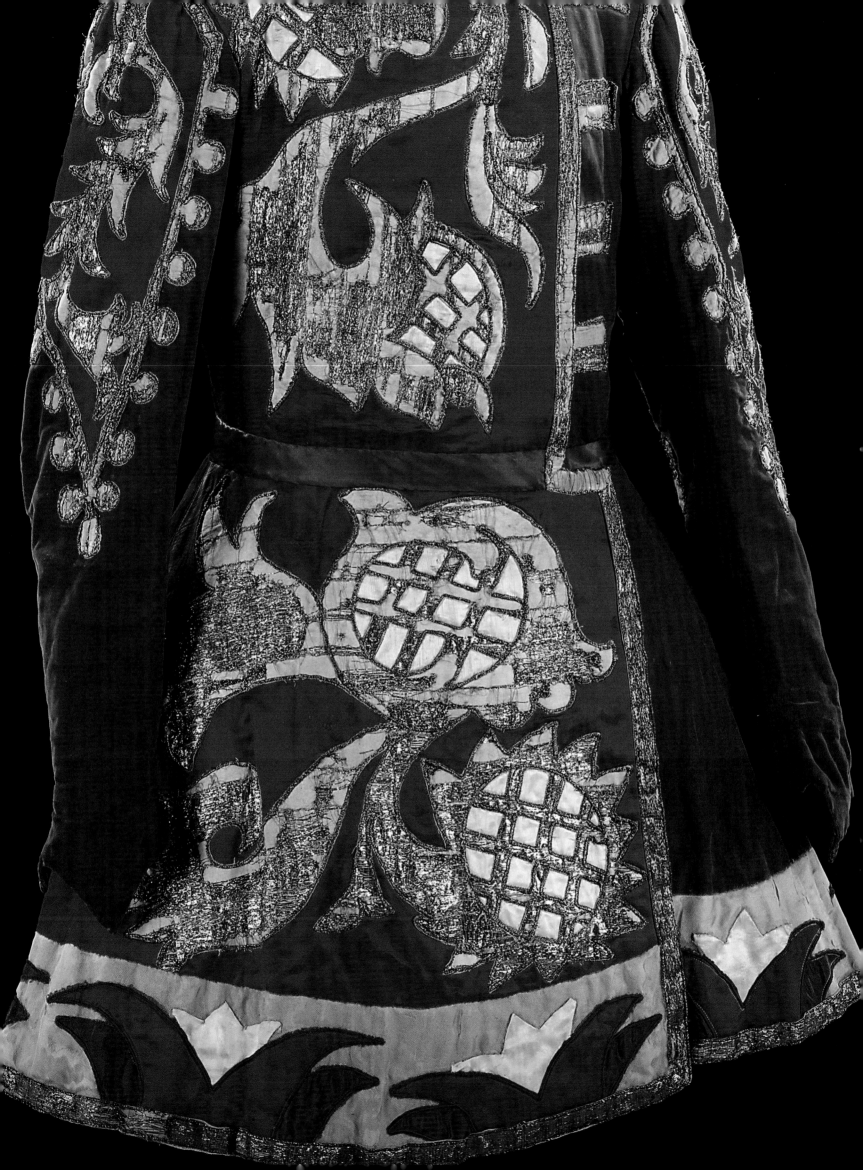

WARDROBE

SARAH WOODCOCK

Like Diaghilev, who always looked immaculate, but sometimes had holes in his shoes, theatre costumes do not always bear close examination. Displayed in glass cases, protected from dust and light, they are often perceived as tatty, tawdry and crude, perhaps only tolerated because of their association with an iconic artist. Yet they were never conceived as 'art' objects, but rather as one element in a stage performance. Redolent of the disreputable, ephemeral, hurly-burly of theatre, costumes reek of life and perspiration, of the nightly stress of performance, when they were thrown on and ripped off, struggled into by other bodies than those for which they were made, then packed into skips still soaked with sweat. They bear honourable scars – hasty repairs alongside more careful darns and patching, alterations for different dancers, the rotted fabric under arms and around belted waists, make-up ingrained into the necks, the names of the first casts neatly written on labels; those of later ones scrawled onto the lining.

Given the association with respectable artists and secondarily with Diaghilev's Ballets Russes (which is often treated as an offshoot of an art movement, not as theatre) costume and set designs were readily admitted into museums as art objects in their own right. Meanwhile, the costumes for which they were the blueprints were overlooked, partly because of their poor condition, partly because boldness was confused with 'crudeness'. Such an attitude has not completely died out and some still prefer to imagine a heavenly stage on which the animated designs dance forever. Yet the success of a design lies not so much in its artistic worth, as in whether the drawing translates successfully into fabric and decoration, or works with the choreography on the dancer as part of the stage picture.

Following the sale of over 1,500 Ballets Russes costumes in the 1960s, those that remain are now scattered across the world. Many principal costumes did not survive the ravages of performance and some of the most successful ballets are represented only by a few walk-ons or late, often bad, remakes. Surviving examples are from failures or near-failures, which saw fewer performances.

The accident of survival benefits some designers and ballets more than others. Only a single example of a costume from *Les Sylphides* remains, yet it was one of the company's most successful works. Most examples of Alexandre Benois's costumes are from *Le Pavillon d'Armide*, *Giselle* and *Petrushka*, which have less obvious theatricality. Henri Matisse's costumes from the little-performed *Le Chant du rossignol* are collected avidly by those desperate to prove that the artist painted every last petal on every costume; some costumes have even been framed and hung like a painting. Few, however, have survived from André Derain's *La Boutique fantasque*, one of the most successful of all the Ballets Russes designs, or from popular works like *Les Matelots*, *Le Soleil de nuit* or *Contes Russes*. If costumes were the only evidence of the company's existence, *Chout* would seem more important than *Schéhérazade*.

Although little exists from *Cléopâtre* or *Schéhérazade*, the range of Léon Bakst's talents is well represented in the costumes from *Daphnis et Chloé* (Greek), *Le Dieu bleu* ('Oriental exotic') and *The Sleeping Princess* (period costume). A single example conveys little of the designer's skill, which lies in creating dozens of costumes to be seen on stage in constant movement. The costumes for Brigands and Greeks designed for *Daphnis et Chloé* (pls 77 and 78) show how the designs worked on stage. Moving in an idyllic, verdant landscape, the Greeks wore tunics in supple fabrics decorated with fluid patterns in soft earth colours. Into the harmony and calm burst the Brigands, dressed in belted tunics and breeches in heavier fabrics, the intense purples, dark blues and ochres painted and appliquéd with hard-edged 'unstable' checkerboards, zigzags and lozenges.

The destruction present in choreography and music is thus carried through into the designs.

The wide range of styles and subjects represented by such costumes would have been inconceivable before the design reforms initiated by Mikhail Fokine. In the 1890s, the prevailing style was detailed realism. There were no trained stage designers in the modern sense; scenery was devised by highly skilled but unimaginative scene painters, who pedantically replicated place and period. In mime roles the performers wore period costumes, while national dances took a few characteristics from the relevant national dress. Almost without exception the ballerina, soloists and corps de ballet wore the bell-skirted tutu decorated with symbols indicating period or country – lotus for Egypt, key pattern for Greece, grapes or leopard skin for a Bacchante – and *pointe* shoes. The men were invariably arrayed in variations on tunics and tights. There was no concept of a harmonious stage picture: frequently, the set designer never saw the costume designs and vice versa. By the end of the nineteenth century stage realism had become an outworn convention, professional but stale, applied without imagination or theatrical flair.[1] Bakst summed up the difference between the old and the new:

…it is goodbye to scenery designed by a painter blindly subjected to one part of the work, to costumes made by any old dressmaker who strikes a false and foreign note in the production; it is goodbye to the kind of acting, movements, false notes and that terrible, purely literary wealth of details which make modern theatrical production a collection of tiny impressions without that unique simplicity which emanates from a true work of art.[2]

Generic costuming was no longer possible because the style and range of the choreography changed with each ballet and individual characters replaced types. Designers had to think dynamically, not statically, and pedantic reconstruction gave way to rhythmic patterning and clear colours, suggesting mood and emotion. Detail was refined to create a heightened reality in which the theatrical became more real than the real. In *Le Tricorne*, Massine and Picasso created such a convincing picture of 'Spain' that when Diaghilev presented *Cuadro Flamenco*, performed by authentic Spanish gypsies, audiences found it strangely un-Spanish.

77. Two pages from *Comœdia Illustré*, 15 June 1912, including photographs of the dancers wearing costumes designed by Bakst for the Brigands from *Daphnis et Chloé*.
V&A: Theatre & Performance Collections
PN 2003 Folio

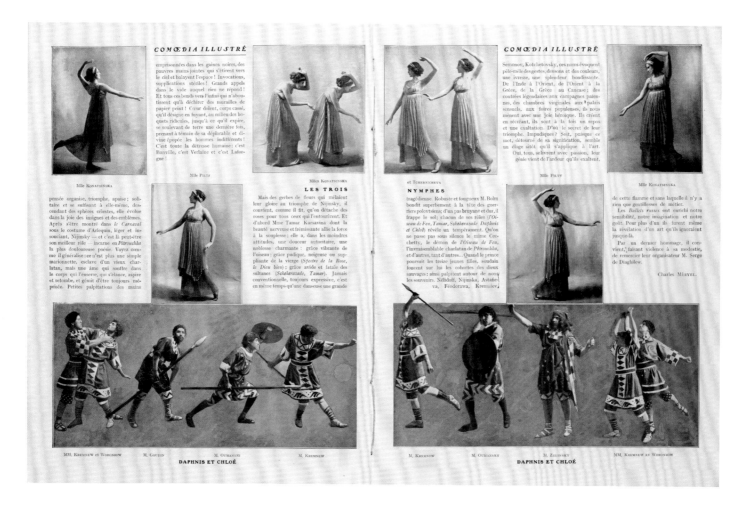

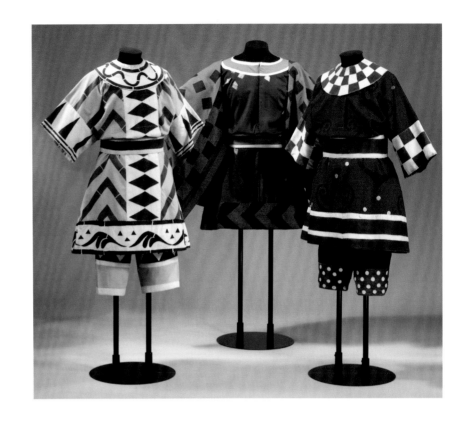

Right
78. After Léon Bakst, costumes for three Brigands from *Daphnis et Chloé*. Wool, cotton and paint, 1912.
V&A: S.639(&A,B)–1980; S.508(&A,B)–1979; S.835(&A,C)–1980

Overleaf, right
80. After Léon Bakst, costume worn by Pierre Vladimirov as Prince Charming from *The Sleeping Princess* (Act III, the Wedding Scene). Silk velvet, cotton, silver tissue and paint, replica sash with original metal bullion fringe, wool hat with metal thread and feather, 1921.
V&A: S.829(&B)–1980 with U.1–2009

Overleaf, left
79. After Léon Bakst, motifs from the costume for the Fairy of the Songbirds from *The Sleeping Princess*, 1921. The motifs were transferred onto a cheaply made tutu decades later.
V&A: S.2492–1986

The old and the new existed briefly side-by-side in Diaghilev's Ballets Russes. In 1911, he purchased costumes from the Moscow Imperial Ballet's 1901 production of *Swan Lake*. Designed in traditional manner by the painter Aleksandr Golovin, there is only a vague sense of period, with no consistency of style or making, and some frankly ugly creations. Upholstery brocades and velvets jostle against painted silks, felted wool, indiscriminate fur and feather trims; the waltz costumes in metallic silver fabric, the bodices swathed with shaded pastel silks and skirts appliquéd with satin flowers are of stupefying vulgarity. By contrast, Bakst's designs for *The Sleeping Princess* in 1921 (pl.79) have cohesion, not only in concept, but also in the making, even though several independent costumiers were employed.

Choreographers and designers began to cross boundaries. Choreographers studied art to learn the significance of gesture, pose and grouping, while designers learned to watch movement, so that their designs would enhance the choreography of each individual ballet. Nicholas Roerich's costumes for *The Rite of Spring* (pls 81 and 82) evolved from his researches into antique and ethnic textiles in the collection of Princess Maria Tenisheva at Talashkino. The basic pattern is the T-shape decorated with an astonishing diversity of patterns – circles and curves, squares, lozenges, lines, bars, various crosses, amoeboid and 'mushroom' shapes – but arranged formally and in symmetrical repeats. The visual complexity added to the

overall effect of primitivism and disorder, but the formality of the patterns created an anchor within the choreography's asymmetry. The intricate mixture of dyeing, stencilling, painting and printing was executed by Caffi, the theatrical costumiers in St Petersburg.

In *Cléopâtre*, E.O. Hoppé noted how the costumes enhanced the gestures and sensuous attitudes, emphasizing the angularity of Fokine's choreography: '[Bakst's] concern is to present a series of gorgeous Oriental patterns in which movement and sound, colour and design, are inextricably mingled, and produce an irresistible appeal to the senses.'[3] In *Narcisse* the curving, flowing scarves in Bakst's designs were built into Fokine's choreography, extending the movements beyond the body.

Picasso sat in on rehearsals for *Le Tricorne* and Massine acknowledged the influence of the evolving designs on the choreography. In *La Boutique fantasque*, the movement of the English ladies as they entered the shop interacted with the sway of André Derain's costumes. Although Derain's costume drawings appear naive and sketchy, his figures ungainly and dumpy, they convey precisely the information that a costumier requires.

Not all artists produced such practical drawings. Matisse's designs for *Le Chant du rossignol* are highly prized, but Tamara Karsavina, who was dancing the Nightingale remembered '... the bewilderment of the costumier, who could not understand the intention of Matisse's sketch,

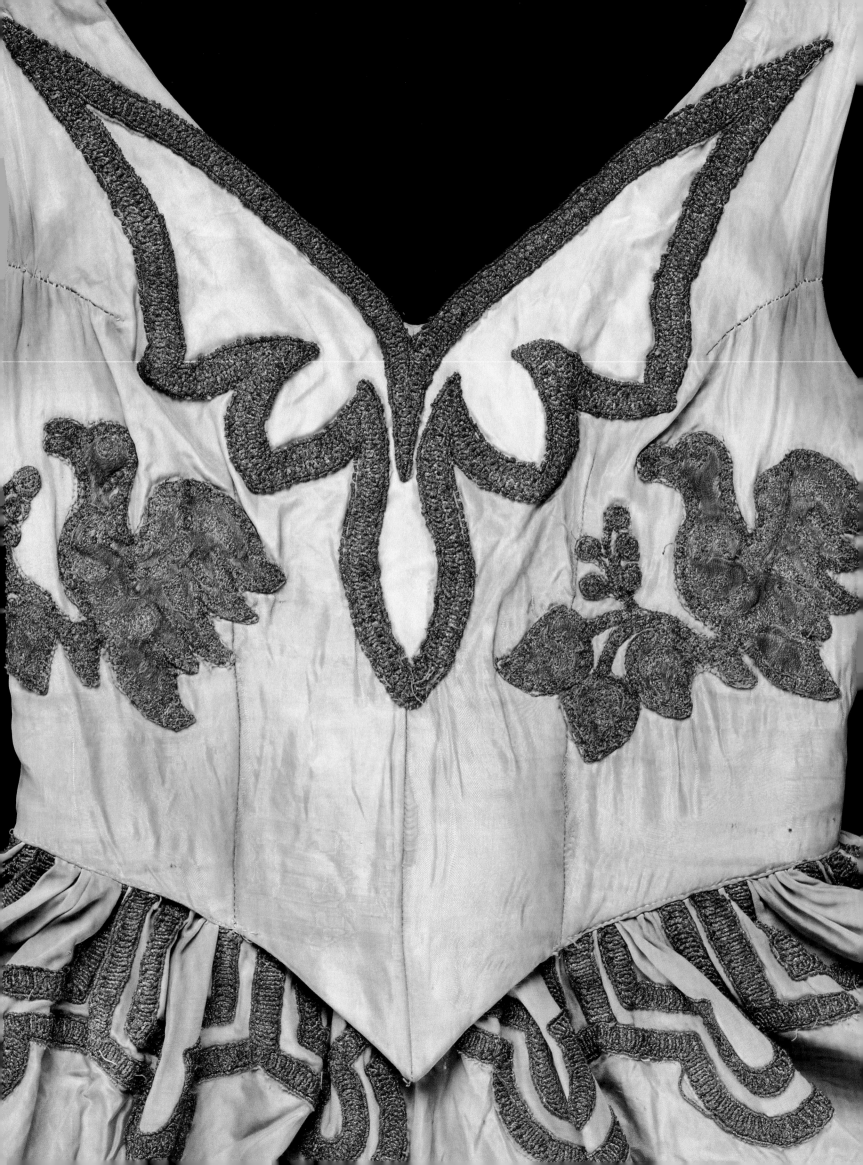

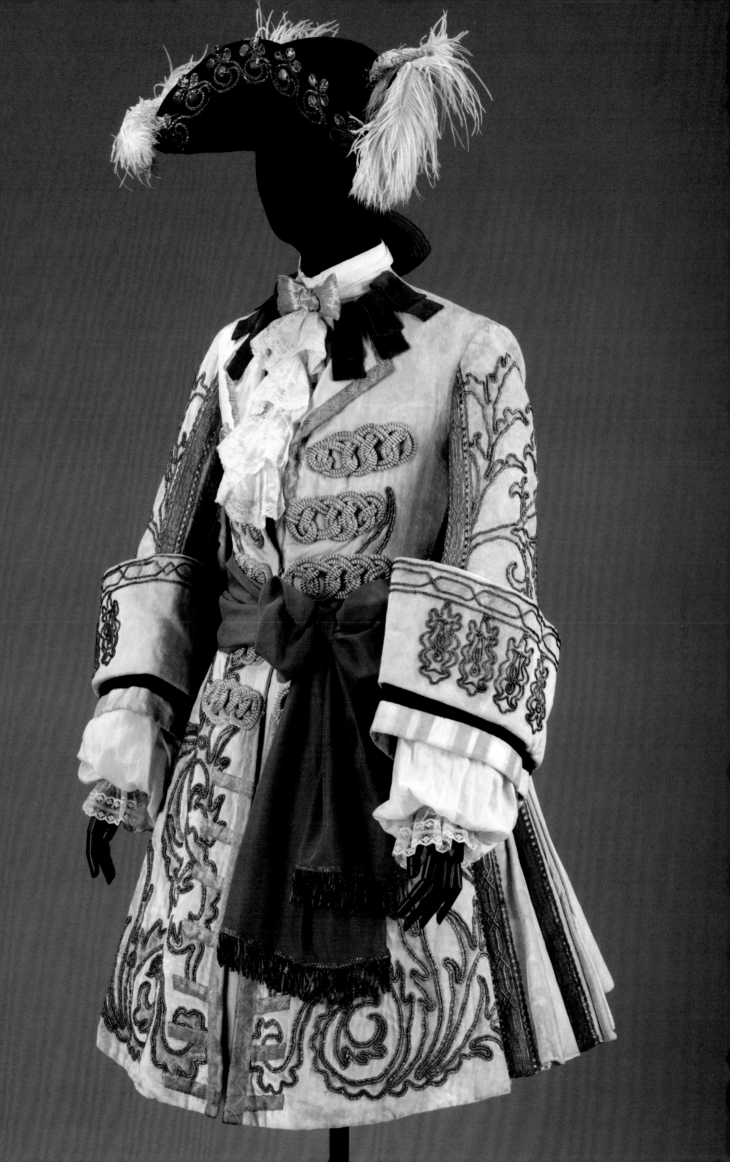

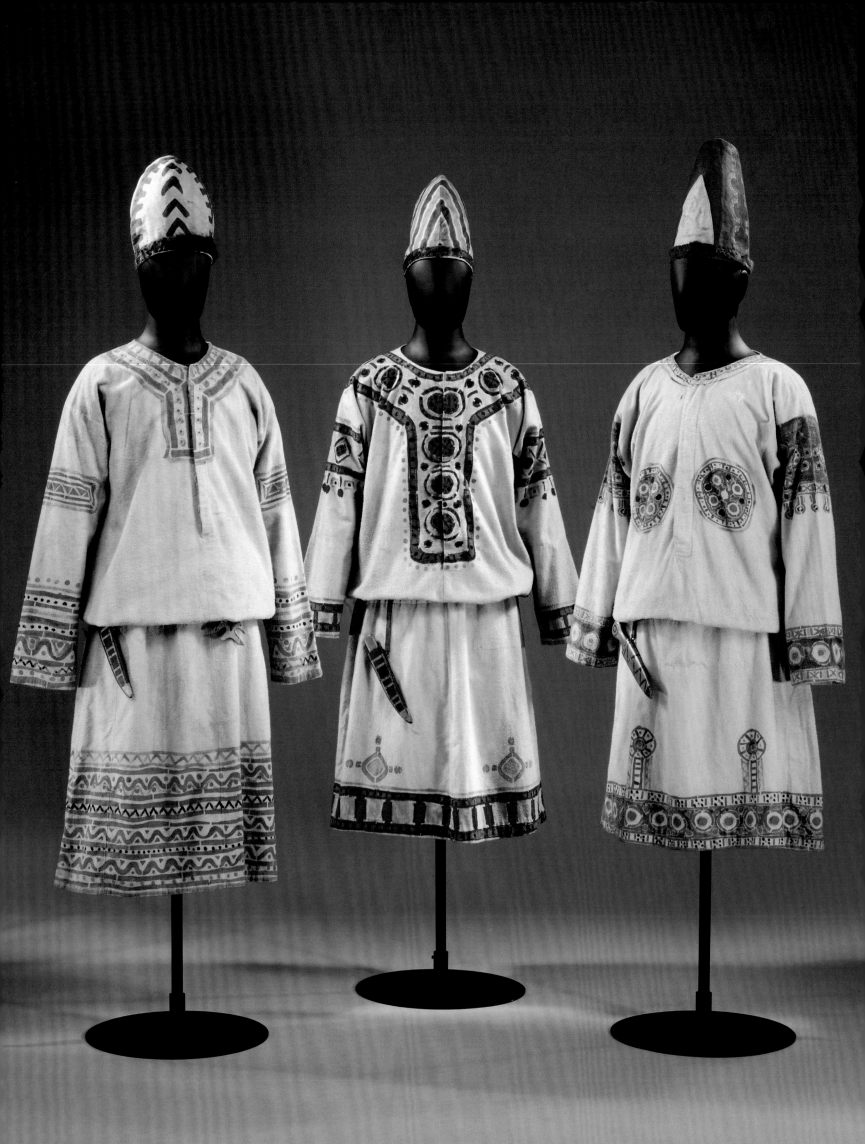

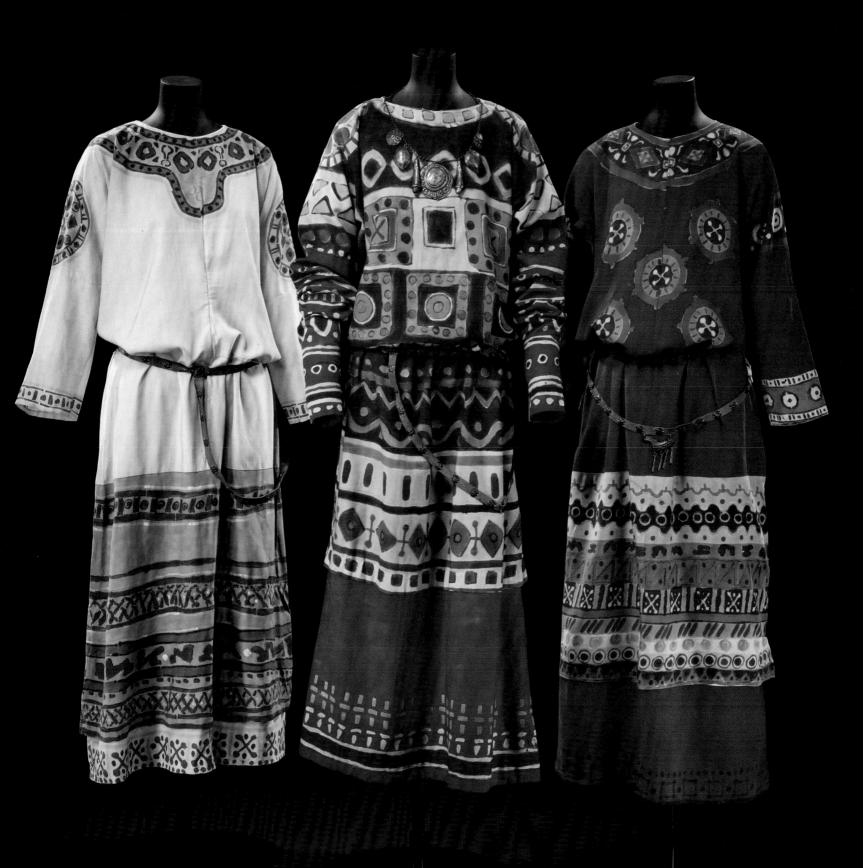

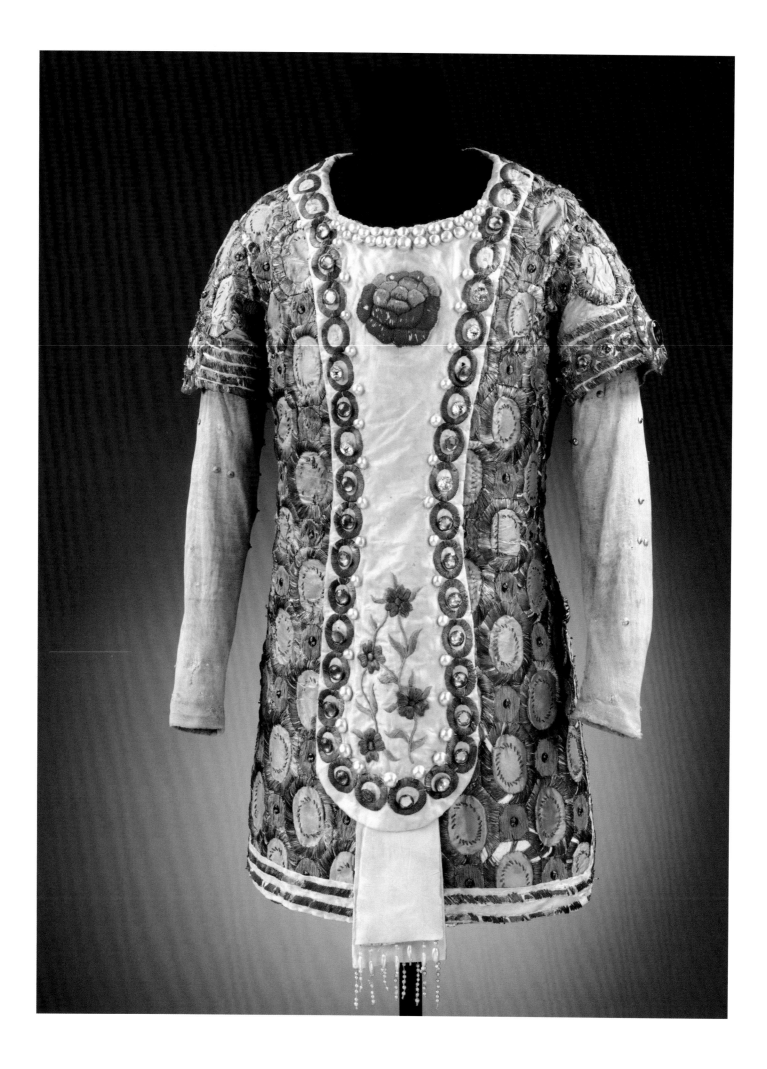

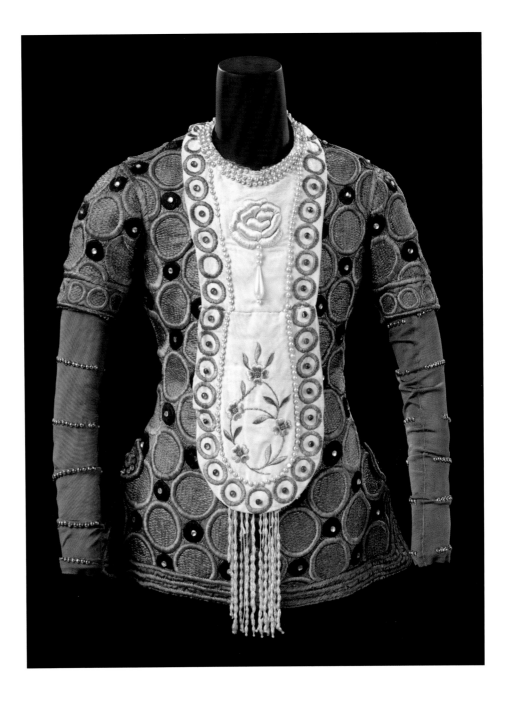

and the half-finished costume pinned in places, feathers moulting off me on the first night'.[4] He visualized each costume as part of a static stage picture, and was aghast when he realized that the dancers wearing them would be constantly moving and regrouping. Massine did, however, retain Matisse's idea for the finale, when the Emperor, restored to life, stands up and his black mantle, lined with vermilion, flows dramatically across the stage.

Two surviving costumes designed by Bakst for a male dancer in *L'Oiseau d'or* show how different makers can interpret the same design. One costume (pl.83), which was probably made in Russia, is more exuberant, less refined and inhibited, and the ovals, which cover the costume, are embroidered in gold metal strip. The other (pl.84), which may have been made in Paris or London, is more elegant,

with the ovals executed in a deeper gold thread. Both are legitimate interpretations.

Making theatre costumes is a different skill from dressmaking. Costumiers need the imagination to see drawings on paper as a finished costume, the ingenuity to translate the fine detail into bold decoration which will register at a distance, and the ability to construct a garment that will withstand the stresses and strains of the choreography, as well as the rigours of touring. They also have to work out the back of the costume, as most designs show only the front,[5] as well as how to execute the decoration – appliqué, embroidery, painting or stencilling. The Bayadère costumes from *Le Dieu bleu* (pl.85) display an astonishing range of techniques, including appliqué, painting and dyeing, embroidery using flossing, flocking, beading and metal studs.

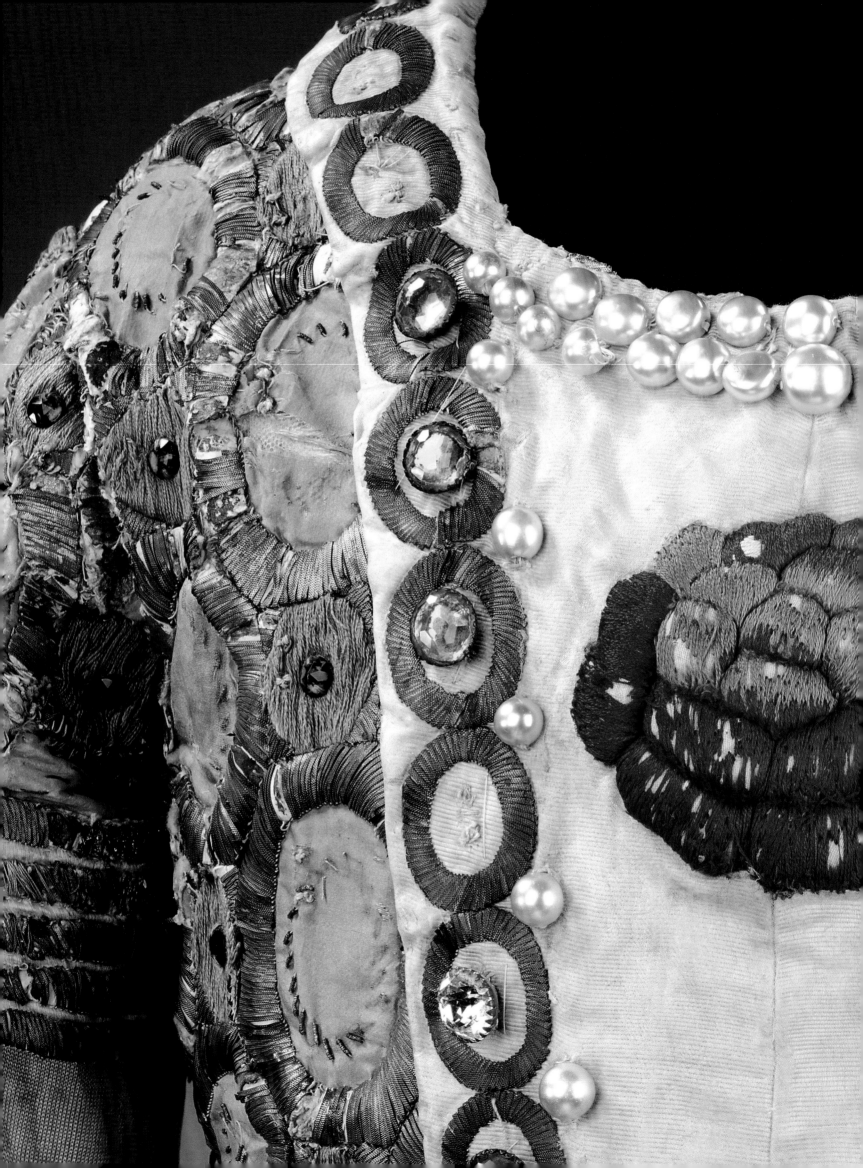

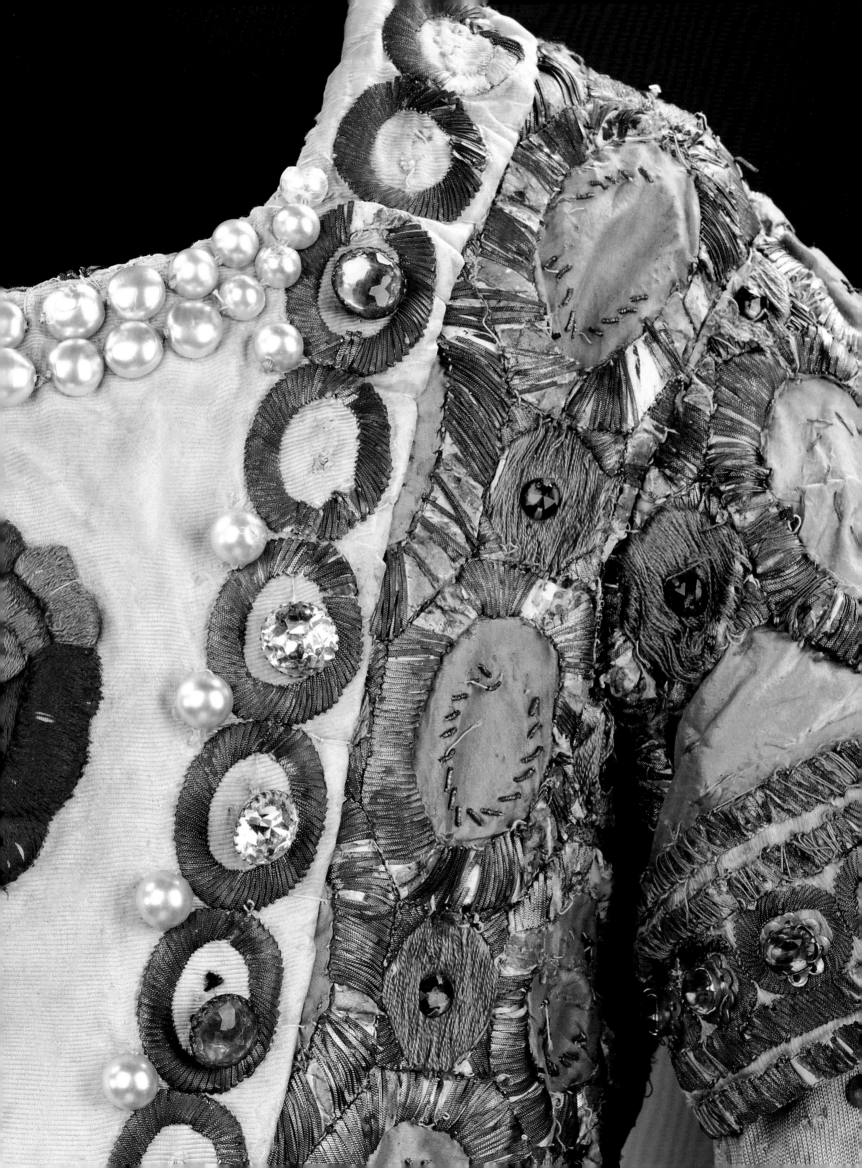

It is an indication of the Ballets Russes' financial buoyancy that this was only one of dozens of equally lavish and expensive costumes. Their cost often lies in the extravagance of the trimmings, such as the expensive *passementerie* on the court costumes in *The Sleeping Princess* or the gold acorn weights on the nymphs in *Narcisse*.

Painted decoration was an alternative to appliqué or embroidery, sometimes mimicking a patterned fabric, as on the courtly costumes in *The Sleeping Princess* and *Le Chant du rossignol*. André Derain took the technique a step further in *La Boutique fantasque*, using it to define structure by painting scallops on the skirts of the Russian Girls, achieving the effect of ruching without the bulk.

Creating Bakst's extravagant and sensuous costumes required a bolder approach than Benois's more precise creations. Massine's early choreography had an energy and childlike exuberance, which found its visual expression in Natalia Goncharova and Mikhail Larionov's decorative, folklorique style for *Soleil de nuit*, with its bold, schematic

animal and plant forms, and stylized fantasy and playfulness. The ideal technique for realizing their vision was appliqué, using a diversity of fabrics to give visual richness on stage. The results were like illustrations from a child's picture book (pl.86).

The choice of fabrics and colour was vital – especially for Bakst, who used colour symbolically as well as decoratively. Fabrics range from authentic ethnic textiles to furnishing materials, expensive silk velvets and stamped linens to the cheapest cottons. Innovative materials, like American cloth, were used for the work clothes in *Le Pas d'acier*, while mica was perfect for the futuristic *La Chatte*. An inappropriate fabric could ruin the choreographic effect; although the flowing scarves in Bakst's designs for *Narcisse* appear filmy and delicate, lightweight fabrics are difficult to control so a fine wool was used. In *The Rite of Spring*, the obvious choice, given the strenuous choreography would seem to be cotton, but the women's costumes were made in a very fine wool and the men's in even heavier flannelette; not

Opposite
85. After Léon Bakst, skirt for a Bayadère from *Le Dieu bleu*, 1912 (detail).
V&A: S.622–1980

Right
86. After Mikhail Larionov, costume for the Snow Maiden added to Massine's ballet *Soleil de nuit*, 1918.
V&A: S.830(&A)–1981

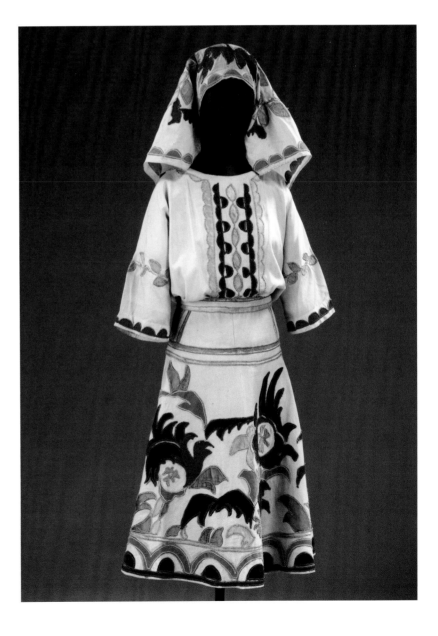

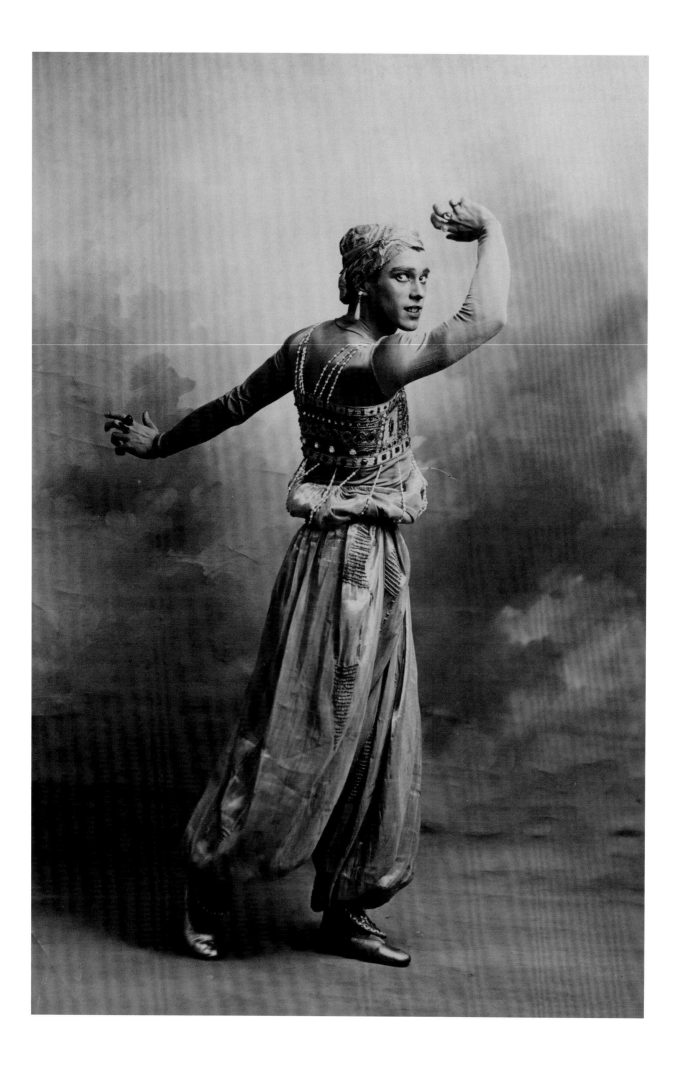

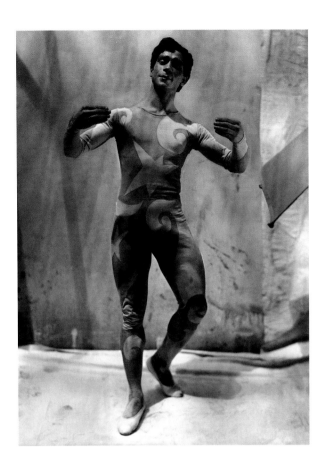

only was this more authentic, it also gave a greater weight to the movement. Most breathtaking of all are the silks used for the Polovtsian Girls in *Prince Igor* – authentic ethnic ikats woven in Uzbekistan – which Nicholas Roerich bought in the markets of St Petersburg.[6] The myriad weaves and colours intensified the power, energy, sensuousness and new freedom in Fokine's choreography, but the kaleidoscopic effect was lost in later remakings when ikat fabrics were no longer available.

Those who affect to despise costume point to the discrepancy between Bakst's designs for *Schéhérazade* and their realization. Hardly surprisingly, the completed costumes lack the eroticism that oozes from the designs, in which wisps of fabric barely cover breasts, thighs and body hair. In fact, the dancers in *Cléopâtre*, *Schéhérazade* and *Le Dieu bleu* were covered, neck to ankle, with prosaic silk for the principals and cotton for the corps de ballet. Although creases at elbows or knees are clearly visible on un-retouched photographs, on stage and in movement, audiences 'saw' bare flesh, as proved by the impact of *Cléopâtre* and the scandalous success of *Schéhérazade* (pl.87).

In 1909 this was a legacy of the Imperial Russian Ballet, where tights like gloves, with a 'finger' for each toe, discreetly concealed bare legs and feet. But it was also a practical solution to a practical problem. Fokine's ballets ran between 20 and 60 minutes, so the dancers appeared in three or four works every evening, each requiring a change not only of costume but also make-up. Covering arms and legs left only

face and hands to be made up, a boon since this consisted of greasepaint and few theatres had adequate washing facilities. Costume inventories reveal that differently toned all-overs were integral to the design. In *Cléopâtre* Nijinsky's fleshings were grey silk, those of the Male Egyptians, Servants and Slaves chestnut-coloured cotton, Amoun's were hazel-coloured silk, the Priest and Female Slaves' 'yellowish' silk, the Priestesses' olive silk, and the Negroes' dark grey cotton.[7] In *Le Dieu bleu* tones included blue-black, olive-black and brown-olive. However, by autumn 1912 the boundaries had changed and although bare midriffs were still built into costumes, legs and arms were uncovered. Diaghilev ignored the dancers' protests.

During the Ballets Russes' lifetime, fleshings evolved into a costume in their own right. Decorating body-tights was a new technique, and makers soon realized that, to avoid distortion, designs had to be applied while the dancer was wearing the costume. Bakst discovered this for himself at the dress rehearsal of *Le Spectre de la rose*; he and Diaghilev stood over dressmaker Maria Stepanova as she removed and redistributed all of the petals while Nijinsky was still wearing the costume. In *L'Après-midi d'un faune*, the tights and body were painted with patches which overlapped fabric and skin. Sometimes the designer executed the painting – Picasso painted the whorls and stars on the Acrobats in *Parade* (pl.88), and Georges Braque the flowers on Flore's tights and bodice in *Zéphire et Flore*. For *Ode*, Pavel Tchelitchev designed unadorned white leotards and tights, the hair

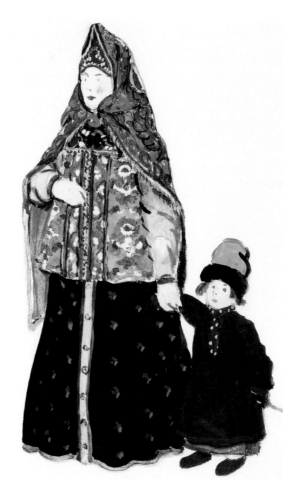

89. Léon Woizikovsky
as the Golfer with Lydia
Sokolova as La Perlouse
from *Le Train bleu*, 1924.
Photograph by Sasha.
V&A: Theatre &
Performance Collections

90. Alexandre Benois,
costume design for a
Peasant and Child from
Petrushka. Watercolour
on paper, 1911.
V&A: S.554–2009

covered by close-fitting white helmets, transforming the dancers into abstract sculptures.

Ballets reflecting society and contemporary themes posed the challenge described by Karsavina as reconciling the 'so often jarring, incompatibility of the balletic and the secular elements'.[8] *Jeux*, based on an episode during a game of tennis, created a stir in 1913 as the first 'contemporary' ballet, in which the women wore fashionable jumpers and skirts supplied by the couturier Paquin when Bakst's costumes were judged unsuitable. However, couturiers did not always appreciate the importance of adapting clothes to accommodate the choreography. In 1924, Chanel dressed *Le Train bleu* from her current collection. Her knitted swimsuits were potentially dangerous as their loose fit made it difficult for Léon Woizikovsky, as the Golfer, to get a firm grip on his partner in the complex throws and catches devised by Bronislava Nijinska. Lydia Sokolova, as La Perlouse, was given fake pearl stud earrings, which became the fashion accessories of the decade but were

unsuitable for stage wear, and so heavy that she could hardly hear the music. Chanel also forgot about shoes, so Sokolova chose rubber bathing slippers, which, not surprisingly, were most uncomfortable to dance in (pl.89).

On the whole, the artists, even those new to stage design, did not make the same mistakes. Picasso gave the American Girl in *Parade* a smart blazer and easy-to-move-in pleated skirt; for *Les Biches* Marie Laurencin created simplified 1920s dresses, executed in chiffons to reflect the superficiality and flightiness of the flappers, while the Hostess' heavier lace dress and rows of pearls indicated a greater sophistication.

In the theatre, everything changes with time. Existing costumes were occasionally modified in line with prevailing fashion. When *Narcisse* was briefly revived in 1924, the ankle-length tunics from 1911 looked dowdy and old-fashioned in a world of short, tubular dresses, so the skirts were shortened. Updating had to be applied with caution, however: in 1926 Natalia Goncharova gave the *Firebird* Princesses fashionable shorter hair, making nonsense of the

original hair-brushing movement. Occasionally, a costume was reinvented – for example De Chirico's up-to-date Sylph in *Le Bal*, wore a costume akin to that of *Les Sylphides*, but with eccentric, surreal wings.

Petrushka was a rarity – a ballet showing the lives of ordinary people enjoying themselves at the traditional Butterweek Fair. Benois's costumes establish at a glance the social level or occupation of each individual, whether peasant, middle class, upper class, nursemaid, stable boy, rich merchant or drunkard (pl.90). From this background emerge the colourful fairground characters – an organ grinder, gypsies, street dancers, various showmen – all of whom set the scene for the exotic, fantastical Showman and the tawdry brightness of the puppets.

Theatre is fluid, but the records are not. Production changes are only intermittently recorded and most writings are based on rehearsal images and records of first nights. Photographs of *Apollon musagète*, taken during the 1928 seasons in Paris and London, show the Muses wearing Chanel-designed knee-length tarlatan skirts with pleated bodices and fitted flower-strewn 'bathing-cap' headdresses (pl.91). These were already replacements for the original André Bauchant Greek tunics, which Diaghilev had rejected, and were themselves jettisoned in 1929, when Chanel produced beautifully flattering jersey Grecian tunics fastened with ties.

How practical were the costumes in performance? Assessing evidence is difficult, as dancers always complain that everything is too heavy or cumbersome. Anything on the head obstructs movement and destroys the line of the head and neck, while wigs are hot and tight. Likewise, they object to the minutest amount of hip padding and surreptitiously remove bones from bodices. Many of Diaghilev's dancers came from traditional state theatres where conventional costuming was still the rule. They had difficulty adjusting to appearing in several works in an evening, each with its own costume and make-up, besides constantly adapting to different stages.

Bronislava Nijinska described the problems. Having mastered the fast, turning solo for Papillon in *Carnaval* in rehearsal, she then tried it in costume and found that she had to dance even more quickly to counteract the drag of the crinoline skirt. She added:

> When I tried to dance my Papillon for the first time onstage in Paris, in costume, I discovered that I had to increase my speed as I circled the stage to hold a precarious balance at a forty-five-degree angle. With the slightest deviation I would fall over, and so I had to do my dance time and time again until finally I had mastered the effect of the incline and was dancing the Papillon on the outermost point of this equilibrium, which contributed so much to my speed, lightness, and freedom of movement.[9]

An unstable or uncomfortable costume could have a detrimental effect on performances. Larionov's painted

designs for *Soleil de nuit* were charming, but the costumes were thick and padded, with kokoshnik headdresses that slipped and were then impossible to adjust. As Sokolova remarked: 'if our movements had been less hampered we could have danced with as much enthusiasm as we did in *Prince Igor*.'[10] In *Le Bal*, the dancers found it difficult to dance the fast, syncopated tarantella with the necessary speed, weighed down as they were by De Chirico's heavy costumes.

Lopokova remembered the aching misery of mastering the positions Massine demanded in *The Good-Humoured Ladies*: 'the knee was always bent and the arms akimbo – the limbs never in a straight line.'[11] Then she saw Bakst's padded, boned eighteenth-century style costume. 'We felt like rugby football players dressed as Eskimos pretending to be the most elegant and dainty females of the eighteenth century.'[12] She also had problems manipulating the can-can costume in *La Boutique fantasque* to give the impression that the heavy lace underskirts were a mass of froth (pl.105).

Some costumes could be positively dangerous, like Chanel's *Train bleu* swimsuits. José-Maria Sert's enormous costumes for *Las Meninas* (the skirts were twice the length of arms and the wigs twice width of shoulders) looked wonderful on stage, but the iron hoops supporting the vast panniers cut into the dancers' shins, making them bleed. Others were simply too cumbersome. The wicker and buckram extensions of the *Chout* costumes swamped the choreography, although they could hardly be seen against the violently coloured Rayonniste scenery with elements 'hurtling rhapsodically through the air in a way which suggests some of the ecstatic pictures of Chagall'.[13]

Usually the dancers came to accept the costumes and their relation to the choreography, although this was no consolation to the barefooted Bacchante in *Narcisse*, manipulating a scarf, cup and jug props while stifling under a red wig. In *Ode*, the dancers felt horribly exposed in Tchelitchev's all-revealing white, unadorned leotards and tights, but Danilova admitted that they were appropriate for the shifting geometrical patterns of Massine's choreography: 'many of the lifts, for instance, would have looked vulgar in a tutu, with the partner's hand visible between the ballerina's legs...'[14]

Dancing in *The Rite of Spring* was always a disagreeable experience – Nijinsky's energetic choreography, the wool and flannel costumes, so many dancers packed together on stage, sweating with exertion, excitement and fear, generated heat like a furnace. Adding to the unpleasantness was the overpowering smell of hot, damp wool. When the original costumes were reused in Massine's *Rite of Spring* in 1920, the dance of the Chosen Maiden was so strenuous that the wool dress had to be replaced by one in silk, and instead of wearing the heavy wig, Lydia Sokolova wore her own hair stitched down with criss-cross tacking stitches.

That a generation of Russian and European painters produced not just memorable but also practical theatrical costumes was largely due to Diaghilev's understanding of what would work on stage and his constant vigilance during

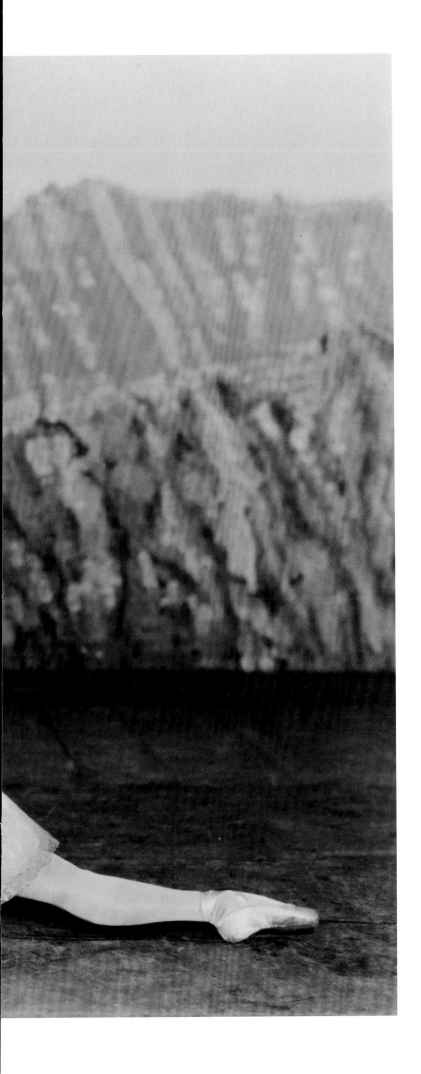

the design process.[15] Some were more successful than others. Although Sert's *Las Meninas* was stunning, Sokolova judged his lead costumes in *Cimarosiana* – decorated with loosely fixed pom-poms and tassels which never bounced on the beat – as the most unattractive she had ever worn. Georges Braque generally got the thumbs down for his unflattering sludge-coloured, unwieldy costume for *Les Fâcheux* and dresses for the Muses in *Zéphire et Flore*, which, according to Alexandra Danilova 'were awful – wool dresses with drop waists that made us look as if we were wearing burlap sacks'.[16] However, he made amends with a delicious costume for Alice Nikitina as Flore, flattering her typically 1920s androgynous figure with an upwards curving neckline, voluminous chiffon cap sleeves to soften the arms and a little half-tutu to give shape at the back.

The design revolution extended to make-up and each costume and character now had an individual look. Nijinsky's make-up was key to his interpretation, and observers related how he became transformed into the character as the make-up went on. Benois marvelled at Bakst's transformation of the dancers in *Schéhérazade* 'to make them creations of his own. Although I knew every performer well, I could recognize none of them in this performance – and this not only from the distance of the auditorium, but also from the proximity of the stage...'[17]

Benois supervised Tamara Karsavina's make-up as the Ballerina in *Petrushka*, which included a red spot on each cheek and eyes outlined to create a doll-like vacancy. Bakst made a detailed sketch for each character in *The Good-Humoured Ladies*, showing the snub noses and curlicued eyebrows, and when in the theatre would add a star, crescent or 'wiggle' to each dancer. Nijinska in *The Sleeping Princess* wore a fantastical make-up with bee-stung lips. For Death in *Le Chant du rossignol*, Matisse experimented on Lydia Sokolova, using illustrations of original Chinese theatrical face paint, before settling on a red foundation to match the costume with white gashes down the cheeks, a black slit for the mouth and slanting black eyes and eyebrows.

Glamour was no longer the aim. For Kikimora (pls 92 and 93), the Russian witch of folklore in *Contes Russes*, Larionov designed one of his most outlandish and repellent costumes, a stained, patched blouse and skirt with gaudy red

91. Serge Lifar and Alexandra Danilova in *Apollon musagète*, 1928. Photograph by Sasha. This shows the first version of the costumes designed by Coco Chanel. Serge Lifar, as Apollo, wore a red tunic with gold accessories; Alexandra Danilova, as Terpsichore, wore a pale mauve tutu and headdress. V&A: Theatre & Performance Collections

92. Bronislava Nijinska
as Kikimora from *Contes
Russes*, 1922.
Photograph by Man Ray

93. Mikhail Larionov,
make-up design for
Kikimora from *Contes
Russes*, 1919.
V&A: S.199–2008

stockings, a wig of matted hair, and the face reduced to three vertical strips, with the contrasting horizontal slash of bared teeth (pl.93). When Nikitina did her standard elaborate make-up in *Barabau*, Diaghilev reprimanded her: 'You're a peasant – and you have stuck false lashes on your eyes. Go and take them off. I want your hands to stink of garlic from afar.'[18]

With even principals dancing several roles in an evening, the process of reapplying make-up was a race against the interval clock. Sokolova once danced Ta-Hor in *Cléopâtre* (face, shoulder, arm and leg make-up, bare feet and black wig), followed by the Girl in *Le Spectre de la rose* (demure Victorian maiden): 'Tired and hot, I had to undo the thirty safety-pins with which my long, thick sash was fixed tightly around me. I was standing in a hot bath, scrubbing the brown make-up and dirt off my feet and legs, when the stage manager flew into my dressing-room.' He told her to re-dress and take another call. 'How I got myself cleaned up or put on the new white make-up with tights and ballet shoes, in order to open *Spectre* looking like a débutante radiant after her first ball, I simply do not know. It is the sort of thing that still happens to me in nightmares.'[19] All while trying to mentally shed one character and assume another.

In establishing his own company, Diaghilev lost access to the workshops and wardrobe that supported the Imperial Theatres on which he had relied for the early seasons. Costumes were usually made in London, Paris or Monte Carlo, but suppliers for the day-to-day running wardrobe had to be found everywhere, as did laundries for daily washing of hundreds of towels, tights, shirts and tunics. The only permanent staff consisted of a wardrobe-mistress and her assistant, so temporary seamstresses were taken on in each venue. Every garment was inspected, repairs were made and costumes that needed dry-cleaning were identified. Then began the endless chore of ironing hundreds of costumes as they came out of the travelling skips. Few costumes were duplicated, so any cast change meant altering the existing costume. Excess baggage costs were a major drain on company finances; in 1926 nearly a thousand costumes were toured, including 150 for *The Firebird*, 100 for *Petrushka*, 65 for *Children's Tales*, 60 for *Prince Igor*, 70 for *Aurora's Wedding* and 150 for *Le Chant du rossignol* (pl.94).[20] A century on, hurried repairs in the wings have been replaced by conservation, often taking hundreds of hours at a cost that would have mounted a small ballet for Diaghilev.

Régisseur Serge Grigoriev kept an eagle eye on the wardrobe, evaluating the condition of the costumes and deciding whether replacement was really necessary or if a costume could be adapted from one in store. When a Nymph in *L'Après-midi d'un faune* pleaded that her costume was so ragged she would soon be appearing naked, Grigoriev merely observed 'That will be charming, Madame.' What he said when a costume had to be remade because a dancer had given the original to an admirer is not recorded, even though it ensured the survival of Lydia Lopokova's Can-Can (pl.105) and *Les Sylphides* costumes, both given to the dance historian Cyril Beaumont.

Diaghilev's dictum that the audience must only see perfection depended on his own vigilance and that of his backstage staff. Each dancer was checked before going on stage and was fined for any changes to the costume and make-up or for wearing unsuitable jewellery. In the 1920s, Chanel and Misia Sert also acted as arbiters of taste, scrutinizing the costumes, deciding whether a tutu was the correct length, whether colours were right, whether trims should be added or removed, but always testing the costume in movement before making a final decision.

Although now divorced from the movement for which they were created, the Diaghilev ballet costumes have a poignancy and emotional force that bring us closer to the performing life of the company than any other remaining artefacts. Designers and makers never thought of the long term when creating the costumes; their horizon was bounded by the first night and the hope that the ballet would be a success. They never dreamed that their work would feed back into live performance, both as an inspiration to generations of theatre designers, and studied by costumiers remaking the costumes for those ballets still in the repertory. Nor that, a hundred years later, they would still influence fashion. Above all, they could never have foreseen that the costumes, independent of the choreography, would become stars of numerous exhibitions and revered as works of art: at once a memorial to the past and an inspiration to the future.

95. After Henri Matisse,
costume for a Courtier
from *Le Chant du*
rossignol. Satin with
gold studs, paint and
gold braid, 1920.
V&A: S.745–1980

Opposite
96. After Henri Matisse,
costume for a Mourner
from *Le Chant du*
rossignol. Wool felt
and velvet, 1920.
V&A: S.750–1980

Overleaf, left
97. After Natalia
Goncharova, costume worn
by Adolph Bolm as the Prince
from *Sadko*. Cotton velvet,
silk satin with 'essence
d'orient' pearls, 1916.
V&A: S.740(&A)–1980

Overleaf, right
98. After Natalia
Goncharova, costume worn
by Doris Faithful as the Sea
Princess from *Sadko*. Silk
satin with appliquéd
sequins, tissue and metal,
raffia plaits, 1916.
V&A: S.741(&A,B)–1980

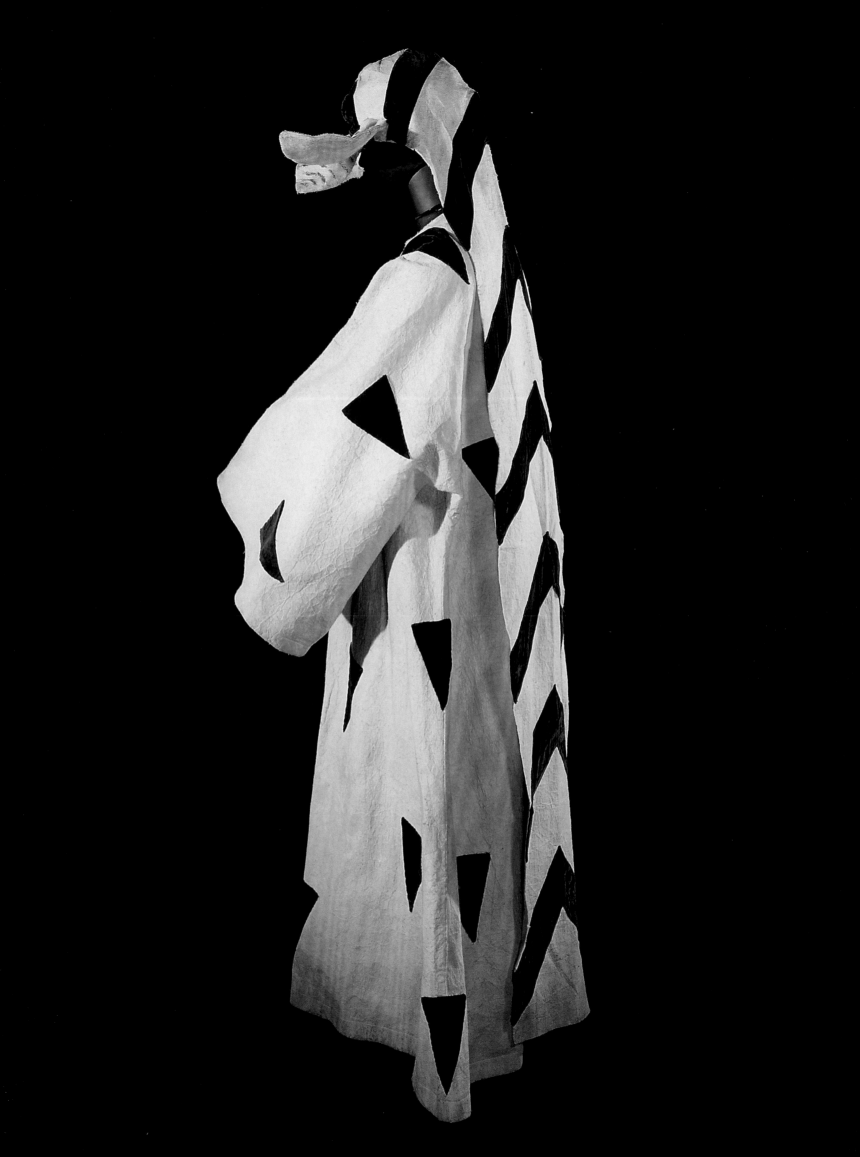

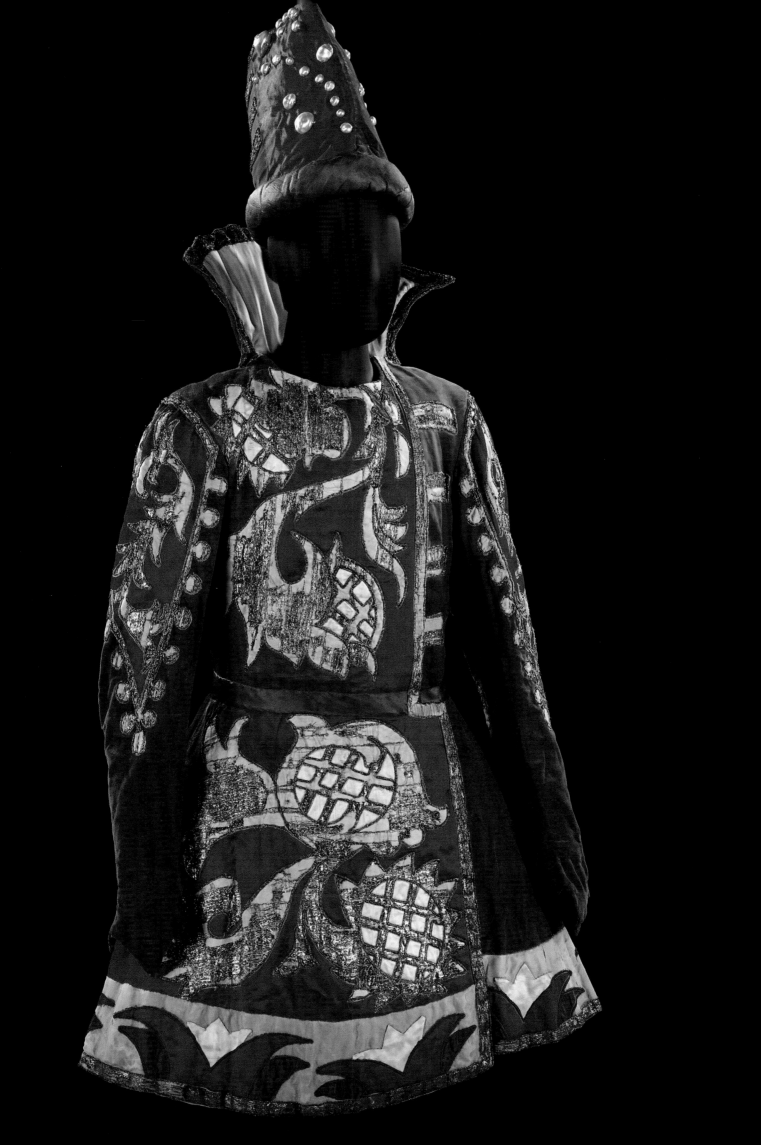

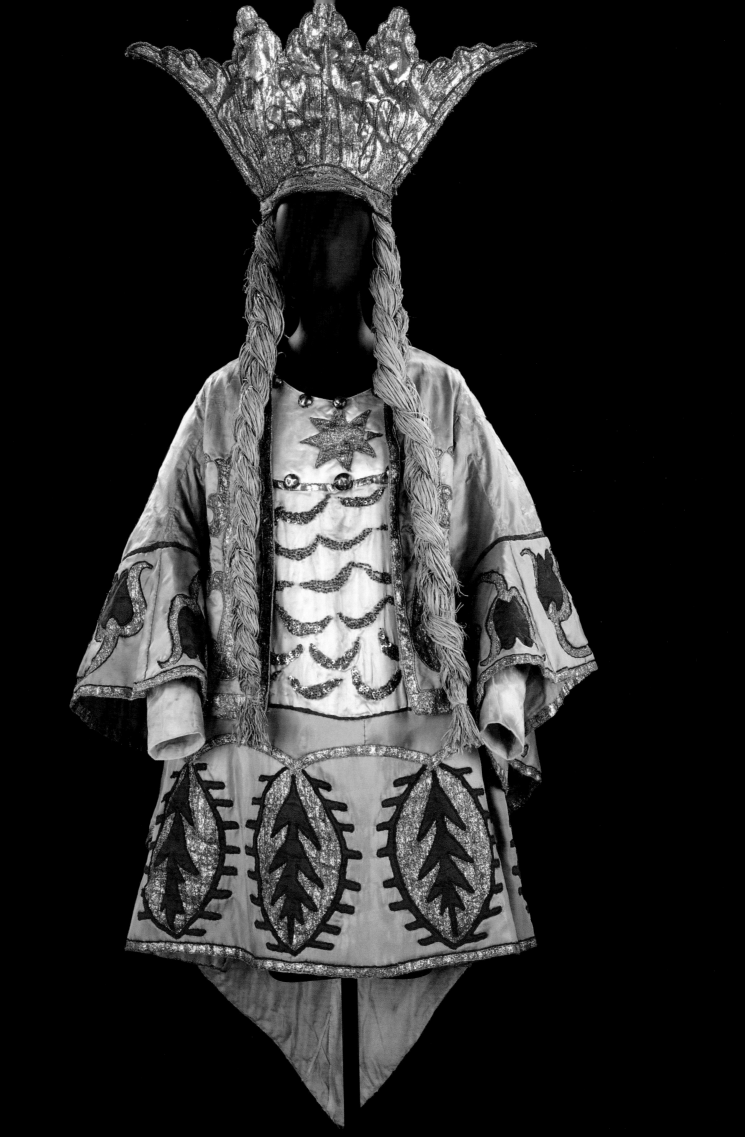

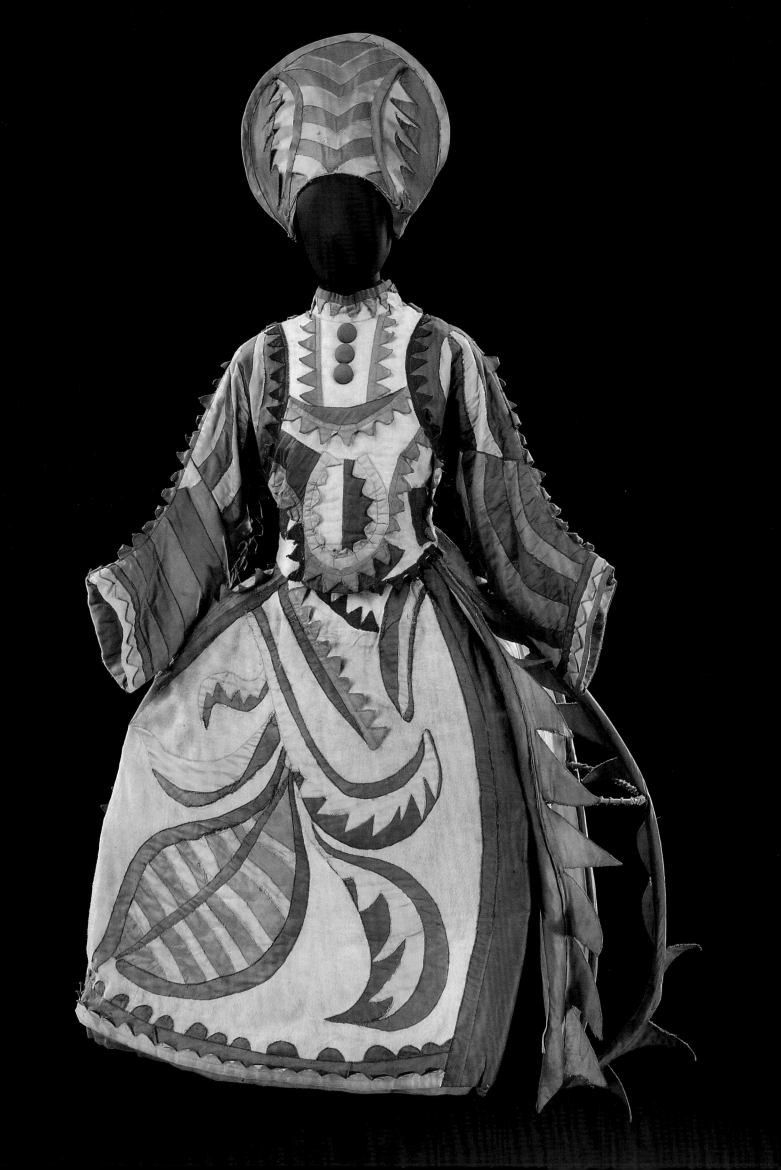

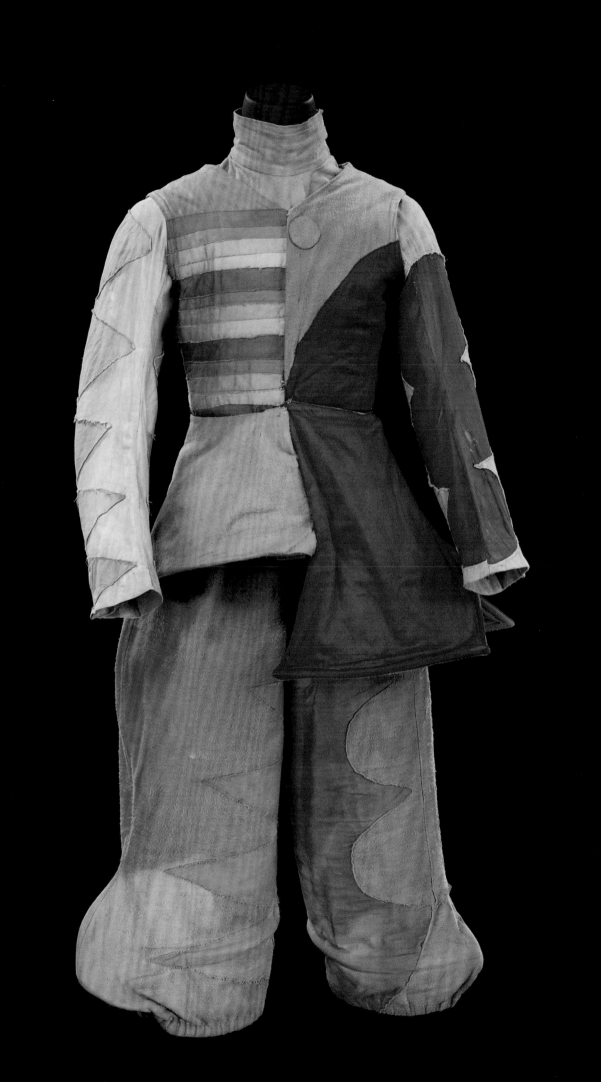

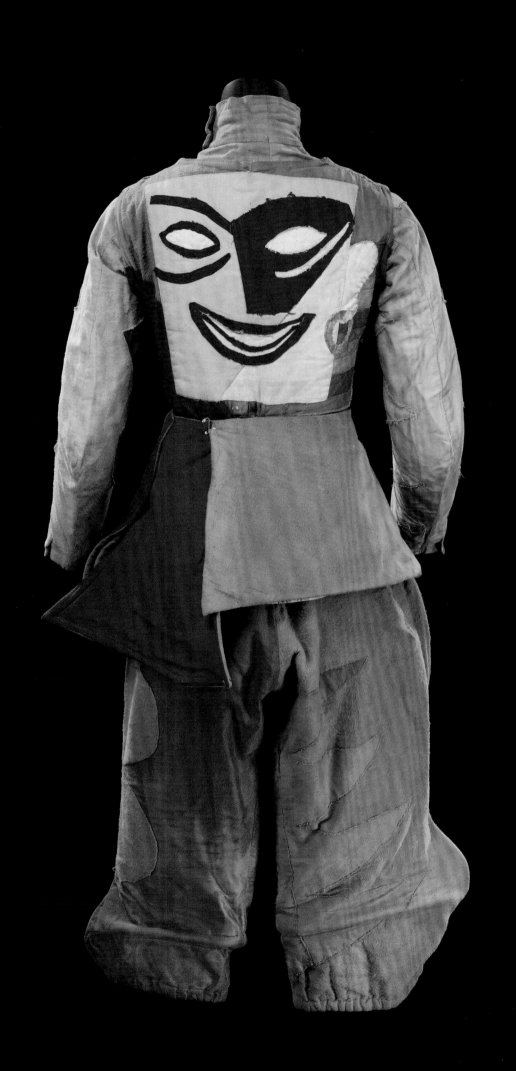

Previous pages, left
99. After Mikhail
Larionov, costume for
the Buffoon's Wife from
Chout. Cane-stiffened
felt and cotton, 1921.
V&A: S.762(&A,B)–1980

Previous pages, right
100. After Mikhail
Larionov, costume for the
Buffoon from *Chout*. Steel-
and cane-stiffened felt
and cotton, 1921.
V&A: S.761(&B,C)–1980

Opposite
101. After Mikhail
Larionov, costume for
the Buffoon from *Chout*
(reverse). Steel- and
cane-stiffened felt and
cotton, 1921.
V&A: S.761(&B,C)–1980

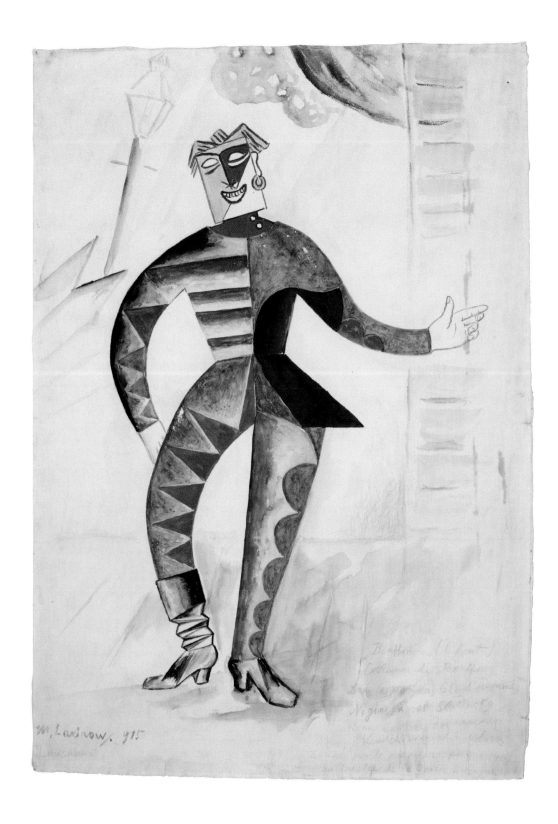

102. Mikhail Larionov,
design for the Buffoon from
Chout. Watercolour and
body-colours on paper, 1915.
When the costume was
made the mask was moved
to the dancer's back – rather
than covering his face.
V&A: E.283–1961

103. Léon Bakst, design
for the Fairy of Wisdom.
Gouache and pencil on
card, 1921.
This design is heavily
annotated with instructions
for the costumiers, however
there was no Fairy of
Wisdom in the Ballets
Russes production of
The Sleeping Princess.
Private collection

Opposite
104. After Léon Bakst,
costume for a Duchess
from *The Sleeping
Princess* (Scene III,
Hunting Scene), 1921.
V&A: S.799(&B)–1980;
S.800A–1980

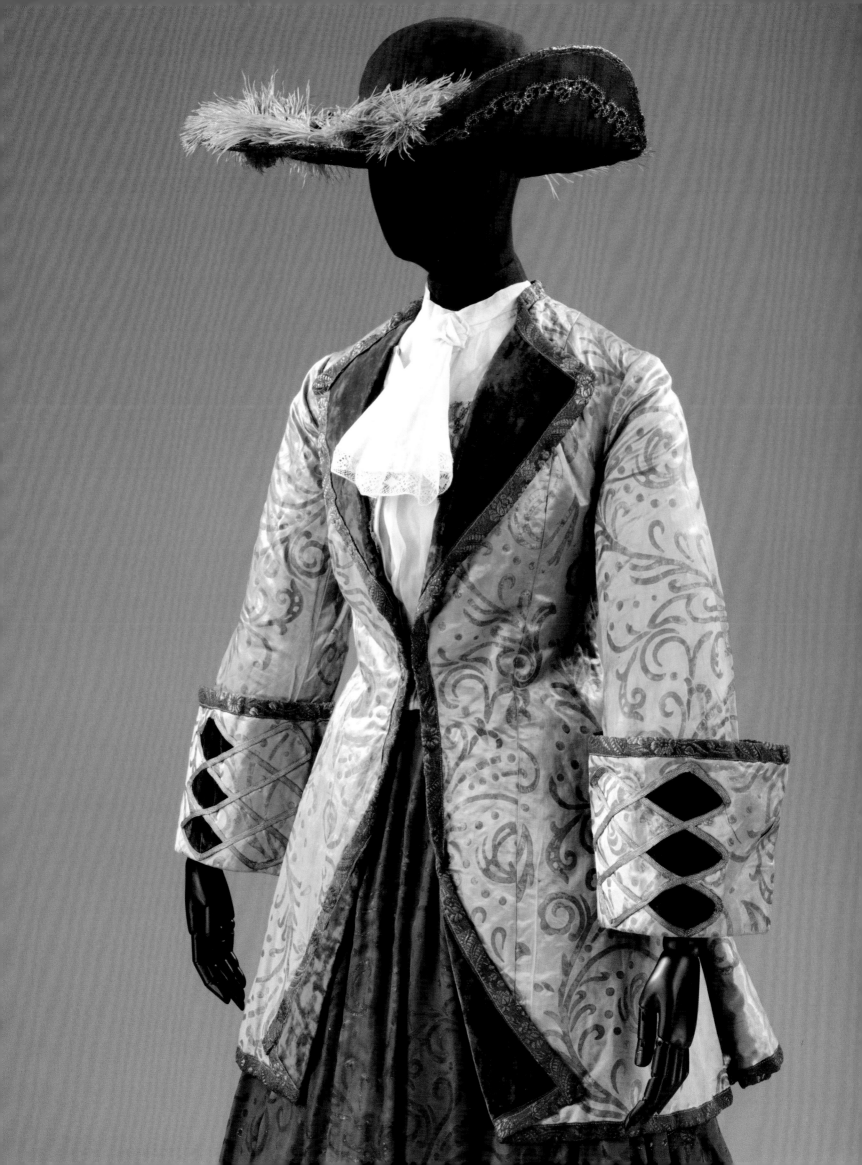

105. After André Derain,
costume worn by Lydia
Lopokova as the
Can-Can Dancer from
La Boutique fantasque,
1919 (with detail).
V&A: S.877–1980

DIAGHILEV AND CHANEL
Keith Lodwick

Coco Chanel was introduced to Diaghilev after the First World War by their mutual friend, Misia Sert. Chanel provided a home for Igor Stravinsky and his family at her house in Garches, near Paris, enabling him to complete the score for *Pulcinella*. She also sponsored the 1920 revival of Stravinsky's *The Rite of Spring*, with new choreography by Léonide Massine, donating a gift of three hundred thousand francs on the condition that no one should know she was the benefactor.

In the 1920s Chanel joined Diaghilev's inner circle of advisers, and he turned to her whenever he was unhappy with costumes designed, or needed a truly contemporary approach. Most famously Chanel provided the outfits (clothes rather than costumes) for the Jean Cocteau/Bronislava Nijinska ballet *Le Train bleu*. The ballet was named for France's luxurious Paris-Riviera express and concerned the fashionable sports of tennis, golf and sea bathing. With *Le Train bleu*, Chanel became a fully-fledged artistic collaborator, designing all the costumes and conferring upon the ballet an air of smart contemporaneity that perfectly suited its theme.

For the Tennis Champion, based on the great tennis star Suzanne Lenglen, Chanel designed a dapper white

Lubov Tchernicheva as Calliope in *Apollon musagète*, 1929. Photograph by Vladimir Dimitriev. This shows the second version of the costumes for the Muses by Chanel. *Dancing Times* archive

Alexandra Danilova in *The Gods Go A-begging*, 1928. Photograph by Sasha. V&A: Theatre & Performance Collections

sporting outfit complete with eyeshade and bandeau. For the Golfer, she specified a sweater and plus fours, an ensemble associated with the young Prince of Wales, later the Duke of Windsor. The rest of the cast wore striped, knitted bathing suits consisting of a pullover worn over the top of loose mid-thigh trunks. To complete the outfit of the bathing belle, Chanel added a head-hugging swimming cap, which soon became an essential part of beach attire, and large fake-pearl earrings. The light-hearted ballet or 'danced operetta' was premiered as part of the main event at the 1924 VIII Olympiad in Paris.

Chanel was asked to step in on a number of productions. To keep *Les Biches* absolutely up-to-date, when Felia Doubrovska took over the role of the stylish Hostess in 1927, Diaghilev sent her to Chanel for a new dress. Chanel designed the costumes for Alexandra Danilova in *The Gods Go A-Begging*, when Diaghilev was generally re-using those from *Les Tentations de la bergère* by Juan Gris (the ballets shared similar plots), and she gave a fresh look to costumes for the three Muses in *Apollon musagète* a year after the ballet's premiere. Her solution exemplified to perfection the simplicity that had taken her to the

top of her field. For each of the women she created a tricot tunic bound around the body in three places with elegant neckties from the House of Charvet.

Chanel worked for Diaghilev without seeking personal glory, and her final act for him demonstrates her kindness and generosity. In the summer of 1929, while cruising along the Dalmatian coast with Misia Sert on the Duke of Westminster's yacht, they received a message from Diaghilev summoning them to Venice. They found him dying at the Grand Hotel des Bains. After his death it was Chanel who paid for his funeral, including interment on the island of San Michele.

Felia Doubrovska as the Hostess in *Les Biches*, 1924. Houghton Library, Harvard Theatre Collection

Léon Woizikovsky, Lydia Sokolova, Bronislava Nijinska and Anton Dolin in *Le Train bleu* photographed on the set of *Baba Yaga* at the London Coliseum, December 1924. Photograph by Sasha. V&A: Theatre & Performance Collections

Lydia Sokolova arranging dancers from The Royal Ballet School in costumes from *Le Chant du rossignol* for the Sotheby's, London, auction, 1968. Photograph by Sotheby's Photo Studio. Collection of Thilo von Watzdorf

Sotheby's auction at the Scala Theatre, London, of the costume for Flore from *Zéphire et Flore* with the front cloth for *Le Train bleu* in the background, 1968. Photograph by Nesta MacDonald. V&A: Theatre & Performance Collections

DIAGHILEV UNDER THE HAMMER
Jane Pritchard

'Diaghilev fashions pop up' and 'How to cover yourself in history' were just two of the newspaper headlines in the years 1967 to 1973 which announced Sotheby's London auctions of sets and costumes created for the Ballets Russes.[1] Buyers 'eager for fresh fields' to collect, encouraged auction houses to diversify into selling everything from vintage motorcars to costumes from Diaghilev's ballets.[2]

The Ballets Russes auctions heralded celebrity sales as events in their own right. The first sale, held at 9pm on Tuesday 13 June 1967, was preceded by a succession of soirées, which were intended to woo survivors of the company to come forward with material for future sales as well as raise funds for charity. For the three first major sales of costumes Lydia

Sokolova, Diaghilev's British *premiere danseuse*, arranged groupings in which students of The Royal Ballet School modelled the costumes, striking poses from the ballets.

The 1967 sale was built round a few star items including Nijinsky's costumes from *Le Festin*, *Le Dieu bleu* and *Giselle*, and Sokolova's Hostess costume from *Les Biches*. Its success was significant, not least for the publicity it received; even the *Sun* newspaper published photographs of dancers modelling Picasso's costumes for the two acrobats in *Parade*, which were bought by the Bibliothèque nationale de France, Paris.[3]

This 'taster' sale encouraged Anthony Diamantidi, chairman of the Diaghilev and de Basil Ballet Foundation, to auction the sets and

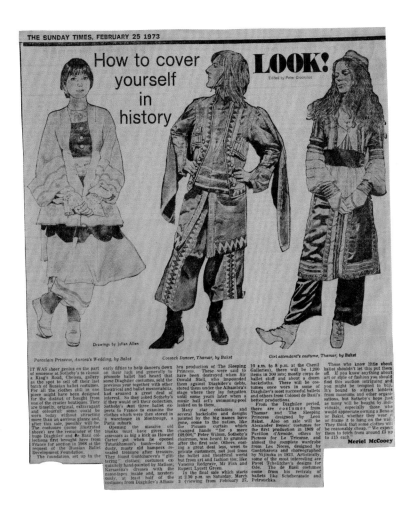

Meriel McCooey's article in the *Sunday Times*, 25 February 1973, previewing the sale at the Chenil Galleries, Chelsea, was illustrated with sketches of hippies dressed in the colourful costumes from *The Sleeping Princess* and *Thamar*.

Marie Rambert posing in Lubov Tchernicheva's costume from *Le Pas d'acier* at a preview for the Sotheby's, London, sale, 1967. Photograph by Nesta MacDonald. Private collection

costumes in its possession, stored for three decades in a Parisian suburb. The impact on those who sorted the material was compared to Howard Carter's opening of Tutankhamen's tomb, particularly when many of the costumes for *The Sleeping Princess*, long thought destroyed, were rediscovered. Three days of sales, from 16–18 July 1968, were devoted to the Ballets Russes. The first and third dealt with archives and drawings, designs and sculpture, but the second day, at the Scala Theatre, London, was devoted to the auction of set cloths and costumes. Memorably, students in costumes from *The Sleeping Princess* danced the polonaise from the ballet's final act and Richard Buckle acquired the '*Train bleu*' front cloth for the British nation.

Further sales were held on

19 December 1969 at Drury Lane (at which Natalia Goncharova's *Firebird* cloths were sold) and finally at the Chenil Galleries, Chelsea, on 3 March 1973 when almost a quarter of the sum raised came from bids placed by the 11-year-old Andrew Strauss, guided by his father, from the nascent National Gallery of Australia. Use of the Chenil Galleries, located among the fashionable boutiques of the King's Road, acknowledged that the costumes were not so different from clothes then on sale in 'swinging London' and many were bought to wear at parties.

Sales of Ballets Russes designs and ephemera became a regular feature in London and New York in the 1970s and 1980s, and there were two further significant costume sales. In 1983 Robin Howard sold, through Christie's,

the collection he had acquired in the earlier sales to help fund his Contemporary Dance Trust, and in 1995 the Castle Howard collection was also sold. Thanks to purchases from the 1960s sales, and the generosity of supporters buying on behalf of the proposed British Theatre Museum, the Theatre & Performance Collections at the V&A now posseses the world's largest holdings of Ballets Russes sets and costumes.

1 Timothy Giles and Valerie Knox, 'Diaghilev fashions pop up', *Sunday Times* (5 May 1986); Meriel McCooey, 'Look! How to cover yourself in history', *Sunday Times* (25 February 1973).
2 G.W., 'Dance and Drama in the Sale-Room', *Apollo* (October 1969), pp.356–60.
3 Katherine Castle, 'Picasso, When he was a Dress Designer', *Sun* (9 May 1967).

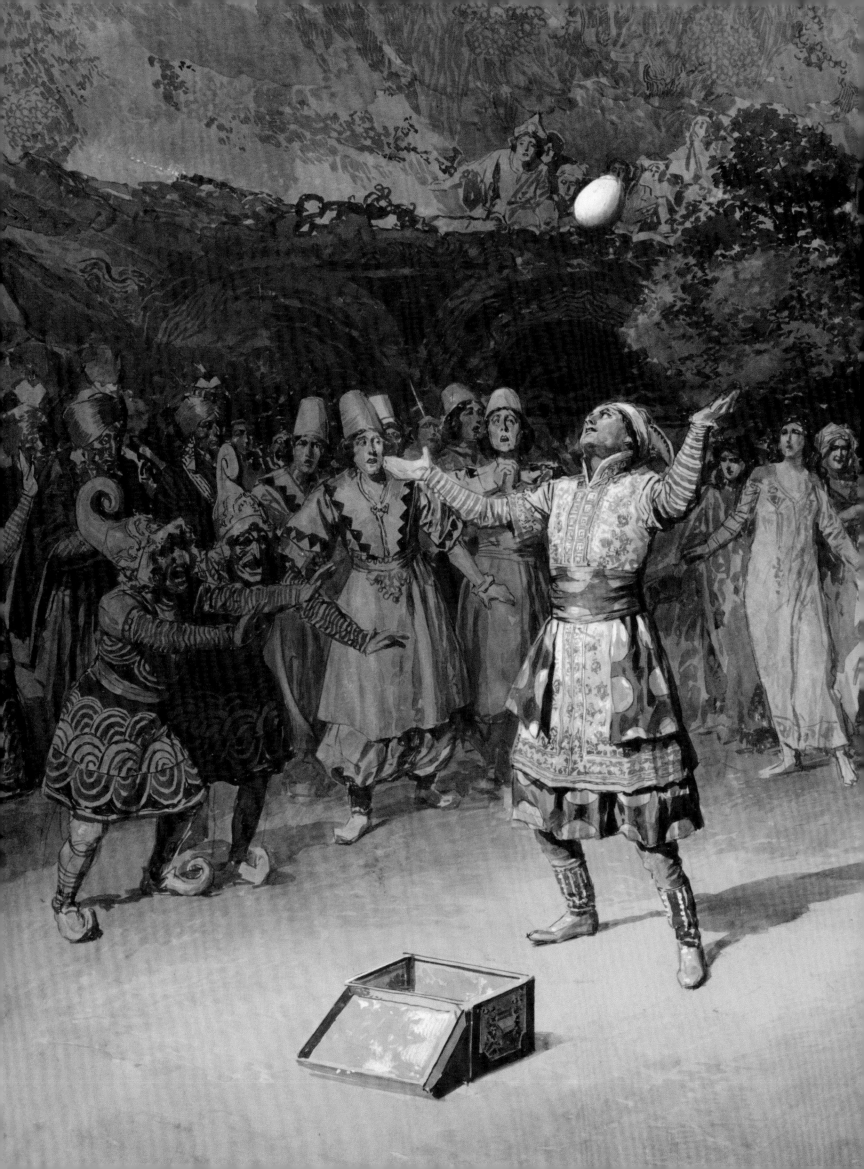

MUSIC AND THE
BALLETS RUSSES

HOWARD GOODALL

It is extremely rare in musical history that the agent of greatest transformation upon the development of music at any one moment should lie outside its own immediate community. Serge Diaghilev is one such figure, as influential on music's twentieth-century journey as he was on that of dance and design. He was a catalyst whose imaginative entrepreneurialism between 1909 and 1929 was to cause as great a revolution in the sound and style of music as, for example, the technological advances brought about by the invention of recorded sound or the mass exodus of Russian Jews to the USA – both of which unfolded in the two decades preceding his arrival in Paris. That the commissioning policy of one man and his company of exiled ballet dancers should have brought about change in not one, but three art forms, and precipitated something close to an earthquake in one of them – music – is almost without precedent.

The two cities of St Petersburg and Paris were to be the turbines behind the cultural revolution orchestrated by Diaghilev at the Ballets Russes. This should be seen not as a sudden, unexpected turn of events but rather the culmination of a process that had been in the making for at least half a century. The pervasiveness of French culture in aristocratic circles in the Russian Empire meant that Paris was the natural goal of many an exile from the East. The influx of aspiring, usually impoverished, young musicians to Paris from elsewhere in Europe continued until the First World War, fuelled by a popular, somewhat idealized conception – captured fondly in Henri Murger's 1851 novel *Scènes de la vie de bohème*, which formed the basis of Puccini's *La Bohème* (1896) – that the bohemian life of the artist was 'understood' better in Paris than any other industrialized capital. Young composers, singers and instrumentalists in Paris in the second half of the nineteenth century and first quarter of the twentieth, were likely to have been financially maintained by one or other of two outstanding patrons,

whose impact on the music that was subsequently produced makes them worthy of investigation.

The first of these was Georges Hartmann, a publisher-philanthropist-librettist-dramatist to whom Claude Debussy's career was profoundly indebted, and who also nurtured the work of Jules Massenet, Georges Bizet, Camille Saint-Saëns, Édouard Lalo and César Franck. Though his interest in the arts was not confined to music (Renoir's 1874 *Portrait of a Woman* at the Musée d'Orsay, Paris, is thought to be Hartmann's wife, posing appropriately in front of a grand piano), Hartmann's championing of the leading French composers of the later nineteenth century was to set a standard for publishers that few matched, especially so since the enterprise bankrupted him at least once and left him virtually ruined at his death in 1900. He cultivated relationships with journalists, opera-house directors and concert promoters on behalf of his composer clients in a manner that would not be out of place in the early twenty-first century. His entrepreneurialism therefore sketches him as a worthy precursor to Diaghilev, even if unlike Diaghilev he was himself often creator as well.

By 1900, the year of Hartmann's death, it was already obvious in Paris and across Europe that Debussy was producing music of startling originality, which was at the time somewhat overshadowed by developments in Vienna, the experiments of the so-called 'Second Viennese School' of composers Arnold Schönberg, Alban Berg and Anton Webern. Critics, university professors and musicologists swallowed the complicated methodology of the Austrian intellectuals wholesale, believing it to be the dawn of a new era in music, a hypnosis that prevented them from fully grasping the enormity of the transformation Debussy was bringing about to the texture, harmony and organization of melody in Paris. Audiences, then as now, seemed less susceptible to the logic of the Viennese experiment, known

as 'serialism' or 'atonality'. Meanwhile a wave of French composers wrestled with Debussy's re-imagining of the musical canvas, chief among these being Erik Satie and Maurice Ravel. Satie (whose lean, acerbic musical style looked forward to a modernist, utilitarian twentieth century) and Ravel (whose rich, nostalgic soundscapes evoked a fast-fading belle époque) were among several leading composers of the early twentieth century to have benefited from the patronage and vision of Winnaretta Singer-Polignac. One of the outstanding supporters of the arts she was an indispensable sponsor of Diaghilev and the Ballets Russes.

The daughter of Isaac Merritt Singer, of the sewing machine fortune, and Isabella Eugenie Boyer (rumoured to have been the model for Bartholdi's Statue of Liberty) Winnaretta and her family emigrated from New York to Paris at the outbreak of the American Civil War before moving to Paignton, Devon, at the outbreak of the Franco-Prussian war. By 1875, Isaac having died, the family returned to Paris, where by the age of 22 Winnaretta was married to the first of two husbands, both princes, both marriages of convenience. From 1894, Singer and her second husband, Prince Edmond de Polignac, established a salon in their Paris home which soon became the epicentre of Parisian musical life; composers and musicians the de Polignacs nurtured, commissioned or befriended included Claude Debussy, Gabriel Fauré, Maurice Ravel, Emmanuel Chabrier, Vincent d'Indy, Erik Satie, Darius Milhaud, Francis Poulenc, Kurt Weill, Manuel de Falla, Karol Szymanowski, Germaine Tailleferre, Percy Grainger, Sergei Prokofiev, Nadia Boulanger, Arthur Rubinstein, Vladimir Horowitz, Igor Stravinsky and Ethel Smyth (with whom Winnaretta had a passionate affair). This extraordinary list overlaps revealingly with the composers engaged by Diaghilev for the Ballets Russes. That Diaghilev himself was also a part of the Singer circle, as were Marcel Proust, Claude-Oscar Monet, Jean Cocteau, Colette and Cole Porter, reveals the extent to which the prince and princess lay at the heart of the artistic community of early twentieth-century Paris.

The phenomenon of Winnaretta Singer's musical patronage highlights two other important aspects of the city's pre-eminence around the turn of the twentieth century, which help us understand the apparently spontaneous firework display of talent set alight by Diaghilev.

The first of these is the issue of gender, the second, sexuality. Underestimating the significance of these factors has been a hallmark of the, specifically, musical criticism and analysis of the period until very recently. Looking at the evidence from a century's distance, it now seems glaringly obvious that the evolving of a society that tolerated homosexuality and allowed, perhaps even encouraged, the professional advancement of women in the arts will have played a critical role in such an extravagant flowering of creativity. It is possible to cite the following noted female composers at work in Paris during the Singers' salon years: Ethel Smyth, Nadia and Lili Boulanger, Augusta Holmès, Mélanie Bonis, Germaine Tailleferre, Louise Héritte-Viardot, Henriette Renié and Cécile Chaminade, the first woman

composer to be awarded the *Légion d'honneur*, and whose *Scarf Dance* for solo piano sold in excess of five million copies. This impressive list, which is by no means exhaustive, should be seen against the backdrop of the disadvantaged position of all women in European society at the time – French women did not get the vote until 1944 (French Muslim women would have to wait until 1958). That the two most influential patrons of the contemporary arts in Paris between 1900 and 1930, Winnaretta Singer and Misia Sert, were both women, both foreign, both themselves musicians, suggests that Paris at this time offered stimulation, encouragement and challenge to artists unlike any other city.

The hostility and anguish experienced by Pyotr Tchaikovsky in Russia's most liberal city, St Petersburg, in the final three decades of the nineteenth century, or the aggressive homophobia accompanying Oscar Wilde's trial in England in 1895, affords us some measure of context for the unabashed community of gay men and women that prospered in the artistic community of turn of the century Paris. That homosexual men and women had thrived in the arts in every century goes without saying, but the relative openness with which the group centred around Diaghilev, Proust and Winnaretta Singer and were able to express their sexuality in their salon society gatherings is no less startling than many of the artistic innovations they concocted between them. It would be odd not to acknowledge that personal and creative freedom, adventure and experiment were profoundly interwoven.

That Paris was unusually open to new ideas and social attitudes by the very end of the nineteenth century helps us understand why creative artists were drawn to it and felt at ease in its milieu, but it does not fully explain the distinctly Russian dimension to the cultural excitement that built around Diaghilev and his circle. With respect to music and dance, this dimension is inescapable.

Despite the high status accorded to culture by Parisians, it would be inaccurate to perceive a huge gulf between the aspirations of the average educated citizens of St Petersburg around 1900 and their counterparts in France. The *All-Russia Exhibition* of October 1896 in Nizhny Novgorod, with its displays of cutting-edge technology, can be compared to the Exposition Universelle held in Paris in 1889. The Imperial capital in the years leading up to the October Revolution in 1905 had been the focus of a re-awakened public interest in Russian ethnic art and architecture, a fashion to some extent promoted by the nationalist leanings of tsars Alexander II and Nicholas II.

After the 1905 Revolution, the relaxing of censorship led to the emergence of a vigorous, modernist artistic community in St Petersburg, most of whom relished the opportunity to develop something new that was explicitly Russian in character. Diaghilev was eager to exploit the potential of a French vogue for Russian culture, rather than a Russian interest in what Paris had to offer. His desire to showcase the best of Russian art and music, in any case, had begun in Russia, for Russians: the extensive exhibition of

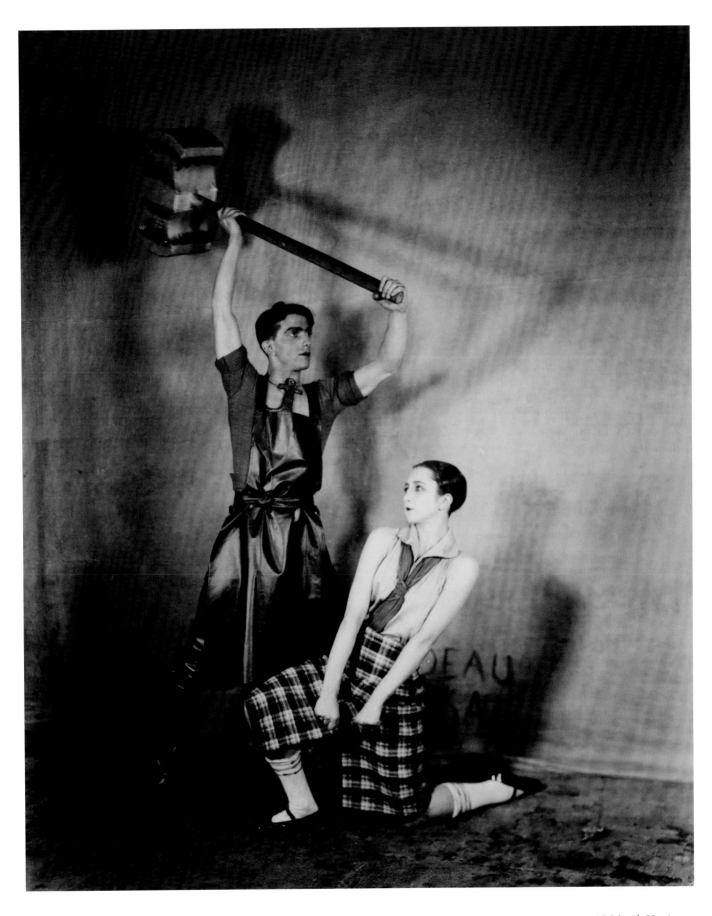

106. Léonide Massine
and Alexandra Danilova
in *Le Pas d'acier*, 1927.
Photograph by Sasha.
V&A: Theatre &
Performance Collections

107. Ernest Ansermet
(conductor), Serge
Diaghilev, Igor Stravinsky
and Sergei Prokofiev after
a rehearsal at the Prince's
Theatre, London, 1921.
Photograph by
Sydney J. Loeb.
V&A: Theatre &
Perfomance Collections

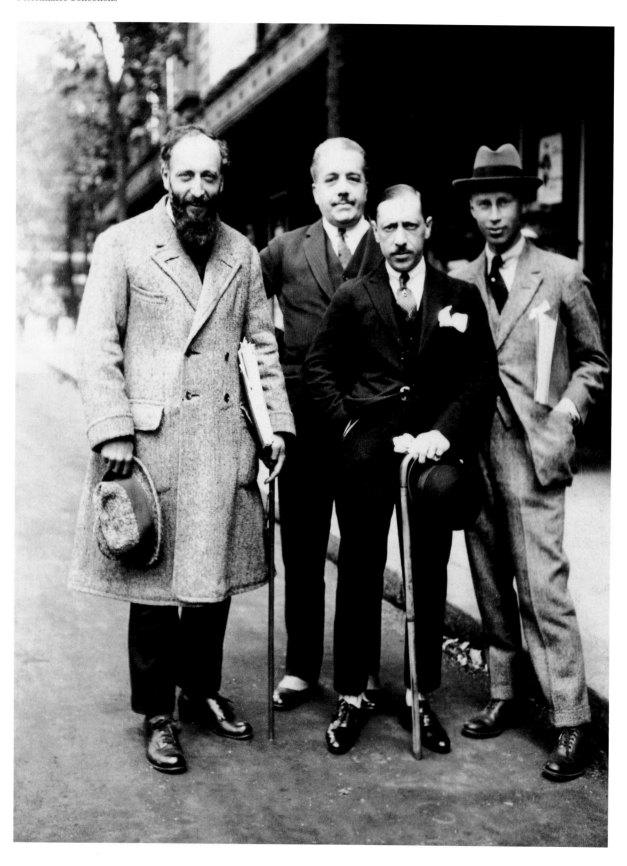

portrait paintings he mounted in St Petersburg in 1905 was intended to show the educated classes of the Imperial capital the great wealth of the country's artistic talents beyond the city's parochial horizon, a collection that he had spent a year researching throughout Russia. It was another exhibition of Russian visual art that he first took to Paris, in 1906, the success of which encouraged him to present a season of Russian concerts there in the following year and to mount Mussorgsky's folklore-imbued opera *Boris Godunov*, starring Fyodor Chaliapin, the year after that. By the time he unleashed his first season of Russian ballet, in 1909, Diaghilev was providing for a Parisian fascination he had himself largely created. He would not, however, have been able to generate such excitement were it not for the fact that St Petersburg had for the previous half-century or so been producing composers of outstanding, world-class talent. It would be hard to find a period in the history of any country that could match the creative timeline that includes Alexander Borodin, Modest Mussorgsky, Nikolai Rimsky-Korsakov, Mikhail Glinka, Pyotr Tchaikovsky, Alexander Gretchaninov, Alexander Glazunov, Alexander Scriabin, Sergei Rachmaninoff, Igor Stravinsky, Sergei Prokofiev and Dmitri Shostakovich. This (with the exception of Shostakovich) was the raw material Diaghilev had to present, in music alone, to the Parisian public. With hindsight, it would have been odd had audiences not responded with some degree of enthusiasm, if not awe.

While it is true that Russian society was convulsed in political turmoil of a calamitous nature for the first 40 years of the twentieth century, it is worth stressing that the rise of Bolshevik communism did not, at first, imperil artistic freedom. Even the loss of aristocratic patronage, which might have been traumatic, was replaced by state subsidy: at the height of Stalinist interference in the arts in the late 1930s and 1950s, the scale of subsidies to the performing arts in the USSR put those of most other countries to shame and it is often overlooked that for many Jewish musicians fleeing Nazi Germany in the 1930s, their destination was the USSR, not the West. Between 1890 and 1930, Russia's musical activity was vigorous and unshackled. Anatoly Lunacharsky, the People's Commissar for Education in the post-1917 Revolution Bolshevik government, once remarked to his friend Prokofiev: 'You are a revolutionary in music, we are Revolutionaries in life. We ought to work together.'[1] Repression of creative artists, along with the rest of the population, began in earnest in the second half of the 1930s under Stalin, by which time the modernist experiments of the Ballets Russes composers were all but exhausted (pl.106).

Thus, cutting-edge Russian composers like Stravinsky and Prokofiev (pl.107) were not compelled to make their daring works known in Paris as an outlet or as a last resort, they *were* modernist, being invited to create works for an interested international audience gathered in Paris. What Stravinsky did find in France that he could not at home, however, was the towering presence, genius and influence of Claude Debussy (pl.108).

108. Claude Debussy, 1908

Traditionally, Debussy was categorized as an 'Impressionist' composer, a sub-section of the 'Late Romantics', who included Gustav Mahler, Richard Strauss, Edward Elgar and Jean Sibelius, but the term is at best vague, at worst dangerously misleading. First, Debussy's music is not contemporaneous with the Impressionist movement in painting. Second, while there are aspects to his style that attempt to create an overall 'wash' of colour from the deliberate merging of components in the sound, Debussy had no intention of creating a parallel in music to the mostly figurative images of Monet, Renoir or Pissarro. In his treatment of harmony, inspired by the complex resonances of the Javanese gamelan orchestra he heard at the 1889 Paris Exposition Universelle, he was attempting an atmospheric or emotional effect rather than a descriptive one. By transplanting the exotic clash of sonorities of Eastern music into the Western palette, he radically challenged the established 'rules' of nineteenth-century music, as dominated – almost exclusively by the 1870s – by Wagner and his use of representative *leitmotifs*.

Wagner, obsessed with the psychological journeys of his music drama characters and archetypes, needed to perfect a mechanism by which audiences could identify them (and how

they were transformed) in the music itself. The *motif* was such a mechanism. All his music is underpinned by the relationship between the *motifs*, cells of melody continuously modified and regurgitated. At its best a *motif* could summon up in the mind of the listener the character (or concept) without needing to see it physically at all. It was music's equivalent of figurative art. So Debussy's almost total abandonment of Wagnerian cell-construction in favour of the colours available to him in shifting blocks of sound alone was a shocking departure. His idea was more analogous to Abstract Expressionism and Colour Field painting than to the scenes, people and watery vegetation portrayed by the Impressionists.

However, because Debussy's taste in harmony and melody was still attached to the 'tonal' world of the late nineteenth century and not to the destructive dissonance of the modernist serialist school with which he was contemporaneous, he seemed to pose no threat to the musical status quo. Because his music was enjoyed, not rejected by the listening public, 'Impressionist' and 'Late Romantic', therefore, seemed more appropriate descriptors of Debussy's music than 'radical' or 'expressionist'. Significantly, a handful of visionary musicians at the time did grasp the enormity of Debussy's approach and followed it. The chief among these, 2,000 kilometres away in St Petersburg, was Igor Stravinsky; the city in which he unveiled his dramatic response to Debussy's challenge, Paris; the impresario who conjured the opportunity, Diaghilev.

The three ballets for Diaghilev in which Stravinsky laid out his stall were *The Firebird* in 1910, *Petrushka* (pl.110) in 1911 and *The Rite of Spring* in 1913 (pl.109). When he was commissioned to compose the first of these he was unknown (and third choice for the job). By the morning after the premiere of the third, he was both the most notorious and the most eagerly championed composer in all Europe. The essential ingredients brought together into Stravinsky's ballet style were the result of his Russian training, especially from his revered mentor Nikolai Rimsky-Korsakov, colliding with his fascination for Debussy.

In terms of musical construction, he doubly rejected the German-Austrian tradition by abandoning both the *motif*-led approach of Wagner and the symphonic development approach inherited from Beethoven that was still alive in the works of, for example, Gustav Mahler, Anton Bruckner, Jean Sibelius and Richard Strauss. This latter method began with small ideas (fragments or melodic phrases, a progression of chords, a short rhythmic pattern) and took them, during the course of a movement, on a journey, playing with them in various ways so that there was a sense of transformation and of destination. Stravinsky bulldozed these methods of construction and started afresh with the notion of musical tapestry, collage and episode. Musical ideas were crudely juxtaposed, one following seemingly randomly after another. There was a clear intention not to expand upon or modify them, they were

109. Valentine Gross,
The Rite of Spring.
Pencil on paper, 1913.
The drawing shows the
tall young women in the
centre with the Maidens
dancing as the tribal
square fractures into
frenzy towards the end
of Scene I.
V&A: S.179–1999

110. Alexandre Benois,
*Stravinsky Playing Piano
for Petrushka*. Pencil on
paper, 1952.
This is a copy by Benois of
an original he made in 1911.
Private collection

presented and discarded in their initial form. The joining up of one section to the next, while not arbitrary, jolted and confused the listener, but gradually created its kaleidoscopic effect by the sheer force of its combinations. It should not surprise us that Stravinsky's music is often easier to describe in pictorial rather than narrative terms. He was consciously circumventing the developmental, narrative approach.

Colour is a key element in his orchestral sound, too, a skill Stravinsky undoubtedly learnt from Rimsky-Korsakov. Precursors to the style of Stravinsky's *Firebird*, *Petrushka* and *Rite of Spring* are hard to find; it is as if he imagined his magnificent, jangling cacophony from scratch. But the Russian legend-inspired operas of Rimsky-Korsakov are close enough to a template: *Kashchei the Immortal*, *Le Coq d'or*, *The Legend of the Invisible City of Kitezh and the Maiden Fevroniya*, *Pan Voyevoda*, *The Tsar's Bride* and *The Tale of Tsar Saltan*, alongside the symphonic suite, *Schéhérazade*. Rimsky-Korsakov, though, was regarded by the time of his death in 1908 as a conservative composer and he disapproved of Stravinsky's early experiments in modernist techniques. In common with the other great Russian composers of the period, he was schooled in traditional, Austro-German techniques (Tchaikovsky, considered then as now as the archetypical Russian composer, nevertheless wrote music that could have been composed in Munich,

Leipzig or Vienna). Rimsky-Korsakov's protégé Stravinsky made no secret of his intention to move away from this pan-European legacy.

Stravinsky's novel combinations of sound and the startling liberties he took with musical architecture both stemmed from his Russian way of looking at the world. His undoubted cosmopolitanism and the ease with which he settled into Parisian artistic society from 1910 onwards should not blind us to the importance of his not being a Western European with respect to the exotic universe of his composing style.

In 1908, the Hungarian composers Béla Bartók and Zoltán Kodály set off into the countryside to record native Magyar folk songs that they would later absorb into an invigorated, modernist Hungarian style. In Britain, Cecil Sharp and others were undertaking a similar process. The potential for similar collection and transcription in Russia was vast, given the size of the Empire, and two musical ethnographers were to play a major part in disseminating the folk songs and choruses of rural Russia through primitive phonograph recordings in the first decade of the twentieth century, Yuly Melgunov and Evgeniya Lineva. The raw, non-Western character of the melodies captured on the recordings made a deep impression on Stravinsky, who unashamedly subsumed them into his own works in the

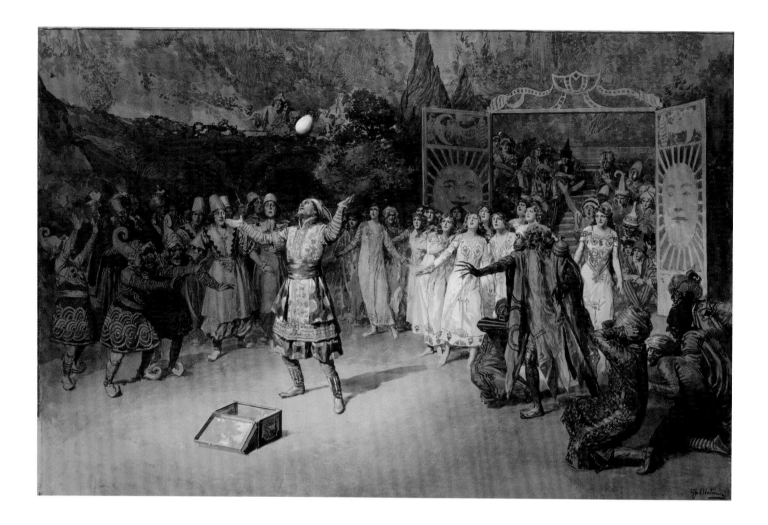

years that followed, particularly the ballet *Petrushka*. A conservatoire professor of composition like Rimsky-Korsakov would never have dared dip his melodic pen so shamelessly into the peasant well, but for Stravinsky it was both a liberation and a calling-card. For all his comfortable upbringing and his dandyish posing as a young man, he was excited by the primitive, ancient rituals still somehow preserved in obscure serf communities beyond St Petersburg's neo-classical walls. Whether it was instinct or guesswork, his compulsion to put it before an audience in Paris that considered itself the very height of sophistication was brilliantly provocative.

He was not just making mischief, though. By being outside Russia, he seemed to clarify his sense of what it meant to him, musically and personally. His increased solidarity with the liturgy, art and ritual of the Russian Orthodox Church as his exile drew on was more than homesickness or nostalgia for the pre-revolutionary Imperial Russia of his childhood: he was clearly more at ease with the perspective of the Orthodox world, encapsulated, perhaps, by the decidedly non-Western representation of the icon. No horizon, landscape, symbolic passer-by or hidden narrative clouds our focus on the Madonna or saint at the gold-leafed centre of the image, mesmerizing the eye. Icons are often

described as having 'reverse perspective'. Similarly, Stravinsky leaves no room for developmental ambiguity or Wagnerian sub-text in his uncompromisingly powerful musical evocations. For all these reasons, ballet, with its short, woven episodes and its restless, physical slideshow, was the form Stravinsky was born to compose.

From the very different background of belle-époque France, Debussy was confronting the very same issues of architecture and form as Stravinsky, and the two composers – who quickly became close friends – arrived at remarkably similar conclusions. Both rejected a Wagnerian mould, but whereas Stravinsky harnessed the raw power and energy of Russian folklore, Debussy's response was to intensify harmony at the expense, almost entirely, of rhythmic pulse. There is a seductive, hallucinogenic quality to much of Debussy's music, like a languorous summer day in the Midi, in contrast to the forceful erotic charge and ritualistic hypnosis of Stravinsky. Standing still on the Russian steppes or the Siberian permafrost might have resulted in hypothermia, after all. It is often overlooked that *Jeux*, Debussy's ballet score for Diaghilev, produced two weeks before *The Rite of Spring*, was almost as harmonically challenging and disorientating as the latter, but it was the primal violence and orgiastic pounding of Stravinsky's work that caused the riot.

The extent to which Stravinsky had broken with orchestral music's Germanic past with his three 'Russian' ballet scores can be starkly revealed by comparing the gorgeously lush, antique sentimentality of Richard Strauss's immensely popular opera *Der Rosenkavalier* of 1910 with Stravinsky's *Firebird* of the same year (pl.111). It scarcely seems possible that the works were written within a century of each other, never mind weeks, or conceived within a few hundred kilometres. Another planet would seem more plausible. After *The Rite of Spring* (1913), composers wherever they were had to address the now inescapable reality of modernism. The shockwaves it sent out were of a far greater magnitude even than the attempts of the Second Viennese School to re-engineer completely the mechanics of Western music ten years earlier. The reason for this is that Schoenberg's radicalism was an internal, musicological debate. Stravinsky, by collaborating with Mikhail Fokine, Alexandre Benois, Vaslav Nijinksy and Léon Bakst at the behest of Diaghilev in the cosmopolitan goldfish bowl of pre-war Paris, took his Russian revolution to the world at large and in turn fed off the creative energies and competing disciplines of others around him. His next two ballets, in 1920, *Le Chant du rossignol* and *Pulcinella*, had sets designed by Henri Matisse and Pablo Picasso, respectively: this was a

collaborative hothouse of an unprecedented order. Music could not, as it had done so many times before, immunize itself against the trends in other forms.

However, the Stravinsky of the first three ballets, culminating in the controversy of the premiere of *The Rite of Spring*, pursued a quite different musical path to the Stravinsky of the post-war years, and the subsequent Ballets Russes productions reflected the new wave of painters, designers and composers of a changing artistic world. This second wave of modernist ballets was to have its own impact on subsequent twentieth-century musical developments, but the interruption of the First World War, the Russian Revolution and the death of Debussy meant that it was quite distinct from its previous incarnation.

The word that perhaps best sums up Erik Satie's (pl.112) score for Picasso and Cocteau's *Parade* (1917) and that of Prokofiev for *The Prodigal Son* (1929), is irony. A sense of mockery and playfulness mingles with a desire to scandalize, though no later scandal matched that of the thoroughly non-ironic *Rite of Spring*. Though a press review of *Parade* is thought to have coined the term 'surrealist', according it a sheen of seriousness, as it did the works that followed imitatively in its wake, it is hard not to conclude with the benefit of distance that much of what the Ballets

113. Igor Stravinsky, score for *Pulcinella*. Ink and coloured pencil on paper, bound in vellum with patterned stencilled paper boards, 1919–20. British Library Zweig 94

Russes circle got up to in the 1920s sounds like student buffoonery. Not that being jocular, self-indulgent or facetious was anything unusual in the post-war years. In some respects, the musical exploits of the Ballets Russes composers in this period were prophetic of the pre-occupations of our own time. The integrated use of non-musical sounds, from typewriters to milk bottles, anticipated the technique of sampling developed by the American composer Steve Reich in the 1960s and 70s and its widespread adoption across all genres of music by the twenty-first century. The deliberate simplification of melody and harmony, the eschewing of any layer of complexity, a change led by Erik Satie, Darius Milhaud, Georges Auric and to some extent Francis Poulenc, can be seen as a precursor to the minimalism of Philip Glass, Michael Nyman and Ludovico Einaudi from the 1980s to the present. Then there is the question of the influence of the then brand new American genres of ragtime and jazz.

While a family link can be made between the piano-derived harmonies pioneered by Chopin and Debussy and later jazz composers, especially in the late 1940s and early 50s, the importation of jazz chords, figurations and rhythm patterns in the classical music of the 1920s and 30s is crude, simplistic and often patronizing. What's more, the transaction between the two worlds has always been of more interest to classical commentators than to their counterparts in jazz. If this era has sometimes been categorized as the birth of what we would now call 'crossover', it is a crossing over with an uneven exchange of goods. While Debussy paid successful tribute to ragtime in some short piano pieces, Stravinsky and Satie misunderstood its underlying logic and regurgitated it as back-of-an-envelope pastiche. At least in the case of Darius Milhaud, whose ballet *Le Train bleu* was the Ballets Russes premiere in 1924, he had experienced jazz (and Brazilian dance music) at first hand during his transatlantic travels. Though his later music betrays some jazz influence, Ravel's only ballet for Diaghilev, *Daphnis et*

Chloé (1912), is – and this is no criticism – as close to Debussy in style as a composer can be.

The fashion among composers of the 1920s and 30s to delve into the works of composers of previous eras has a variety of sometimes contradictory origins and produced a variety of equally contradictory processes. Sometimes, a particular work of a past master would be resurrected in order for it to be added to, modified and edited by the modern composer. Stravinsky's re-working of music he thought was originally by Pergolesi (an early eighteenth-century Italian composer) in his ballet for Diaghilev, *Pulcinella* (1920), exemplifies an approach that is either cheekily inventive (by 're-composing' the pieces with a twentieth-century, Stravinskian twist), or derivative and lazy, whichever way one may choose to appraise it (pl.113).[2]

An alternative to this approach was to re-orchestrate an existing work or works to enrich and modernize the sound with the prevailing tastes of the new era, while leaving the scored notes largely untouched. Ottorino Respighi's orchestral embellishing of early nineteenth-century piano pieces by Rossini for the 1919 ballet *La Boutique fantasque* (one of the few Ballets Russes premieres to be held in London) falls into this category. In the post-war economic climate, though, the general trend was to reduce rather than increase the instrumental forces available to composers and one explanation for a return to seventeenth- or eighteenth-century genres is straightforward expedience. Orchestral forces, including the size of the instruments themselves, had steadily grown since Bach's time, so that the kind of ensemble he would have expected to perform a concerto, perhaps 20 players, had expanded into a standard symphony orchestra of 80 players or more by 1900. The First World War and its aftermath (including revolutions in Russia and Germany) instigated a tightening of musical belts and a return to the relative austerity in scale and sound of the early eighteenth century. No doubt the pendulum swing of taste also had its part to play – the titanic scale of some of Richard

Strauss and Giacomo Puccini's orchestral and operatic works seemed to modernist composers of the 1920s excessive on almost every level, including that of emotional gesture. Stravinsky's disdain was typical: 'I would like to admit all Strauss operas to whichever purgatory punishes triumphant banality.'3

The music of previous centuries had one other key role to play in the musical upheavals that followed the First World War, namely its ability to lend ready-made form and structure to new music. One upshot of the turbulence that gripped music between 1890 and 1930 as modernism, experiment and the avant-garde took centre stage was a loss of confidence in the structures that had sustained classical music for most of the preceding two centuries – symphony, concerto, sonata, theme and variations. The popularity of the 'symphonic poem' in the last quarter of the nineteenth century was evidence that composers were seeking freer forms, since the symphonic or 'tone' poem had virtually no given architecture at all. It may as well have been called 'uninterrupted piece for orchestra of any length or shape'. Absence of architectural template, however, was not a state many composers were comfortable with for long and by the 1920s a desire to resurrect the more rigid forms of the eighteenth century became ubiquitous. Thus, composers like Stravinsky, Prokofiev, Poulenc and Bartók, despite employing dissonances and sounds that would have terrified Vivaldi or Mozart, nevertheless borrowed their

textbook symphony, concerto and sonata forms. This phenomenon can be seen worked out in virtually all the Ballets Russes commissions from *Pulcinella* onwards, with antique dance forms from the seventeenth and eighteenth centuries dusted down and put back into service, more often than not combined on stage with *commedia dell'arte* themes. Prokofiev's *Chout* (*The Tale of the Buffoon*) (1921), Poulenc's *Les Biches* (1924) and Satie's *Jack-in-the-Box* (1926) followed the vogue. In Stravinsky's words: 'In borrowing a form already established and consecrated, the creative artist is not in the least restricting the manifestations of his personality. On the contrary, it is more detached and stands out better, when it moves within the limits of a convention.'4

One outcome of this antiquarian trawl through the attic of mostly Italian, French and Spanish music and dance forms was that Stravinsky's style, weathervane of twentieth-century musical trends, became for a while less Russian in flavour. One of his Ballets Russes commissions of the 1920s bucked this westward drift in a spectacular manner, paving the way for developments that even Diaghilev could not have foreseen. The ballet was *Les Noces*, premiered in June 1923, and though its reception did not repeat the clamour of the opening of *The Rite of Spring* ten years earlier, nor in the ensuing decades did it enjoy the multitude of concert performances and theatrical revivals, it can be seen from the perspective of the twenty-first century to have had a

114. Poster for the Théâtre Gaîté-Lyrique, Paris, 13–21 June 1923. Lithograph, 1923. The poster advertises the premiere of *Les Noces* and features Picasso's design for the Chinese Conjuror from *Parade*, 1923. V&A: S.4605–1995

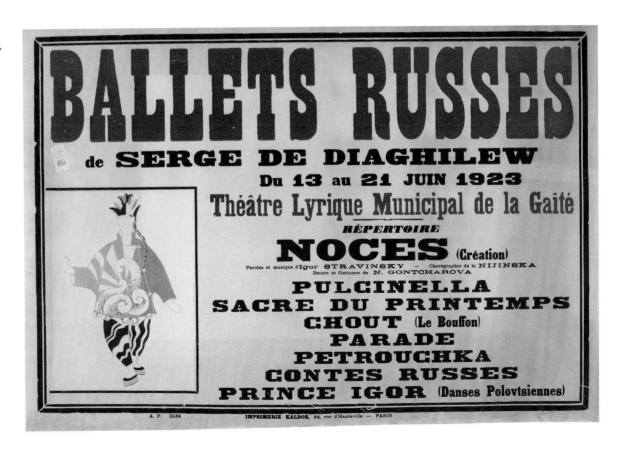

179

remarkable musical impact (pl.114). Its sound world is one that still captures the imagination of composers today.

The basic premise of the work is the re-creation of a peasant wedding ritual, using as its often-bewildering libretto spoken, declaimed and sung fragments of speech Stravinsky compiled with the help of the 1911 anthology, *Songs Collected by P.V. Kireevsky*. The use of voices, chorus and soloists as quasi-instrumental, sound-effect texture was revolutionary enough in itself, but the nature of the rest of the ensemble is more startling still: a battery of pitched and unpitched percussion, including four pianos. Stravinsky had at various points in the genesis of the work toyed with the inclusion of synchronized pianolas (mechanical roll-operated pianos), harmoniums and keyboard-controlled cimbaloms (a hammered-string folk instrument prevalent in Eastern Europe and Russia). The resulting amalgamated sound, which is brittle, full of attack, sharp edge and a kind of out-of-tune resonance, would have been – literally – unimaginable to audiences of the day but to other composers it proved irresistible. It is hardly an exaggeration to say that the impact of this soundscape can be heard in the contemporary work of composers in every decade since.

This then is the background against which we must view Serge Diaghilev's historic involvement with the development of Western music. He was neither, strictly speaking, patron (in the mould of individuals like Winnaretta Singer and companies like Hartmann's) nor was he a creative protagonist like Nijinsky, Matisse or Stravinsky. His role was one we recognize easily in the twenty-first century – nurturing, promoting and developing talent through an enlightened policy of commissioning and the inventive combining of personalities and skills. Stravinsky later described it thus:

> Diaghilev did not have so much a good musical judgement as an immense flair for recognizing the potentiality of success in a piece of music or work of art in general. In spite of his surprise when I played him the beginning of the *Sacre* [*The Rite of Spring*] at the piano, in spite of his at first ironic attitude to the long line of repeated chords, he quickly realized that the reason was something other than my inability to compose more diversified music; he realized at once the seriousness of my new musical speech, its importance and the advantage of capitalizing on it.[5]

Stravinsky reported Diaghilev's response to the controversial first performance of *The Rite of Spring* in May 1913 in similar terms:

> He certainly looked contented. No one could have been quicker to understand the publicity value and he immediately understood the good thing that had happened in that respect. Quite probably he had already thought about the possibility of such a scandal when I first played him the score, months before...[6]

115. *Aurora's Wedding*,
showing the company's
orchestra in performance
at Montreux, Switzerland,
June 1923.
Private collection

THE PLEASURE
OF HIS COMPANY
Catherine Haill

Parties associated with productions by Diaghilev's company were vital for its success. These were not just for the cast, but were events at which Diaghilev could win or cultivate the patronage of wealthy influential art lovers and enhance the position of the Ballets Russes in society. Superbly catered and elegantly-dressed gatherings in opulent surroundings were opportunities for the hosts to demonstrate their munificence, their enlightened appreciation of contemporary arts, and their familiarity with the rising stars of modernism.

Diaghilev's ease in social situations had developed from his university days in St Petersburg. He mastered French and German from an early age, and was a skilled pianist and singer. His subsequent genius as an impresario relied as much on his ability to find backers by making friends and influencing the right people, as on his boundless energy and talent for cultivating brilliant performers.

Elegant surroundings suited Diaghilev's style and image. He made the Savoy Hotel his London base, and he would 'hold court' with Lady Ripon and other patrons in the Savoy Grill. After the penultimate performance of *The Rite of Spring* at Drury Lane Theatre on 22 July 1913, a party was held at London's imposing Carlton Hotel, at the corner of the Haymarket and Pall Mall, at which the young virtuoso pianist Arthur Rubinstein entertained the guests and the hotel chef was the legendary Auguste Escoffier. In 1916, when Diaghilev and his company were

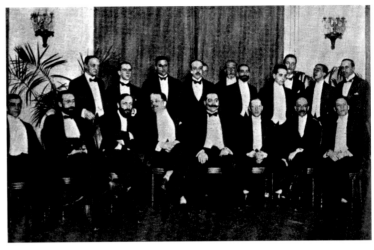

on tour in the United States, the dancers performed in the ballroom for an after-show party at Washington's stately Russian Embassy. They socialized, too, as Lydia Sokolova recalled in a letter: 'We drank champagne and got home at four o'clock.'[1]

Diaghilev had a flair for organizing events. After the first public performance by the Ballets Russes of *Le Renard* at the Paris Opéra on 18 May 1922, the wealthy English couple, Violet and Sydney Schiff, hosted a legendary supper party for 40 or 50 guests in a private dining room at the luxurious Hotel Majestic in Avenue Kléber, and delegated the arrangements to Diaghilev. They invited the leaders of European modernism to a champagne-fuelled evening, including Pablo Picasso, Igor Stravinsky, Marcel Proust, Mikhail Larionov and James Joyce. Diaghilev, recovering from a financially disastrous London season and keen to cultivate the Schiffs and their wealthy friends, was both guest of honour and master of ceremonies.[2]

Another memorable party in Diaghilev's honour took place at a more unusual venue in Paris. The wealthy Americans, Sara and Gerald Murphy, rented a converted barge on the Seine for a dinner on 17 June 1923 to celebrate the premiere of *Les Noces* at the Théâtre Gaîté-Lyrique. Forgetting that flowers were unavailable on Sundays, Sara decorated the tables instead with inspired Surrealistic flair using cheap toys from Montparnasse market. The informal surroundings, coupled with copious cocktails and champagne, encouraged more riotous behaviour than usual. Diaghilev and Boris Kochno were there, with Serge Lifar, Vera Nemchinova, Larionov, Natalia Goncharova and Léonide Massine, among others. Stravinsky rearranged the place cards, Cocteau purloined the captain's uniform, Goncharova read everyone's palms, while Picasso, captivated by the toys, 'rearranged them into a giant assemblage that culminated in a stuffed cow atop a fire truck's ladder'.[3]

1 Sokolova 1960, p.78.
2 See Davenport-Hines 2006.
3 Vaill 1998, p.119.

BEAUMONT
SOUVENIRS
Andrew Kirk

When the Ballets Russes first performed in Britain, Cyril Beaumont was already an established bookseller, working from his shop at 75 Charing Cross Road in London's West End. A keen follower of Diaghilev's company, he soon identified a demand for souvenirs among fellow enthusiasts.

Beaumont's first idea was for painted wooden figures, 'something between a photograph and a statue … that would preserve the *pose*, feeling and colour of the dancer'. The artist Adrian Allinson produced the initial designs, with later ones by Eileen Mayo, Vera Willoughby, Randolph Schwabe and Ethelbert White. Accuracy was always paramount. To assist this, Diaghilev

gave Beaumont and his artists passes to watch the company's performances and gain access backstage, where they could see the dancers in their costumes close-up. The wooden figures were cut by the Aldon Studios and then hand-painted by the artist who had done the design. The figures could be bought at Beaumont's shop or by post (being advertised in his book catalogues), and cost seven shillings and sixpence each.

Combining the role of publisher and dance historian, Beaumont's next project was to create souvenir books, each dedicated to an individual ballet. Early drafts by his chosen author were not as he had intended, so Beaumont undertook the writing himself. The text

Right
Ethelbert White, hand-coloured souvenir print of *Parade*, *c*.1925. The print shows the finale of the ballet in London.
V&A: S.487–2000

Below
Eileen Mayo, wooden figures showing Alice Nikitina as the Cat, and Serge Lifar as the Youth from *La Chatte*. Gouache and wood, *c*.1928.
V&A: S.952(A&B)–1982;
S.953(A&B)–1982

gave both an artistic and thematic description of the ballet followed by a more technical account of 'the dancers' actions and movements' (a skill later developed in Beaumont's 1937 work *The Complete Book of Ballets*). Each book was individually decorated and illustrated with scenes from the named ballet. The artists (all of whom also illustrated volumes published by the Beaumont Press) were Adrian Allinson (*Cleopatra, The Good-Humoured Ladies, Le Carnaval, Schéhérazade*), Michel Sevier (*Children's Tales, Petrushka, La Boutique fantasque*) and Ethelbert White (*L'Oiseau de Feu, Thamar, The Three-Cornered Hat*). Since Beaumont could not afford to have the illustrations

printed in colour, he and his wife hand-tinted them. Deluxe editions printed on Japanese vellum cost ten shillings and sixpence, while the standard editions printed on cartridge paper were six shillings each. The series appeared under the title *Impressions of the Russian Ballet* and between 1918 and 1919 Beaumont published ten volumes. In 1921 he produced a further two volumes for *The Sleeping Princess* illustrated by Randolph Schwabe. There is evidence of at least six further works being planned but never realized.

To expand the artistic record of the ballets, Beaumont next decided to issue souvenir prints. Once again he called on his pool of artists and, as with the figures

and the books, demanded absolute accuracy in the representation of costume and scenery. Twenty-two prints have been identified, from existing works and also Beaumont's catalogues, the artists being Allinson (3), Mayo (4), Schwabe (1) and White (14).

The importance of the Beaumont souvenirs to dance historians cannot be overestimated. The figures, books and prints give a contemporary account of the performances of the Ballets Russes, both in words and coloured illustrations, using the costumes, sets and dancers directly as their source.

Adrian Allinson, Michel Sevier and Ethelbert White, covers for titles in the series *Impressions of the Russian Ballet*, published by C.W. Beaumont, 1919–20. Titles given as the title-pages of the books. V&A: Theatre & Perfomance Collections

Carnaval
V&A: GV1790.C24

Children's Tales
V&A: GV1790.C58

Thamar
V&A: GV1790.T52

L'Oiseau de Feu
Private collection

A GIANT THAT CONTINUES TO GROW – THE IMPACT, INFLUENCE AND LEGACY OF THE BALLETS RUSSES

JANE PRITCHARD

From the earliest Saison Russe in 1909, the artists Diaghilev brought to Paris had an impact on many aspects of life. They revitalized opera, dance and stage design, introduced an innovative palette of colour combinations, influenced fashion and furnishings, and lent glamour to Russian culture. That the company's art and productions seeped into the consciousness of West-European society is evident from the wealth of Ballets-Russes inspired cartoons that appeared wherever they danced. Diaghilev's ballets made it respectable for artists and composers to collaborate. Painters and sculptors welcomed the heightened profile gained by their involvement in stage works, and the concert hall benefited from many fine new dance scores.

Among the immediate influences was the change in the public's perception of dancers. The male dancer was restored to a central role which had been lost for much of the nineteenth century and ballet ceased to be a meditation on femininity performed by women to satisfy the masculine gaze. From 1909 it was the men who attracted the greatest attention: the virile Adolph Bolm and his Polovtsian hordes in *Prince Igor* (pl.117) contrasted with the virtuosity of the constantly transformed Vaslav Nijinsky. The number of men equalled or exceeded the women in the company, but they were never effeminate, even when the male body was knowingly dressed or unclothed to satisfy a homosexual perspective. This interest in male dancers continued after 1929, but they did not attract anything like the same attention again until the emergence of Rudolf Nureyev as a superstar in the 1960s.

Female dancers were also undergoing a metamorphosis in the early twentieth century. With the Ballets Russes it is possible to see the evolution of a slim, long-limbed ballerina, her small head emphasized by her parted and sleekly dressed hair. The statuesque Ida Rubinstein heralded the trend in the first seasons, but the style only really emerged in the

1920s with Olga Spessivtseva, the boyish Alice Nikitina and the elegant Felia Doubrovska – George Balanchine's Film Star in *La Pastorale* (pl.118) and Siren in *The Prodigal Son*.

The new dancers also became models for the latest fashions. With the advent of the illustrated periodical, performers found a sideline displaying haute couture, and the chic dancers of the Ballets Russes were soon in great demand. There was a very clear symbiosis between fashion and the Ballets Russes. The interchange between the designers Paul Poiret and Léon Bakst is evident. As well as designing for the stage, Bakst created dresses for Jeanne Paquin, and it was the House of Paquin that came to the rescue to modify the costumes for Nijinsky's futuristic game of tennis in *Jeux*. Chanel's role with the Ballets Russes is well known if confusingly documented, but just as fashion was contributing to the ballet, Diaghilev's stage designers were influencing fashion. Natalia Goncharova, like Bakst, used glorious fabrics in vivid hues, and her appliquéd decorations enhanced the evening clothes produced by the House of Myrbor in Paris (pl.116). Similarly Sonia Delaunay, responsible for the striking 1918 costumes for Cleopatra and Amoun in *Cléopâtre*,[1] was creating coats, dresses, bathing costumes and knitwear in colourful geometric patterns. In the mid-1920s the Ballets Russes presented a succession of what one critic described as 'unglamorous modern ballets' in contemporary dress.[2] These included *Les Biches*, *Le Train bleu* and *La Pastorale*, and were costumed in street and leisurewear rather than a romanticized form of fashion, a precursor to design for dance much later in the twentieth century.

The designs of the Ballets Russes have influenced fashion ever since the 1920s, particularly following the 1960s rediscovery of the costumes. In 1976 Yves Saint Laurent produced his iconic Russian Collection, and the impact of Bakst's palette and costumes, and Matisse's decorations,

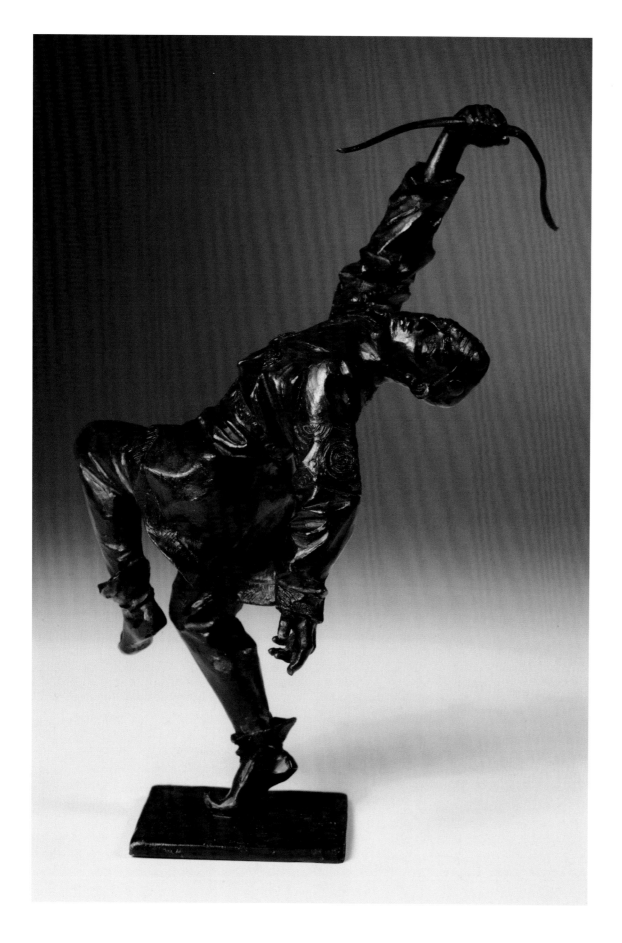

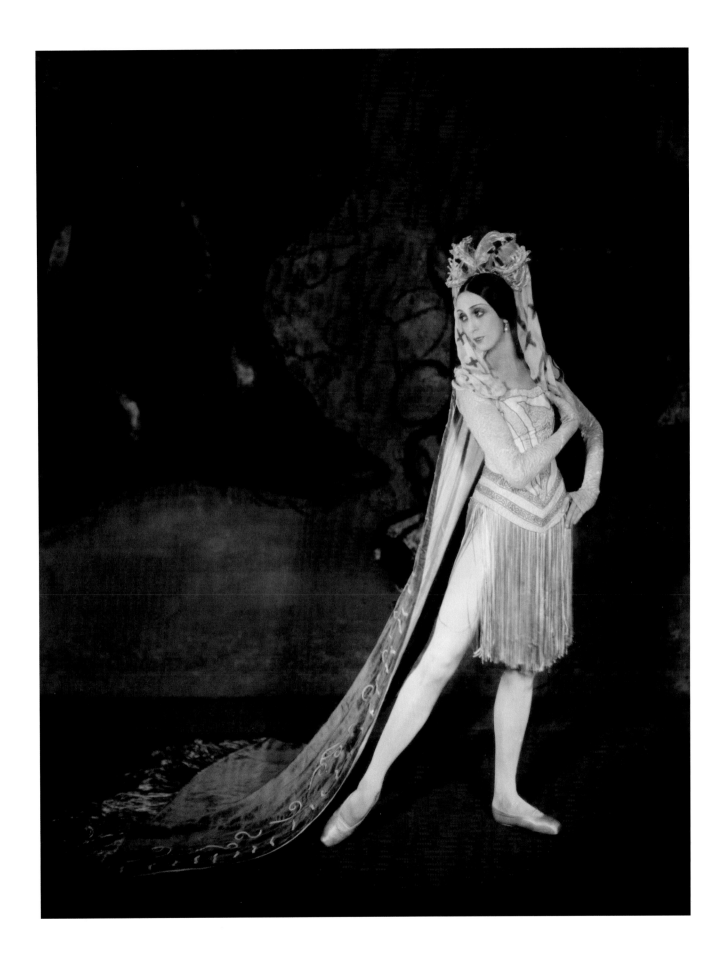

119. Yves Saint Laurent,
original sketch with notes
and swatches for the
Fall/Winter Collection,
1976. Pencil, ink and fabric
on paper, 1976.
Fondation Pierre Bergé -
Yves Saint Laurent

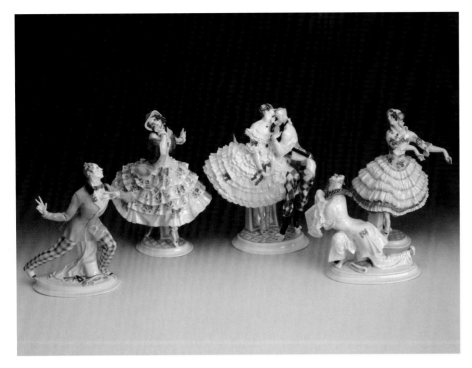

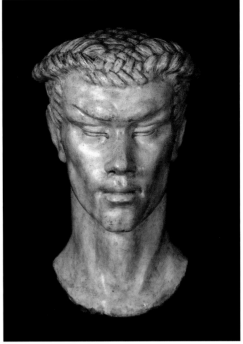

120. Paul Scheurich,
Meissen figures of
Eusebius, Estrella,
Columbine and Harlequin,
Pierrot and Chiarina
from *Le Carnaval*.
Polychromed glazed
ceramic, *c*.1914.

V&A: S.706–2009;
S.707–2009; S.708–2009;
S.710–2009; S.709–2009
Purchased with assistance
from the Friends of the
Victoria and Albert
Museum and the London
Archives of the Dance

121. Una Troubridge,
Vaslav Nijinsky as the
Faun from *L'Après-midi
d'un faune*. Plaster, 1912.
V&A: S.86–1976

were also evident in other seasons' presentations (pl.119).
It was not only fashion that derived an interest from the
colours and geometric patterns of designs for the Ballets
Russes. Clarice Cliff, the prolific designer of Art Deco
ceramics, allegedly found inspiration for her 'Bizarre'
design in Vladimir Polunin's front cloth for the 1925
Ballets Russes season at the London Coliseum.

The Ballets Russes has been celebrated in a wide range
of exhibitions. During the company's lifetime these focused on
the designers, a new development in recognizing the crossover
between fine art and stage design. As early as 1912 the Musée
des Arts Décoratifs in Paris organized an exhibition of Léon
Bakst's designs (and acquired much of the collection), and
this was followed in 1913 by a similar display at the Fine Art
Society, London. After the First World War, Natalia
Goncharova and Mikhail Larionov exhibited their theatre
work in Paris at the Galerie Sauvage (1918) and contributed to
the exhibition of Russian Arts and Crafts at the Whitechapel
Art Gallery, London (1921).

Artists captured the essence of dancers' performances
and life behind the scenes in a variety of materials. Sculpture
ranges from Maurice Charpentier-Mio's bas-reliefs and
Auguste Rodin's Nijinsky to Paul Scheurich's figures for
Meissen (pl.120). In the 1920s the Russian Lomonosov
Porcelain Factory reproduced Karsavina as the Firebird,

a role she never even danced in Russia. One of the first
exhibitions of sculpture was held in 1910 at the Galerie
Hébrard, Paris, with 22 statuettes of French and Russian
dancers by Boris M. Frödmann-Cluzel, including the famous
bronzes of Adolph Bolm performing the Polovtsian Dances
from *Prince Igor* and Ludmila Schollar in *Cléopâtre*. Notable,
too, was the March 1914 exhibition of Nijinsky portraits at
the Fine Art Society, London. The display comprised 19
works by Valentine Gross, Una Troubridge's bust of the Faun
(pl.121) from *L'Après-midi d'un faune* with four studies and a
statuette of Nijinsky in *Les Sylphides*, further works by the
artists Alberto Montenegro, John Singer Sargent, Glyn
Philpot and Jacques-Émile Blanche, and Jean Cocteau's
poster of Nijinsky in *Le Spectre de la rose*.

Leading portrait painters, including Blanche and
Augustus John, immortalized many of the stars. Sketches by
Pablo Picasso (a number of which were directly copied from
photographs) and Valentine Gross in France, Ernst Oppler
and Arthur Grunenberg in Germany, and Duncan Grant and
Eileen Mayo in London (pl.122), were shown in exhibitions
either during the lifetime of the company or in subsequent
years, and many also featured in programmes and periodicals.
Their immediacy when drawn from life often gives a greater
sense of movement than any other form of documentation.
Photographs can look static next to the lively sketches

122. Eileen Mayo, scene from George Balanchine's *La Chatte* designed by Antoine Pevsner and Naum Gabo. Hand-coloured print, *c*.1927. V&A: S.496–2000

(action photography was still in its infancy) but with the major photographers eager to record the leading dancers in their studios, these too have become the subject of exhibitions.

The British artist Laura Knight had rare permission from Diaghilev to draw and paint backstage in dancers' dressing rooms and from the wings, and in 1920 she held an exhibition at the Leicester Galleries, London, in which the Ballets Russes featured strongly. After the war Cyril Beaumont commissioned a significant and sometimes unlikely collection of British artists to record the company and he, too, was privileged to take his artists behind the scenes.

After Diaghilev's death a succession of exhibitions was presented in homage to his work. Among the earliest was the display of Serge Lifar's collection of set and costume designs at Claridges in London. These were acquired in 1934 by the Wadsworth Atheneum, Hartford, enabling Lifar to pay off debts incurred while touring in the USA. April to May 1939 saw the largest of all the Ballets Russes exhibitions at the Pavillon de Marsan, Paris. The catalogue listed 556 exhibits, including eight cloths and three further fragments of sets together with designs, sculptures, posters and books, but only eight costumes.

The French exhibition became the inspiration for Richard Buckle when in 1954 he was invited to curate a modest show for the Edinburgh Festival of designs for the Ballets

Russes. Never one to accept restrictions, Buckle decided it was his mission 'to collect every single surviving Diaghilev design in the world'. Such ambition may have been unrealistic, but his innovative exhibition, which created a range of ambiences and pioneered the inclusion of aural and odoriferous experiences, moved in an expanded form with 650 exhibits to Forbes House, London, and provided welcome nostalgia, exoticism and colour in austere post-war Britain.[3]

Performances have naturally been significant in extending the influence of the Ballets Russes. Productions have been reproduced, both officially and unofficially, from the company's earliest years. As the copyrighting of ballets was not widely recognized until the end of the twentieth century some were mounted without the permission or collaboration of the creators, although others were recreated with care. Much to his irritation, ballets by Mikhail Fokine were the most frequent target of piracy, particularly the iconic *Les Sylphides* and adaptations of *Schéhérazade* and *The Swan*. Almost two decades after Theodore and Alexis Kosloff first copied *Schéhérazade* in the USA and Britain, Fokine was continuing to write his letters of complaint over the repeated performances of their adaptation of his ballet.[4]

Even during the existence of Diaghilev's company certain ballets created for him were officially presented elsewhere. In 1913 and 1914 Fokine staged *Cléopâtre*, *Les Sylphides*, *Le Spectre*

123. Gluck (Hannah
Gluckstein), *Léonide Massine
Waiting for his Cue to go on
Stage in 'On with the Dance'*.
Oil on canvas, 1925.
The painting shows the
London Pavilion theatre,
where Massine's ballet was
part of the C.B. Cochran
revue 'On with the Dance'.
V&A: S.83–1986

de la rose, *Le Carnaval* and *Schéhérazade* for the Royal Swedish Ballet[5] and in 1921 he mounted *Daphnis et Chloé* for the Paris Opéra.[6] Vaslav Nijinsky's repertoire for his ill-fated 1914 season at the Palace Theatre, London, was drawn from the Ballets Russes although a revised arrangement of the music for *Les Sylphides* and new setting suggested a different production.[7] Other choreographers also presented versions of their ballets elsewhere. Massine took *The Good-Humoured Ladies* on tour to South America after his dismissal from the Ballets Russes and his divertissement programmes included extracts from Ballets Russes works including his solo from *Le Tricorne*. In 1926 Bronislava Nijinska mounted *Le Train bleu* for the Teatro Colón, Buenos Aires.

Diaghilev was less concerned by productions mounted in countries he rarely visited but disliked 'his' choreographers creating new ballets in his own arenas. There was particular resentment concerning Léonide Massine (pl.123), a charismatic dancer as well as successful arranger of ballets, who owed his breakthrough to Diaghilev more than any other dancer/choreographer in the Ballets Russes. Diaghilev seemed unhappy about Massine's creations for C.B. Cochran's revues in London when his own company was dancing at the London Coliseum – they were rivals in popular theatre – and when plans were afoot for the Ballets Russes to return to the USA in 1928 the American management was determined

that Massine should perform with the Ballets Russes rather than concurrently present his own ballets at the Roxy in New York.[8]

Diaghilev never appeared to have a strong 'ownership' of the operas he presented. Certainly in 1914 the British conductor and impresario Thomas Beecham kept the sets and costumes for *Le Chant du rossignol* designed by Benois and *Le Coq d'or* by Goncharova, both of which he had subsidised. He subsequently mounted the two operas in London in 1918/19 without any acknowledgement of Diaghilev, or indeed the designers of the productions.[9]

Diaghilev was concerned when his most important collaborators became involved with, or set up, high profile rival companies. Ida Rubinstein, who had risen to stardom through the Ballets Russes productions of *Cléopâtre* and *Schéhérazade* where her roles in Fokine's ballets were tailored to her strengths, produced independent productions, initially in collaboration with Bakst. Correspondence between Diaghilev and Lifar[10] suggests Diaghilev felt especially threatened by her ballet company in 1928–9 when the choreographers were Massine and Nijinska, the designer Alexandre Benois, and for which Stravinsky had composed *Le Baiser de la fée* (*The Fairy's Kiss*). In reality Rubinstein curtailed her success by claiming the ballerina role in all productions despite her limited technique. Her company is therefore best remembered for the

richness of the scores she commissioned and for launching the international careers of the dancer/choreographers Frederick Ashton and David Lichine.

Other rivals in the 1920s also followed the template for Diaghilev's productions, inviting major artists and composers to collaborate with innovative choreographers. The Ballets Suédois, which operated out of the Théâtre des Champs-Elysées, was one of two serious rivals between 1920 and 1925, a period when the identity of the Ballets Russes was at its weakest in Paris. While Diaghilev was struggling for funds, the Ballets Suédois called on the Swedish art collector Rolf de Maré to pay for their productions. The other rival, Soirée de Paris, existed only for one season and was again the creation of a wealthy patron, Comte Étienne de Beaumont, who quickly discovered that running a company both drained his purse and failed to suit his lifestyle.[11]

Inevitably, the restaging of ballets increased after Diaghilev's death in 1929. As a result of the perceived vacuum in the world of dance there were two developments: the rise of 'national' companies and a succession of new international companies, many of which included the words 'Ballets Russes' in their title. Whereas the former mixed popular ballets created for Diaghilev with new works, the second-generation Ballets Russes called on choreographers and dancers from Diaghilev's original company and combined these with newly discovered talent. They inherited Diaghilev's sets and costumes and toured worldwide, reaching countries such as Australia, where Diaghilev's company never performed. Most relied on nostalgia and glamour, although others, like the short-lived Les Ballets 1933, were more interested in extending the frontiers of dance with a varied repertoire of new works. Boris Kochno, working with Balanchine, was at the heart of Les Ballets 1933 and was responsible for the equally innovative Ballets des Champs-Elysées in the late 1940s. The latter, as the critic Richard Buckle noted, created as much excitement in London after the Second World War as Diaghilev's Ballets Russes had after the First.[12] Its initial choreographer, Roland Petit, took a lead in collaborating and invited the finest array of artists and couturiers to design his ballets.[13]

124. Alicia Markova as the Nightingale in Balanchine's *Le Chant du rossignol*, 1926. V&A: Theatre & Performance Collections

125. Alicia Markova teaching the title role of Balanchine's *Le Chant du rossignol* to Iohna Loots, 1995. Photograph by Graham Brandon. V&A: Theatre & Performance Collections

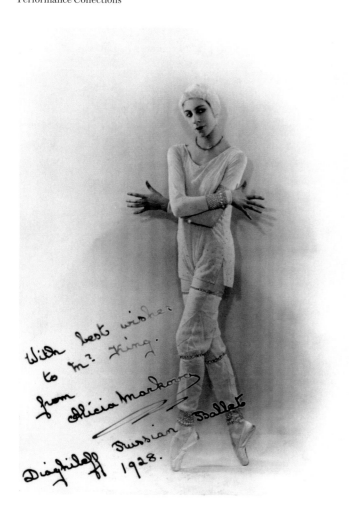

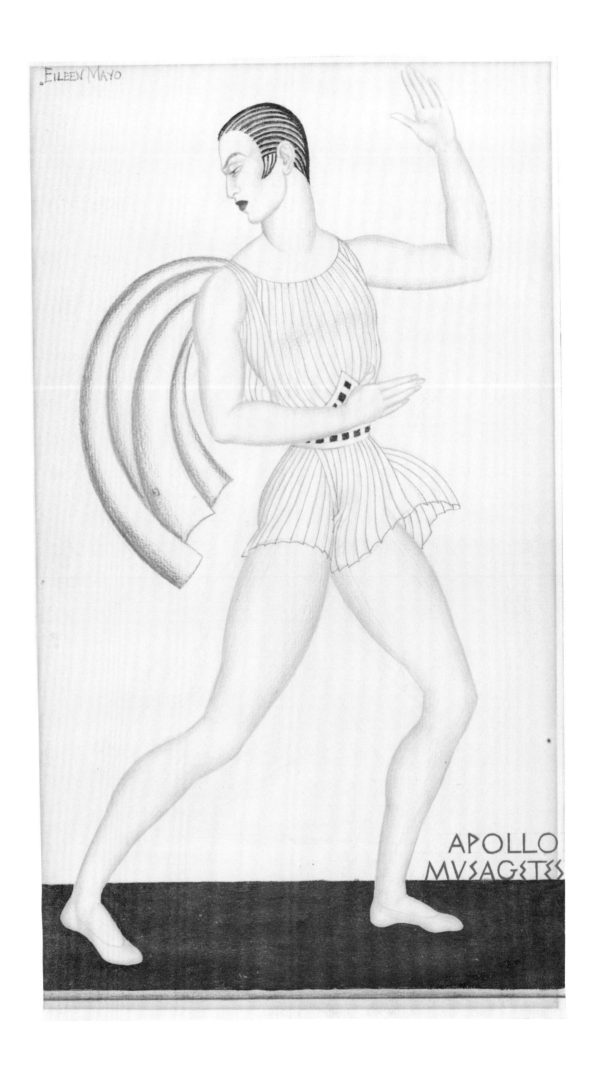

126. Eileen Mayo, *Serge Lifar as Apollo* in *Apollon musagète*. Pencil, pastel, gouache and gold paint on paper, 1928.
V&A: S.454–2000

While many of the Ballets Russes companies flourished in the 1930s, the new national companies were also putting down roots. Their members had to dance core works from the Ballets Russes to an impressive standard to win the approval of audiences and critics, who might then return to watch novelties. In Britain, the involvement with the Ballets Russes would continue for half a century: Marie Rambert, Ninette de Valois, Alicia Markova (pls 124 and 125) and Anton Dolin, all former dancers with the Ballets Russes who established companies in Britain, called on the services of Tamara Karsavina, Stanislas Idzikowski, Léon Woizikovsky, Lydia Sokolova, Lubov Tchernicheva and Diaghilev's *régisseur* Serge Grigoriev. In the late 1940s, after her Sadler's Wells Ballet had moved into the Royal Opera House, de Valois invited Léonide Massine to dance, choreograph and mount ballets for them. In the 1960s Bronislava Nijinska revived *Les Biches* and *Les Noces* for The Royal Ballet, and in the 1970s Massine set *Parade* and *Le Tricorne* for London Festival Ballet.

But it was not only in Britain that these ballets were being kept alive. In Australia the Borovansky Ballet and later the Australian Ballet performed a selection of works from the Ballets Russes. In the USA, the Ballet Theatre (later American Ballet Theatre), founded in 1939, included Fokine, Massine and Nijinska among its first choreographers while the younger Joffrey Ballet performed works by the Ballets Russes in the 1970s. The growth of such productions for the Joffrey Ballet coincided with the demise of the official Ballets Russes companies, which after 1950 operated primarily on the American continent. Robert Joffrey's Ballets Russes project began with an invitation to Massine to produce *Le Tricorne*, *Parade*, *Pulcinella* and Fokine's *Petrushka*, and at the end of the 1970s Joffrey turned his attention to ballets danced by and choreographed by Nijinsky, inviting Millicent Hodson to reconstruct *The Rite of Spring* in 1987. Meanwhile, Balanchine's New York City Ballet, also a descendant of the Ballets Russes, focused on being choreographically creative, albeit often with little emphasis on decorative design.

127. Vaslav Nijinsky in *Jeux*, 1913. Photograph by Gerschel. V&A: Theatre & Performance Collections THM/165

128. Deborah Bull, Bruce Sansom and Gillian Revie in The Royal Ballet's reconstruction of *Jeux* by Millicent Hodson and Kenneth Archer, 2000. Photograph by Graham Brandon. V&A: Theatre & Performance Collections

Balanchine only retained an interest in two of his creations for Diaghilev, *Apollon musagète*, which he altered considerably, and *The Prodigal Son* (pl.126).

Productions by the original choreographers while they were still alive commanded authority, even though they, like Balanchine, might introduce changes to suit new dancers and altered times. But many of the ballets were passed on like 'Chinese whispers' from dancer to dancer, so that some became ghosts of their former productions or were distorted. At the same time, particularly following the Ballets Russes auctions of the 1960s, there was a desire to reproduce designs accurately.

There have been several approaches to reconstructing works. Serious attempts have been made to decipher notation written down by the original choreographers, for example the productions of *L'Après-midi d'un faune* by Ann Hutchinson Guest and Claudia Jeschke, based on the choreographic score written by Nijinsky while under house arrest as an enemy

alien in Budapest between 1914 and 1916. Since the 1980s there has also been an archaeological approach, in which every surviving shred of information about a production is unearthed before being pieced back together. Although it involves informed guesswork, there can be an excitement at seeing such evocations of lost ballets (pls 127 and 128). The leading exponent of this genre is the choreographer Millicent Hodson, working with her partner Kenneth Archer who supervises the reconstruction of the designs. Together, they have recreated Nijinsky's ballets *The Rite of Spring* (1987), *Till Eulenspiegel* (1994), *Jeux* (1996, pl.128) and Balanchine's *La Chatte* (1991), *Le Chant du rossignol* (1999) and *Le Bal* (2005). Although their work is controversial, Hodson is honest about the limitations of their sources and much has been discovered about the Ballets Russes through their research.[14]

In the twenty-first century some reconstructions have moved further away from their origins. In mounting *Pas d'acier* at Princeton in 2005 the team of musicologist Simon

129. Ivan Putrov and
Roberta Marquez of
The Royal Ballet in Jerome
Robbins's *Afternoon of
a Faun*, 2006.
Photograph by
Graham Brandon.
V&A: Theatre &
Performance Collections

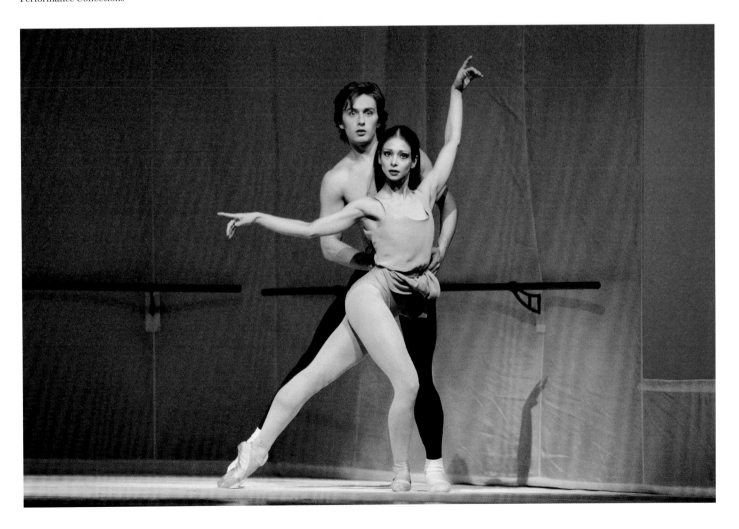

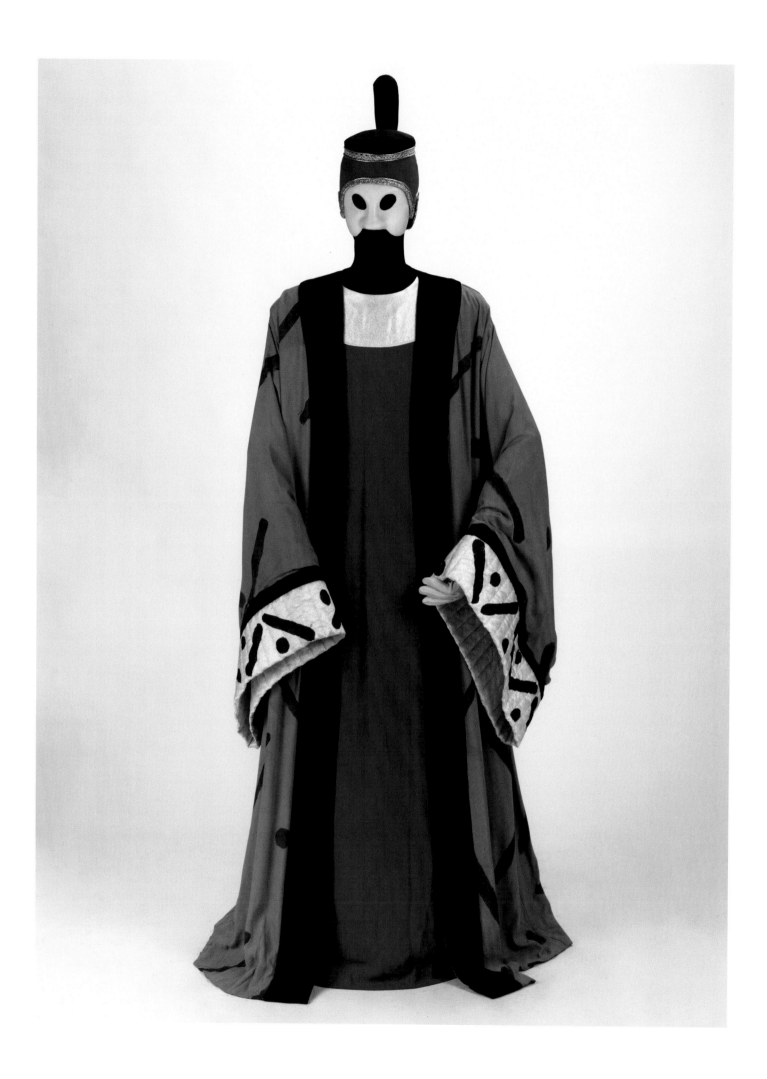

Morrison and dance/theatre historian Lesley-Anne Sayers decided that although they were reconstructing the set and presenting Prokofiev's score as faithfully as they could, Massine's 1927 choreography had failed to fulfil the intentions of the composer and designer developed two years earlier. Therefore, they invited Hodson to choreograph the work afresh according to the 1925 synopsis.

Certain recent Russian productions, particularly those by Andris Liepa, have taken their interpretations further, cashing in on the brand name of 'Les Saisons Russes'. Thus Leipa's *Thamar* and *Le Dieu bleu* have entirely new choreography by Jurius Smorighines and Wayne Eagling respectively, with sets and costumes that are only very loosely based on the original designs. *Le Dieu bleu* used a score by Alexander Scriabin not Reynaldo Hahn, and *Thamar* opened with a green laser display.

The scores created for Diaghilev's Ballets Russes have been a treasure trove for choreographers. To date there have been more than 200 different choreographic works to *The Rite of Spring*, over 100 to *The Firebird* and 75 to *Les Noces*. While some modern interpretations are bewildering and remote from the original creators' intentions, others give the scores a greater immediacy for contemporary audiences. One of the most effective is *Afternoon of a Faun* by Jerome Robbins, created in 1953, which subtly quotes from the 1912 work (pl.129). With just two dancers it presents a similar narrative and mood to Nijinsky's original choreography but instead of Nymphs and Faun set in a rural Greek landscape Robbins's production concerns dancers in a ballet studio.

In Britain, creative collaborations between choreographer, composer and artist/designer have been used to extend the traditions established by Diaghilev, although usually lacking a Diaghilev-figure to supervise or guide the collaborators. During the 1980s a number of leading artists became involved in stage productions. In 1981 the British team of John Dexter and David Hockney produced two triple bills at New York's Metropolitan Opera House, clearly developed in the spirit of Diaghilev. The first, *Parade*, used Satie's score and a cast derived from Picasso's designs to introduce the characters for Francis Poulenc's *Les Mamelles de Tirésias* and the Colette/Ravel collaboration *L'Enfant et les sortilèges*. The second was a Stravinsky programme of *The Rite of Spring*, *Le Chant du rossignol* (pl.130) and *Oedipus Rex*. At the same time in London, the former Director of the Whitechapel Art Gallery, Bryan Robertson, encouraged Ballet Rambert and The Royal Ballet to invite fine artists including Bridget Riley, Howard Hodgkin and John Hoyland to design ballets, often in collaboration with up and coming choreographers. More recently, for The Royal Ballet, the choreographer Wayne McGregor collaborated with architect John Pawson and the artists Julian Opie and Tatsuo Miyajima to create the visual settings, and the composers Joby Talbot, Max Richter and Kaija Saariaho the scores for *Chroma* (2006), *Infra* (2008) and *Limen* (2009) respectively. The involvement of artists and innovative composers in dance works is not restricted to collaborations. The American modern choreographer, Merce Cunningham, worked alongside artists including Jasper Johns, Robert Rauschenberg, Frank Stella and Andy Warhol, and composers John Cage, David Tudor and Gavin Bryars. Their creations simply occupied the same time and space, any other links emerged entirely by chance as the creators only ever brought their elements together in performance.

Many of Diaghilev's collaborators were active for decades after his death. Composers who had learnt their craft under his guidance continued to write for ballet. Stravinsky famously composed for Balanchine in America and Prokofiev created three full evening ballets in the Soviet Union, two of which, *Romeo and Juliet* and *Cinderella*, have become staples of virtually every ballet company. French ballet in the 1930s and 1950s in particular drew on the work of Diaghilev's French composers such as Henri Sauguet, who collaborated on several of Boris Kochno's projects including the score for Roland Petit's *Les Forains*. Meanwhile in Britain, Constant Lambert, who had first been exposed to working with a ballet company when composing *Romeo and Juliet* in Monte Carlo in 1926, became the influential founding musical director of The Royal Ballet.

Similarly, many of Diaghilev's designers retained an interest in theatre alongside other art forms. Picasso never again created designs as effective as those for *Le Tricorne* but Matisse went on to devise sets and costumes for Massine's symphonic *Rouge et Noir* (1939). André Derain produced lively stage designs throughout his career, working with many of the twentieth century's great choreographers. Pavel Tchelitchev, who in 1928 had projected film onto gauzes in *Ode*, continued to experiment with light and fabric, although the use of projection in set design only became commonplace in the late twentieth century. Natalia Goncharova continued to design for ballet, particularly for Boris Kniaseff's companies in France and South America, but her work had long been out of fashion

130. After David Hockney, costume for the Bonze from *The Nightingale (Le Rossignol)*. Costume and headdress in crêpe, lamé, velvet and cotton, with plastazote mask, 1983.
V&A: S.26:1 to 6–2003

131. The breaking of the egg that contains Kashchei's soul in The Royal Ballet Company's production of *The Firebird* at The Royal Opera House, Covent Garden, 2006. Photograph by Graham Brandon. V&A: Theatre & Performance Collections

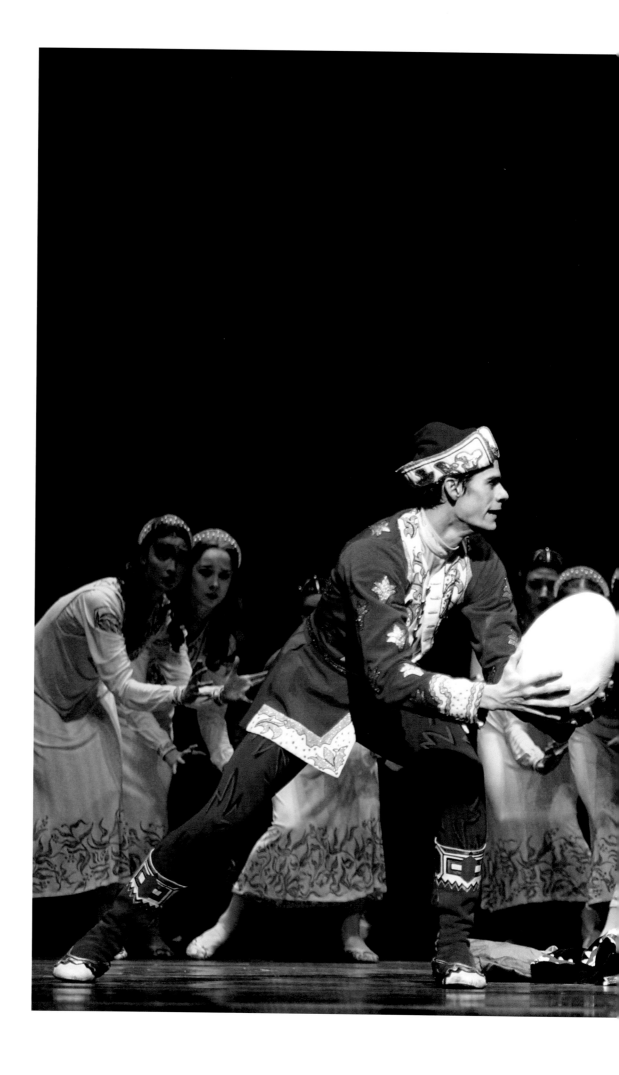

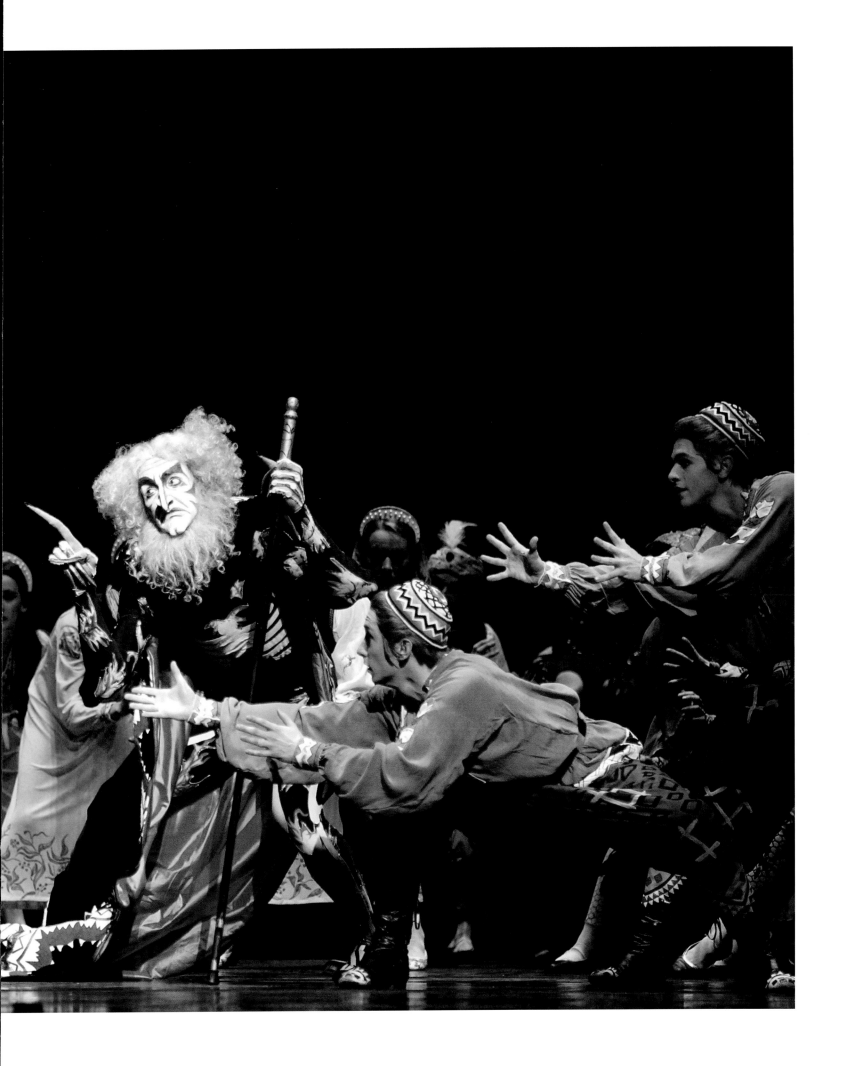

by the time *The Firebird* was revived by the Sadler's Wells Ballet in 1954 (pl.132). The production reminded the art world of her talent and her work again became in demand. Since her death in 1962, Goncharova has been the focus of numerous high-profile exhibitions and in June 2008 her early Rayonniste painting, *Les Fleurs*, from about 1912, created a new record for a female artist, selling at auction for over 5.5 million pounds.

Alexandre Benois never went out of fashion and his nostalgic designs for early ballets such as *Petrushka* and revived classics including *Giselle* and *The Nutcracker* were repeated many times. He also established a dynasty of designers with his son Nicola (who became principal scenographer for La Scala, Milan) and niece Nadia (who designed for the British stage), both continuing in his footsteps. Benois was also one of the key figures in shaping the way in which subsequent generations would view the Ballets Russes. In the first generation of literature Walter Nouvel (pl.133), who had supported Diaghilev from the days of *Mir iskusstva* throughout the existence of the Ballets Russes, Alexandre Benois and Serge Lifar were the main sources of first-hand information. While the Ballets Russes was active, illustrated monographs on star dancers, the stories of the ballets and art volumes on designers' work were published. After Diaghilev's death, Nouvel lent his unpublished manuscript of the company's history to Arnold Haskell for his *Diaghilev: His Artistic and Private Life* (1935) while Benois guided Prince Peter Lieven before publishing the story under his own name. Both approached the history from the perspective of *Mir iskusstva* and Benois allowed

himself a far more central role in the company's evolution than now appears justified. Inevitably, they privileged the Russian creations over Diaghilev's avant-garde French productions. In Paris, Lifar and his associates at the centre of Russian émigré society, also emphasized the Russian aspects in *Serge Diaghilev: His Life, His Work, His Legend: An Intimate Biography* (1940), which reinforced Lifar's line of succession as Director of the Paris Opéra Ballet.

This perspective remained unquestioned until Nesta MacDonald's investigation of newspaper reports in *Diaghilev Observed by Critics in England and the United States: 1911–1929* (1975) and Lynn Garafola's analysis of the company's business dealings in *Diaghilev's Ballets Russes* (1989). It was not until 2009 that the first complete biography of Diaghilev was published – Sjeng Scheijen's *Diaghilev: A Life* – detailing his early years in Russia and presenting a fully rounded perspective of the man. Comprehensive itineraries of the company's extensive tours were also published in the same year, providing a clearer picture of what was performed and just how far its members travelled.[15]

It has been an ongoing frustration that Diaghilev's Ballets Russes were never filmed. Diaghilev prevented it by writing into his contracts a clause that forbade dancers from performing in front of the camera.[16] There is a certain irony in this, since several of Massine's ballets, including *Parade* and *The Good-Humoured Ladies*, were influenced by film characters or techniques, and Massine used film to assist in his studies of Spanish dance leading to the creation of *Le Tricorne*. In addition, from 1910 to the late 1920s several of Diaghilev's dancers, including Vera Karelli, Anna Pavlova,

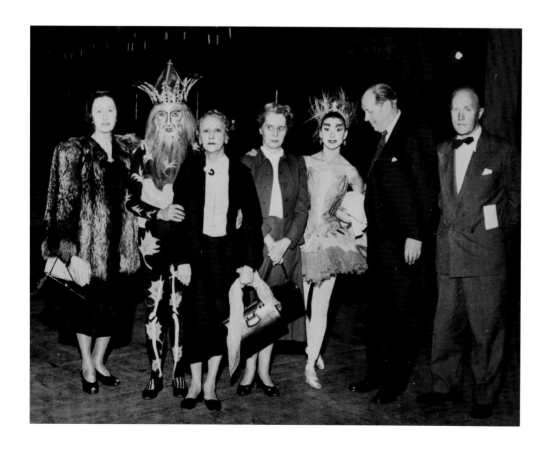

132. Lubov Tchernicheva, Frederick Ashton, Tamara Karsavina, Ninette de Valois, Margot Fonteyn, Serge Grigoriev and Harijs Plucis after a rehearsal of *The Firebird*, 1954. Photograph by Douglas Elston. Private collection

Opposite
133. Walter Nouvel, Serge Diaghilev and Serge Lifar on the Lido, Venice, August 1927. V&A: Theatre & Performance Collections

Tamara Karsavina and Lydia Kyasht, performed in feature films in Russia, Hollywood, Germany and Britain respectively.[17] Preliminary plans to film the Ballets Russes were made on three separate occasions. Soon after the debut of Diaghilev's company at the Théâtre du Châtelet, Paris in 1909, it was hoped that the Polovtsian Dances from *Prince Igor* would be recorded. As Prince Peter Lieven recalled: 'Everything was arranged, a field was found outside Paris to represent the Russian Steppes, and a day was fixed. Unfortunately, at the last moment the scheme collapsed over money matters, and a valuable and very interesting document was thus lost.'[18] On 29 December 1921, *The Times* announced the forthcoming filming of *The Sleeping Princess* in colour with synchronized music, but this also came to nothing. Correspondence in the V&A's Ekstrom Archive indicates that the USA tour planned for the autumn of 1928 or 1929 was to have included a period of filming the company's repertoire using film with sound, but none of these arrangements were ever realized.

Given that in America an awareness of Russian ballet coincided with the development of film it is little surprise that on the silver screen most ballerinas are 'Russian'. But it was really the idea of Diaghilev as a Svengali figure that intrigued film producers. This becomes evident with the 1931 Warner Brothers film *The Mad Genius*, choreographed by Adolph Bolm, in which John Barrymore plays a cripple who nurtures a talented boy dancer, only to destroy him when he falls for a ballerina. It instigated a succession of ballet films leading to the famous 1948 Emeric Pressburger and Michael Powell production, *The Red Shoes*. While providing inspiration for film-makers, Diaghilev and Nijinsky did not appear as characters in film until Herbert Ross's 1980 film *Nijinsky*; the challenge of finding performers to evoke such personalities delayed the recording for decades.[19]

The lack of film material meant that makers of documentaries turned to recordings of ballets created for the Ballets Russes as danced by later companies. The entertaining documentary, *Ballets Russes* (2005) by Dayan Goldfine and Dan Geller, is enriched by footage from 'home movies' recorded by J. Ringling Anderson during the 1930s tours in Australia. From the 1950s a number Ballets Russes creations were recorded for television and film, often in stagings by Serge Grigoriev and his wife Lubov Tchernicheva. For example, *The Firebird* danced by The Royal Ballet was recorded by both Paul Czinner in colour on film in a stage setting with Margot Fonteyn in the title role, and by Margaret Dale in a careful adaptation for black and white television starring Nadia Nerina. One of the best television recordings of a ballet remains Bob Lockyer's *Les Noces* in a programme that also showed Nijinska at work in the studio. Lockyer had been the picture researcher on the most significant television recording concerning the Ballets Russes, John Drummond's two-part *Omnibus* entitled *Diaghilev: The Years Abroad and The Years in Exile* (1968). Made over a period of two years, Drummond began by persuading dancers, particularly Karsavina and Sokolova, to appear on camera in old age

and went on to interview 18 individuals who participated in or witnessed the Ballets Russes. He allowed their words, supported by designs, photographic images and music, to convey the complexity of the man and the atmosphere of the company. Rightly, he refused to have other dancers impersonate performers of the Ballets Russes: 'I am convinced that a still photograph of Nijinsky is more eloquent than any other dancer dancing' (pl.134).[20]

Throughout the twentieth century the influence of the Ballets Russes, its designers, ballets and dancers reached unlikely places. In the 1920s, although the Ballets Russes never visited Asia, designs by Léon Bakst were printed on fabrics in Japan, and a teashop in London was named 'The Good-Humoured Ladies'. Not only did Osbert Lancaster satirize the first Russian period of interior decoration, that style also became evident in set design for Amanda's flat in the National Theatre's 1999 production of Noel Coward's *Private Lives*. Indeed the myth of Nijinsky has resonated beyond the world of dance. The racehorse named after him, ridden by Lester Piggott, won the English Triple Crown and was voted by *Sun* readers as the 'horse of the millennium'.

Since 1989 (60 years after Diaghilev's death), and with the growth of Glasnost and the fall of the Berlin Wall, new opportunities to study the Ballets Russes have opened up. This is particularly so in Russia, where Diaghilev's reputation has grown with a greater understanding of his contribution to the arts in the rest of Europe and the Americas. In 2003 a regular festival of performances and events, *Diaghilev Seasons*, began in Perm in the Urals, and in 2009, to celebrate the centenary of the Ballets Russes, there was a major exhibition in Moscow, and a festival in St Petersburg. In March 2010 it was announced that the British architect David Chipperfield would rennovate and extend the Perm Opera House and Ballet Theatre, to create an appropriate memorial to one of the city's most famous citizens.

Today there are a still a few people in Britain who can recall seeing the Ballets Russes in its last years in the late 1920s, but the majority of us rely on the music, pictures, costumes, archives and interviews to evoke this fascinating chapter in the evolution of the performing arts. Diaghilev and the artists he cajoled into creating some of their finest work continue to insipre their successors in many walks of life. More than ever, it seems that the composer Sergei Prokofiev was prescient in his observation that Diaghilev was 'a giant … whose dimensions increase the more he recedes into the distance'.[21]

134. Signed photograph of Vaslav Nijinsky in *Le Spectre de la rose*, 1911. Photograph by Bert. Marie Rambert said 'When he danced *Spectre*, he was the very perfume of the rose, because in everything he extracted the essence.' V&A: Theatre & Performance Collections THM/165

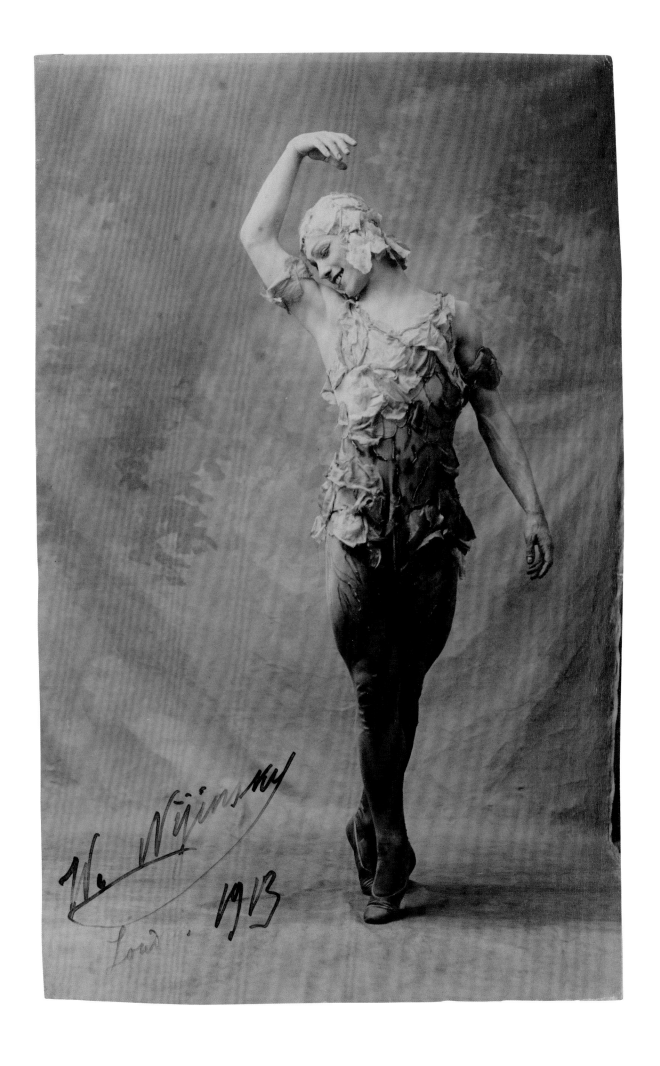

DIAGHILEV'S DEATH

Nina Lobanov-Rostovsky

Serge Diaghilev died in Venice at the Grand Hotel des Bains on 19 August 1929. His death signalled the end of an extraordinarily creative 20 years in the history of ballet, music and stage design. In addition to the dancers, choreographers, musicians and painters whom he discovered and nurtured, he left a legacy of uncompromising ideas and ideals for dance, which still influence us today. His death was front-page news in Europe and the USA, and numerous obituaries and reminiscences appeared in the countries in which the Ballets Russes had danced. In the USSR his death was mentioned in only one journal devoted to literature and art.

Two days later, a large funerary gondola containing Diaghilev's coffin set off from the Grand Hotel on the Lido, followed by two other gondolas transporting a few close friends, among them: Boris Kochno, Serge Lifar, Coco Chanel, Misia Sert and Diaghilev's cousin Pavel Koribut. They headed across the lagoon for the island of San Michele where Diaghilev was buried in the Greek Orthodox section of the cemetery. A Greek Orthodox priest held a brief service during which a grief-stricken Lifar had to be restrained from throwing himself into the grave. Diaghilev's tomb, designed by the Greek artist Paolo P. Rodoconachi, was erected in the late summer or autumn of 1931. It is engraved with the words: '*Venise, inspiratrice éternelle de nos apaisements*' (Venice, source of peace). According

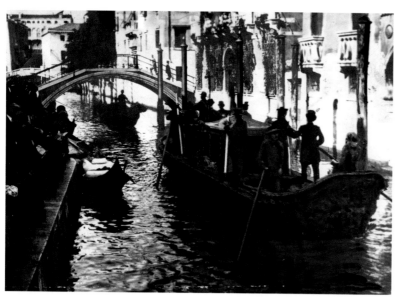

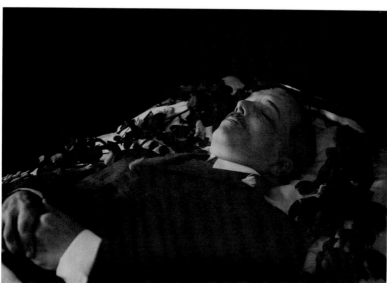

Left
Diaghilev's funeral gondola.

Left, below
Diaghilev laid out on his deathbed, 21 August 1929. Archives Nouveau Musée National de Monaco, Serge Lifar Collection

Opposite, left
Diaghilev's grave on the island of San Michele, Venice, Italy.

Opposite, right
Diaghilev's final complete hotel bill, from the Grand Hotel des Bains, Venice, 1929. V&A: Theatre & Performance Collections THM/7/4/5/50

to Lifar, Alexandre Benois suggested the quotation, which comes from Théophile Gautier.

Diaghilev fell deeply in love with Venice on his first trip there aged 18, and returned repeatedly for his summer holidays during the last 20 years of his life. Like many others before him, Diaghilev saw Venice as a fantastic stage. His hero Richard Wagner had died there and Diaghilev was convinced that he too would end his days in the city, predicting this as early as 1902 in a letter to his beloved stepmother.

Diaghilev died suddenly of blood poisoning. He was bedridden for the last week of his life, nursed devotedly by a former lover Boris Kochno and one of his last lovers Serge Lifar. It is mistakenly believed that he died penniless. In fact

he had a large sum of money in the hotel safe, which he asked Kochno to withdraw and re-deposit in his name. He had also assembled an important and valuable collection of Russian books, pictures and letters, which later went to Kochno and Lifar. Furthermore, the summer of 1929 was one of the few times in his hectic professional life that Diaghilev could have relaxed without financial worries. The 1928 season had been successful in every way, and good contracts were signed for 1929.

In later years, Diaghilev's close friend Misia Sert reminisced about the last time she saw him, on the eve of his death. He was lying upon his bed dressed in his dinner jacket. It was terribly hot: 'We evoked old memories and you then said to me – you who had

discovered one after another all the composers who were to influence and shake up the music of our time – that your secret favourites were Tchaikovsky's *Pathétique* and Wagner's *Tristan and Isolde*.'[1] Diaghilev's temperature soared and he was only semi-lucid towards the end, but he hummed and sang snatches of these two favourite works. He died as he had lived, celebrating music.

1 *Ballets russes de Diaghilew. 1909 à 1929*, 1939, p.10.

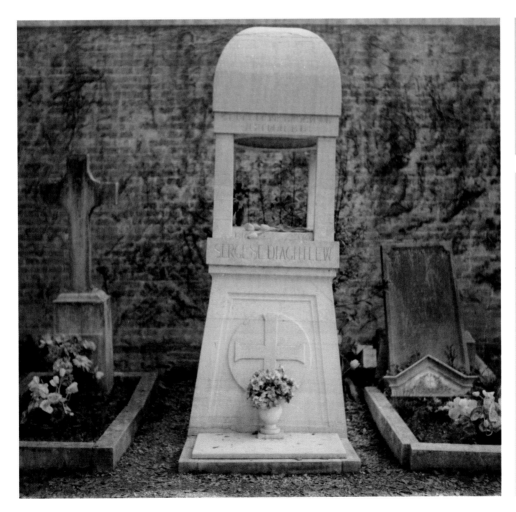

NOTES AND
REFERENCES

B

SERGE DIAGHILEV AND THE STRANGE BIRTH OF THE BALLETS RUSSES

Geoffrey Marsh

1 Held in the Tauride Palace, St Petersburg 19 March–9 October 1905 with settings designed by Léon Bakst. The exhibition contained over 4,000 portraits. See Scheijen 2009, p.132.

2 On 17 February 1905. Grand Duke Sergei was Governor General of Moscow from 1891–1905.

3 *Vesy* (1905), no.4, pp.45–6.

4 On 22 January 1905, troops stationed outside the Winter Palace fired into a huge crowd of over 200,000 peaceful demonstrators, killing and wounding hundreds.

5 Almost all such posts were part of the Imperial bureaucracy with most organizations formally led by the tsar or one of his numerous relatives. Ironically, following the overthrow of the tsar in 1917, Diaghilev was invited to become Minister of Culture by Kerensky's provisional government. However, by then he was fully occupied with the Ballets Russes and declined the offer.

6 Zilbershteyn and Samkov 1982, ii, p.335.

7 In 1897, 1898, 1899, 1900, 1901, 1902, 1903 and 1906. For precise dates see O. Brezgin, 'Sergei Diaghilev: A Chronology', in Boult, Tregulova and Giordano 2009, pp.313–16.

8 Established in 1898 with Alexandre Benois, Léon Bakst and Diaghilev's cousin Dima Filosofov.

9 On 22 September 1899 he was appointed Special Projects Administrator under Prince Volkonsky, Director of the Imperial Theatres. There he produced the well-regarded Year Book in 1900 for the 1899/1900 season. He was fired in March 1901 from this post and from all future government service after upsetting key figures in the Establishment. The latter penalty was removed by Imperial Decree on 31 January 1902 and Diaghilev received a post in the tsar's personal chancery. See Scheijen 2009, p.121.

10 He was also an accomplished academic researcher and writer. His monograph *Russian Painting in the Eighteenth Century: D.G. Levitsky*, published in April 1902, was given the Supreme Uvarov Award by the Russian Academy of Sciences in 1904.

11 For a vivid impression of the city see Andrei Bely's *Petersburg*, first published in 1916, which captures the febrile atmosphere in this period.

12 The Imperial Theatres, providing drama, opera and dance in St Petersburg and Moscow, were a department of the Imperial bureaucracy.

13 On his accession he apparently stated: 'What am I going to do? I am not prepared to be a Tsar. I never wanted to become one.' See Figes 1996, p.18.

14 For example, the Holy Synod banned the performance of Oscar Wilde's *Salomé*, see Scheijen 2009, p.177.

15 Culminating in the 'Bolshevik' uprising in Moscow in December 1905 when over 1,000 people were killed. It was followed by mass arrests and summary executions. See Figes 1996, p.201.

16 The victory established Japan as the world's sixth strongest naval power while the Russian navy declined to being barely stronger than that of Austro-Hungary.

17 In February there had been protests at the Conservatoire, which led to its director Rimsky-Korsakov being fired. Among the 12 delegates elected by the strikers were Anna Pavlova, Tamara Karsavina and Mikhail Fokine, all of whom were to work for the Ballets Russes. See Garafola 1989, pp.3–5.

18 Letter to Benois, 16 October 1905, quoted in Scheijen 2009, p.138.

19 The title and date of Repin's painting is given in old style. It promised personal immunity and freedom of religion, speech, assembly and association. It also proposed broad participation in the Lower House of Parliament (Duma), the introduction of universal male suffrage and acceptance that no law should come into force without the consent of the Duma.

20 In the preliminary sketch, now in the State Central Museum of Contemporary Political History of Russia, Repin gave prominence to a marching band of sailors. Their removal in the final version accentuates the bourgeois mix of professors, intellectuals, students and middle-class women with the workers relegated to the background.

21 See Lifar 1940, p.160. Diaghilev's aunt, Anna Filosofova, was a noted radical and campaigner for women's rights.

22 Brother of the famous dancer Nicolas Legat. He was a teacher of Nijinsky and married to Marius Petipa's daughter Marie.

23 This included an annual subsidy from 1900 of 15,000 roubles a year for *Mir iskusstva* reduced to 10,000 roubles from 1903. There was also a subsidy for the 1905 portrait exhibition.

24 Letter to Benois, quoted in Scheijen 2009, p.138.

25 'I closed the exhibition almost without any scenes … But I am not sure the pictures sent back will get to their right places! … but at present I am just tediously and dully waiting for events without knowing where they will take one', Scheijen 2009, p.137. Many of the portraits were subsequently destroyed in the upheavals of 1905–21.

26 By the end of 1905 Russia was effectively bankrupt. On 16 April 1906 the largest-ever Russian loan of 2,250 million francs was raised in Paris with British support. There was concerted political opposition from the Left who claimed the loan would just support political repression. Gorky famously wrote: 'I spit in your eyes, beautiful France!'

27 Until 1891 Russia's international strategy had been based on alliance with Germany. However, the growing belligerence of the Kaiser led to a reassessment and a growing rapprochement with France. This was sealed by a military pact in December 1893. From then on Russia's rapid industrial expansion became increasingly dependent on French investment. See Lincoln 1983, p.17.

28 The effectiveness of this strategy is revealed in the writings of Sir Arthur Nicholson of the British Foreign Office in 1914. 'I wish indeed that we could bring the feelings of the public in this country in a similar state towards Russia as they are towards France … You may laugh at me for saying so, [but] both the Russian ballet and the Russian opera have done good. Knowledge of Russian literature too is tending to show that Russians are not such barbarians as most people tend to think', letter to the British Ambassador, Berlin, 17 April 1914, in Nicholson Papers, FO 800/373.

29 See Rimsky-Korsakov 1942, p.436, quoted in Garafola 1989, p.171.

30 The idea may have originated with Benois, see Scheijen 2009, p.148. The Salon d'Automne was started in 1903 by a group of painters and sculptors led by Pierre-Auguste Renoir, Auguste Rodin, Albert Marquet, Georges Rouault, André Derain and Henri Matisse as an alternative to the strict conservative policies of the official Paris Salon.

31 Duma elections took place from mid-March to late April, with the opening on 27 April. By then political reaction was setting in with a crackdown on the press in late March, and 70 per cent of country remained under martial law. That Diaghilev was abroad at this time gives an indication of his interest in domestic politics.

32 I am indebted to Sjeng Scheijen for this information. These were the so-called Intercalated Games, which were considered a major success after the relative failures in Paris (1900) and St Louis (1904) where the games were overshadowed by the concurrent International Exhibitions. Medals were awarded as normal but these Games were subsequently 'demoted'.

33 In 1906 the Greek railway system was not yet connected to the European network. Diaghilev seems to have taken a boat from Constantinople to Athens.

34 The artists Léon Bakst and Valentin Serov, who were both fascinated by Greece, undertook a major tour around this time.

35 In architecture, sculpture, painting, literature and music.

36 Due to the eruption of Vesuvius on 7 April 1906, the Rome Games were cancelled and moved to London where they were combined with the Franco-British Exhibition at the White City.

37 The countess's account of her meeting with Diaghilev, given in Lifar 1940, pp.167–8, places the date in June 1906 when he had only just arranged his painting show. In October a concert of Russian music was presented to coincide with the Russian painting exhibition.

38 In 1906, Diaghilev had also met Gabriel Astruc a leading French-Jewish music promoter and

DIAGHILEV
THE MAN
Sjeng Scheijen

publisher in Paris. Astruc provided a strong organizational base in Paris and probably did much to boost Diaghilev's confidence in the viability of promoting performing arts events. He was also helped by Robert Brussel, the music critic of *Le Figaro*.

39 The first concert was attended by four grand dukes and the Russian ambassador. As soon as the 1907 season was over, Diaghilev began to plan for a full opera season in 1908, to showcase *Boris Gudonov* starring Chaliapin.

40 Buckle 1979, pp.95–101, gives a detailed description of the concerts.

41 Along with the other major European countries, Russia's empire expanded throughout the later nineteenth century through a mixture of conquests, protectorates and other agreements.

42 It is not certain exactly when Diaghilev left St Petersburg but he was in Paris on 23 December 1906.

43 For most Europeans, Russia was simply remote and undeveloped. By contrast, Paris was recognized as the international city *par excellence*. This reputation was actively promoted by the series of great international exhibitions in 1855, 1867, 1878, 1889 and 1900, which attracted millions of visitors, including, in 1900, Diaghilev.

44 The sources of Diaghilev's income are obscure for much of his life. In 1895 he inherited 60,000 roubles from his mother on coming of age. However, much of this seems to have been spent on paintings and furniture for his apartment. Like many cultural entrepreneurs Diaghilev was probably adept at 'top slicing' gifts and subsidies to give him the income to cover his own requirements.

45 Letter of 1928, quoted in Lifar 1940, pp.176–7. Also during 1899–1901, he worked on the abortive production of Delibes's ballet *Sylvia*.

46 The events at this time are complicated. See Scheijen 2009, pp.177–82. The sudden death of Grand Duke Vladimir, who had been Diaghilev's key protector at court in February 1909, was undoubtedly a severe blow. Arguably this was the key turning point for Diaghilev. His critical success in 1909, despite these problems, must have been a huge boost to his confidence and gave him the resolve to fight Astruc's temporary efforts in late 1909 to force him out of Paris.

47 Performing Arts Section, New York Public Library, Astruc Papers, telegram 6 April 1909.

48 The rehearsals, which started on 15 April 1909, are often taken as the starting point of the company. In reality, Diaghilev was hiring the tsar's dancers during their vacations from the Imperial Ballet. It was only after two ballet seasons that, in the autumn of 1910, Diaghilev decided to establish his own permanent company and began signing contracts with key individuals.

49 He did seek renewed subsidy from the tsar in 1910 but was ultimately rebuffed.

50 He organized exhibitions of ballet-related designs on several occasions.

51 Diaghilev would also have been well aware that 1913 was the tercentenary of the Romanov dynasty, which would have been a great opportunity to show off his Ballets Russes, particularly in Moscow, if he could secure a venue.

52 Buckle suggests this was his last visit (Buckle 1979, p.272). Scheijen presents evidence that he may have returned briefly as late as August 1914, following the death of his father (Scheijen 2009, p.303). Thereafter, Diaghilev largely lived in hotels although he did rent an apartment in Paris in the late 1920s to house his outstanding book collection.

53 Although there were various successor companies, the Ballets Russes came to an end with his death.

54 Letter of 30 August 1929, Nouvel to Stravinsky, quoted in Scheijen 2009, p.443.

1 Heyman 1997, p.109.

2 Letter from Serge Diaghilev to V.V. fon Mekk, 9 January 1900. N.L. Prijmak, 'Pis'ma S.P. Diaghileva v.v. Fon Mekku', in Belyaeva 1987, p.131.

3 From a letter to his stepmother. S.P. Diaghilev to E.V. Diaghileva, 22 August 1902, Institute of Russian Literature, St Petersburg, fond 102, ed. khr. 84, l.406-7.

4 These architects were the Austrian, J.M. Olbrich, and the Scot, Charles Rennie Mackintosh. Dmitry Filosofov, 'Sovremennoe Iskusstvo i Kolokol'nja Sv. Marka', in Filosofov 2004, p.237.

5 Ibid., pp.243–5.

6 Zilbershteyn and Samkov 1982, ii, pp.463–4. The document referred to is located in the manuscript division of the Russian National Library in St Petersburg, fond 124 d. khr. 1608e.

7 For an extensive description of the career of Diaghilev's father in the army see Panchulidzeva 2008, p. 258.

8 The declaration of bankruptcy and the subsequent auctions are published in the *Permskiye gubernskiye vedomosti*, nos 76, 78, 87, 97, 102, between 22 September and 22 December 1890.

9 The source for this story is Diaghilev himself, who told it to many people including a journalist. See 'Around the world with the Russian Ballet', a previously unpublished interview with Serge Diaghilev in *Dance Magazine* (September 1979).

10 S.P. Diaghilev to L.N. Tolstoy, 19 March 1893, ORGMT (Tolstoy Museum, Moscow), fond. 1, op. 2, 148/139.

11 Diaghilev to Diaghileva, 14 October 1892, Institute of Russian Literature, St Petersburg, fond 102, ed. khr. 84, l.23–4.

12 Telyakovsky 2002, p.439.

13 Aleksandr Benua, dnevniki 1906, diary entry of 4–8 June in *Nashe Nasledie* (2008), no.86.

14 Harry Graf Kessler, diary entry of 30 October 1911. Kessler 2005, pp.734–5.

15 Lopokova to Keynes, 14 January 1924. Hill and Keynes 1989, p.141.

16 Drummond 1997, p.301.

17 Serge Diaghilev to Yelena Diaghileva, 19 November 1893, Institute of Russian Literature, St Petersburg, fond 102, ed. khr. 87, p.18 (427).

THE TRANSFORMATION OF BALLET
Jane Pritchard

1 Igor Stravinsky, 'The Diaghilev I Knew', *The Atlantic Monthly* (November 1953), vol.192 (5), pp.33–6.

2 'The Russian Influence on English Art', *Tatler* (2 December 1914), pp.202–3.

3 This was hardly surprising in British productions, most of which were presented in music halls under the 1843 Theatres Regulation Act which remained in operation until 1912 and forbade the presentation of narrative works in theatres licensed as music halls.

4 *Féeries* were entertainments, often but not exclusively derived from fairy tales, incorporating two or three ballets on specific themes. Among the most successful were *The Black Crook* (which in an 1866 adaptation in the USA would contribute to the development of the American musical) and Jacques Offenbach's *Le Voyage dans la lune* (1875). *Voyage*, with its acclaimed 'Snow Ballet' by Henri Justamant, was presented internationally, launching a flurry of ballets on the same theme including the 'Land of Snow' in the Imperial Ballet's *The Nutcracker*, a ballet that was at its premiere condemned, in spite of Tchaikovsky's score, for being like a *féerie*.

5 For example in 1918, the Ballets Russes was rescued from collapse by Oswald Stoll inviting Diaghilev to present his company at the London Coliseum. Although Diaghilev felt that performing in variety was a come down, the Coliseum in the 1910s and 1920s was London's primary dance house.

6 The post-Romantic ballet did not die with the advent of the Ballets Russes, indeed in 1922–3, when the company first made Monte Carlo its base, Diaghilev's dancers had to participate in ballets produced by M. Belloni such as *Coppélia*, *La Korrigane* and *Les Deux pigeons*, a curious mixture of old ballets and new dancers.

7 See Giannandrea Poesio, trans. Anthony Brierley, 'The Story of the Fighting Dancers', *Dance Research* (Spring 1990), VIII (1), pp.28–36.

8 André Levinson, in Beaumont 1930, p.xi.

9 *La Bayadère*, created at the Bolshoi Theatre, St Petersburg on 4 February 1877, included the hero's drug-induced multiple vision of the ghost of his beloved temple dancer. 'Ballet blanc' is a commonly used shorthand reference for the scenes in nineteenth-century ballet in which the corps de ballet, usually representing visions, ghosts and spirits is dressed in pale colours, if not actually in white.

10 The divertissements that Diaghilev presented under the title *Le Festin* included dances to music by Russian nationalist composers; in its 1909 form: Mikhail Glinka, Nikolai Rimsky-Korsakov, Pyotr Tchaikovsky, Alexander Glazunov and Modest Mussorgsky.

11 Carlotta Brianza toured in the United States for the Kiralfy Brothers (1883–4) before achieving fame in Europe in 1886 dancing in *Brahma* and *Vivienne* at the Eden-théâtre, Paris. After *Excelsior* at the Arcadia Theatre, St Petersburg (1887) she starred in 'music-hall' ballets choreographed by Katti Lanner at the Empire Theatre, London, and in 1888 creating the title role in *Dilara*. Brianza danced in St Petersburg on a number of occasions, commuting in the 1890s between the Maryinsky, St Petersburg, the Eden-théâtre, the Empire and La Scala. Brianza then danced at the Théâtre royal de la Monnaie, Brussels (1902) and at the Opéra Comique, Paris (1903–4).

12 Ballets by Marius Petipa included *La Bayadère* (1877), *The Sleeping Beauty* (1890) and, with his assistant Lev Ivanov, contributions to *The Nutcracker* (1892) and *Swan Lake* (1895).

13 Gorsky never choreographed for Diaghilev although there were plans for him to create a ballet to music by Nikolai Tcherepnin based on Edgar Allan Poe's *The Mask of the Red Death* in 1913. A czardas (a Hungarian dance) he choreographed was included in *Le Festin*.

14 In productions by Stanislavsky (1863–1938) actors appeared as rounded characters and the crowd became a collection of individuals rather than a uniform chorus.

15 In St Petersburg, extracts from *Sylvia* Act II had been danced by Antoinette del'Era at the Arcadia Theatre in 1886 and the complete ballet seen in Georgio Saracco's production starring Adelina Rossi at the Mikhailovsky Theatre.

16 *Sylvia* had been presented as a full evening's entertainment at its premiere at the Théâtre national de l'Opéra, Paris, in 1876, choreographed by Louis Mérante. Within a decade it was being performed in the USA and Vienna.

17 This last was choreographed by the Legat brothers and was the first ballet designed by Léon Bakst. Possibly, because Diaghilev had found this work charming, he used it as the basis for his *La Boutique fantasque* 16 years later, which premiered at the Alhambra, London to enormous acclaim. London had seen earlier adaptations of *Die Puppenfee* including *The Dancing Doll* at the Empire Theatre in 1905 and Anna Pavlova's *The Fairy Doll*.

18 Diaghilev's company gave its first performance at Monte Carlo on 6 April 1911; previous performances were given by artists on leave from the Imperial Theatres.

19 Letter from Diaghilev to a French journalist, in which he states that the costumes for Boris Godunov will be 'exact replicas ... based on ... the famous engraving *The Embassy of Ivan the Terrible to Emperor Maximilian* ... The accessories are from authentic documents shut away in the secret rooms of the Moscow museums.' I am grateful to Lynn Garafola for drawing my attention to the letter in the Jerome Robbins Dance Division, New York Public Library for the Performing Arts (NYPL (S)*MGZMC-res.10).

20 Charles Kean (1811–1868) was an actor-manager whose antiquarian revivals of plays had designs for sets and costumes based on archaeological and historical evidence to give them a 'reality' and magnificence. His most famous productions included Byron's *Sardanopolis* (1853), Sheridan's *Pizarro* (1856) and Shakespeare's *The Merchant of Venice* (1858).

21 The Théâtre du Châtelet, built close to the Seine, had a long tradition of water effects.

22 The horses appear to have been cut during the first run and by the ballet's return bold *jetés* or jumps replaced the flying at the start of the ballet, although the Firebird was still 'hovering' over the coronation finale when the ballet was first performed in London in 1912.

23 The Ekstrom Collection includes payments to dancers and staff including some extras – see V&A: THM/7/4/2. The account book for the 1913 season (V&A: THM/7/4/2/33) gives information on the chorus from the Bolshoi Theatre, Moscow, employed in the season's operas.

24 Following on from the romantic ballet *La Sylphide* (1832) there were numerous divertissement ballets called *Les Sylphides*, including one performed at the Royal Opera House, Covent Garden, in 1861. In Stockholm in 1897, just two years after the Glazunov arrangements of Chopin's Polonaise, Nocturne, Mazurka and Tarantella were published, Max Glaseman choreographed *Chopiniana* adding a Waltz to the arrangement just as Fokine did for his first version in 1906. Prior to Fokine's ballet a *Chopin Tänze* was created in Vienna in 1905. Obviously any discussion of the use of Chopin has to take in Isadora Duncan's use of Chopin's music. See Nesta MacDonald, 'Isadora, Chopin & Fokine', *Dance and Dancers* (December 1983), pp.30–32.

25 After 1917 Monte Carlo provided a refuge for Russians escaping the Revolution contributing a logic to the Ballets Russes long residencies there in the 1920s. For the émigrés it was surely a nostalgic evening when in 1924 the Ballets Russes star, Vera Trefilova, performed in *Swan Lake*. For all his concern with novelty, Diaghilev would use the past to his advantage.

26 Lydia Kyasht, sister of George, was a contemporary of Tamara Karsavina at the Imperial Ballet School graduating in 1902. She became ballerina at the Empire Theatre, London in 1908–13 and later made the London Coliseum her primary performance base. She remained in Britain establishing her own company. She danced with Diaghilev's Ballets Russes for its winter tour 1912–13, including the title role of the Firebird, and again for Diaghilev's 1919 season at the Alhambra, London.

27 Tamara Karsavina and Theodore Kosloff presented a divertissement at the London Coliseum, 28 June–7 August, 1909, their

CREATING PRODUCTIONS
Jane Pritchard

troupe also involving Maria Baldina, Alexis Kosloff, Georges Rosay, Nicolai Kremnev, Leonide Leontiev and Alexander Orloff, all of whom had danced for Diaghilev. Their success was such that Karsavina and Kosloff signed to return the following summer from 16 May–23 July and Karsavina had to beg special leave to perform with Diaghilev in Paris as the Firebird.

28 Among the early ventures by Russian dancers in the USA were Anna Pavlova's tours, and during the 1911–12 season the All-Star Imperial Ballet and Gertrude Hoffmann's Saison Russe.

29 The Grande Saison Russe Opéras et Ballets at the Théâtre Sarah Bernhardt appears to have run from 2 May–6 June 1911. The announced repertoire included the opera *La Roussâlka* (Dargomynski), *The Demon* (Rubinstein), *La Fiancée du Tsar*, *La Nuit de Mai* (both Rimsky-Korsakov) and *The Queen of Spades* and *Eugene Onegin* by Tchaikovsky, and ballets *The Enchanted Forest* (Ivanoff) and extracts *from The Little Hump-backed Horse*, *The Sleeping Beauty* and *Swan Lake* as well as a divertissement. The ballet company was led by Lubov Egorova, Julie Sedova, Marie Piltz and Nicolas Legat.

30 The Russians in London during 1911 included Anna Pavlova and company at The Palace, Olga Preobrajenska and a company of 20 presenting *Swan Lake* and a divertissement at The Hippodrome, and stars from the Bolshoi in Moscow performed *The Dance Dream* (a potpourri of choreography from productions by Alexander Gorsky arranged by him into a new ballet) at the Alhambra Theatre.

1 Tamara Karsavina in Drummond 1997, p.85.
2 Beverley Nichols, 'Woad! Celebrities in Undress: XIV – Diaghilev', *The Sketch* (30 June 1926), p.526.
3 Ibid.
4 Hanna Järvinen, 'The Russian Barnum: Russian Opinions on Diaghilev's Ballets Russes, 1909–1914', *Dance Research* (2008), vol.26 (1), pp.18–41.
5 Brian Blackwood, 'The Black Notebook of Serge Diaghilev', *Bulletin of the New York Public Library Astor, Lenox and Tilden Foundations* (October 1971), pp.345–56.
6 Nabokov 1951, p.75.
7 Richard Alston 'Collaborations' in Rupert Martin, *Artists Design for Dance 1909–1984* (exhib. cat., Bristol, 1984), p.52.
8 Henri Sauguet in Drummond 1997, pp.233–4.
9 Fokine 1961, p.183.
10 Fokine's reforms were presented his letter to *The Times* of 6 July 1914 reproduced in Beaumont 1945, which also translates and reproduces Fokine's 'The New Ballet', *Argus* (1916), vol.1.
11 Fokine 1961, p.149.
12 Beaumont in Drummond 1997, p.126.
13 Deborah Howard, 'A Sumptuous Revival: Bakst's Designs for Diaghilev's Sleeping Princess', *Apollo* (1970), vol.XCI (98), pp.301–8.
14 Edward Ricco, 'The Sitwells at the Ballet', *Ballet Review* (1977–8), vol.6 (1).
15 John Reeve (1799–1838) was a comic actor and *bon viveur* whose popularity was reflected in numerous theatrical prints. In 1832 he appeared as the eponymous Cupid in a light-hearted production described as a 'Burletta Burlesqued' initially at the Olympic and then the Adelphi theatres in London. Prints of him in this role show him initally in a simple white tunic and ballet shoes, dancing *en pointe* on the head of a sunflower. Mme Auriol (d.1862) was a dancer who regularly featured as Columbine in the harlequinades at the end of pantomimes.
16 Ekstrom Collection, Theatre & Performance Collections, V&A: THM/7/2/1/225.
17 Sokolova 1960, pp.70–2.
18 Nicoletta Misler, 'Siamese Dancing and the Ballets Russes', in Baer 1988, pp.78–83.
19 Kenneth Archer, 'A Modern Ming Fantasy with Traces of Tibet: Matisse's Designs for Le Chant du Rossignol', in *Reconstruction: Le Chant du Rossignol* (Theatre Programme, London, 2004).
20 Other productions for which poems or songs provided inspiration included *Thamar*, with a narrative based on Mikhail Lermontov's poem concerning the Georgian Queen who lured passers-by to their deaths, and *Barabau*. Conversely, it was Debussy's score for *Prélude à l'après-midi d'un faune* rather than Nijinsky's choreography that was inspired by Stéphane Mallarmé.
21 Idzikovski's leaving and rejoining the Ballets Russes is documented in correspondence in the Cyril Beaumont Archive, Theatre & Performance

Collections, V&A: THM/239, and the Ekstrom Collection, Theatre & Performance Collections, V&A: THM/7/1/2/11/3.
22 Nectoux 1989, pp.18–22.
23 Edwin Evans, 'Ballet Memories', *Radio Times* (25 June 1937), p.9.
24 Beaumont in Drummond 1997, pp.127–8.
25 Karsavina in Drummond 1997, p.98.
26 Dolin 1953, p.110.
27 Buckle 1979, p.420.
28 Ekstrom Collection, Theatre & Performance Collections, V&A: THM/7/4/4.
29 *Grace Lovat Fraser Remembers* (BBC Radio 1962).
30 Allegri painted sets for *Le Pavillon d'Armide*. Annisfeld painted the sets for *Prince Igor*, *Cléopâtre*, *Le Carnaval*, *Les Orientales*, *Petrushka* and the first production of *Sadko*, which he also designed. Both Allegri and Annisfeld contributed to *Giselle*. Other scene painters included Nikolai Charbé, G. Golov, Peter Lambin, Nikolai Sapunov, Serge Sudeikin and Stepan Yaremich.
31 The sets painted by Vladimir and Elizabeth Polunin for Diaghilev include *La Boutique fantasque*, *Cléopâtre*, *The Good-Humoured Ladies*, *Le Tricorne*, *Pulcinella*, *Le Astuzie Femminili*, *Les Tentations de la bergère* and *Mercure*. Those by Schervashidze included: *Les Fâcheux*, *Zéphire et Flore*, *Les Matelots*, *Barabau*, *Romeo and Juliet*, *La Pastorale*, *Jack-in-the-Box*, *Triumph of Neptune*, *Apollon musagète* and *The Prodigal Son*, as well as the front cloth for *Le Train bleu*.
32 Brigitte Léal, 'The Polunin Album' in Clair and Michael 1998, 106–11.

LÉON BAKST, NATALIA GONCHAROVA AND PABLO PICASSO
John E. Bowlt

WARDROBE
Sarah Woodcock

1 Léon Bakst, 'The Theatre of the Future', *Music Magazine* (1911), no.5, p.9.
2 St Petersburg State Museum of Theatre and Music; Theatre & Performance Collections of the Victoria and Albert Museum, London; Musée de l'Opéra, Paris; Library for the Performing Arts at Lincoln Center, New York; Wadsworth Atheneum, Hartford.
3 M. Larionov, 'The Art of Stage Decoration', *Continental Daily Mail* (13 December 1949).
4 On Bakst see, for example: Schouvaloff 1991; on Goncharova: *M. Larionov. N. Goncharova* 1999; and *Mikhail Larionov. Natal'ia Goncharova* 1999; on Picasso and the stage: Cooper 1967.
5 Movshenson 1960, p.68.
6 Parts of Bakst's novel, 'Zhestokaia pervaia liubov', the manuscript of which is in the Department of Manuscripts at the State Tretyakov Gallery, Moscow (Call No. f. 111, ed khr. 2337–2338), will be published in the forthcoming collection of Bakst's writings edited by Elena Terkel, Olga Kovaleva and John E. Bowlt (Iskusstvo XXI vek, Moscow).
7 Bakst 1911, pp.8–9.
8 From an interview with Bakst conducted by Rose Strunsky dated Paris, 29 July [1915] and entitled 'Léon Bakst on the Modern Ballet. Art is strong when it is too young to be weakened by civilization; it is great enough to conquer when it is sincere – This is the faith of the artist who has expressed in line and color the gorgeous emotions of the Russian ballet', *New York Tribune* (5 September 1915), Special Feature Section, front page.
9 See, for example, 'Nagota na stsene Beseda s L.S. Bakstom o vystupleniiakh A. Dunkan i I. Rubinshtein', *Peterburgskaia gazeta* (10 December 1909).
10 See A. Potemkin, 'Krasota ili pornografiia? Kvystupleniiu Ol'gi Desmond', *Peterburgskaia gazeta* (20 November 1908).
11 Letter from Bakst to Walter Nouvel dated 3 November 1897, Russian State Archive of Literature and Art, Moscow (Call No. f. 938, op. 1, ed. khr. 46, I. 66).
12 Anon., 'Gowns of Two Sexes: Women's Dress Masculine by Day, Feminine in Evening', *Daily Mirror* (3 April 1913).
13 L. Bakst, 'O sovremennom teatre. "Nikto v teatre bol'she ne khochet slushat, a khochet videt!"', *Petersburgskaia gazeta* (21 January 1914), no.20, p.5.
14 N. Evreinov, 'Ektsessivnyi teatr dlia sebia', in *Teatr dlia sebia* (St Petersburg, 1915), Part 1, pp.139–208.
15 See Viktor Flambeau, 'Colored Movies and Radio Accompaniment. Such is Léon Bakst's Conception of Film Possibilities. Great Russian Artist Seeks to Bring Art into Closer Relations with Life of Everyday World', *Washington Herald* (23 March 1924), p.5.
16 This is the title of one of the reviews of the 1917 *Masquerade*, quoted in Lansere 1941, p.35.
17 Letter (undated) from Bakst to Huntley Carter in the Manuscript Department of the Victoria and Albert Museum, London. I would like to thank Alexander Schouvaloff for this reference.
18 *Abstract Portrait of Sergei Diaghilev* is the title accompanying the original gouache (50 × 31 cm) of the *pochoir* sold as lot 35 by Sotheby's, London, at the auction, 'Ballet and Theatre Material and Related Reference Books', 4 March 1982.
19 The Goncharova and Larionov library, still maintained in the 1970s by Larionov's second wife, Aleksandra Tomilina, in their apartment on the rue Jacques Callot, Paris, contained, for example, V. Stasov, *Slavianskii I vostochnyi ornament po rukopisiam drevniago I novago vremeni* (St Petersburg, 1887); and D. Rovinsky, *Russkiia narodniia kartinki* (St Petersburg, 1900).
20 N. Goncharova, Preface to catalogue of one-woman exhibition (Moscow, 1913). Translation in Bowlt 1988, p.59.
21 Goncharova, Larionov and Vorms 1955, p.32.
22 Beaumont 1939, p.127.
23 Fokine 1961, p.316.
24 P. Florensky, 'Khramovoe deistvo kak sintez iskusstv', *Makovets* (Moscow, 1922), no.1, pp.28–32.
25 Letter from Serge Diaghilev to Igor Stravinsky dated 8 March 1915. Quoted in Kochno 1970, p.101.
26 Massine 1968, p.74.
27 Diary entry by Ivan Bunin for 16 August 1929, in Grin 1981, pp.230–1.
28 N. Goncharova, 'Le Costume Théâtral', in Georges-Michel and George 1930, p.22. For a detailed discussion of the entire episode of *Liturgie*, see V. Antonov, 'Neudavshiisia zamysel Diagileva', in *Russkie novosti* (1953), no.427, p.6. For further commentary see A. de Stael, 'Apostoly Goncharovoi', *Teatr* (1922), no.14, pp.8–9.
29 B. Nijinska, 'Svadebka' Stravinskogo', *Novoe russkoe slovo* (9 November 1983), p.5.
30 Kochno 1970, p.189.
31 S. Grigoriev, 'Gontcharova et Larionov. Peintres-Décorateurs des Ballets de Diaghilev', in Loguine 1971, p.113. For more information on Bronislava and the production of *Les Noces* see N. Van Norman Baer, 'The Choreographic Career of Bronislava Nijinska', *Experiment* (1996), no.2, pp.60–78.
32 Grigoriev 1953; reprinted New York, n.d., p.186.
33 D. Milhaud on *Le Tricorne*. Quoted in Lifar et al. 1969, p.159.
34 Buckle 1979, p.330.
35 Propert 1931, p.7.
36 J. Cocteau in *Comoedia* (21 December 1920). Quoted in Kahane et al. 1992, p.103.
37 V. Polunin. Quoted in Schouvaloff 1998, p.275.
38 Cooper 1967. Quoted in Migel 1978, p.viii.
39 Lemaire 1987, p.40.
40 Buckle 1979, p.123.
41 D. Milhaud on *Pulcinella*. Quoted in Lifar et al. 1969, p.170.
42 Buckle 1979, p.362.
43 Propert 1931, p.8.
44 G. Apollinaire: Programme note for *Parade*, 1917. Quoted in Kochno 1970, p.121.

1 Fokine and Diaghilev were not alone in using painters as designers. Across Europe a younger generation challenging accepted values in theatre was often reaching the same conclusion.
2 Quoted in Schouvaloff 1991, p.33.
3 E.O. Hoppé, *The Art of the Theatre: The Russian Ballet*, Valentine Gross Archive, Theatre Collection V&A.
4 Tamara Karsavina, 'Dancers of the Twenties', *Dancing Times* (February 1967), p.253.
5 Exceptions are Picasso's drawing of the Chinese Conjurer for *Parade* and Braque's designs for *Les Fâcheux*.
6 Nicholas Roerich's passion for authenticity extended to lining the men's jackets with all-over patterned printed cottons, which the audience would never have seen. These are traditional linings for ikat robes and decorative hangings, inspired by French designs, but produced in Russia for the home market.
7 Inventory of costumes, Ekstrom Collection, Theatre & Performance Collections, V&A: THM/7/8/5/1.
8 Tamara Karsavina, 'Dancers of the Twenties', *Dancing Times* (February 1967), p.252.
9 Nijinska 1982, p.294.
10 Sokolova 1960, p.71.
11 Newman 2004, p.228.
12 Newman 2004, p.228.
13 Sokolova 1960, p.180.
14 Danilova 1986, p.93.
15 It is often forgotten that theatre design was a new experience for Bakst and Benois as well as for Picasso and Matisse.
16 Danilova 1987, p.78.
17 Alexandre Benois, quoted Lieven 1973, p.123.
18 Nikitina 1959, p.55.
19 Sokolova 1960, p.92.
20 'The Russian Ballet's Thousand Costumes', *Daily Mail* (19 November 1926).

MUSIC AND THE BALLETS RUSSES
Howard Goodall

A GIANT THAT CONTINUES TO GROW – THE IMPACT, INFLUENCE AND LEGACY OF THE BALLETS RUSSES

1 Nice 2003, p.142.
2 In fact, the source material has since been identified as mostly the work of Pergolesi's contemporaries Carlo Ignazio Monza, Domenico Gallo, Alessandro Parisotti and Unico Wilhelm van Wassenaer.
3 Stravinsky and Craft 1959, p.75.
4 Stravinsky 1936, p.215.
5 Stravinsky and Craft 1959, p.46.
6 Stravinsky and Craft 1959, pp.46–7.

1 Robert and Sonia Delaunay were responsible for the new designs for *Cléopâtre* at the London Coliseum on 5 September 1918. Robert's design for the set with temple and pyramids was described as the first modernist set seen in Britain. Sonia designed new costumes for the principal dancers while other characters wore those of the first production originally designed by Bakst.
2 *The Queen* (8 July 1925), p.7.
3 The exhibition in Edinburgh ran at the College of Art, Edinburgh, 22 August – 11 September 1954 and at Forbes House, London, 3 November 1954 – 16 January 1955.
4 'Open letter to Mr. A. Kosloff from Michel Fokine', 28 May 1928. Carbon copy in Cyril Beaumont Archive V&A: THM/239.
5 *Cléopâtre* and *Les Sylphides* were first performed at the Opera House in Stockholm on 14 March 1913, *Le Spectre de la rose* on 10 January 1914 and *Le Carnaval* and *Schéhérazade* on 25 January 1914. Mikhail Fokine and his wife Vera danced in all these productions. See Strömbeck et al. 1974, p.137. Studio and production photographs taken in Stockholm are often presented as being performances for Diaghilev's Ballets Russes.
6 The Paris Opéra's production of *Daphnis et Chloé* opened on 20 June 1921.
7 The 'Saison Nijinsky' opened at the Palace Theatre on 2 March 1914 with *Les Sylphides* (with an apparently different or partially different selection of Chopin orchestrated by Maurice Ravel), *Danse Orientale* and *Le Spectre de la rose*, all designed by Boris Anisfelt. On 16 March Nijinsky was scheduled to present *Le Carnaval*, *L'Oiseau et le Prince*, *Danse Grecque* and *Danse Polovtsian* but his illness prevented this and the remainder of the season was cancelled.
8 Details of the insistence on Massine's involvement in the USA season are found in telegrams and letters from the impresarios Goetz and Seligsberg in V&A: THM/7/2/1/56.
9 *Le Chant du rossignol* and *Le Coq d'or*.
10 Diaghilev's letters to Lifar are reproduced in Lifar 1954, pp.269–73.
11 *Soirée de Paris* at the Théâtre de la Cigale 17 May– 30 June 1924 was presented as a benefit season in aid of war widows and Russian refugees had a collaborative team including Léonide Massine, Lydia Lopokova, Stanislas Idzikovski, Georges Braque, André Derain, Jean Hugo, Marie Laurencin, Pablo Picasso, José-Maria Sert, Darius Milhaud, Henri Sauguet, Jean Cocteau, Loïe Fuller and Tristan Tzara. There was every reason for Diaghilev to be jealous.
12 Buckle 1982, p.53.
13 See Mannoni 1990; Fiette and Jeanmaire 2007.
14 See Hodson 1996; Hodson 2007. From the former it is evident that Hodson has supporting evidence for about 10 per cent of the ballet.

15 Jane Pritchard, 'Serge Diaghilev's Ballets Russes – An Intinerary' Part 1, *Dance Research* (Summer 2009), 27.1, Part 2, *Dance Research* (Winter 2009), 27.2, and Boris Courrège et al in Auclair and Vidal 2009.
16 Clause 23.
17 Vera Karelli made many important Russian films with Evgeni Bauer including *After Death* (1915) and *The Dying Swan* (1916). Anna Pavlova featured in *The Dumb Girl of Portici* (1916), Tamara Karsavina starred in *The Old Wives' Tale* (1921) and Lydia Kyasht in *The Black Spider* (1920). Lydia Lopokova, Anton Dolin and George Balanchine were filming the dance sequences in the film *Dark Red Roses* in 1929 when Diaghilev died.
18 Lieven 1936, p.96.
19 Alan Bates played the role of Diaghilev with George de la Pena as Nijinsky and London Festival Ballet as the Ballets Russes. Romola Nijinsky had published her biography of her husband (written with assistance from Lincoln Kirstein) with an eye on it being turned into a film.
20 John Drummond, 'Big Serge on the Box', *Dance and Dancers* (April 1968), pp.28–31, 51.
21 Prokofiev to Asafiev, 29 August 1929. Quoted in Scheijen 2009, p.441.

BIBLIOGRAPHY

Aplin, Arthur, *The Stories of the Russian Ballet*
(London, 1911)

Auclair, Mathias, and Vidal, Pierre, *Les Ballets Russes*
(Paris, 2009)

Baer, Nancy Van Norman, *Bronislava Nijinska:
A Dancer's Legacy* (San Francisco, 1986)

Baer, Nancy Van Norman, *The Art of Enchantment:
Diaghilev's Ballet Russes 1909–1929*
(London, 1989)

Ballets Russes de Diaghilew: 1909 à 1929
(exhib. cat., Paris, 1939)

Beaton, Cecil, *The Glass of Fashion* (London, 1954)

Beaumont, Cyril W., *Enrico Cecchetti: A Memoir*
(London, 1929)

Beaumont, Cyril W., *A History of Ballet in Russia
(1613–1881)* (London, 1930)

Beaumont, Cyril W., *Five Centuries of Ballet Design*
(London, 1939)

Beaumont, Cyril W., *The Diaghilev Ballet in London:
A Personal Record* (London, 1940)

Beaumont, Cyril W., *Michel Fokine and his Ballets*
(London, 1945)

Bely, Andrei, *Petersburg* (London, 2009)

Belyaeva, N.V. (ed.), *Sergei Diaghilev i
khudozhestvennaya kul'tura XIX–XX vv*
(Perm, 1987)

Benois, Alexandre, trans. Mary Britnieva,
Reminiscences of the Russian Ballet (London, 1941)

Bowlt, John E., *The Silver Age: Russian Art of the
Early Twentieth Century and the 'World of Art'
Group* (Newtonville, Mass, 1979)

Bowlt, John E., *Russian Stage Design Scenic
Innovation, 1900–1930 from the Collection
of Mr. and Mrs. Nikita D. Lobanov-Rostrovsky*
(Jackson, 1982)

Bowlt, John E. (ed.), *Russian Art of the Avant-Garde:
Theory and Criticism 1902–1934* (London, 1988)

Bowlt, John E., Tregulova, Zelfira and Giordano,
Natalie Rosticher (eds), *A Feast of Wonders:
Sergei Diaghilev and the Ballets Russes*
(Milan, 2009)

Buckle, Richard, *The Diaghilev Exhibition*
(exhib. cat., Edinburgh and London, 1954)

Buckle, Richard, *In Search of Diaghilev* (London, 1955)

Buckle, Richard, *Nijinsky* (London, 1971)

Buckle, Richard, *Nijinsky on Stage* (London, 1971)

Buckle, Richard, *Diaghilev* (London, 1979)

Buckle, Richard, *In the Wake of Diaghilev:
Autobiography Two* (London, 1982)

Burt, Ramsay, *The Male Dancer: Bodies, Spectacle,
Sexualities* (London, 1995)

Chadd, David, and Gage, John, *The Diaghilev Ballet
in England* (exhib. cat., Norwich, 1979)

Clair, Jean, and Michael, Odile, *Picasso 1917 – 1924
The Italian Journey* (exhib. cat., Milan, 1998)

Cooper, Douglas, *Picasso: Theatre* (London, 1967)

Danilova, Alexandra, *Choura: The Memoirs of
Alexandra Danilova* (New York, 1986;
London, 1987)

Davenport-Hines, Richard, *A Night at the Majestic*
(London, 2006)

Deslandres, Yvonne, *Poiret* (London, 1987)

Detaille, Georges, and Mulys, Gérard, *Les Ballets
de Monte Carlo 1911–1944* (Paris, 1954)

Dolin, A., *Divertissement* (London [1930])

Dolin, A., *Markova: Her Life and Art* (London, 1953)

Drummond, J., *Speaking of Diaghilev* (London, 1997)

Durey, Philippa, and Léal, Brigitte,
Picasso Le Tricorne (exhib. cat., Lyons, 1992)

Erté, *Things I Remember: An Autobiography*
(London, 1975)

Fiette, Alexandre, *Roland Petit – Un Patrimoine
pour la danse* (Geneva and Paris, 2007)

Figes, Orlando, *A People's Tragedy: The Russian
Revolution 1891–1924* (London, 1996)

Filosofov, D.V., *Zagadki Russkoj Kul'turi*
(Moscow, 2004)

Fokine, Michel, *Fokine: Memoirs of a Ballet Master*,
trans. Vitale Fokine (London, 1961)

Garafola, Lynn, *Diaghilev's Ballets Russes*
(Oxford, 1989; New York, 1998)

Garafola, Lynn, and Baer, Nancy Van Norman,
The Ballets Russes and its World (London, 1999)

Garafola, Lynn, 'The Sexual Iconography of the
Ballets Russes', *Ballet Review* (2000), vol.28 (3)

García-Márquez, Vincente, *España y los
Ballets Russes* (exhib. cat., Granada, 1989)

Georges-Michel, M., and George, W., *Les
Ballets Russes* (Paris, 1930)

Glendinning, V., *Vita: The Life of Vita Sackville-West*
(London, 1983)

Goncharova, Natalia, Larionov, M., and Vorms, P.,
*Les Ballets Russes: Serge de Diaghilew et la
décoration théâtrale* (Paris, 1955)

Green, Martin, and Swan, John, *The Triumph of
Pierrot: The Commedia dell'Arte and the Modern
Imagination* (New York, 1986)

Grigoriev, S.L., *The Diaghilev Ballet 1909–1929*
(London, 1953)

Grin, M. (ed.), *Ustami Buninykh* (Munich, 1981)

Haldey, Olga, 'Savva Mamontov, Serge Diaghilev,
and a Rocky Path to Modernism', *Journal of
Musicology* (Autumn 2005), vol.22 (4),
pp.559–603

Hall, Susan (ed.), *From Russia with Love: Costumes
for the Ballets Russes 1909–1933* (Canberra, 1998)

Haskell, Arnold, *Diaghilev: His Artistic and
Private Life* (New York, 1935)

Healy, Robin, and Lloyd, Michael, *From Studio
to Stage: Costumes and Designs from the Russian
Ballet in the Australian National Gallery*
(Canberra, 1990)

Heyman, Jacques, *The Stone Skeleton: the structural
engineering of masonry architecture*
(Cambridge, 1997)

Hill, Polly, and Keynes, Richard (eds), *Lydia and
Maynard, the letters of Lydia Lopokova and John
Maynard Keynes* (London, 1989)

Hilton, Alison, *Russian Folk Art* (Indiana, 1995)

Hodson, Millicent, *Nijinsky's Crime Against Grace*
(Hillsdale, NY, 1996)

Hodson, Millicent, *Nijinsky's Bloomsbury Ballet*
(Hillsdale, NY, 2007)

H(oppé), E.O., *The Art of the Theatre: The Russian
Ballet* (unidentified publication, Valentine Gross
Archive, Theatre Collection V&A, London)

Iribe, Paul, *Les Robes de Paul Poiret racontées par
Paul Iribe* (Paris, 1908)

Johnson, A.E., *The Russian Ballet* (London, 1913)

Kahane, Martine et al., *Les Ballets Russes à l'Opéra*
(Paris, 1992)

Kahane, Martine, *Nijinsky 1889–1950* (Paris, 2000)

Kahane, Martine, *Opéras Russes à l'Aube des Ballets
Russes* (Paris, 2009)

Karsavina, Tamara, *Theatre Street* (London, 1930)

Kessler, Harry Graf, *Das Tagebuch, Vierter Band
1906–1914* (Stuttgart, 2005)

Kirstein, Lincoln, *Nijinsky Dancing* (London, 1976)

Kochno, Boris, *Diaghilev and the Ballets Russes*
(New York, 1970)

Koda, Harold, and Bolton, Andrew, *Poiret*
(exhib. cat., New Haven and London, 2007)

Kodicek, Ann (ed.), *Diaghilev: Creator of the Ballets
Russes* (exhib. cat., London, 1996)

Kschessinskaya, Mathilda, *Dancing in St Petersburg:
The Memoirs of Kschessinska* (London, 1960)

Lancaster, Osbert, *Homes Sweet Homes*
(London, 1939)

Lansere, E., 'Maskarad' Lermontova v teatral'nykh
eskizakh A.Ya. Golovina* (Moscow, 1941)

*M. Larionov. N. Goncharova. Parizhskoe nasledie v
Tret'iakovskoi galeree. Grafika, teatr, kniga,
vospominaniia* (exhib. cat., Moscow, 1999)

*Mikhail Larionov. Natal'ia Goncharova. Shedevry iz
parizhskogo naslediia. Zhivopis'* (exhib. cat.,
Moscow, 1999)

Legat, Nadine Nicolaeva (as told to Constance
White), *Dancing My Prayers: The Legat Story*
(unpublished manuscript)

Lemaire, G.-G., *Picasso* (Florence, 1987)

Lepape, Georges, *Les Choses de Paul Poiret* (Paris, 1911)

Lieven, Prince Peter, *The Birth of the Ballets Russes*
(London, 1936; New York, 1973)

Lifar, Serge, *Serge Diaghilev: His Life, His Work,
His Legend: An Intimate Biography*
(London, 1940)

Lifar, Serge, *A History of Russian Ballet from its
Origins to the Present Day*, trans. Arnold Haskell
(London, 1954)

Lifar, Serge et al., *Les Ballets Russes de Serge
Diaghilev 1909–1929* (exhib. cat.,
Strasbourg, 1969)

Lincoln, Bruce L., *In War's Dark Shadow: The
Russians Before the Great War* (New York, 1983)

Loguine, T., *Gontcharova et Larionov* (Paris, 1971)

MacDonald, Nesta, *Diaghilev Observed by Critics in
England and the United States: 1911–1929* (New
York and London, 1975)

Mackrell, Alice, *Paul Poiret* (London, 1990)

Mackrell, Judith, *Bloomsbury Ballerina: Lydia
Lopokova, Imperial Dancer, and Mrs John Maynard
Keynes* (London, 2008)

Mannoni, Gérard, *Roland Petit: Un chorégraphe et
ses peintres* (Paris, 1990)

Martin, Rupert, *Artists Design for Dance 1909–1984* (exhib. cat., Bristol, 1984)

Massine, Léonide, *My Life in Ballet* (London, 1968)

Migel, P., *Pablo Picasso. Designs for 'The Three-Cornered Hat' (Le Tricorne)* (London, 1978)

Movshenson, A., *Alexandr Yakovlevich Golovin* (Leningrad-Moscow, 1960)

Mühl, Albert, *Internationale Luxuszüge* (Freiburg, 1991)

Nabokov, Nicolas, *Old Friends and New Music* (London, 1951)

Nabokov, Vladimir, *Speak, Memory: An Autobiography Revisited* (London, 1989)

Näslund, Erik, *Ballets Russes* (Stockholm, 2009

Nectoux, Jean-Michel, *Les Dossiers du Musée d'Orsay: L'après-midi d'un Faune* (Paris, 1989)

Newman, Barbara, *Striking a Balance: Dancers talk about Dancing* (Boston, 1982)

Newman, Barbara, *Grace Under Pressure* (Alton, 2004)

Nice, David, *Prokofiev: from Russia to the Coast, 1891–1935* (New Haven and London, 2003)

Nijinska, Bronislava, *Early Memoirs* (London, 1982)

Nikitina, Alice, *Nikitina, By Herself*, trans. Baroness Budberg (London, 1959)

Panchulidzeva, S.A. (ed.), *Sbornik Biografii Kavalergardov, 1826–1908* (Moscow, 2008)

Pastori, Jean-Pierre, *Soleil de Nuit La Renaissance des Ballets Russes* (Lausanne, 1993)

Petrova, Evgenia, *Diaghilev: The Beginning* (St Petersburg, 2009)

Pischl, A.J., 'A Catalogue of Souvenir Dance Programmes', *Dance Index* (1948), vol.VII, pp.76–127

Poiret, Paul, *My First Fifty Years* (London, 1931)

Polunin, Vladimir, *The Continental Method of Scene Painting*, ed. Cyril W. Beaumont (London, 1927)

Potter, Michelle, 'Mir Iskusstva: Serge Diaghilev's art journal', *NLA News* (July 2005), vol.XV (10)

Pritchard, Jane, 'Serge Diaghilev's Ballets Russes – An Itinerary', *Dance Research* (2009), vol.27 (1–2)

Propert, W.A., *The Russian Ballet in Western Europe 1909–1920* (London, 1921)

Propert, W.A., *The Russian Ballet, 1920–1929* (London, 1931)

Ricco, Edward, 'The Sitwells at the Ballet', *Ballet Review* (1977–78) vol.6 (1)

Rimsky-Korsakov, N.A., *My Musical Life* (New York, 1942)

Rothstein, N. (ed.), *Four Hundred Years of Fashion* (London, 1984)

Salmina-Haskell, Larissa, *Catalogue of Russian Drawings* (London, 1972)

Salmond, Wendy, *Arts and Crafts in Late Imperial Russia* (Cambridge, 1996)

Scheijen, Sjeng, *Diaghilev: A Life* (London, 2009)

Schouvaloff, Alexander, *Theatre on Paper* (New York, 1990)

Schouvaloff, Alexander, *Léon Bakst: The Theatre Art* (London, 1991)

Schouvaloff, Alexander, *The Art of Ballets Russes: The Serge Lifar Collection of Theater Designs, Costumes, and Paintings at the Wadsworth Atheneum, Hartford, Connecticut* (New Haven, 1998)

Shead, Richard, *Ballets Russes* (London, 1989)

Sokolova, Lydia, *Dancing for Diaghilev*, ed. Richard Buckle (London, 1960)

Spencer, Charles, *The World of Serge Diaghilev* (London, 1974)

Stoneley, Peter, *A Queer History of the Ballet* (London, 2007)

Stravinsky, Igor, *Chronicle of My Life* (London, 1936)

Stravinsky, Igor, and Craft, Robert, *Conversations with Igor Stravinsky* (London, 1959)

Strong, Roy et al., *Designing for the Dancer* (London, 1981)

Strong, Roy et al., *Spotlight* (exhib. cat., London, 1981)

Strömbeck et al., *Kungliga Teatern Repertoar 1773–1973* (Stockholm, 1974)

Telyakovsky, Vladimir, *Dnevniki direktora imperatorskikh teatrov, 1901–1903* (Moscow, 2002)

Vail, Amanda, *They Were So Young* (London, 1998)

Walker, Katherine Sorley, *Cyril W. Beaumont Dance Writer and Publisher* (Alton, 2006)

White, Palmer, *Poiret* (London, 1973)

Winestein, Anna, 'Quiet Revolutionaries: the "Mir Iskusstva" Movement and Russian Design', *Journal of Design History* (2008), vol. 21 (4), pp.315–33

Zilbershteyn, I.S., and Samkov, V.A (eds), *Valentin Serov v vospominaniyakh, dnevnikakh, i perepiske sovremenikov* (Leningrad, 1971), 2 vols

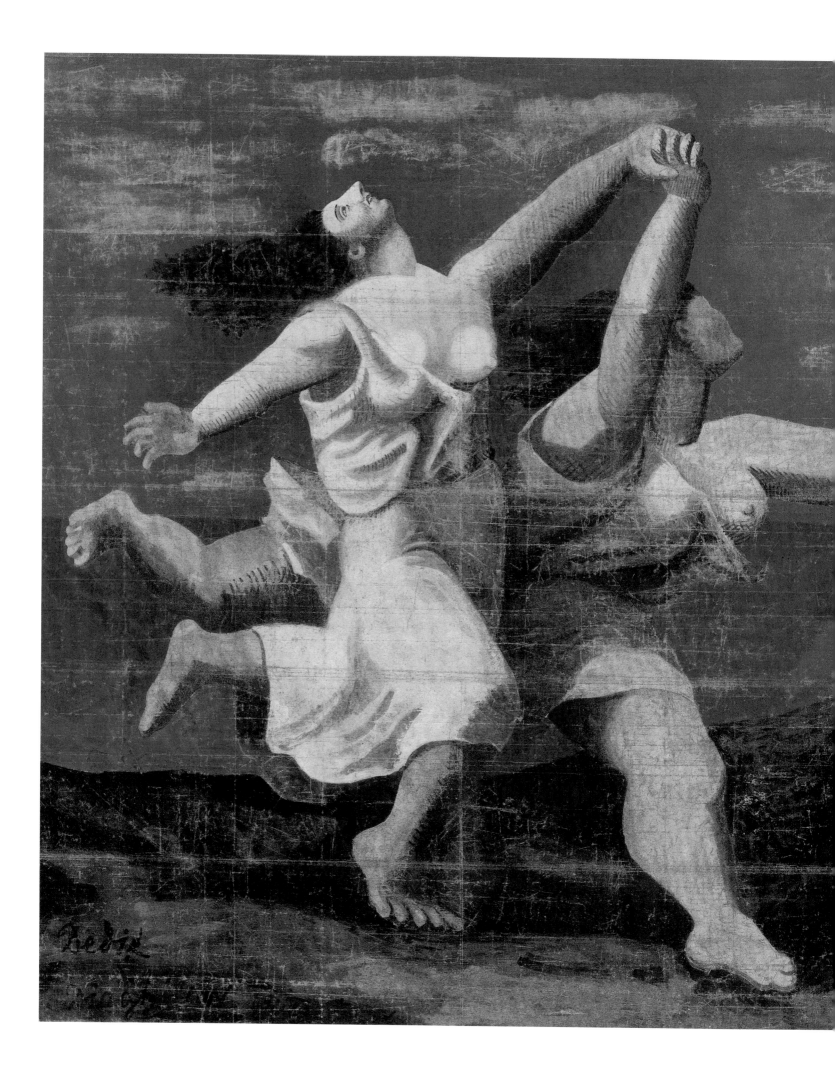

Alexander Schervashidze
after Pablo Picasso, the
front cloth for *Le Train bleu*.
Oil on canvas, 1924.
V&A: S.316–1978

REPERTOIRE

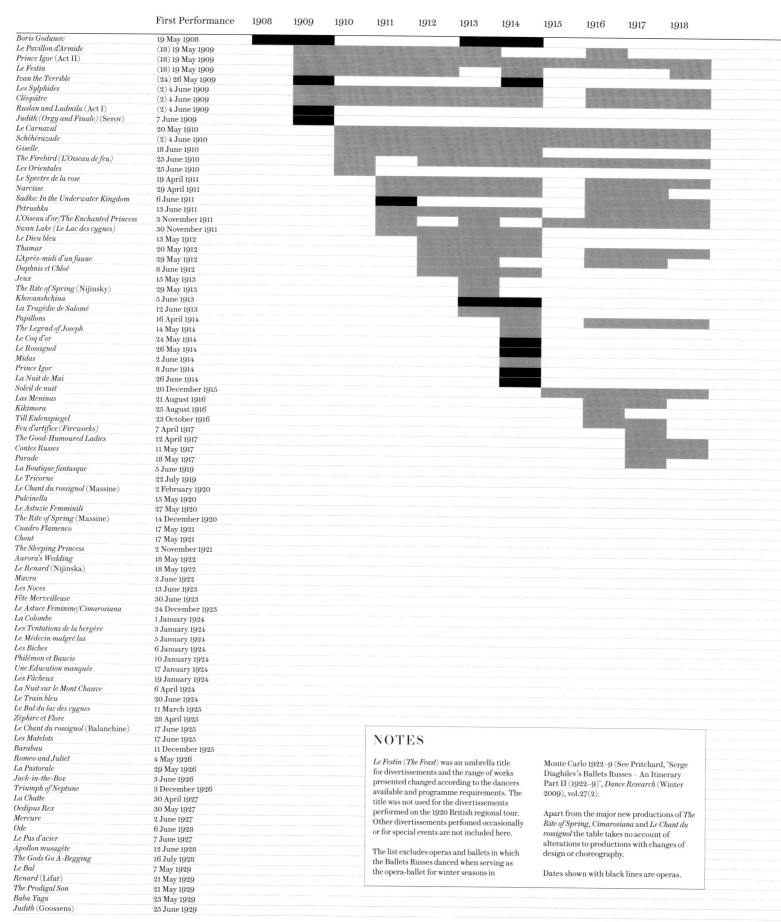

	First Performance	1908	1909	1910	1911	1912	1913	1914	1915	1916	1917	1918
Boris Godunov	19 May 1908											
Le Pavillon d'Armide	(18) 19 May 1909											
Prince Igor (Act II)	(18) 19 May 1909											
Le Festin	(18) 19 May 1909											
Ivan the Terrible	(24) 26 May 1909											
Les Sylphides	(2) 4 June 1909											
Cléopâtre	(2) 4 June 1909											
Ruslan and Ludmila (Act I)	(2) 4 June 1909											
Judith (Orgy and Finale) (Serov)	7 June 1909											
Le Carnaval	20 May 1910											
Schéhérazade	(2) 4 June 1910											
Giselle	18 June 1910											
The Firebird (L'Oiseau de feu)	25 June 1910											
Les Orientales	25 June 1910											
Le Spectre de la rose	19 April 1911											
Narcisse	29 April 1911											
Sadko: In the Underwater Kingdom	6 June 1911											
Petrushka	13 June 1911											
L'Oiseau d'or/The Enchanted Princess	3 November 1911											
Swan Lake (Le Lac des cygnes)	30 November 1911											
Le Dieu bleu	13 May 1912											
Thamar	20 May 1912											
L'Après-midi d'un faune	29 May 1912											
Daphnis et Chloé	8 June 1912											
Jeux	15 May 1913											
The Rite of Spring (Nijinsky)	29 May 1913											
Khovanshchina	5 June 1913											
La Tragédie de Salomé	12 June 1913											
Papillons	16 April 1914											
The Legend of Joseph	14 May 1914											
Le Coq d'or	24 May 1914											
Le Rossignol	26 May 1914											
Midas	2 June 1914											
Prince Igor	8 June 1914											
La Nuit de Mai	26 June 1914											
Soleil de nuit	20 December 1915											
Las Meninas	21 August 1916											
Kikimora	25 August 1916											
Till Eulenspiegel	23 October 1916											
Feu d'artifice (Fireworks)	7 April 1917											
The Good-Humoured Ladies	12 April 1917											
Contes Russes	11 May 1917											
Parade	18 May 1917											
La Boutique fantasque	5 June 1919											
Le Tricorne	22 July 1919											
Le Chant du rossignol (Massine)	2 February 1920											
Pulcinella	15 May 1920											
Le Astuzie Femminili	27 May 1920											
The Rite of Spring (Massine)	14 December 1920											
Cuadro Flamenco	17 May 1921											
Chout	17 May 1921											
The Sleeping Princess	2 November 1921											
Aurora's Wedding	18 May 1922											
Le Renard (Nijinska)	18 May 1922											
Mavra	3 June 1922											
Les Noces	13 June 1923											
Fête Merveilleuse	30 June 1923											
Le Astuce Feminine/Cimarosiana	24 December 1923											
La Colombe	1 January 1924											
Les Tentations de la bergère	3 January 1924											
Le Médecin malgré lui	5 January 1924											
Les Biches	6 January 1924											
Philémon et Baucis	10 January 1924											
Une Education manquée	17 January 1924											
Les Fâcheux	19 January 1924											
La Nuit sur le Mont Chauve	6 April 1924											
Le Train bleu	20 June 1924											
Le Bal du lac des cygnes	11 March 1925											
Zéphire et Flore	28 April 1925											
Le Chant du rossignol (Balanchine)	17 June 1925											
Les Matelots	17 June 1925											
Barabau	11 December 1925											
Romeo and Juliet	4 May 1926											
La Pastorale	29 May 1926											
Jack-in-the-Box	3 June 1926											
Triumph of Neptune	3 December 1926											
La Chatte	30 April 1927											
Oedipus Rex	30 May 1927											
Mercure	2 June 1927											
Ode	6 June 1928											
Le Pas d'acier	7 June 1927											
Apollon musagète	12 June 1928											
The Gods Go A-Begging	16 July 1928											
Le Bal	7 May 1929											
Renard (Lifar)	21 May 1929											
The Prodigal Son	21 May 1929											
Baba Yaga	23 May 1929											
Judith (Goossens)	25 June 1929											

NOTES

Le Festin (The Feast) was an umbrella title for divertissements and the range of works presented changed according to the dancers available and programme requirements. The title was not used for the divertissements performed on the 1920 British regional tour. Other divertissements perfomed occasionally or for special events are not included here.

The list excludes operas and ballets in which the Ballets Russes danced when serving as the opera-ballet for winter seasons in Monte Carlo 1922–9 (See Pritchard, 'Serge Diaghilev's Ballets Russes – An Itinerary Part II (1922–9)', Dance Research (Winter 2009), vol.27(2).

Apart from the major new productions of The Rite of Spring, Cimarosiana and Le Chant du rossignol the table takes no account of alterations to productions with changes of design or choreography.

Dates shown with black lines are operas.

Dates in (brackets) are *répétitions générales*.

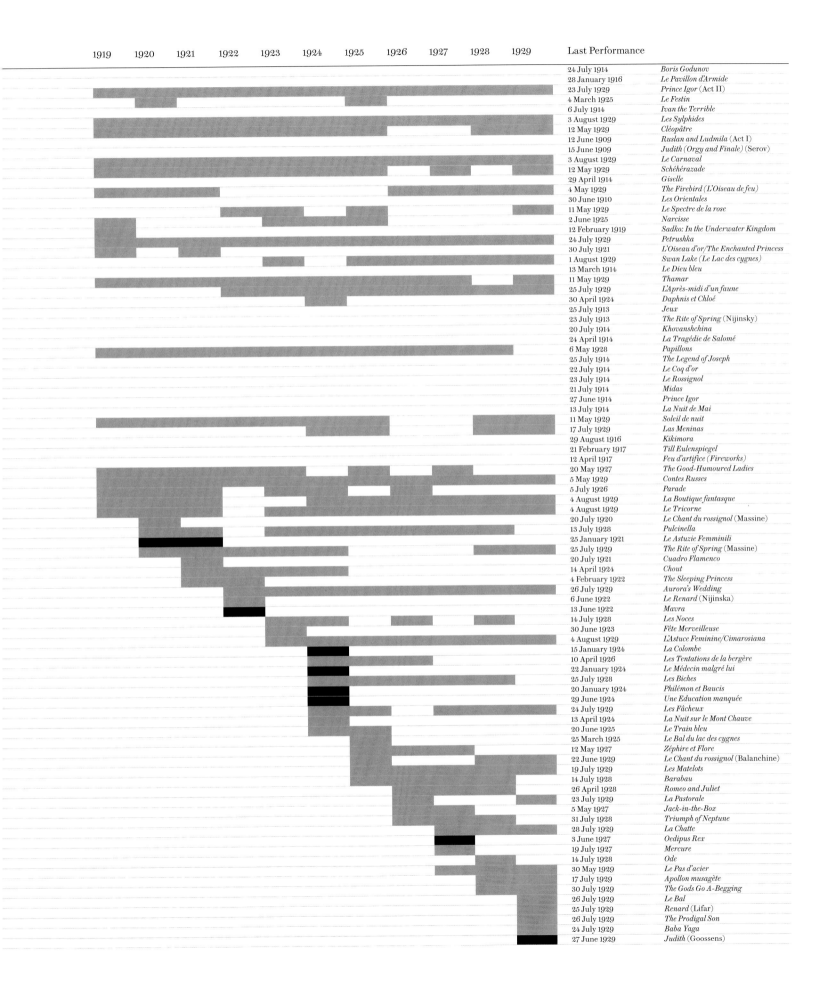

	1919	1920	1921	1922	1923	1924	1925	1926	1927	1928	1929	Last Performance	
												24 July 1914	*Boris Godunov*
												28 January 1916	*Le Pavillon d'Armide*
												23 July 1929	*Prince Igor* (Act II)
												4 March 1925	*Le Festin*
												6 July 1914	*Ivan the Terrible*
												3 August 1929	*Les Sylphides*
												12 May 1929	*Cléopâtre*
												12 June 1909	*Ruslan and Ludmila* (Act I)
												15 June 1909	*Judith (Orgy and Finale)* (Serov)
												3 August 1929	*Le Carnaval*
												12 May 1929	*Schéhérazade*
												29 April 1914	*Giselle*
												4 May 1929	*The Firebird (L'Oiseau de feu)*
												30 June 1910	*Les Orientales*
												11 May 1929	*Le Spectre de la rose*
												2 June 1925	*Narcisse*
												12 February 1919	*Sadko: In the Underwater Kingdom*
												24 July 1929	*Petrushka*
												30 July 1921	*L'Oiseau d'or/The Enchanted Princess*
												1 August 1929	*Swan Lake (Le Lac des cygnes)*
												13 March 1914	*Le Dieu bleu*
												11 May 1929	*Thamar*
												25 July 1929	*L'Après-midi d'un faune*
												30 April 1924	*Daphnis et Chloé*
												25 July 1913	*Jeux*
												23 July 1913	*The Rite of Spring* (Nijinsky)
												20 July 1914	*Khovanshchina*
												24 April 1914	*La Tragédie de Salomé*
												6 May 1928	*Papillons*
												25 July 1914	*The Legend of Joseph*
												22 July 1914	*Le Coq d'or*
												23 July 1914	*Le Rossignol*
												21 July 1914	*Midas*
												27 June 1914	*Prince Igor*
												13 July 1914	*La Nuit de Mai*
												11 May 1929	*Soleil de nuit*
												17 July 1929	*Las Meninas*
												29 August 1916	*Kikimora*
												21 February 1917	*Till Eulenspiegel*
												12 April 1917	*Feu d'artifice (Fireworks)*
												20 May 1927	*The Good-Humoured Ladies*
												5 May 1929	*Contes Russes*
												5 July 1926	*Parade*
												4 August 1929	*La Boutique fantasque*
												4 August 1929	*Le Tricorne*
												20 July 1920	*Le Chant du rossignol* (Massine)
												13 July 1928	*Pulcinella*
												25 January 1921	*Le Astuzie Femminili*
												25 July 1929	*The Rite of Spring* (Massine)
												20 July 1921	*Cuadro Flamenco*
												14 April 1924	*Chout*
												4 February 1922	*The Sleeping Princess*
												26 July 1929	*Aurora's Wedding*
												6 June 1922	*Le Renard* (Nijinska)
												13 June 1922	*Mavra*
												14 July 1928	*Les Noces*
												30 June 1923	*Fête Merveilleuse*
												4 August 1929	*L'Astuce Feminine/Cimarosiana*
												15 January 1924	*La Colombe*
												10 April 1926	*Les Tentations de la bergère*
												22 January 1924	*Le Médecin malgré lui*
												25 July 1928	*Les Biches*
												20 January 1924	*Philémon et Baucis*
												29 June 1924	*Une Education manquée*
												24 July 1929	*Les Fâcheux*
												13 April 1924	*La Nuit sur le Mont Chauve*
												20 June 1925	*Le Train bleu*
												25 March 1925	*Le Bal du lac des cygnes*
												12 May 1927	*Zéphire et Flore*
												22 June 1929	*Le Chant du rossignol* (Balanchine)
												19 July 1929	*Les Matelots*
												14 July 1928	*Barabau*
												26 April 1928	*Romeo and Juliet*
												23 July 1929	*La Pastorale*
												5 May 1927	*Jack-in-the-Box*
												31 July 1928	*Triumph of Neptune*
												28 July 1929	*La Chatte*
												3 June 1927	*Oedipus Rex*
												19 July 1927	*Mercure*
												14 July 1928	*Ode*
												30 May 1929	*Le Pas d'acier*
												17 July 1929	*Apollon musagète*
												30 July 1929	*The Gods Go A-Begging*
												26 July 1929	*Le Bal*
												25 July 1929	*Renard* (Lifar)
												26 July 1929	*The Prodigal Son*
												24 July 1929	*Baba Yaga*
												27 June 1929	*Judith* (Goossens)

TOUR LOCATIONS

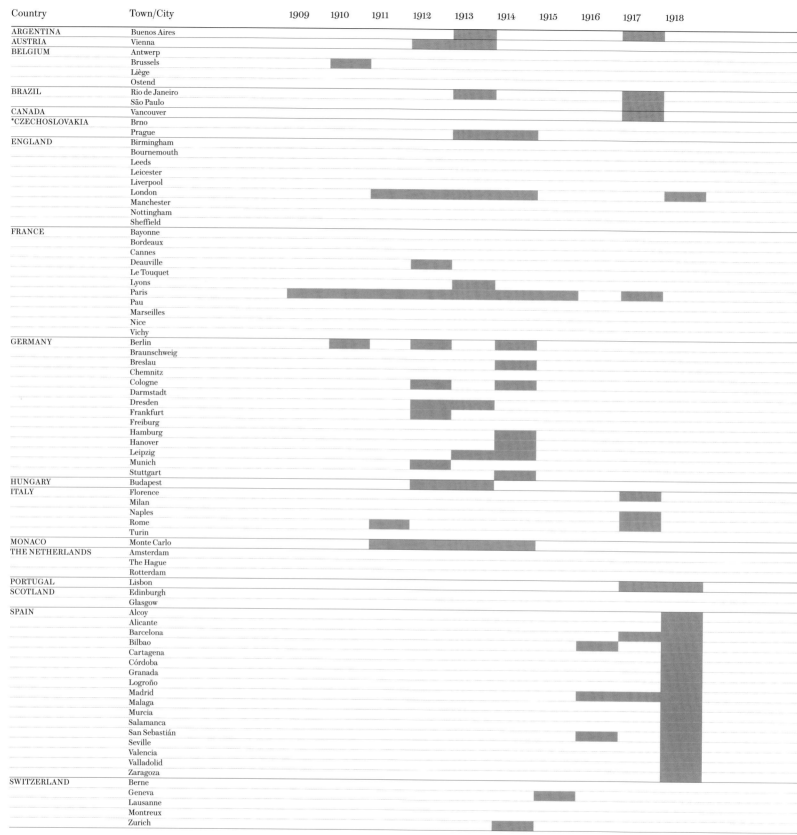

Country	Town/City	1909	1910	1911	1912	1913	1914	1915	1916	1917	1918
ARGENTINA	Buenos Aires					■					
AUSTRIA	Vienna				■	■					
BELGIUM	Antwerp										
	Brussels		■								
	Liège										
	Ostend										
BRAZIL	Rio de Janeiro					■				■	
	São Paulo										
CANADA	Vancouver									■	
*CZECHOSLOVAKIA	Brno										
	Prague					■	■				
ENGLAND	Birmingham										
	Bournemouth										
	Leeds										
	Leicester										
	Liverpool										
	London			■	■	■	■				■
	Manchester										
	Nottingham										
	Sheffield										
FRANCE	Bayonne										
	Bordeaux										
	Cannes										
	Deauville				■						
	Le Touquet										
	Lyons					■					
	Paris	■	■	■	■	■	■	■		■	
	Pau										
	Marseilles										
	Nice										
	Vichy										
GERMANY	Berlin		■		■		■				
	Braunschweig						■				
	Breslau						■				
	Chemnitz										
	Cologne				■		■				
	Darmstadt										
	Dresden				■	■					
	Frankfurt					■	■				
	Freiburg										
	Hamburg						■				
	Hanover						■				
	Leipzig						■				
	Munich				■						
	Stuttgart						■				
HUNGARY	Budapest				■	■					
ITALY	Florence									■	
	Milan										
	Naples									■	
	Rome			■							
	Turin										
MONACO	Monte Carlo			■	■	■	■				
THE NETHERLANDS	Amsterdam										
	The Hague										
	Rotterdam										
PORTUGAL	Lisbon									■	■
SCOTLAND	Edinburgh										
	Glasgow										
SPAIN	Alcoy										■
	Alicante										■
	Barcelona									■	■
	Bilbao								■		■
	Cartagena										■
	Córdoba										■
	Granada										■
	Logroño										■
	Madrid								■		■
	Malaga										■
	Murcia										■
	Salamanca										■
	San Sebastián								■		■
	Seville										■
	Valencia										■
	Valladolid										■
	Zaragoza										■
SWITZERLAND	Berne										
	Geneva							■	■		
	Lausanne										
	Montreux										
	Zurich						■				

* Names follow post-Second World War designations.

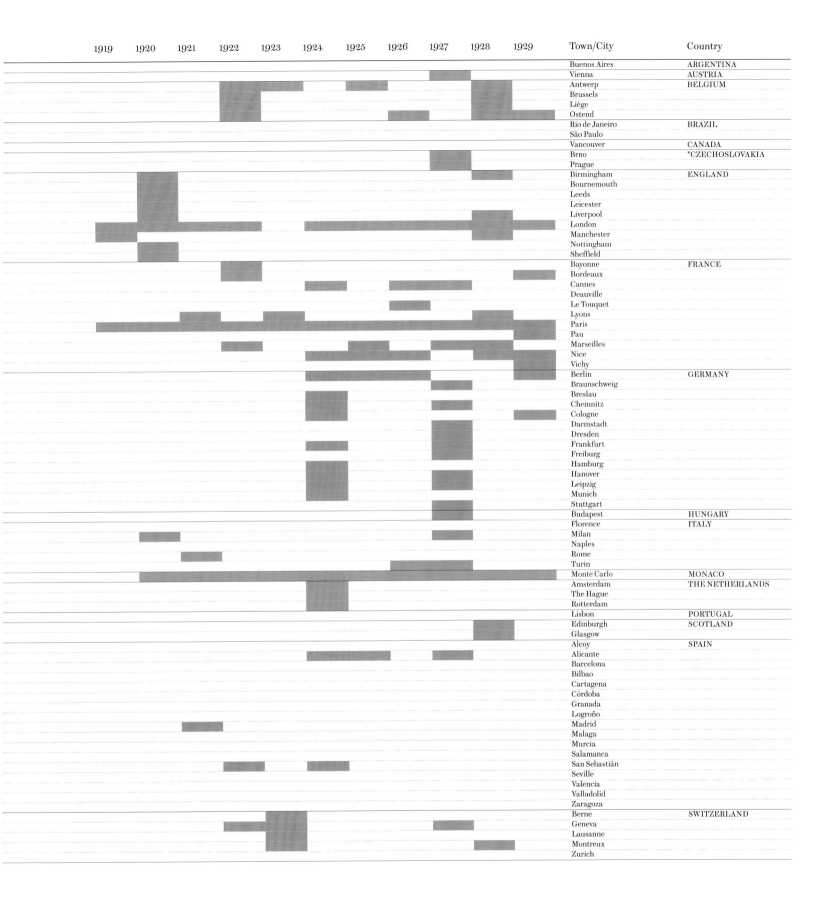

1919	1920	1921	1922	1923	1924	1925	1926	1927	1928	1929	Town/City	Country
											Buenos Aires	ARGENTINA
											Vienna	AUSTRIA
											Antwerp	BELGIUM
											Brussels	
											Liège	
											Ostend	
											Rio de Janeiro	BRAZIL
											São Paulo	
											Vancouver	CANADA
											Brno	*CZECHOSLOVAKIA
											Prague	
											Birmingham	ENGLAND
											Bournemouth	
											Leeds	
											Leicester	
											Liverpool	
											London	
											Manchester	
											Nottingham	
											Sheffield	
											Bayonne	FRANCE
											Bordeaux	
											Cannes	
											Deauville	
											Le Touquet	
											Lyons	
											Paris	
											Pau	
											Marseilles	
											Nice	
											Vichy	
											Berlin	GERMANY
											Braunschweig	
											Breslau	
											Chemnitz	
											Cologne	
											Darmstadt	
											Dresden	
											Frankfurt	
											Freiburg	
											Hamburg	
											Hanover	
											Leipzig	
											Munich	
											Stuttgart	
											Budapest	HUNGARY
											Florence	ITALY
											Milan	
											Naples	
											Rome	
											Turin	
											Monte Carlo	MONACO
											Amsterdam	THE NETHERLANDS
											The Hague	
											Rotterdam	
											Lisbon	PORTUGAL
											Edinburgh	SCOTLAND
											Glasgow	
											Alcoy	SPAIN
											Alicante	
											Barcelona	
											Bilbao	
											Cartagena	
											Córdoba	
											Granada	
											Logroño	
											Madrid	
											Malaga	
											Murcia	
											Salamanca	
											San Sebastián	
											Seville	
											Valencia	
											Valladolid	
											Zaragoza	
											Berne	SWITZERLAND
											Geneva	
											Lausanne	
											Montreux	
											Zurich	

Country	Town/City	1909	1910	1911	1912	1913	1914	1915	1916	1917	1918
USA	Albany, NY										
	Atlanta, GA										
	Atlantic City, NJ										
	Austin, TX										
	Baltimore, MD										
	Birmingham, AL										
	Boston, MA										
	Bridgeport, CT										
	Brooklyn, NY										
	Chicago, IL										
	Cincinnati, OH										
	Cleveland, OH										
	Columbia, SC										
	Dallas, TX										
	Dayton, OH										
	Denver, CO										
	Des Moines, IA										
	Detroit, MI										
	Fort Worth, TX										
	Grand Rapids, MI										
	Hartford, CT										
	Houston, TX										
	Indianapolis, IN										
	Kansas City, MO										
	Knoxville, TN										
	Los Angeles, CA										
	Louisville, KY										
	Memphis, TN										
	Milwaukee, WI										
	Minneapolis, MN										
	Nashville, TN										
	New Haven, CT										
	New Orleans, LA										
	New York, NY										
	Oakland, CA										
	Omaha, NE										
	Philadelphia, PA										
	Pittsburgh, PA										
	Portland, OR										
	Providence, RI										
	Richmond, VA										
	Rochester, NY										
	Salt Lake City, UT										
	San Francisco, CA										
	Seattle, WA										
	Spokane, WA										
	Springfield, IL										
	St Louis, MO										
	St Paul, MN										
	Syracuse, NY										
	Tacoma, WA										
	Toledo, OH										
	Tulsa, OK										
	Washington, DC										
	Wichita, KS										
	Worcester, MA										
URUGUAY	Montevideo										

1919	1920	1921	1922	1923	1924	1925	1926	1927	1928	1929	Town/City	Country
											Albany, NY	USA
											Atlanta, GA	
											Atlantic City, NJ	
											Austin, TX	
											Baltimore, MD	
											Birmingham, AL	
											Boston, MA	
											Bridgeport, CT	
											Brooklyn, NY	
											Chicago, IL	
											Cincinnati, OH	
											Cleveland, OH	
											Columbia, SC	
											Dallas, TX	
											Dayton, OH	
											Denver, CO	
											Des Moines, IA	
											Detroit, MI	
											Fort Worth, TX	
											Grand Rapids, MI	
											Hartford, CT	
											Houston, TX	
											Indianapolis, IN	
											Kansas City, MO	
											Knoxville, TN	
											Los Angeles, CA	
											Louisville, KY	
											Memphis, TN	
											Milwaukee, WI	
											Minneapolis, MN	
											Nashville, TN	
											New Haven, CT	
											New Orleans, LA	
											New York, NY	
											Oakland, CA	
											Omaha, NE	
											Philadelphia, PA	
											Pittsburgh, PA	
											Portland, OR	
											Providence, RI	
											Richmond, VA	
											Rochester, NY	
											Salt Lake City, UT	
											San Francisco, CA	
											Seattle, WA	
											Spokane, WA	
											Springfield, IL	
											St Louis, MO	
											St Paul, MN	
											Syracuse, NY	
											Tacoma, WA	
											Toledo, OH	
											Tulsa, OK	
											Washington, DC	
											Wichita, KS	
											Worcester, MA	
											Montevideo	URUGUAY

TIMELINE

	WORLD EVENTS	CULTURAL EVENTS	DIAGHILEV AND THE BALLETS RUSSES
1870	Franco-Prussian War. 4 September: capture of Paris and foundation of French 3rd Republic.	25 May: creation of the ballet *Coppélia* at Paris Opéra.	4 May: Alexandre Benois born in St Petersburg.
1871			
1872			31 March: Serge Pavlovich Diaghilev born near Novgorod. 31 March: the great art patron Misia Sert is born in St Petersburg.
1873	15/16 September: last German troops leave France.	13 January: premiere of Rimsky-Korsakov's opera *The Maid at Pskov (Ivan the Terrible)* in St Petersburg.	
1874			14 October: Diaghilev's father marries second wife Elena V. Panaeva; family moves to St Petersburg.
1875		Leo Tolstoy publishes the first chapters of *Anna Karenina* in the *Russian Herald*.	
1876	1 May: Queen Victoria proclaimed Empress of India. 10 March: first telephone call made by Alexander Graham Bell.	14 June: premiere of the ballet Sylvia choreographed by Louis Mérante at Paris Opéra.	
1877	April: Russia declares war on Turkey.	4 March: premiere of Pyotr Tchaikovsky's first ballet, *Swan Lake*, at the Bolshoi Theatre, Moscow.	
1878	13 June–13 July: Congress of Berlin settles Russia's advance into the Balkans and Caucasus.		
1879	Thomas Edison files patents for the electric light bulb.		Diaghilev moves with his family to their estate in Perm.
1880	1880–1: the first Boer War.		23 April: Mikhail Fokine is born in St Petersburg.
1881	1 March: Alexander II is Assassinated, Alexander III succeeds as Tsar of Russia.	11 January: premiere of the ballet *Excelsior* at La Scala, Milan.	25 October: Pablo Picasso is born in Malaga, Spain.
1882			17 June: Igor Stravinsky is born in Oranienbaum, near St Petersburg.
1888		13 February: Richard Wagner dies in Venice.	
1884		Summer: Société des Artistes Indépendants founded in France.	
1885	Karl Benz patents the 'Motorwagen', the first petrol-powered automobile.	Savva Mamontov forms the Russian Private Opera in Moscow. First performances: *A Life for the Tsar* (Mikhail Glinka), *The Snow Maiden* (Nikolai Rimsky-Korsakov).	9 March: Tamara Karsavina born in St Petersburg.
1886	28 October: Statue of Liberty unveiled in New York.	Last Impressionist exhibition in Paris.	
1887		Construction of Eiffel Tower begins for 1889 Paris Exposition Universelles.	
1888	15 June: Wilhelm II Becomes Emperor of Germany and King of Prussia.		20 February: Marie Rambert born in Warsaw, Poland (then under Russian rule).
1889			

	WORLD EVENTS	CULTURAL EVENTS	DIAGHILEV AND THE BALLETS RUSSES
1890		First performances of Alexander Borodin's *Prince Igor*, Tchaikovsky's *Queen of Spades* and *The Sleeping Beauty* in St Petersburg.	12 March: Vaslav Nijinsky born in Kiev, Ukraine. Diaghilev's father bankrupted. Diaghilev meets Alexandre Benois in St Petersburg. Diaghilev first visits Western Europe. September: Diaghilev begins a Law degree at St Petersburg University.
1891	Construction of Trans-Siberian Railway begins.		23 April: Sergei Prokofiev born in Sontsovka, Ukraine (then under Russian rule).
1892	Summer drought triggers a famine in Russia.		Diaghilev and Dima Filosofov meet Leo Tolstoy in Moscow.
1893		29 October: premiere of Tchaikovsky's 6th Symphony (*Pathétique*). 6 November: Tchaikovsky dies in St Petersburg.	
1894	1 November: Tsar Alexander III dies at the age of 49, succeeded by Nicholas II.	22 December: *Prélude à l'après midi d'un faune* by Claude Debussy performed in Paris.	Diaghilev graduates.
1895	Wilhelm Röntgen discovers X-rays.	28 December: Auguste and Louis Lumière show first Cinématographe film in Paris.	
1896	First modern Olympic Games held in Athens, Greece.	Fydor Chaliapin makes his Moscow debut in *A Life for the Tsar*. 17 October: Anton Chekhov's *The Seagull* premiered at the Alexandrinsky Theatre in St Petersburg.	
1897		22 June: Konstantin Stanislavsky founds the Moscow Art Theatre. Vienna Secession is founded with Gustav Klimt as first president.	
1898	Russian Museum opens in St Petersburg.	7 January: *Sadko* by Nikolai Rimsky-Korsakov premieres in Moscow, presented by the Russian Private Opera; sets designed by Korovine, Maliutin and Vrubel.	Diaghilev and Alexandre Benois found *Mir iskusstva* (*World of Art*), magazine.
1899	1899–1902: the second Boer War.	*The Interpretation of Dreams* by Sigmund Freud is published in Vienna.	September: Diaghilev employed by the Imperial Theatres for special assignments, including editing the Theatres' Year Book.
1900	Eastman Kodak introduces the Brownie camera. Count Ferdinand von Zeppelin invents the first rigid airship.	Exposition Universelles in Paris, which includes Loïe Fuller's theatre.	
1901	22 January: Queen Victoria dies, succeeded by Edward VII.	Alexandre Benois appointed Scenic Director of Maryinsky Theatre in St Petersburg.	Diaghilev dismissed from the Imperial Theatres.
1902		Georges Méliès's film *La Voyage dans la lune* plays in Paris.	Diaghilev and Filosofov travel in Europe, and visit Baron Richard von Krafft-Ebing's sanatorium in Graz, Austria.
1903	Second Congress of the Russian Social-Democratic Labour Party, and Bolshevik / Menshevik Split.	First Salon d'Automne held at Grand Palais, Paris, organized by Henri Matisse, Georges Rouault and André Marquet.	
1904	8 February: outbreak of Russo-Japanese War. 8 April: Entente Cordiale between the UK and France.	17 January: Stanislavsky directs the premiere of *The Cherry Orchard* at Moscow Art Theatre. 15 July: death of Anton Chekhov. 15 July: Isadora Duncan dances in Russia.	*Mir iskusstva* (*World of Art*), ceases publication. 22 January: George Balanchine born in St Petersburg.

	WORLD EVENTS	CULTURAL EVENTS	DIAGHILEV AND THE BALLETS RUSSES
1905	1905 Revolution. 9 January: 'Bloody Sunday' Massacre outside Winter Palace, St Petersburg. Russia changes from Absolute to Constitutional Monarchy.	Salon d'Automne exhibition opens in Paris, where 'Fauvism' is first defined.	6 March: opened by the tsar, Diaghilev's *Exhibition of Russian Historical Portraits* goes on display at the Tauride Palace, St Petersburg.
1906			Diaghilev's survey of Russian Art opens at the Salon d'Automne, Grand Palais; the exhibition tours to the Schulte Salon, Berlin.
1907			Diaghilev's Russian art exhibition appears at the eighth Venice Biennale. Diaghilev and Nikolai Rimsky-Korsakov organize Russian music concerts at the Paris Opéra.
1908	Henry Ford begins production of the Model T automobile. Summer Olympiad held in London.		Diaghilev produces *Boris Godunov*, directed by Alexander Sanin, starring Fyodor Chaliapin and featuring the chorus of the Bolshoi, Moscow at the Paris Opéra.
1909		F.T. Marinetti publishes the 'Founding and Manifesto of Futurism'.	Diaghilev's first season of ballet and opera at the Théâtre du Châtelet, Paris, makes a significant loss but achieves critical success.
1910	Death of King Edward VII, accession of King George V.	20 November: death of Leo Tolstoy. 8 November: Roger Fry's *Manet and the Post-Impressionists* exhibition opens at the Grafton Galleries, London.	Diaghilev returns to Paris for a second season, when Stravinsky's first ballet, *The Firebird*, is presented. Diaghilev also presents ballet in Berlin and Brussels.
1911		Edward Gordon Craig publishes *On the Art of Theatre*.	Nijinsky dismissed from the Imperial Ballet. The Ballet Russes becomes a permanent company, giving its first performances at Monte Carlo, Rome and the Coronation Season in London. Ida Rubinstein leaves the Ballets Russes.
1912	April: RMS Titanic sinks. 8 October 1912–17 May 1913: Balkan Wars in Europe.		First tours of Central Europe. Nijinsky choreographs *L'Après-midi d'un faune*. Fokine leaves the Ballets Russes.
1913	300-year anniversary of Romanov rule in Russia.		First performances in South America. Fokine is invited back following Nijinsky's marriage and dismissal.
1914	1 August: outbreak of World War I. St Petersburg renamed Petrograd.		Diaghilev's last season in Paris and London of Russian opera and ballet before the war. July: Company disperses after last night at Drury Lane.
1915		8 February: premiere of D.W. Griffith's film *The Birth of a Nation* in Los Angeles.	May: company reforms in Switzerland; only two performances, one each in Geneva and Paris. Massine emerges as the company's choreographer.
1916	1 July: beginning of the Battle of the Somme.	Picasso's *Les Demoiselles D'Avignon* is displayed at the Salon d'Antin, in a gallery on the premises of Paul Poiret's fashion house, Paris.	Two long tours of the United States; first performances in Spain. Nijinsky rejoins the Ballets Russes in America and Spain.
1917	Russian Revolutions of 1917: Tsar Nicholas II abdicates. July–October, Provisional Government headed by Alexander Kerensky.	27 September: death of Edgar Degas. 17 November: death of Auguste Rodin.	Only Ballets Russes season in Paris during the war includes creation of *Parade*. Last tour to South America.

	WORLD EVENTS	CULTURAL EVENTS	DIAGHILEV AND THE BALLETS RUSSES
1917 (ctd)	25 October (Julian calendar), 7 November (Gregorian calendar): Bolsheviks take over with Lenin as head. 30 October: Kerensky repulsed outside Petrograd. Russian Civil War begins.		
1918	11 November: end of World War I.		Company invited to perform at the London Coliseum.
1919	5–12 January: Spartacist uprising in Berlin.	The Ballets Suédois performs first season at the Théâtre des Champs-Elysées, Paris.	The Ballets Russes give 375 performances in Britain, including the premieres of *La Boutique fantasque* and *Le Tricorne*, and three in Paris.
1920	10 August: Treaty of Sèvres, Ottoman Empire dismantled.		The Ballets Russes restarts tours of Europe.
1921		Alexander Rodchenko and Varvara Stepanova publish 'Constructivist Art'.	Massine leaves the Ballet Russes. *The Sleeping Princess* is presented at the Alhambra, Leicester Square, London.
1922	Soviet Russia becomes USSR (Union of Soviet Socialist Republics). 3 April: Stalin becomes General Secretary of the Communist Party of the Soviet Union. 22 October: Benito Mussolini becomes Prime Minister of Italy.		February: Diaghilev bankrupted and company suspended. May: company reforms in Monte Carlo. Ballets Russes becomes resident opera-ballet company in Monte Carlo for the winter season.
1923			
1924	Lenin dies. Creation of Triumvirate headed by Stalin. Summer Olympics held in Paris.	Soirée de Paris season at Théâtre de la Cigale, Paris (17 May – 30 June 1924).	Diaghilev presents French Opera season at Monte Carlo; first major post-war tour of Germany. Bakst dies. Balanchine joins the Ballets Russes.
1925	Adolf Hitler publishes vol. I of *Mein Kampf*.	Exposition Internationale des Arts Décoratifs et Industriels Modernes in Paris. Sergei Eisenstein directs *The Battleship Potemkin*. 1 July: death of Erik Satie. 2 October: Josephine Baker first performs at the Théâtre des Champs-Elysées, Paris.	
1926	General Strike in Britain.	Frederick Ashton choreographs *A Tragedy of Fashion*. Fritz Lang directs *Metropolis*.	
1927		Martha Graham opens school of dance in New York. Premiere of *The Jazz Singer*, the first feature-length talking picture.	Diaghilev's half-brother Valentin is deported to the Solovki prison camp.
1928	Alexander Fleming discovers penicillin.	Ida Rubinstein commissions and performs in Maurice Ravel's *Boléro*. Rudolf Laban publishes *Labanotation*, a system of recording human movement.	
1929	February: Stalin Expels Trotsky from the USSR. October: United States stock market crashes.		4 August: last performance by Diaghilev's Ballets Russes at Casino Theatre, Vichy. 19 August: Diaghilev dies in Venice. 21 August: Diaghilev is buried on the island of San Michele. Weeks later, Diaghilev's half-brother Valentin is executed.

ACKNOWLEDGEMENTS

Diaghilev and the Golden Age of the Ballets Russes 1909–1929 has been made possible by the assistance of many people. We would like to thank the staff of the Theatre & Performance Collections of the V&A who have been a constant support, with seven members of the curatorial team contributing to this publication. We would also thank our former colleagues and supporters of the T&P who enabled the V&A to build its impressive collection. Most notable among these are Richard Buckle, Pip Dyer, Alexander Schouvaloff and Sarah Woodcock. The exhibition has also benefited from the assistance of volunteers and interns including Antigone Antoniou, Natalia Budanova, Diana Damian, Veronica Isaac, Hannah Kauffman, Anna Landreth-Strong, Eirini Marouli, Katerina Pantelides and Zoe Perry.

For the exhibition we have benefited from the work of our Exhibition Coordinators, Penny Wilson and Diana McAndrews, assisted by Anu Ojala. Our thanks go to them and to Laura Shaw who served as Research Assistant in the early days of the project. Also in the Exhibitions Department our thanks go to Rebecca Lim and Linda Lloyd Jones as well as to our exhibition text editor Mark Kilfoyle.

For the design of the exhibition we thank Tim Hatley, Angela Drinkall and Paul Dean of HatleyDrinkallDean, who worked with exhibition graphic design by Chris Bigg, and lighting by David Atkinson of DALD. The project was managed by Keith Flemming and Sor Lan Tan of Flemming Associates.

Much of the AV material for the exhibition was specially made and we would like to thank all those who contributed, particularly Richard Alston and the Richard Alston Dance Company, Howard Goodall, Martin Rosenbaum and Rebecca Savage (Camera), Adam Rickets and Mark Swinglehurst (Sound) and Charles Chabot together with Jill Evans and David Bickerstaff of New Angle.

We would particularly like to thank those individuals (including those who prefer to remain anonymous) and institutions who have lent material to the exhibition and those who have facilitated loans: Michael Phillips of Bethlem Royal Hospital; Mathias Auclair and Pierre Vidal of the Bibliothèque-musée de l'Opéra and Viviane Cabannes, Thierry Delcourt, Anne-Sophie Lazou, Bruno Racine and Françoise Simeray of the Bibliothèque nationale de France; Nicholas Bell and Laura Fielder of the British Library; Julia Blanks and Alexandra Gerstein of the Courtauld; Erik Näslund, Constance Trolle and Nils-Albert Eriksson of the Dance Museum (Dansmuseet), Stockholm; Brian Stewart of Falmouth Art Gallery; Gaël Mamine and Olivier Flaviano of the Fondation Pierre Bergé-Yves Saint Laurent; Mike Smalley of the Imperial War Museum, James Mitchell of John Mitchell Fine Paintings; Laurent Salomé of the musées de la Ville de Rouen; Isaac Gewirtz and Deborah Straussman of New York Public Library; Pallant House, Chichester; Derick Dreher, Judy Guston and Karen Schoenewaldt of the Rosenbach Museum and Library; Anna Meadmore of The Royal Ballet School; John Neumeier and Hans-Michael Schäfer of Stiftung John Neumeier, Hamburg; Eric Zafran of Wadsworth Atheneum, Hartford; Geoffrey Munn of Wartski; Honor Godfrey of the Wimbledon Lawn Tennis Museum; and Roja Dove, Francesca Galloway, Alex Lachmann, Bob Lockyer, Peter Sayers and Sjeng Scheijen.

During the preparation of this exhibition and publication we have been privileged to have access to many public and private collections, and appreciate the assistance that the curators, a number of whom have also curated their own exhibitions on the Ballets Russes, have given us. In addition to those listed above we would like to thank Iris Fanger and Frederic Woodbridge Wilson of the Harvard Theatre Collection, Elizabeth Aldrich of the Library of Congress, Natalia Metelitsa of the State Museum of Theatre and Music, St Petersburg; Francesca Franchi of The Royal Opera House Collections; Frances Pritchard of Whitworth Museum and Art Gallery; the staff of the Jerome Robbins Dance Collection, New York Public

Library for the Performing Arts, Jody Blake of the Marion Koogler McNay Art Museum, San Antonio; and Musée des arts décoratifs, Paris.

Other scholars and friends who have been particularly helpful include Julian Barran, Alex Bissett, Frances Byrnes, Richard Copeman, Clement Crisp, John Croft, Richard Davenport-Hines, Hugh Davies, Kate Flatt, Andrew Foster, Lynn Garafola, David Garnett, Cécile Godefroy, Jonathan Gray, Cynthia Harvey, Philippa Heale, Millicent Hodson and Kenneth Archer, Claudia Jeschke, Susan Jones, Rex Lawson, Nesta MacDonald, Anna Mackey, John Malmstad, Maria Mileeva, the descendants of Vladimir and Elizabeth Polunin, Mary Pritchard, Nancy Reynolds, David Robinson, Brad Rosenstein, Lesley-Anne Sayers, Jane Sharp, David Vaughan, Patrizia Veroli, Jenny Walton and Anna Winestein.

For an exhibition including a large proportion of the V&A's own collection, the museum's conservation, mounting and preservation teams have played a significant role. We would like to acknowledge the work of Clair Battisson, Valerie Blyth, Susan Catcher, Albertina Cogram, Sophie Connor, Cynthea Dowling, Sam Gatley, Chris Gingell, Joanne Hackett, Diana Heath, Lynda Hillyer, Charlotte Hubbard, Susana Hunter, Merryl Huxtable, Sung Im, Brenda Keneghan, Marion Kite, Dana Melchar, Keira Miller, Roisin Morris, Richard Mulholland, Victoria Oakley, Jane Rutherston, Janine Spijker and Natalia Zagorska-Thomas. The conservation of elements of the sets was a huge undertaking and we particularly thank Nicola Costaras in collaboration with Jim Dimond, Julia Nagle, Catherine Nunn and Laura Zukauskaite as well as Simon Jessel of Scenery Jessel for conserving and displaying the front cloth for *Le Train bleu*. Much of the conservators' work, together with other material, has been photographed by Pip Barnard, Richard Davis, Ken Jackson, Clare Johnson and Paul Robins, and their work also enhances the book.

We also thank other colleagues within the Museum: Melanie Appleby, Richard Ashbridge, Chris Breward, Julius Bryant, Juliet Ceresole, John Clarke, Richard Edgcumbe, Mark Evans, Rupert Faulkner, Robert Fitzgerald and the framing technicians of the Word & Image Department, Catherine Flood, Ruth Hibbard, Elizabeth James, Annabel Judd, Robert Lambeth, Christopher Marsden, Daniel Milford-Cottam, Liz Miller, Jane Scherbaum, Sandra Smith, Sonnet Stanfill, Lucy Trench, Damien Whitmore, Claire Wilcox and the V&A technical services team.

In respect of this book we would like to thank our copy-editor, Kate Bell, and our designers, Simon Elliott and Rupert Gowar-Cliffe at Rose, as well as Clare Davis, Mark Eastment, Laura Potter and Tom Windross of V&A Publishing.

Jane Pritchard and Geoffrey Marsh

PICTURE CREDITS

TEATRO ALLA SCALA

(ENTE AUTONOMO)

Recita **34** d'abbonamento
(Serie **A**)

STAGIONE 1926-1927

Recita **50ª**
(25ª del PRIMO Turno)

MERCOLEDÌ 12 GENNAIO 1927 - alle ore 21 precise

SECONDA RAPPRESENTAZIONE dei BALLI DIAGHILEW

CIMAROSIANA

Musica di **DOMENICO CIMAROSA**

Scene di **L. BAKST** — Costumi di **J. M. SERT** — Coreografia di **L. MASSINE**

Interpreti: Signore LUBOV TCHERNICHEVA, LYDIA SOKOLOVA, ALEXANDRA DANILOVA, VERA SAVINA, VERA PETROVA, DORA VADIMOVA, NATALIE BRANITSKA, HENRIETTE MAIKERSKA, LUBOV SOUMAROKOVA, TATIANA CHAMIÉ

Signori LÉONIDE MASSINE, LÉON WOIZIKOVSKY, STANISLAV IDZIKOVSKY, SERGE LIFAR, THADÉE SLAVINSKY, GEORGES BALANCHINE, CONSTANTIN TCHERKAS, NICOLAS EFIMOW, NICOLAS KREMNEW, RICHARD DOMANSKY

LE LAC DES CYGNES

Poema coreografico in un atto
Musica di **P. TCHAÏKOWSKY**

Scene di **C. KOROVINE** · Coreografia di **MARIUS PETIPA**

Signorina OLGA SPESSIVA · Signor SERGE LIFAR

Passo a tre: Signor STANISLAV IDZIKOVSKY; Signore LYDIA SOKOLOVA, VERA PETROVA

L'OISEAU DE FEU

Musica di **IGOR STRAWINSKY**

Scene e Costumi di **N. GONTCHAROVA** — Coreografia di **M. FOKINE**

Interpreti: Signorina OLGA SPESSIVA, Signor SERGE LIFAR — Signora LUBOV TCHERNICHEVA, Signor GEORGES BALANCHINE

Maestro Concertatore e Direttore:

ROGER DÉSORMIÈRE

Direttore della messa in scena: **SERGE GRIGORIEFF**
Direttori del Macchinario: **GIOVANNI e PERICLE ANSALDO**

PREZZI

Biglietto d'ingresso alla Platea ed ai Palchi . L. **15**,—	Biglietto d'ingresso alla prima Galleria . . . L. **8**,—	
Poltrone (oltre l'ingresso) " **70**,—	Posti numerati Prima Galleria (oltre l'ingresso) " **20**,—	
Poltroncine (oltre l'ingresso) " **45**,—	Biglietto d'ingresso alla Seconda Galleria . . " **6**,—	
Posti numerati di Platea (oltre l'ingresso) . . " **20**,—	Posti Numerati Seconda Galleria (oltre l'ingresso) " **15**—	

PALCHI

Prima fila . L. **400**,— Seconda fila . L. **500**,— Terza fila . L. **400**,— Quarta fila . L. **300**,—

A tutti i prezzi suesposti sarà applicato l'aumento governativo del 12 % come da R. Decreto del 23 gennaio 1921.
Le frazioni di centesimi devono essere arrotondate sino a 10 centesimi (R. Decreto 4 maggio 1920 N. 567).

IN PLATEA NON VI SONO POSTI IN PIEDI
È PRESCRITTO L'ABITO NERO PER LA PLATEA E PER I PALCHI

Durante l'esecuzione dello spettacolo è vietato di accedere alla Platea e alle Gallerie. È pure vietato di muoversi dal proprio posto prima della fine di ogni atto.

Gli indumenti e gli altri oggetti depositati alle guardarobe non possono essere ritirati che negli intervalli tra gli atti o alla fine dello spettacolo.

Ragioni d'ordine e d'arte hanno indotto la Direzione a vietare le repliche dei pezzi durante la rappresentazione. Il Pubblico è pregato di uniformarsi a tale disposizione.

Le biglietterie del Teatro e l'Ufficio Palchi si aprono alle ore 10 di ciascun giorno di rappresentazione per la vendita e per la prenotazione dei posti, dei palchi e per la vendita dei biglietti d'ingresso alla Platea e Palchi.

Per disposizione del Prefetto è assolutamente vietato agli spettatori di accedere a qualsiasi posto della Sala (Platea e Gallerie) con soprabiti, pellicce, bastoni, ombrelli e simili.

Per disposizione del Regolamento sulla vigilanza dei Teatri il pubblico può lasciare la sala, alla fine dello spettacolo, da tutte indistintamente le porte d'uscita.

Il Teatro si apre alle ore 20,15 — Le Gallerie alle ore 20

LA DIREZIONE.

Edizioni S. E. S. - Arti Grafiche Milanesi Reparto Manifesti - Milano, Corso S. Gottardo, 45 - Telef. 31-478

S.183 / 2008

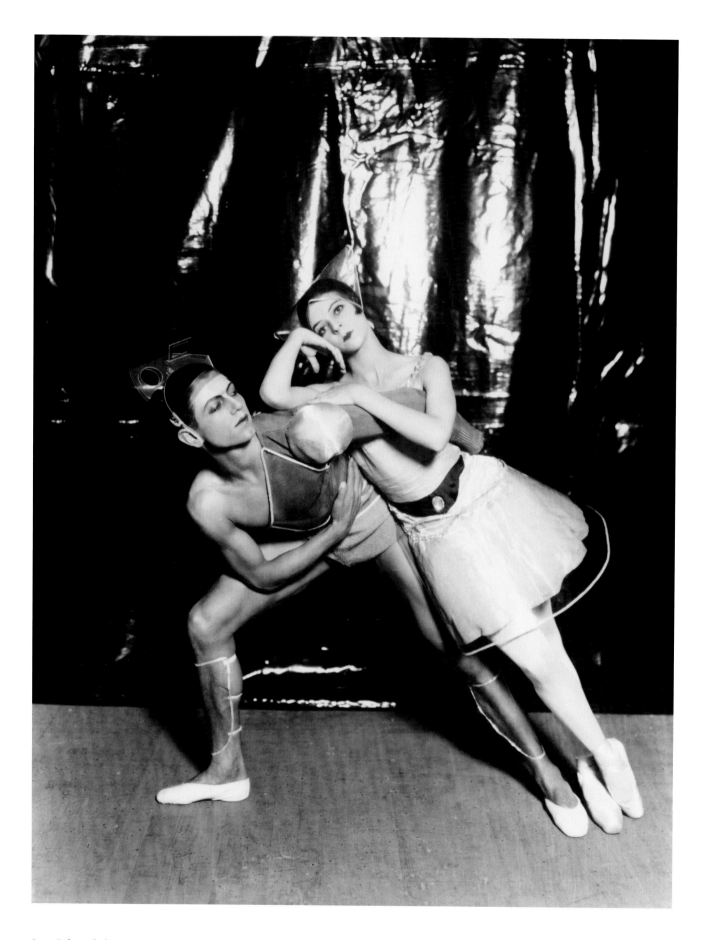

Serge Lifar and Alice
Nikitina in *La Chatte*, 1927.
Photograph by Sasha
V&A: Theatre &
Performance Collections

INDEX

Numbers in (brackets) are primary citations;
those in *italics* refer to illustrations.

240